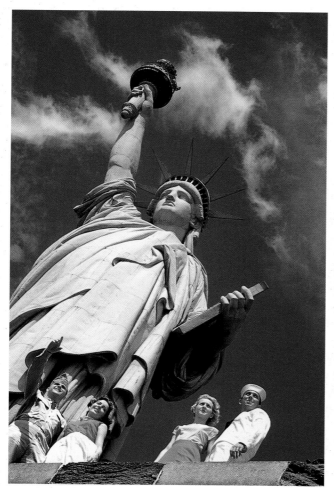

1954, Statue of Liberty, New York Harbor David S. Boyer

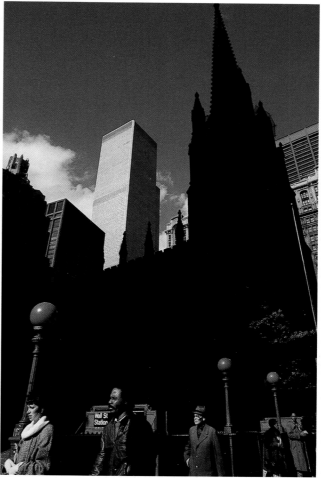

1988, Trinity Church, New York City Jodi Cobb

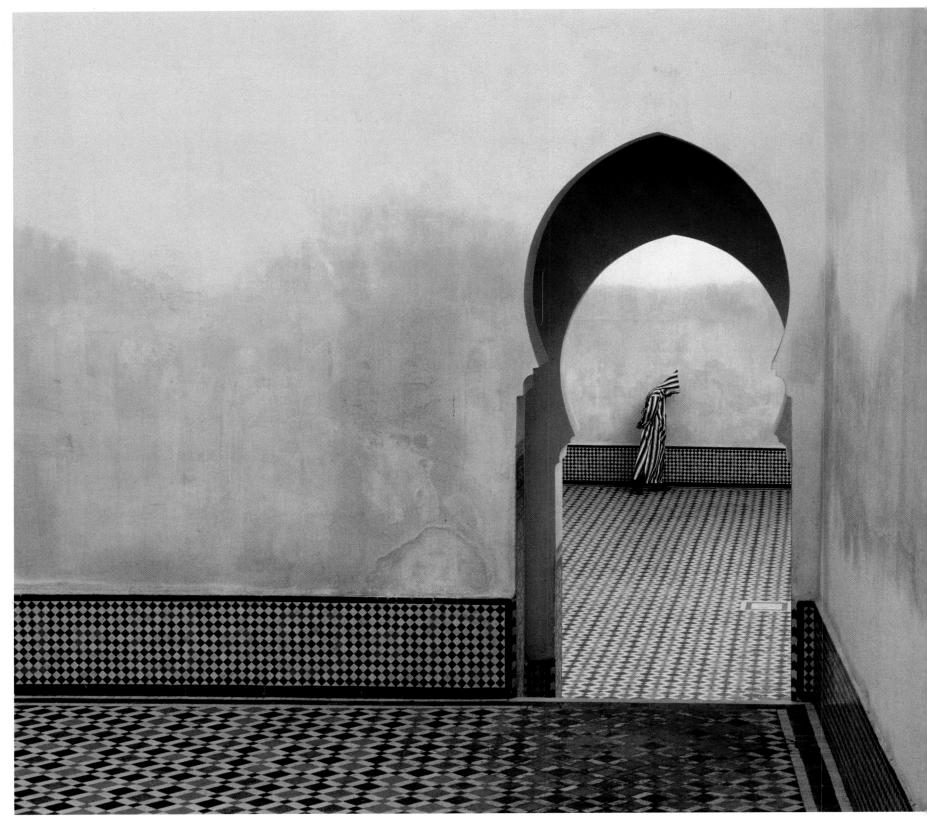

1996, Pilgrim at Shrine of Moulay Ismail, Morocco Bruno Barbey

NATIONAL GEOGRAPHIC
PHOTOGRAPHS

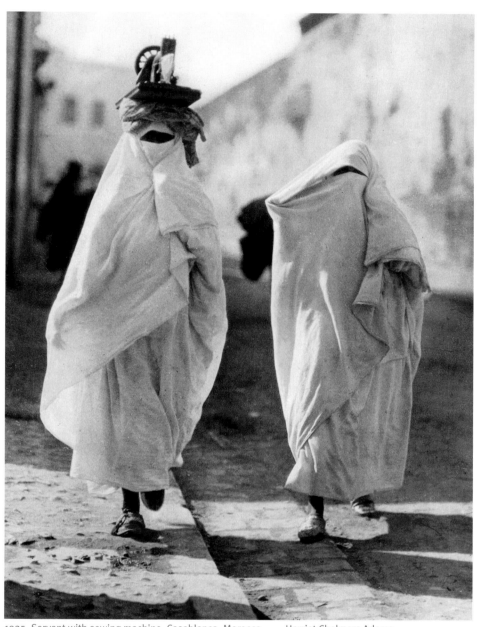

1925, Servant with sewing machine, Casablanca, Morocco Harriet Chalmers Adams

THEN AND NOW

PHOTOGRAPHS
THEN AND NOW

PUBLISHED BY
The National Geographic Society

John M. Fahey, Jr.
President and Chief Executive Officer

Gilbert M. Grosvenor
Chairman of the Board

Nina D. Hoffman
Senior Vice President

PREPARED BY THE BOOK DIVISION

William R. Gray
Vice President and Director

Charles Kogod
Assistant Director

Barbara A. Payne
Editorial Director and Managing Editor

David Griffin
Design Director

STAFF FOR THIS BOOK

Leah Bendavid-Val and Barbara Brownell
Project Editors

Lyle Rosbotham
Art Director

Barbara Brownell
Text Editor

Vickie M. Donovan
Illustrations Researcher

Marfé Ferguson Delano
Researcher and Legends Writer

Mary Jennings
Contributing Researcher

Janet A. Dustin
Illustrations Assistant

Peggy J. Candore, Kevin G. Craig, Dale-Marie Herring
Staff Assistants

R. Gary Colbert
Production Director

Lewis R. Bassford
Production Project Manager

MANUFACTURING AND QUALITY CONTROL

George V. White
Director

John T. Dunn
Associate Director

Vincent P. Ryan, Gregory Storer
Managers

Mark Wentling
Indexer

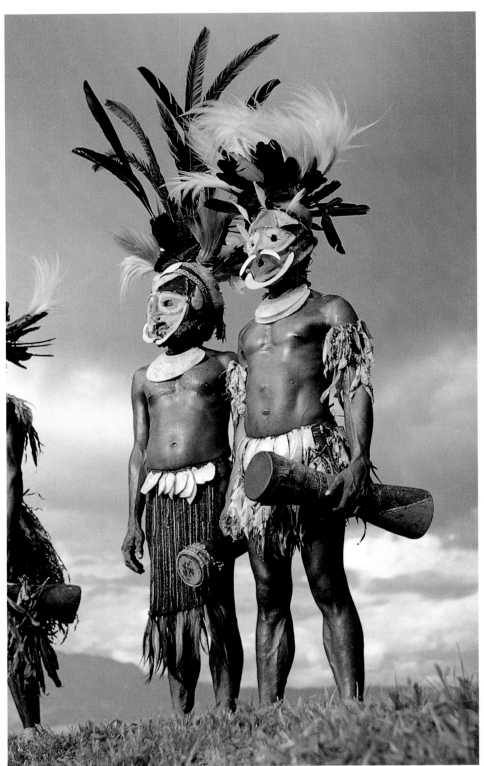

1953, Masked dancers, New Guinea E. Thomas Gilliard and Henry Kaltenthaler

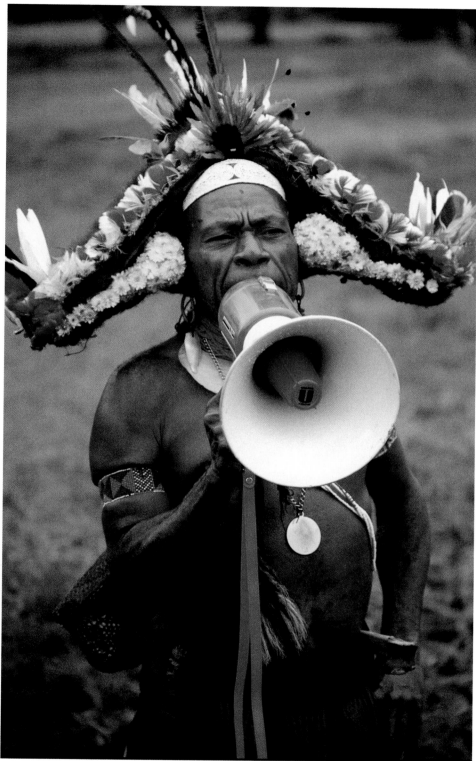

1982, Clan leader keeps order, Papua New Guinea David Austen

CONTENTS

Foreword

PHOTOGRAPHS
THEN AND NOW

1936, Jerusalem, Palestine
Household goods support a family business along this
centuries-old trade route between Egypt, Syria, and Asia.
Gervais Courtellemont

How large was the world when you were five years old? Fifteen? Now? As your awareness grew, your world expanded. Now as we can see and hear the entire planet, we have a global consciousness. In earlier years our experiences and contacts were more local—our neighborhood, town, state, or country. Today, our reach extends to the planet and beyond. We know of an earthquake in Afghanistan and warfare in East Africa within minutes or hours.

Our knowledge of the world's excitement and of its tragedies gives us new understanding with each report. We have much more to comprehend—and we need someone to provide the context and explanations for our expanding world. For well over a century NATIONAL GEOGRAPHIC has presented observations of our planet, its origin, its flora and fauna, and its people. Our role

today as reporters and presenters is essential as more and more information overwhelms us. How to capture knowledge from information? How has the world changed? What have we lost?

Our mission, *the increase and diffusion of geographic knowledge,* has allowed us to watch the world change while we covered it. We are explorers. We are adventurers. We are scientists. And writers and photographers. We are those who make history. And we are those who report it.

"We," being the collective group of people who make up the staff and contributors of the NATIONAL GEOGRAPHIC magazine. The individuals come and go, but the "we" is a fixed pronoun and a permanent presence. It is an inheritance from the time the Society was a "gentleman's club" of pin-striped suits, debates of esoteric questions, and membership in the scientific elite. Today khakis and climbing boots replace the suits, our journalists must get beneath the surface of issues and places in the face of pressing deadlines to produce better articles for each issue, and we reach nearly 50 million readers in every country in the world. Fatigue, frustration, and tetanus shots are the current amenities of travel. Understandably our editors have on their walls such consolations as "Adventure is inconvenience rightly viewed," or "An adventure is a sign of poor planning."

And yet it still surprises me every time I come to a place where "we've" been or I hear a name on the list of legacies who defined the GEOGRAPHIC. Luis Marden, one of our famed veterans, has truly seen the world, and the world remembers him. GEOGRAPHIC writers and photographers on assignment often face the unexpected query about Mr. Marden from the most unlikely sources.

An Eskimo in the Arctic remarked to a GEOGRAPHIC writer that he had already promised an interview to Luis Marden. A treasure hunter in Bermuda asked a GEOGRAPHIC photographer, "How's Luis Marden?" Others on the list of Marden inquirers: a dive-shop operator in Tahiti, a jungle guide in Venezuela, and the owner of an island off the coast of Brazil.

And in April when I was in Jordan, the Crown Prince said as we met: "Please give my best regards to Luis Marden."

There is a subtle comfort-level that accompanies our staff members on assignment. They learn the language and customs. They spend weeks or months researching a place and even more time just getting to know the people.

After 110 years of this kind of coverage, the GEOGRAPHIC has a wealth of contacts and friends across the world. And the good trails left by one generation of our staff pave the way for the next. As the times have changed, so has the GEOGRAPHIC's approach.

In the magazine's younger years, we filled numerous pages with charming words and pictures. Today, the resounding yellow border represents a bolder magazine that covers the places and the people in a steelier light. As you will see throughout this book, the photography and the writing of the magazine shifted from the panoramic sweep to more focused, sometimes tragic, occasionally humorous looks at reality.

Of course, it was not a sudden transition. It took several editors, scores of writers and photographers, and the occasional gun-bearing director of photography (even if the bullets were only blanks). The varying personalities of the magazine's staff certainly reflected the changing world around them. Fieldwork continued to be dangerous and demanding, even bizarre. In order to abandon the feel of the foreigner in the intimate confines of another culture, writers and photographers have had to adapt quickly. In some cases, they've been known to partake in local cuisine ranging from raw (and still warm) liver of various animals to insects to fresh python.

Staff archaeologist George Stuart and pilot landed a helicopter on a Mexican dirt road to ask a traveler on his bicycle in which direction could they find Guatemala.

And photographer Jim Stanfield snapped away even as his Vicker's Vimy crash-landed in a rice paddy in Sumatra. The fact that Stanfield was thrilled at the great photo opportunities while ignoring the screams of the pilot to get strapped in remains an example of true dedication to work ethic gone awry.

Our coverage changed to accommodate a changing world. But in the pages of this book, time after time, the past displays its strong hold on the future. As I looked through the photographs and read the descriptions, I was struck by the fact that through all this change, the people remained so much the same. The geishas in Japan's oldest entertainment district were not so different from their contemporary counterpart using a cellular phone. The hooded penitent hurrying to a Holy Week procession in Spain is much like earlier Spaniards who observed the holiday.

We are a collaboration of people and stories past as well as present. Our domain has grown and changed until those hands that once sought to reach every corner of the world have done so—again and again. We have become a reflection of our world—both then and now.

Bill Allen

Editor, NATIONAL GEOGRAPHIC

ABOUT THIS BOOK

The intrigue of *Then and Now* is in the pictures, but it is also in the way the pictures and the words work together to take you on a journey through time and across continents, experiencing change in landscapes, in people, in the way we look at the world. Photo-

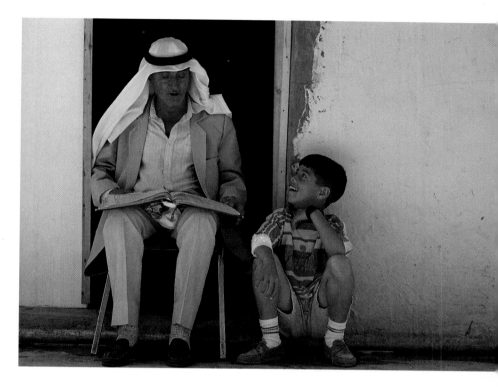

1994, Galilee, Israel
Outside the shack he uses for meditation, Abu Mofid Kosum pauses from reading the Koran to share a moment of levity with a young friend.
Annie Griffiths Belt

graphically, eight regions define the book: North America, Central and South America, Europe, Asia, the Middle East and North Africa, Africa, Oceania, and the Poles. Beginning each chapter, a veteran National Geographic writer or photographer reveals in an essay his or her experiences covering that area over time, with anecdotes that show how the magazine has been sensitive to the changes in a place. Following the essay, each double-page section might be considered a puzzle of sorts. The images draw you in. The captions not only identify the images, but link them to reveal the "then" and "now," sometimes dramatic, sometimes subtle; playful or heartrending. Finally, excerpts from NATIONAL GEOGRAPHIC articles accompany some pictures, lending further insight into the changes in a place and how the magazine has recorded them always in tune with the times.

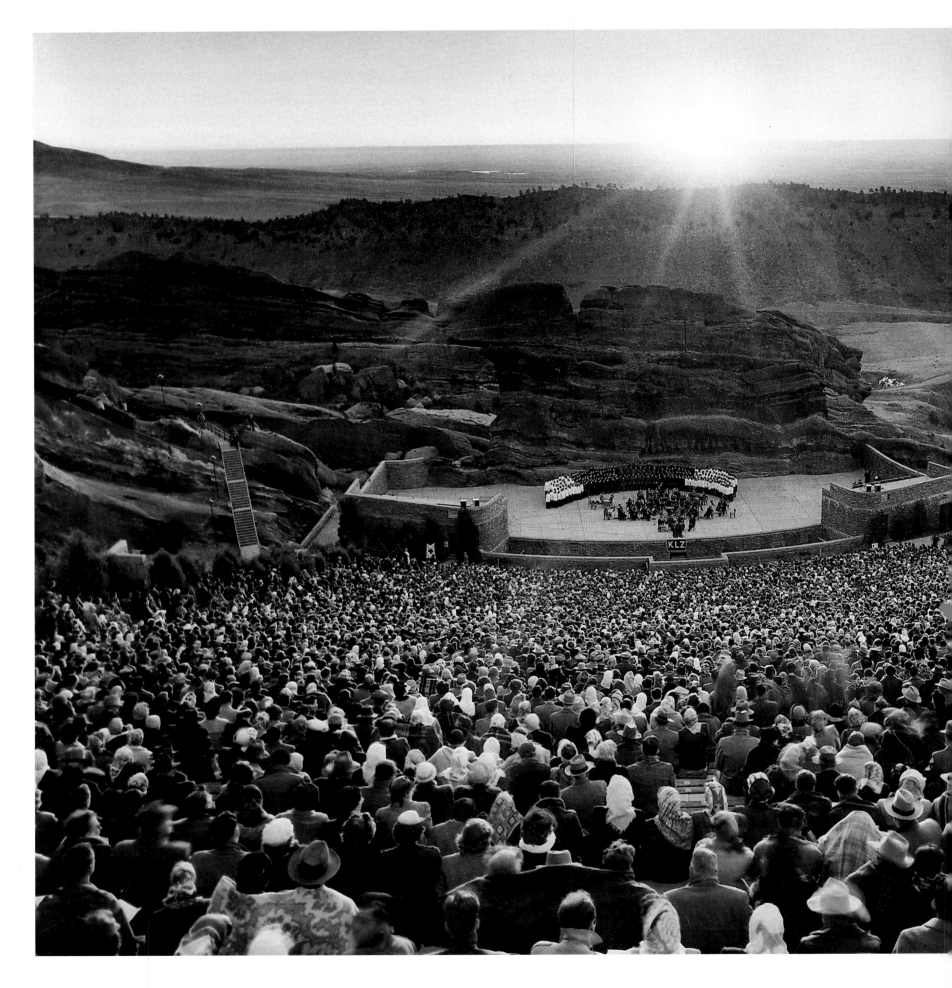

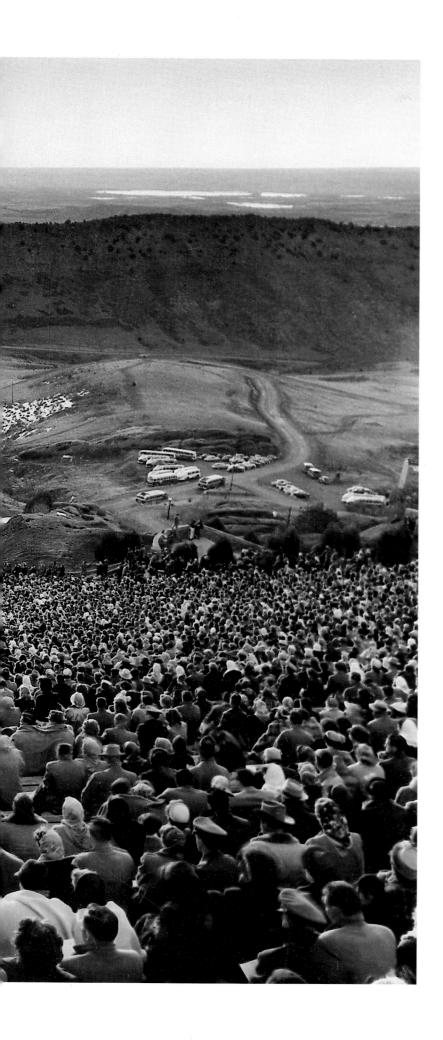

NORTH AMERICA

By Leslie Allen

1954, Colorado

First rays of dawn inspire worshipers at Easter sunrise service in Red Rocks Park, near Denver. The stones of the rugged amphitheater act as a sounding board.

Floyd H. McCall, *Denver Post*

following pages:

1994, Chicago, Illinois

Viewed from the 94th-floor observatory of the John Hancock Center, nighttime Chicago glitters like a diamond-studded carpet across 29 miles of Lake Michigan shoreline. The glowing towers (foreground) are 900 North Michigan Avenue, noted for its luxury shopping.

Gail Mooney

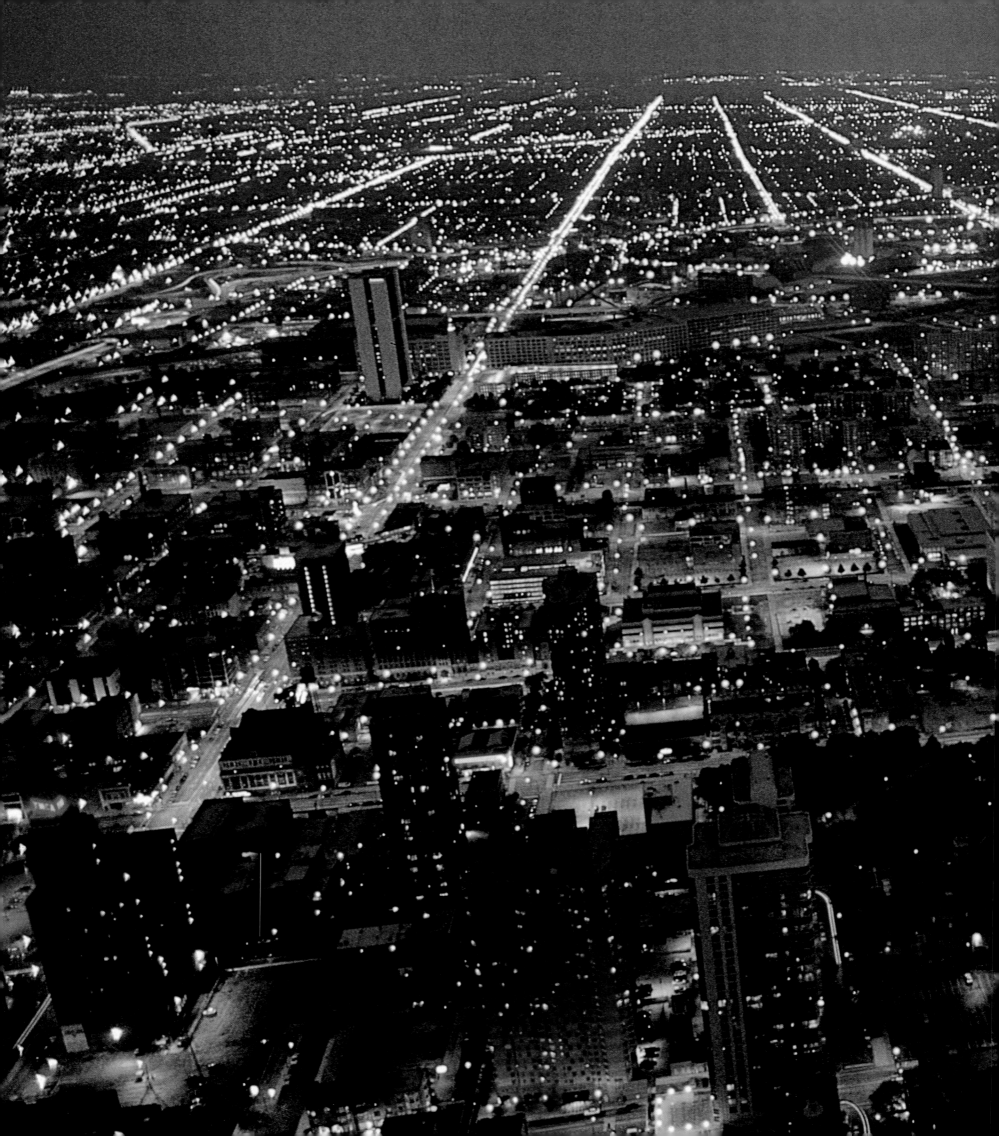

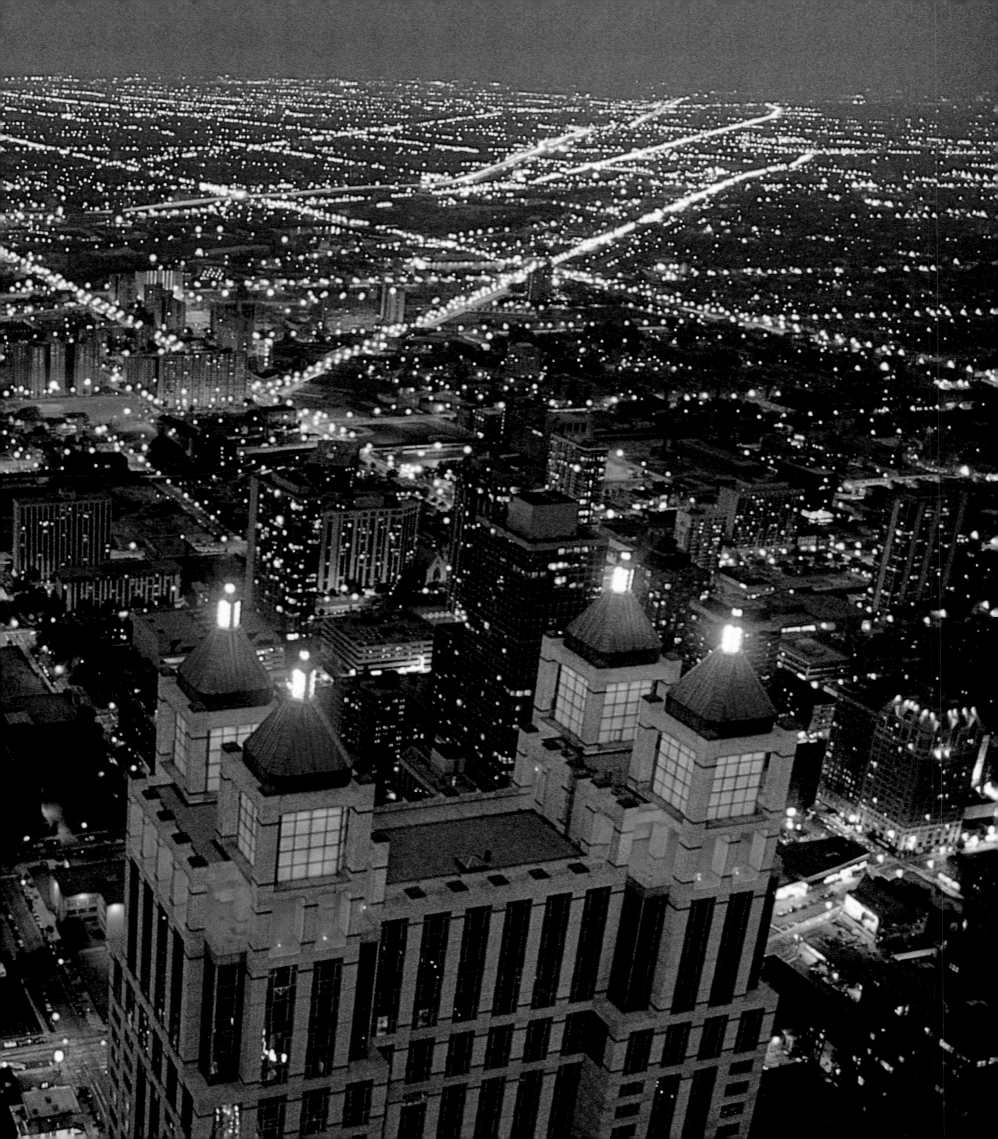

With heart-stopping booms, the night sky burst into flower, lighting more than a million upturned faces. In the darkness that followed, clouds of pungent phosphorous wafted over the crowd and the excited sounds of a score of languages mingled. I never lost track of where I was—the Statue of Liberty was dead ahead of me in New York Harbor—but time had become another matter, fluid and amorphous as quicksilver.

The date was July 4, 1986, and I had joined the crush of humanity in New York City to celebrate the Statue of Liberty's centennial. For me, the events also marked the end of an arduous professional journey: I had just spent more than a year writing the book *Liberty: The Statue and the American Dream* for the GEOGRAPHIC, which in turn had produced it as the official volume for this centennial. Ranging as far and wide into the precincts of "the American dream" as this brief time allowed, my work had taken me beyond the story of the Statue itself, through the history of American immigration, and on to the century of vast national change whose beginning, in the late 1800s, coincided with the Statue's arrival. *Vast* change? To say that change has been mind-boggling is no exaggeration.

And yet…there I was, fireworks bursting overhead, and my mind kept drifting back to words I had written to describe a similar scene at the Statue's unveiling a hundred years earlier. Despite all the change the century had framed, the scene around the Statue of Liberty that night also emphasized what was changeless: American bigness and brashness, maybe, but also openness and exhilaration (in many languages), expectation, and the open-endedness of the very idea of liberty.

The first century spanned by the Statue of Liberty, that most American of symbols, paralleled that of another American stalwart, NATIONAL GEOGRAPHIC, which first appeared in 1888. As I've mulled over more than a century's worth of pictures and text for this essay, I've experienced again and again that odd sensation of rapid, almost dizzying change mingled with those other unchanging qualities—a sensation akin to looking through a kaleidoscope at an image constantly reforming around an unchanging center.

In no other part of the world has change accelerated as quickly. (The phenomenal pace of change has itself served as an invitation for NATIONAL GEOGRAPHIC to return again and again over the years to a region, a city, a state.) Yet from distinguished early visitors like deTocqueville and Dickens on down through smalltown barbershop bards today, commentators have also pointed to similar unifying, unchanging qualities of land and people. NATIONAL GEOGRAPHIC reflects both these truths.

In hundreds of articles and in dozens of books, NATIONAL GEOGRAPHIC has focused on subjects close to home—on the land, the people, the cities and states, the phenomena of nature, and the alterations of man in the United States and, to a lesser extent, its North American neighbors. Casting a wide net, the magazine has covered subjects ranging from "The Geographical Distribution of Insanity in the United States" (1903) to "The Vanishing Prairie Dog" (1998). To many, the depth and breadth of North American coverage comes as a surprise. NATIONAL GEOGRAPHIC, after all, is synonymous with the exotic. It is an American icon best known for photographs and words about the world's remotest reaches and its most alien cultures. Focusing on the more familiar has often been its own challenge.

Photographers and writers bring a multitude of formative experiences to this task. For me, home has always held a touch of the foreign and unfamiliar: Born within a mile of the White House, I stood as a very young American child on the deck of the S.S. *Constitution* and waved goodbye to the Statue of Liberty, not to return until adulthood. I grew up with the landscapes and languages of Latin America, Europe, and the Far East; my journey home has been, personally and professionally, one of ongoing discovery. But whether raised on midwestern farms or in New York apartment houses, in the U.S. or abroad, magazine contributors succeed by seeing American subjects, like more exotic foreign ones, with first-time freshness and a readiness for surprise.

In 1888, chunks of North America literally remained to be seen for the first time, remote as any ends of the earth. Geologist Israel C. Russell led the Society's first expedition, sponsored with the U.S. Geological Survey in 1890, to explore and map a vast mountainous region of southeastern Alaska. In 1891, the magazine published Russell's "Summary of Reports on the Mt. St. Elias Expedition," which laid down the tradition of first-person adventure reporting. Russell brought his audience along, placing them squarely in the path of "huge grizzly bears" and "roaring avalanches."

Gilbert H. Grosvenor, NATIONAL GEOGRAPHIC's first editor, wanted writing like Russell's—writing "that sought to make pictures in the reader's mind." Increasingly, during the 20th century's first years, advances in photography allowed the pictures to do their own talking. In 1911, a panoramic, eight-foot-long view of the Canadian Rockies appeared as a special supplement to the magazine. In 1917, Robert Griggs's "Kodaks and halftones" of his Society-supported expedition to Alaska's 17-mile-long Valley of Ten Thousand Smokes riveted readers and led to the establishment, a year later, of the Delaware-size Katmai National Monument.

Natural-color photographs, including 23 Lumière Autochromes, made their NATIONAL GEOGRAPHIC debut in 1916 in an American story, Gilbert Grosvenor's own "The Land of the Best." Early American stories focused not on people but on places. One exception: the lineups of the newly arrived at Ellis Island for the 1905 article "Our Immigration During 1904." Ironically, even at home, the camera focused first, to quote an early caption writer, on subjects in "true native dress"—including the land's original inhabitants, by then tragic and defeated.

A widespread sense that what was foreign belonged abroad was one result of World War I's horrors; among millions of victims of Europe's killing fields were some 320,000 American casualties. Americans longed for the lost innocence and security of small-town front porches and homespun values, and NATIONAL GEOGRAPHIC's upbeat state stories both reassured and instructed. While noting the transformation of Paul Revere's Boston neighborhood into Little Italy, the 1920 article "Massachusetts—Beehive of Business," was an album of industry on parade, with photographs of watches, shoes, and other products, including NATIONAL GEOGRAPHIC paper, in the making. In 1923, there was "Massachusetts and Its Position in the Life of the Nation" by Calvin Coolidge, whose prolix style offset his reputation as Silent Cal. Photographs of Plymouth Rock, Concord's North Bridge, and Old South Church memorialized the state's proud history; there were few "people shots" to interrupt the static views.

But coverage was about to be set in motion. In the 1920s there were "America from the Air" and "Seeing America with Lindbergh," among some 30 different aviation articles. The year Calvin Coolidge's story appeared, so did "The Automobile Industry: An American Art That Has Revolutionized Methods in Manufacturing and Transformed Transportation." This was a major article, featuring 76 illustrations on 79 pages, that signaled a whole new way for NATIONAL GEOGRAPHIC's readers to see the U.S.A. The automobile was already taking intrepid GEOGRAPHIC correspondents into such back-of-beyond spots as Sumatra's Batak Highlands and "the Deserts and Jungles of Africa." But it was in its own backyard that the magazine's "road stories" hit their stride. What, after all, could be more quintessentially American than taking to the open road? Than a narrative shaped by the road itself?

The evolution of these stories over several decades speaks eloquently of change, disruption, and the search for enduring touchstones. "A Patriotic Pilgrimage to Eastern National Parks" (1934), an automobile tour, gave way to "U.S. Roads in War and Peace" (1941) and the postwar optimism of "America on the Move"

(1946) and "You Can't Miss America by Bus" (1950). Then, in 1952, there was "Vacation Tour Through Lincoln Land," the first of editor Ralph Gray's summer excursions with his family. All were full of history, sunshine, and patriotism, qualities well served by the era's reliance on bright Kodachromes and picture postcard scenes of places and smiling people. In 1968—a year better known for the escalating Vietnam War, the assassinations of Robert Kennedy and Martin Luther King, Jr., and urban rioting— NATIONAL GEOGRAPHIC published "Our Growing Interstate High-

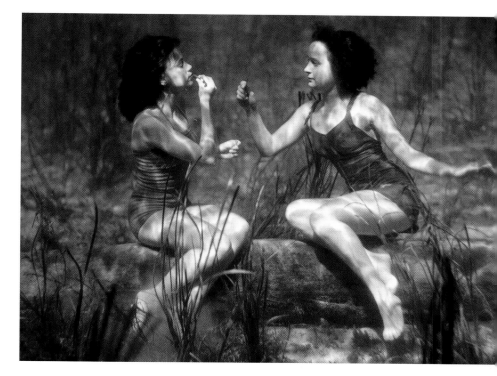

1944, Florida
Stunt swimmers stage a makeup session in the crystal-clear waters of Wakulla Springs, near Tallahassee.
J. Baylor Roberts

way System," which opened with these words: "Americans are living in the midst of a miracle."

Nevertheless, there seemed to be more and more shunpikers about, at least in the pages of NATIONAL GEOGRAPHIC. Some shunned wheels altogether. In the early 1970s, the Society published both articles and books based on the experiences of hikers who traveled the length of the Pacific Crest Trail and the Appalachian Trail, among others. These travelers were "on the road," in a time-honored American sense, but sustained notes of reflection regularly crept into their coverage. When I hiked through the West more than a decade later for the book *Pathways to Discovery*, my main discovery was the gift of intimacy with the land

that a journey under one's own power bestows. My feet read the record of land beneath them—clinking lava, shattered obsidian, springy loam. I wrote the words that come back to me every time I hit the trail: "To the hiker, moving along at two or three miles an hour, the landscape beheld is forever in the process of becoming...."

We slowed down, took our time; the photographs moved closer, physically and psychologically, to their subjects.

No one took his time more than young Peter Gorton Jenkins, who had just graduated from college in New York State in 1973 and had decided to walk across the United States. "I'd been so discouraged by all I'd been hearing about this country," he explained earnestly in "A Walk Across America" (1977), "that I decided I'd go and find out for myself." Heading south with his half-malamute dog, Cooper, Jenkins passed time with a hermit; lived with an African-American family in a trailer; sipped moonshine; worked on a commune in Tennessee; and buried Cooper after a truck ran him over. By the time Part II appeared in 1979, Jenkins—now accompanied by his new wife, Barbara—had walked 4,751 miles over five years. His photographs—like his words, those of an amateur—were intimate and straightforward, yet reverent; his articles, among the GEOGRAPHIC's most popular.

With "Discovering America" (1988), by the Polish husband-wife, photographer-writer team of Tomasz Tomaszewski and Malgorzata Niezabitowska, the American "road story" took new turns. This article had a different flavor than Jenkins's stories. It reflected not an American voyage of self-discovery—the kind of pilgrimage only an American could embrace—but a come-what-may approach.

If Jenkins's portraits depict the mostly worthy, kind-hearted Americans he came upon in his travels, Tomaszewski's images unblinkingly record whomever and whatever he came across. Here is a grinning towhead surrounded by kittens; there, former Ku Klux Klan president David Duke, speaking of the "endangered" white race. In a two-page opener, a junked car sprawls in the foreground while Manhattan's office towers bristle beyond.

In NATIONAL GEOGRAPHIC, the change over more than a century from exploration account to travel story to roadside realism is not confined to "road stories" and other American journeys. But these stories, with their elements of questing and nostalgia, with their mix of images familiar and jarring to millions of readers, bear a lot of freight. One of the most recent such articles, "Romancing the Road" (1997), a sentimental journey down Route 66, was used to introduce a new series, "Americana." Its purpose, according to its editor's note: "To celebrate the extraordinary breadth, diversity, and vitality of our cultural landscape...."

It would seem to be a mission of ever expanding, virtually limitless possibilities. Where to begin? Our cultural landscape—as big as, well, the landscape itself; as small as?... Increasingly, NATIONAL GEOGRAPHIC has, in exploring some American subjects, taken bigger bites off smaller plates. The "city" subject, a staple for decades, has in recent years gone uptown—or down—to focus tightly on a small part of the cultural landscape. In 1977, the GEOGRAPHIC published a neighborhood story, "To Live in Harlem," written and photographed by African Americans. In producing a basically optimistic piece, the magazine hewed to its traditional mandate; in focusing on African Americans and in breaking stereotypes about the inner city, it trod new ground. Since then, NATIONAL GEOGRAPHIC has presented other cultural views: "Growing Up in East Harlem" (1990), "Broadway: Street of Dreams" (1990), and "Sunset Boulevard: Street to the Stars" (1992).

This new breed of "city stories" is another reminder of the vastness of change: Our large cities are no longer one place but many, fragmented by freeways and demarcated by class, language, and other frontiers. Such division has also meant, in some urban landscapes, breakdown—a reality that the GEOGRAPHIC's photographers and writers have gradually come to face squarely.

As a people, Americans have always had a love-hate relationship with our cities. Our real shrines—the cathedrals of our cultural landscape—are to be found far from urban centers. The magazine dealt with natural wonders well before the turn of the century and with "Our National Parks" for the first of many times in 1912. In 1933, a GEOGRAPHIC special feature called "Nature's Scenic Marvels of the West" offered a heavily illustrated armchair tour of marvels, compiled in large part from official National Park Service views and Army Air Corps aerials. It included the Grand Canyon, Zion and Bryce Canyons, Lower Yellowstone Falls, giant redwoods, and towering cliffs at Rocky Mountain National Park.

Contrast this with Copper Canyon as seen for the 1991 story, "The Colorado: A River Drained Dry": hundreds of swimsuit-clad revelers in craft jammed together for a Labor Day tie-up. You can't see the scenery for the scene. Or with the most recent Grand Canyon article, "The Grand Managed Canyon" (1997), focusing on the effects that millions of visitors each year have on the canyon.

NATIONAL GEOGRAPHIC's images of our natural treasures have changed because so many of North America's unique natural landscapes have been altered by humans. And although you can find, in the magazine's index, an exception like "Pollution of the Potomac River" back in 1897, coverage of these places has changed because the National Geographic Society itself has evolved rather

remarkably. While generally advocating conservation, the GEO-GRAPHIC early on became legendary for tiptoeing around controversy—especially controversy close to home. As Editor Frederick G. Vosburgh famously said before his retirement in 1970, "The GEOGRAPHIC's way is to hold up the torch, not to apply it."

Ironically, the Editor was unknowingly holding up a semaphore: Like a venerable ocean liner, NATIONAL GEOGRAPHIC was starting a slow turnabout. The environment gained real prominence in the 1980s. In the 1990s, environmental concerns came to the fore in U.S. coverage with such strong, visually arresting pieces as "Dead or Alive: The Endangered Species Act" (1995), "Our Disappearing Wetlands" (1992), and "Our National Parks: Legacy at Risk" (1994).

One of the things that makes these stories powerful—and poignant—is their juxtaposition of beauty and loss. Not some faraway people's, either: *Our* beauty. Our loss. It was the sense I had when, on assignment for *Trails,* I walked in wonder through an ancient forest in Oregon, and then, emerging, faced the shocking nakedness of clearcut slopes. It is also the sense now shared by many other Americans who have had similar experiences. And with the threat of loss comes the more startling realization of limits. The U.S. is, according to historical belief, the land of limitless possibility. But these stories tell us and show us that in our natural lands and resources, what we see in these beautiful photographs is all we have, to lose or preferably to cherish forever. There are not scores of unknown plants and animals out there awaiting a "field man's" triumphant discovery. There are places called "wilderness" but there is not another uncharted mountain range. Once in a great while an exception comes along—New Mexico's vast, previously unexplored Lechuguilla Cave (1991), for instance.

In 1888, when the National Geographic Society came into existence, there was still, officially, an American frontier. The concept became obsolete just a few years later, but the frontier's "closing" has been a much longer time coming in the minds of Americans. NATIONAL GEOGRAPHIC reflects this growing sense of limits in its coverage of our great natural areas, but also by carefully and objectively explaining the issues surrounding their future. At the same time, there persists an underlying message of hopefulness that is in keeping with the magazine's own traditions—and with changeless qualities of Americans themselves, qualities that I have heard in hundreds of voices, dozens of landscapes.

In the magazine, this sense of limits is also portrayed by a greater acknowledgment of the interconnectedness of the United States and its neighbors. NATIONAL GEOGRAPHIC's interest in Mexico, for instance, had long been largely archaeological; then in August 1996 the magazine appeared as a special issue devoted entirely to Mexico, coverage rarely given to a single nation.

Alongside this outlook, another change has been the lessening distinction between how Americans and others appear in the pages of the magazine. Americans appeared later than the "natives" of other lands. During the first several decades that they did, the photographs had the cheerful, impersonal gloss of postcards or even ads peopled by the fair and the fair-haired. But all the while, the people who called themselves Americans were becoming ever more

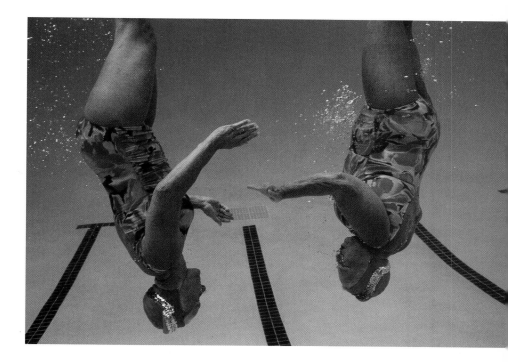

1997, Laguna Hills, California
Seniors rehearse an underwater ballet at the city's Leisure World retirement community.
Karen Kasmauski

following pages:
1929, Washington, D.C.
In the Capitol's shadow, a two-pump gas station does its part to keep the nation running.
Edwin Wisherd

diverse. While the GEOGRAPHIC was out photographing other peoples of the world, the U.S. was becoming that world. In my work and in my life, this has made the very idea of "home" more dynamic, interesting, complex, even elusive than I imagined possible when I returned from abroad to live here again.

In its newer U.S. stories, the GEOGRAPHIC has now risen to a great challenge that most other kinds of articles don't have to: turning the lens into a mirror.

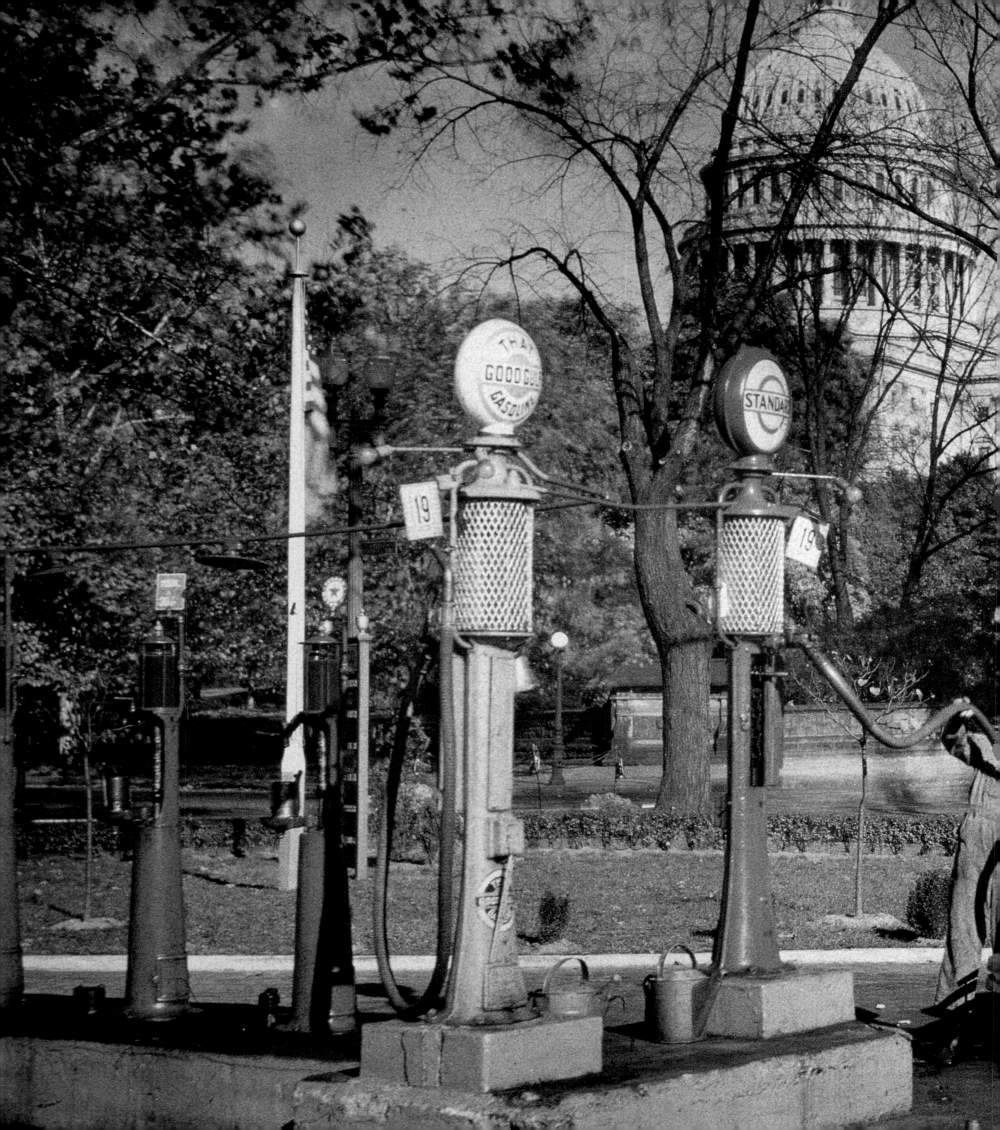

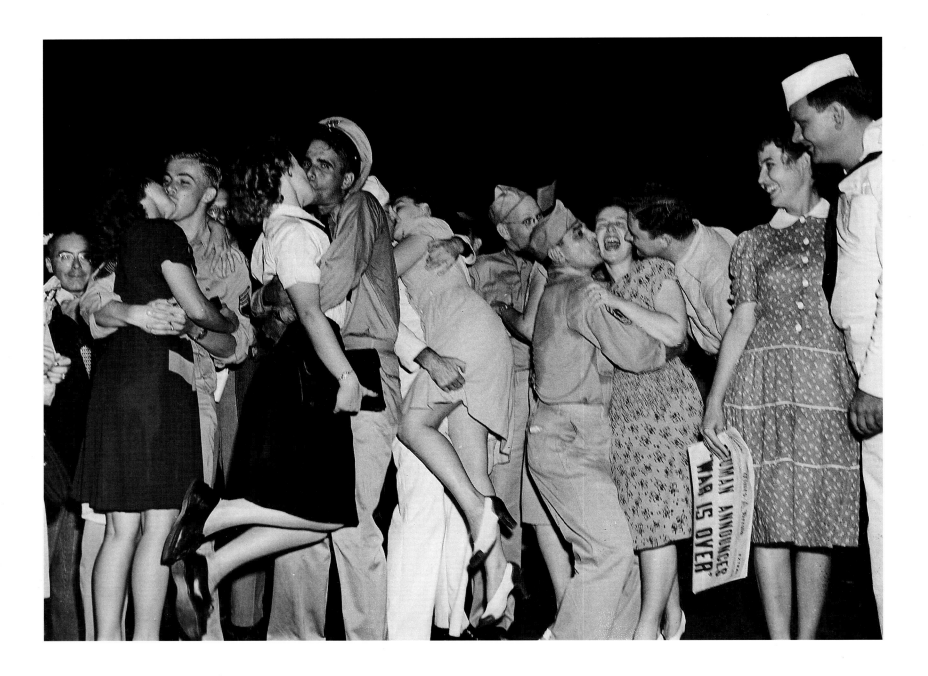

1945, Washington, D.C.
Taking to the streets to celebrate Japan's surrender, jubilant servicemen seal the good news with a kiss for the nearest girl.
Acme Photo

Washington…when I was young seemed a place of endless delight. I remember long summers of fishing off the rocks below Chain Bridge. Now and then there was a perch to be carried home with pride, though I can't recall a hero's welcome. I never could bear to let it out of my sight, so that it lay all day on the rocks. No one at home seemed interested in sun-broiled perch, so instead there was a hero's burial. There was a polo field near the Lincoln Memorial, with its taste of dust on summer afternoons. And…other tastes: the Sunday-night one of crackers and milk at the old Cosmos Club; the burnt flavor of potatoes roasted in a bonfire on winter nights when we went skating on the Chesapeake and Ohio Canal.

December 1964, NATIONAL GEOGRAPHIC
from "Washington: The City Freedom Built"
by William Graves

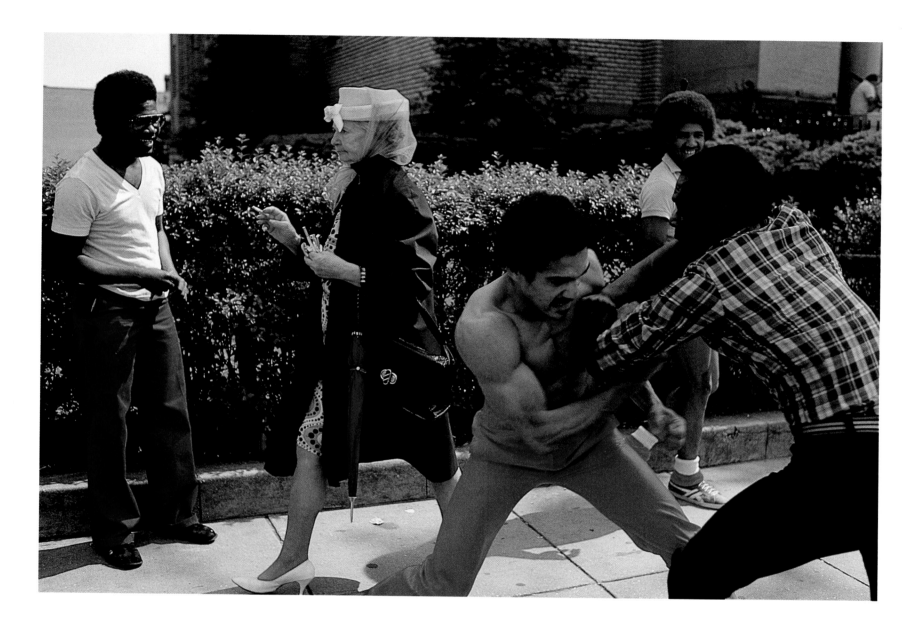

"Sometimes [says Bennie Bolton, 17], it's a temptation to spend four hours or so practicing on the court, but I know I have to go home and study. Coach Wootten says basketball comes fourth, after God, my family, and school. Then basketball. I like music, especially disco, and sure I like girls, but I'm not in any hurry about them. They'll be there, they aren't going anywhere. And I have goals to reach."

Sadly, for many poor blacks, and whites, I must add, reaching goals can be harsh, indeed. Their lives take expression in the drug traffic and vice that curse some city streets. Washington's urban jungles change locale as police drive away drug dealers and prostitutes—but they do not disappear.

January 1983, NATIONAL GEOGRAPHIC
from "Washington, D.C.: Hometown Behind the Monuments"
by Henry Mitchell

1983, Washington, D.C.
Good-natured sparring between street boxers draws grins from onlookers and studious inattention from a tight-lipped passerby in Adams-Morgan, a neighborhood noted for its ethnic and economic mix.
Adam Woolfitt

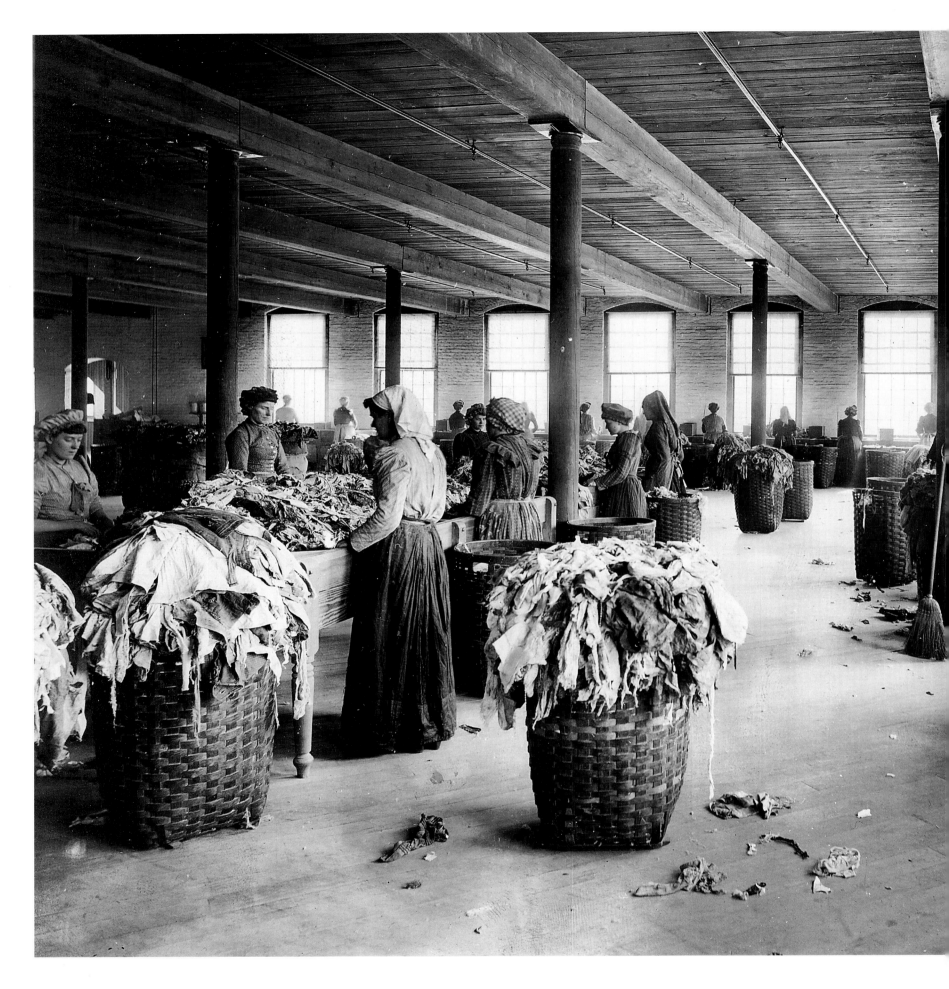

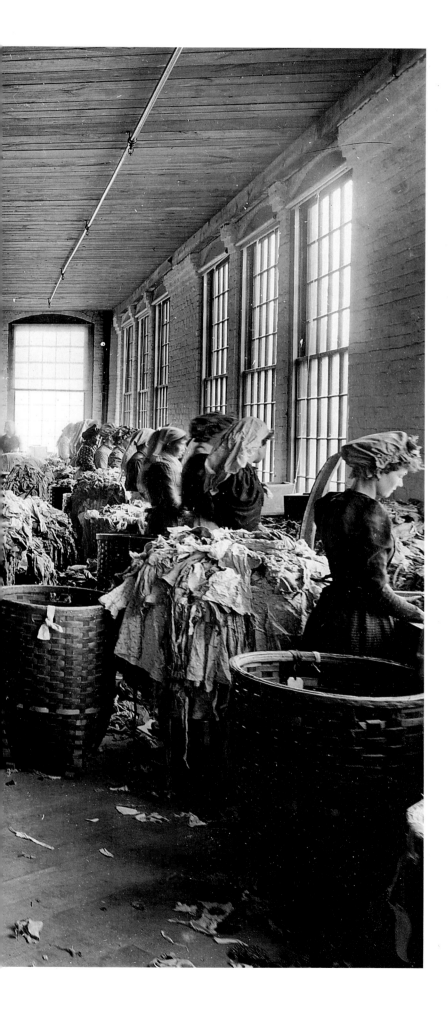

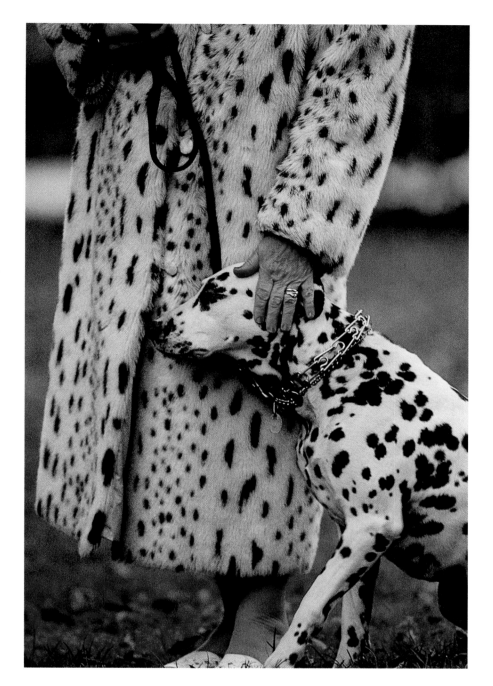

1993, Boston, Massachusetts
Perfect match, Dr. Hedda Rev-Kury and her dalmatian, Dorado,
stroll on Beacon Street, a thoroughfare of Boston's Brahmins.

Joel Sartore

left:

1916, Holyoke, Massachusetts
Sun lights the routine of ragpickers at a paper factory: an
endless cycle of ripping open seams and removing buttons,
zippers, and hooks from bales of discarded clothes. The rags
were then ground into pulp.

American Writing Paper Co.

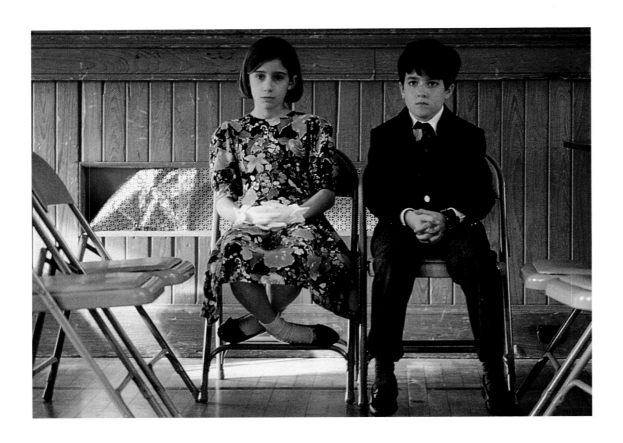

1992, Greenwich, Connecticut
Prisoners of propriety, a girl and boy endure instructions for etiquette and formal
dancing at the Round Hill Community House.

Joel Sartore

right:

1952, Rockland, Maine
Rosy from cheek to claw, "lobsterettes" perform in a pageant during the annual
summer festival of this port city, then the self-proclaimed lobster capital of the world.

Luis Marden

following pages:

1994, Everglades National Park, Florida
In canoes they built using Seminole Indian design, Everglades locals cruise the
grassy swamp. The waters sustain damage from development upstream.

Chris Johns

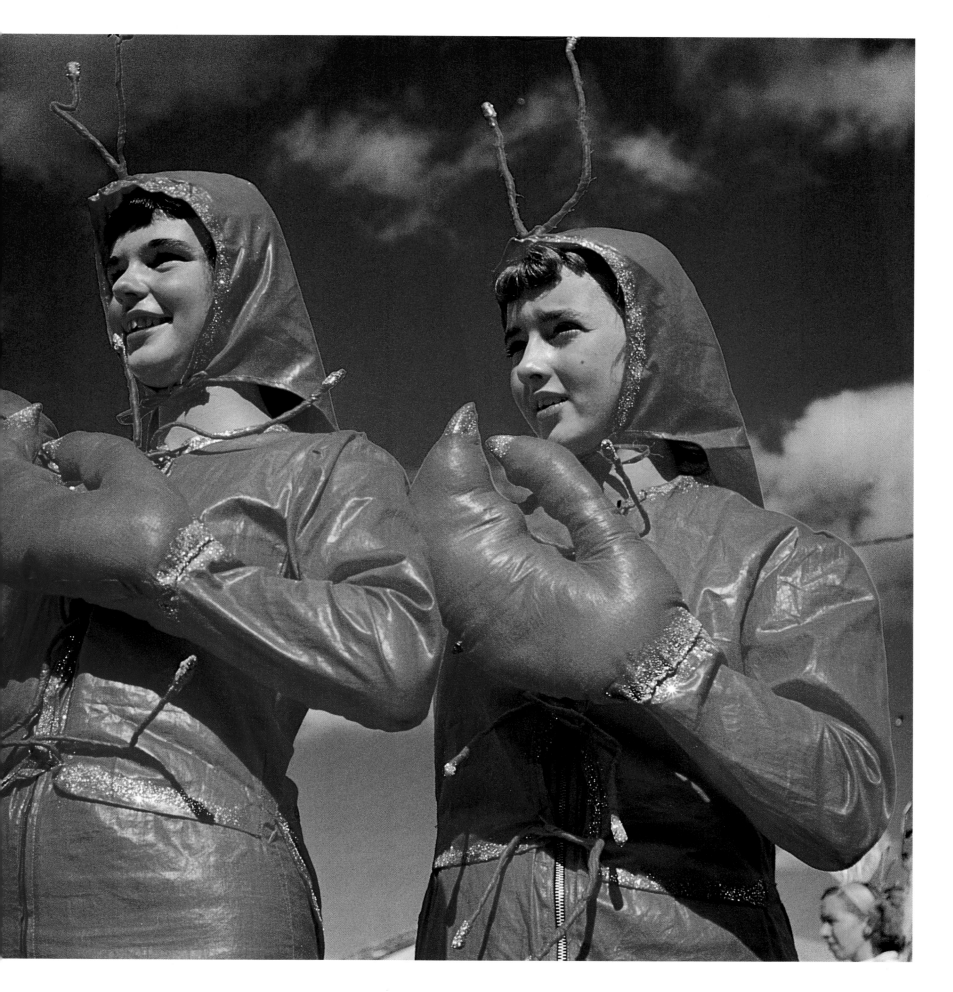

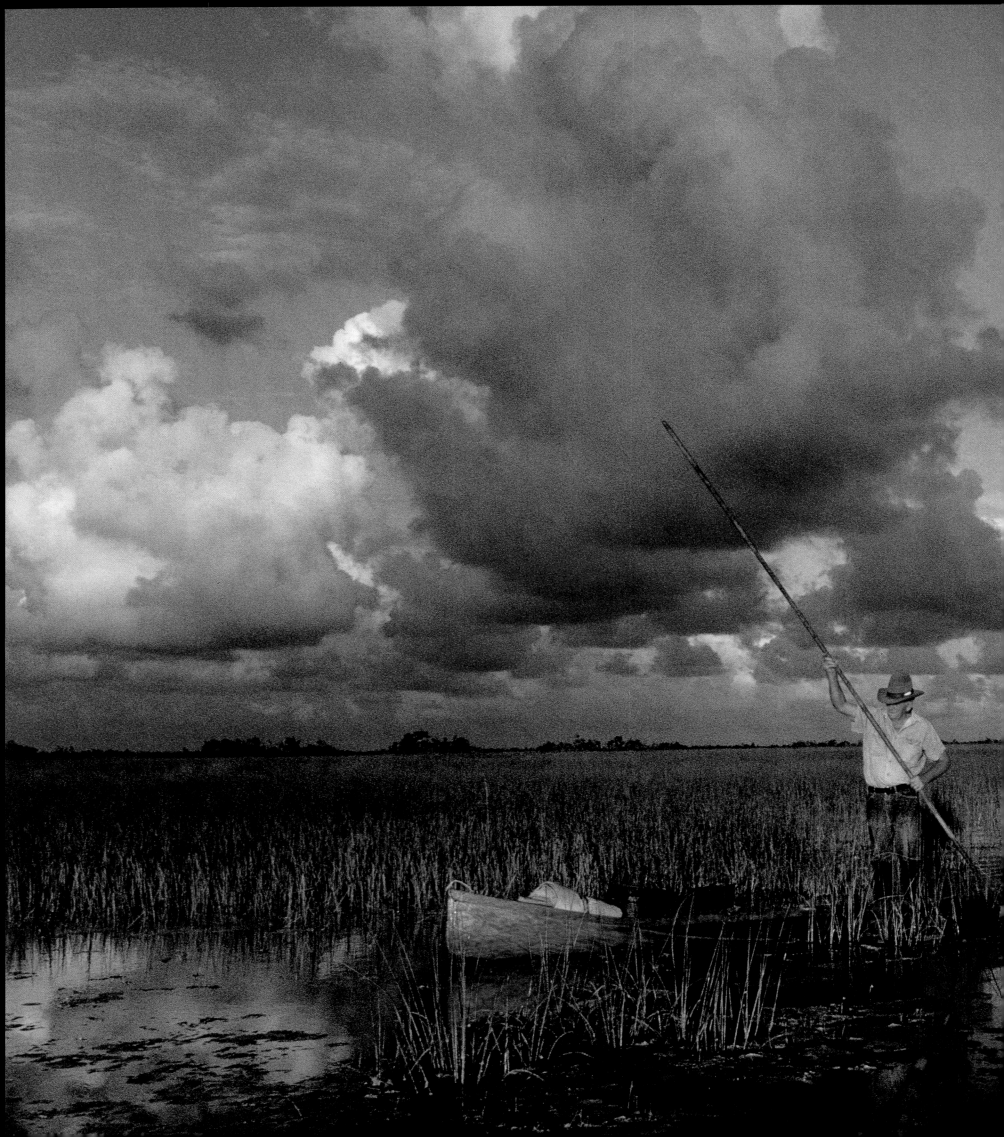

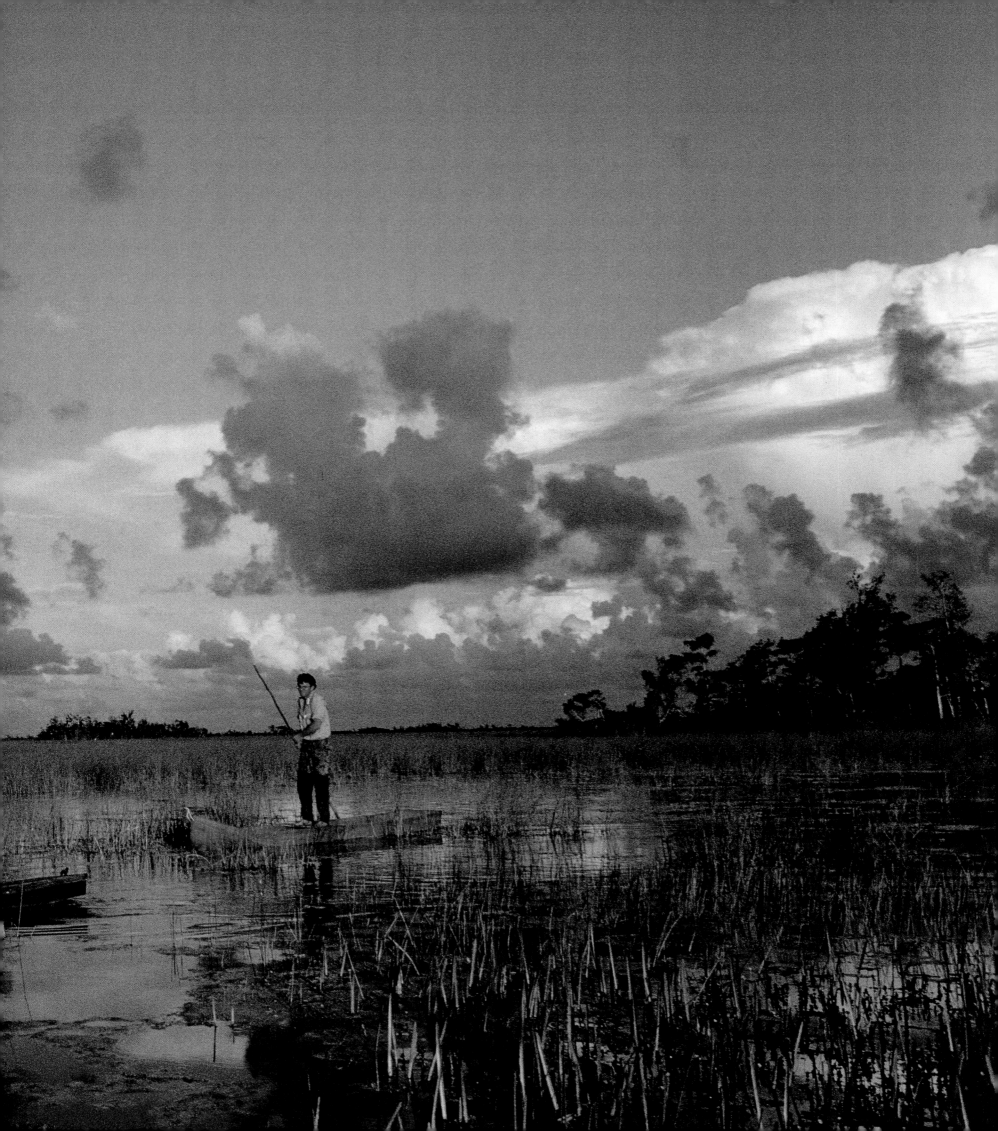

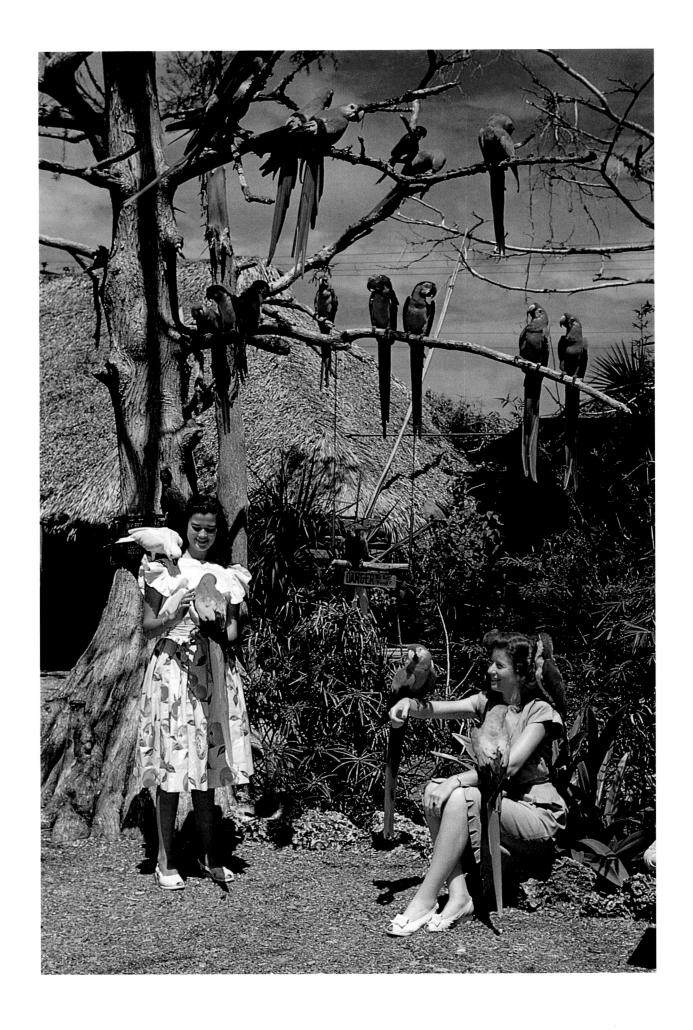

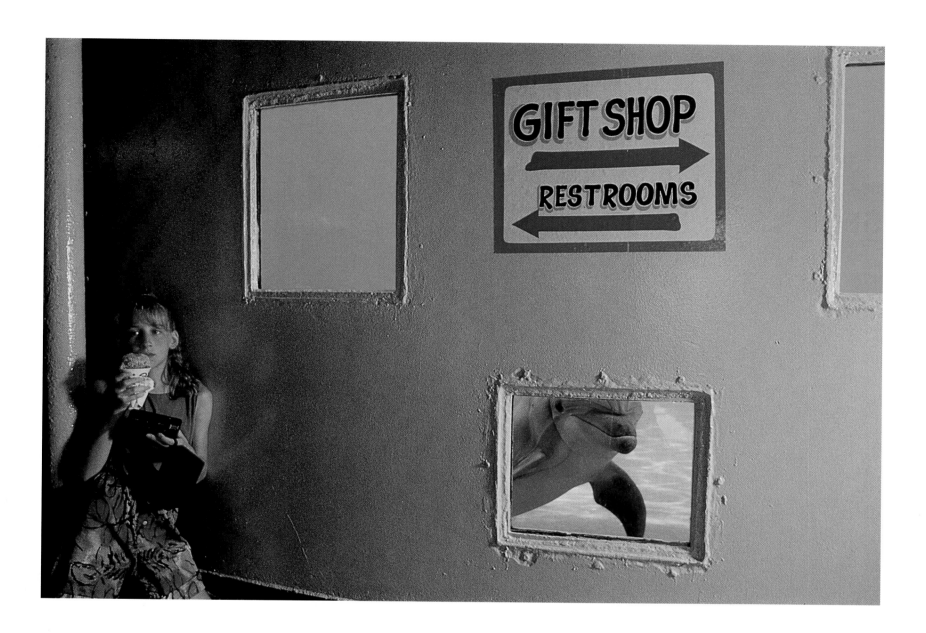

Miami has burst into bloom so suddenly and so effusively that it sometimes seems not to know what to do with itself. Immigration, especially, has recast the city's culture and economics, transforming what less than 30 years ago was a sleepy southern city into an energetic metropolis. "Actually, we're a child of a city," says Miami Mayor Xavier Suarez, "and it's hard to predict when we will reach adulthood. Some days it seems the pimples will not go away." But if Miami has youth's uncertainty, it also has its excitement. Merrett Stierheim, who heads the Greater Miami Convention and Visitors Bureau, exclaims: "We changed in a swirling, tension-filled, beautiful, exciting way. We're still changing." And says bank executive Robin Reiter Faragalli, a native: "It's like looking through a prism. Nothing is ever the same twice."

January 1992, NATIONAL GEOGRAPHIC
from "Miami"
by Charles E. Cobb, Jr.

1991, Fort Walton Beach, Florida
At Gulfarium—a Gulf Coast aquarium—a waterborne resident looks in on a human at feeding time.
Joel Sartore

left:
1950, Miami, Florida
Petting zoo, Miami-style: Brilliantly plumed macaws perch on trees and tourists at the city's Parrot Jungle.
W. R. Culver

1953, New Orleans, Louisiana
Wakeup at the celebrated Morning Call café in the old French market is routine for serious coffee drinkers who insist that "the spoon stand up in the cup." At the time, New Orleans boasted the largest per-capita consumption of coffee in the United States.

Justin Locke

right:

1992, New Orleans, Louisiana
In a city where the pursuit of pleasure is an art form, Mardi Gras revelers whoop it up at the Superdome's Endymion Extravaganza. New Orleans, noted author Douglas Bennett Lee, "prefers its own music as it goes about its time-honored trades: transshipping goods from Mississippi's vast drainage and playing host to whoever may come to eat, drink, dance, sin, and be forgiven."

Joel Sartore

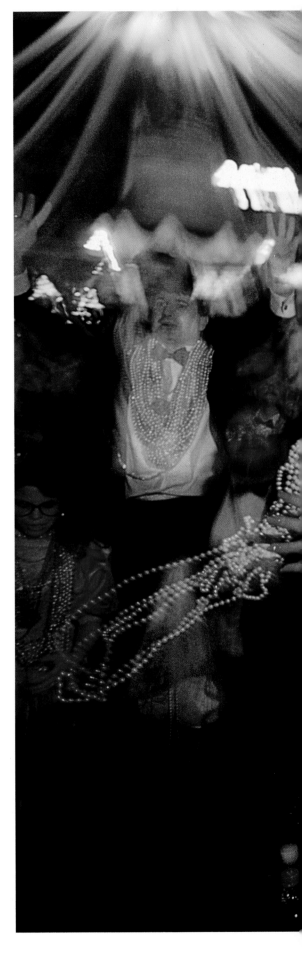

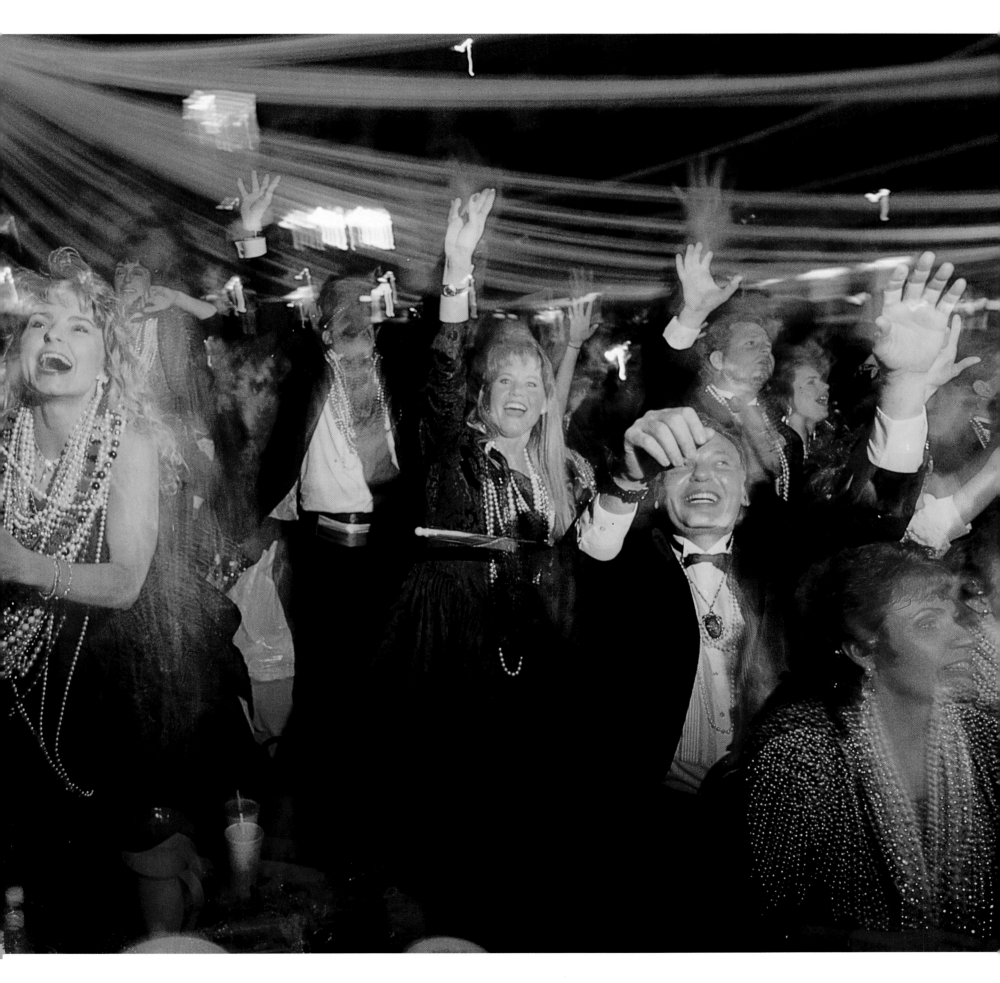

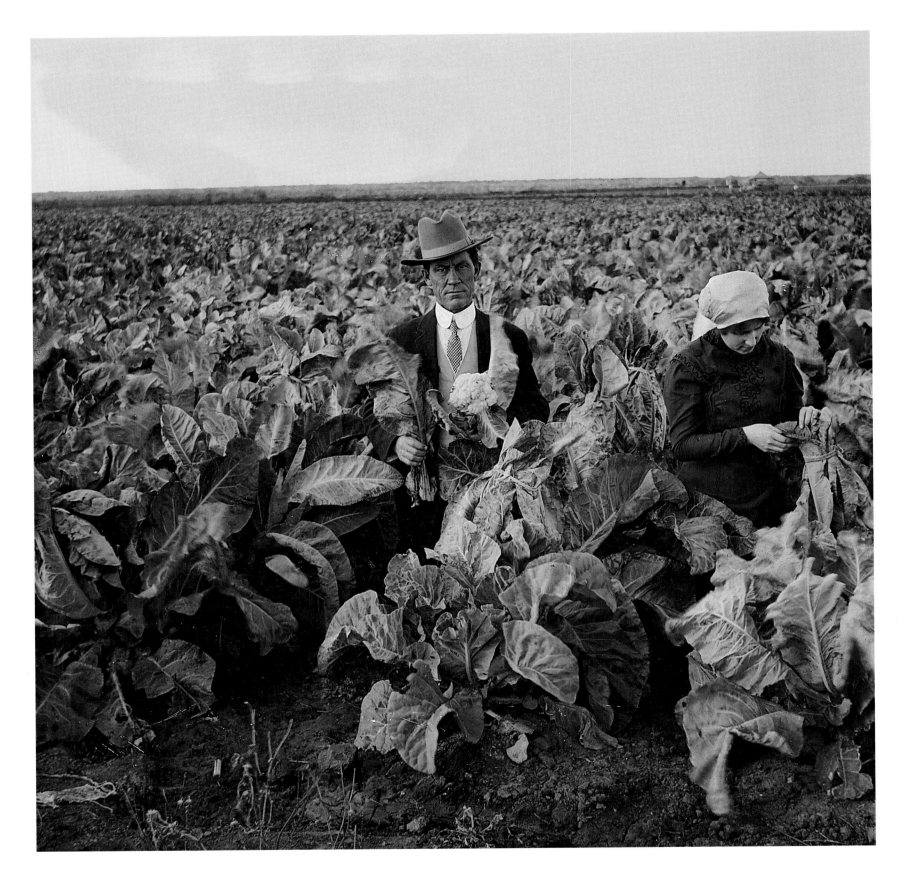

1913, Texas
Cauliflower king, owner of a prosperous truck farm near Brownsville, stands amid his prize-winning specimens.
The Joint Texas Immigration Bureau

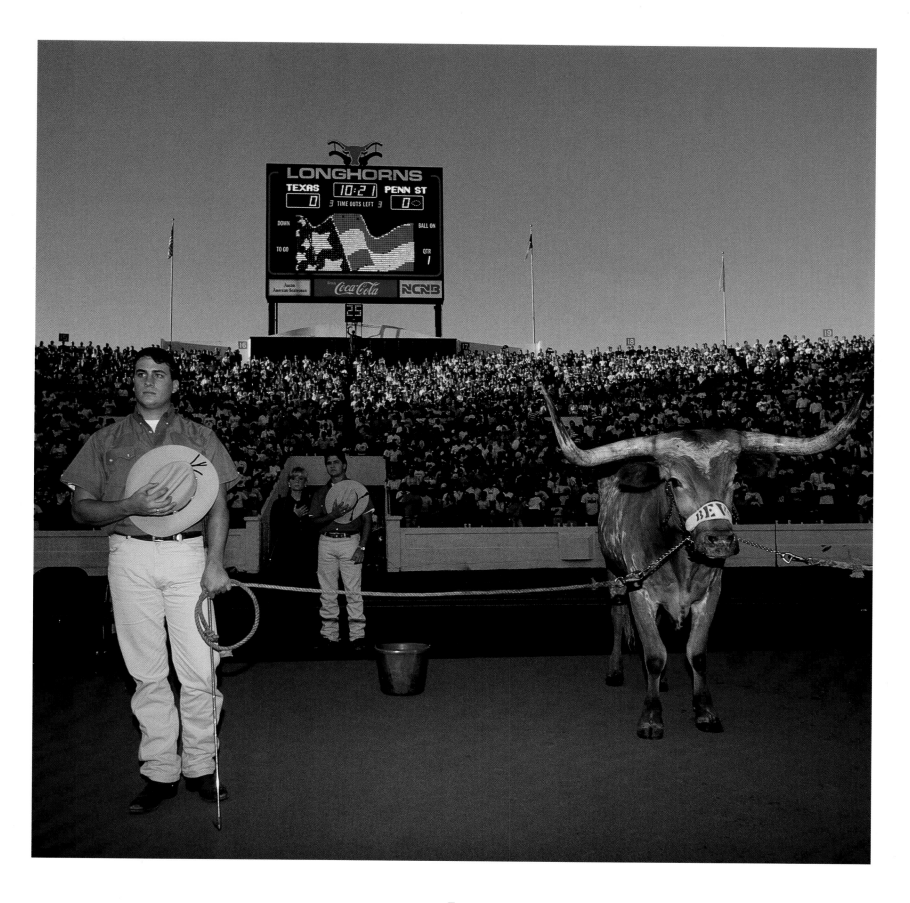

1990, Texas
Football pre-game at the University of Texas features the National Anthem with Bevo, the Longhorns' team mascot, standing at attention.
Michael O'Brien

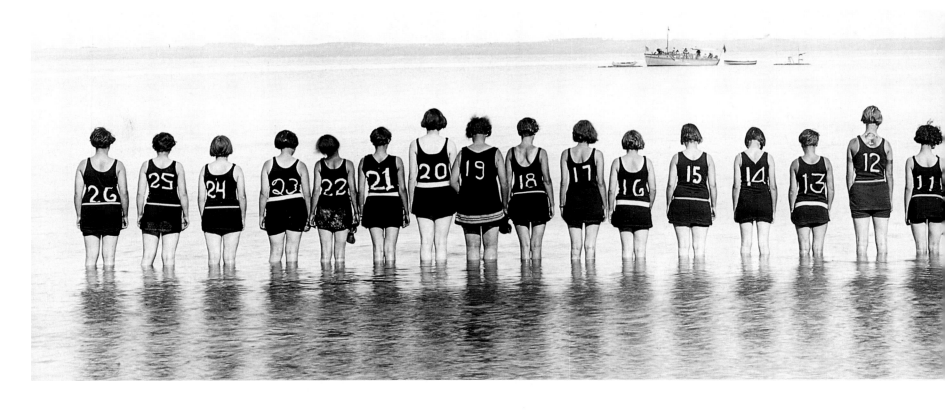

1924, Chicago, Illinois
On their marks, stalwart racers face their course across the chill waters of Lake Michigan.

Kaufmann & Fabry Co.

right:

1958, Mille Lacs Lake, Minnesota
Frozen stiff as baseball bats in the 25°-below-zero F cold, walleyes stand in silent testimony to one family's weekend catch. Ranging from a pound and a half to seven pounds, the fish were snagged through holes cut in the icebound lake.

Thomas J. Abercrombie

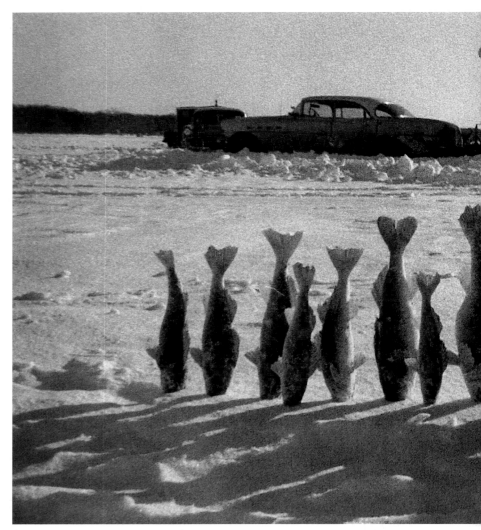

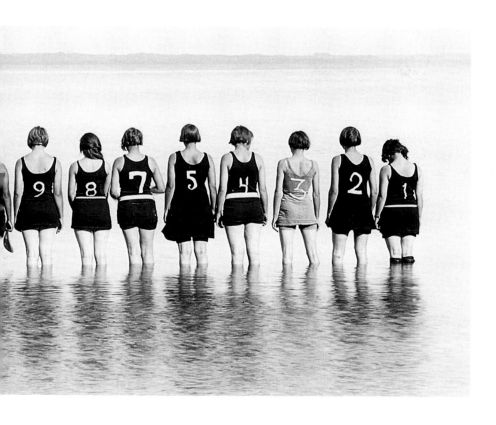

On some lakes winter sportsmen haul more fish though the ice than spring and summer anglers take from the water. As soon as the ice thickens, temporary towns spring up on many lakes. "Perchville," a shanty village on Lake Huron's Tawas Bay, has its own mayor, who sets up city hall at "Perch Street" and "Pike Avenue." To make these photographs, I motored through the ice-fishing belt in Michigan, Wisconsin, and Minnesota. Using a snowmobile sled, I breezed across frozen lakes. With Aqua-Lung and camera, I dived into ice-covered depths and recorded a perch's-eye view of fishermen. What is the lure, I asked, that draws the outdoor zealots from their cozy fireplaces? One old-timer had the answer. "Fishing is the best sport," he said. "Why let winter stop you?"

December 1958, NATIONAL GEOGRAPHIC
from "Ice Fishing's Frigid Charms"
by Thomas J. Abercrombie

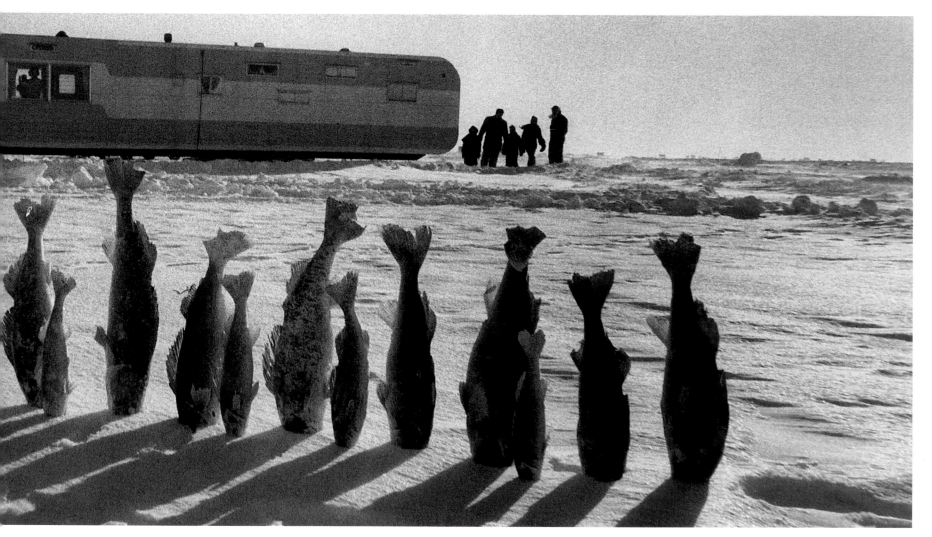

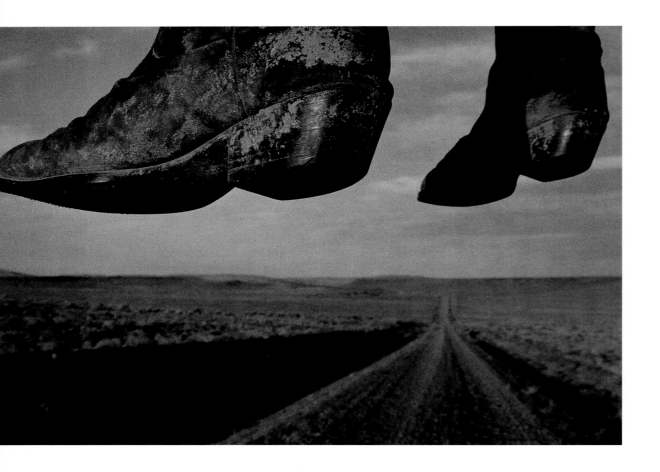

1996, Nevada
At Sheldon National Antelope Refuge, riding the range takes on new meaning
from the back of a pickup truck.

Joel Sartore

right:

1994, Warm Springs Indian Reservation, Oregon
Reflection in a truck mirror guides the hand of a Native American as he paints his
face for a religious ceremony honoring the salmon. Long considered sacred by
tribes of the Pacific Northwest, the fish has been sharply reduced in numbers in
recent years due to the damming of the Columbia River and its tributaries.

Joel Sartore

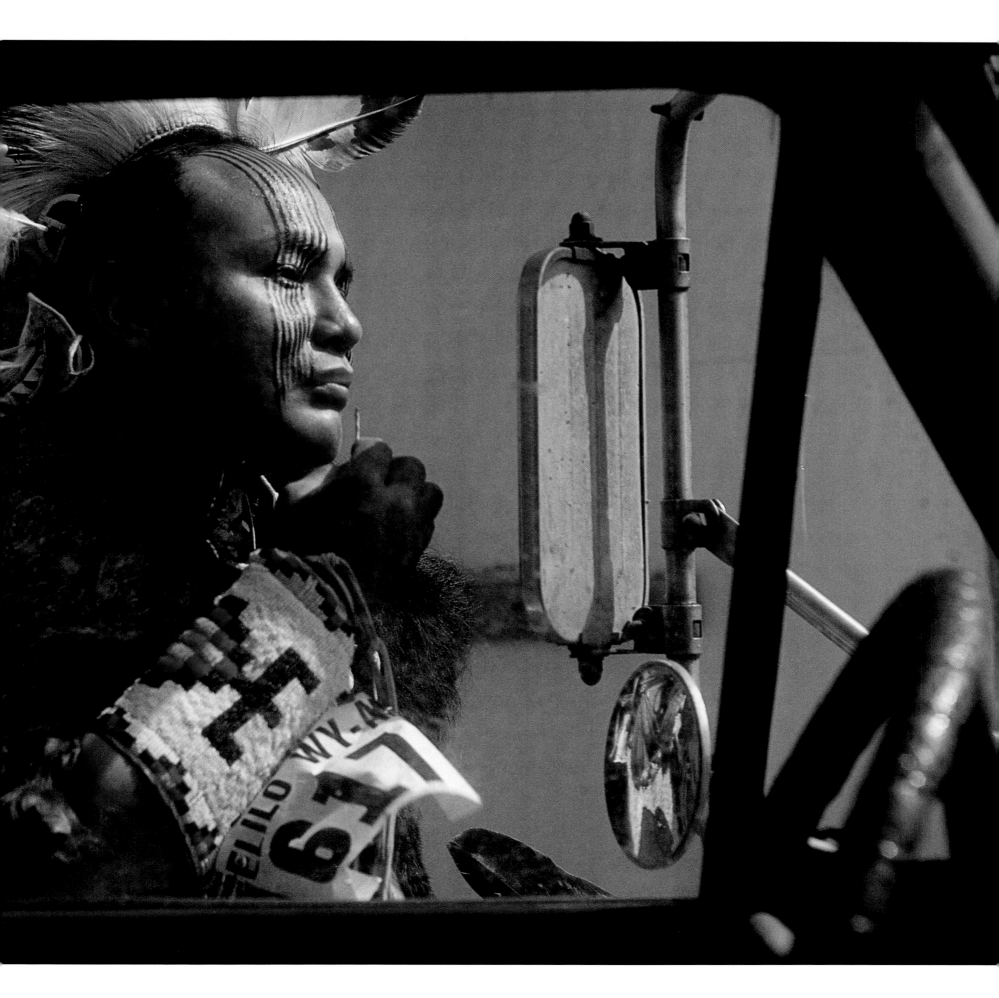

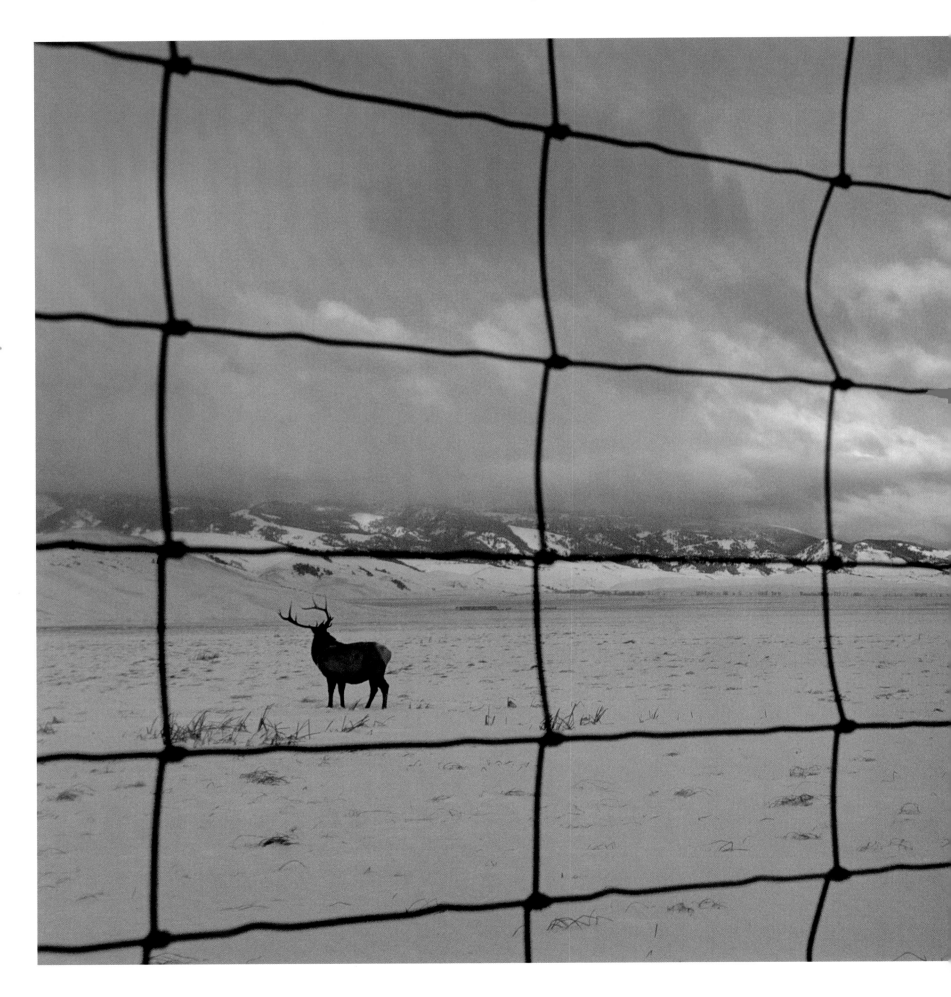

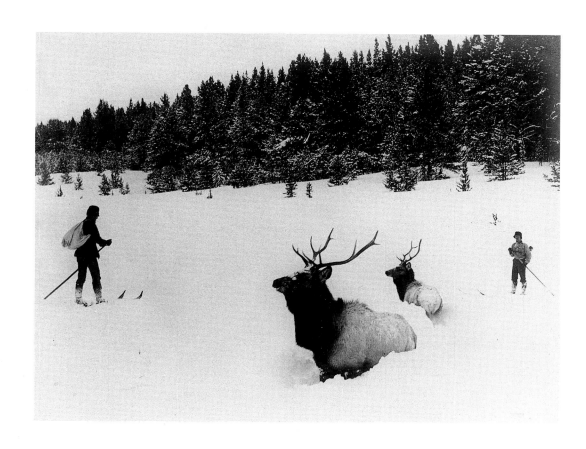

1908, Yellowstone Park
Belly-deep drifts slow elk in Yellowstone Park, the first government reserve for endangered animals. "Despite some poaching," the accompanying article noted, "elk, antelope, and mountain sheep have steadily increased in numbers, while buffalo also have thriven wonderfully."

F. J. Haynes

left:
1996, Wyoming
Driven down from summer pasture by hard weather, a solitary elk roams wintering grounds in the National Elk Refuge. Fences keep elk out of the nearby town of Jackson. During the winter, as many as 10,000 head may congregate in the refuge.

Joel Sartore

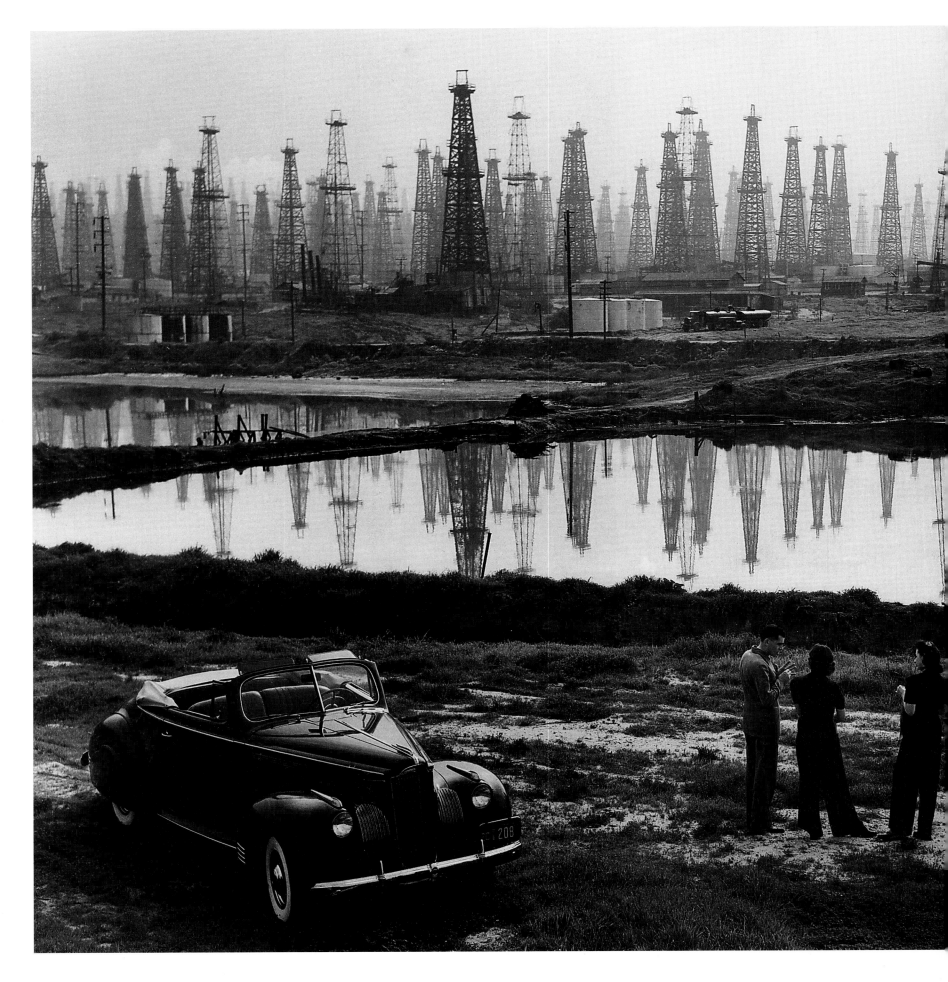

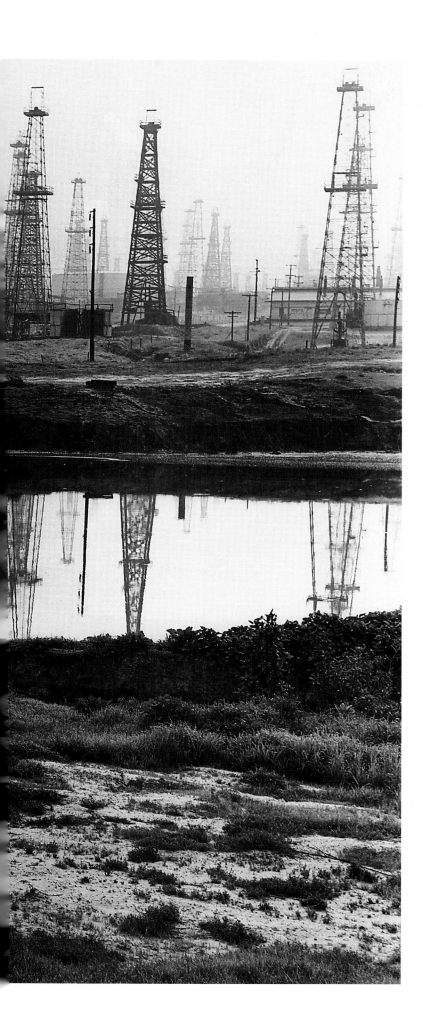

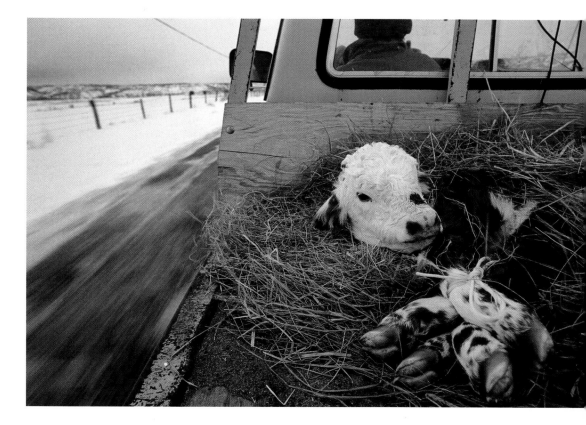

1993, Northern California
Trussed and tucked into a bed of hay, a wayward calf settles in for a ride back to the ranch.
Joel Sartore

left:

1941, Signal Hill, California
Nearly a century after California's first gold rush, fields of black gold spread outside Los Angeles, sometimes into suburban backyards. "Since 'oil is where you find it,'" noted one article, "your neighbor may get rich while you bore only a dry hole."
B. Anthony Stewart

Rob us of oil, with its grease and gasoline, and our life rhythm would freeze. Every truck and automobile in the United States would die in their tracks. Of course we had wheels and machines long before we struck oil. But about the time man found oil [for making] axle grease, the then "machine age" had reached a peak. Power we had; but the problem of friction had reached the point where the grease from tallow, castor beans, pig fat, and fish was not enough.

June 1941, NATIONAL GEOGRAPHIC
from "Today's World Turns on Oil"
by Frederich Simpich

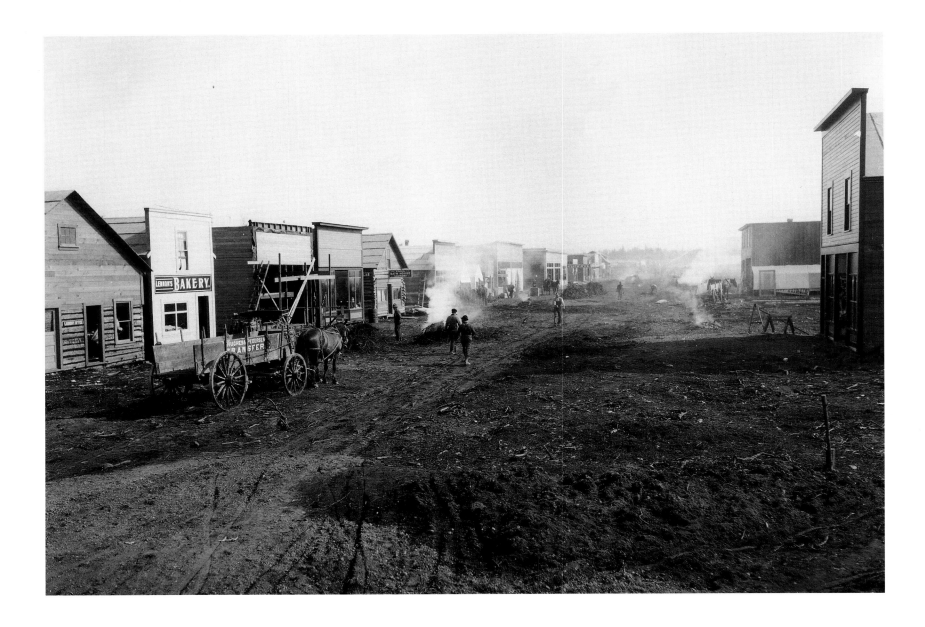

1915, Anchorage, Alaska
Building burgeoned when Ship Creek, renamed Anchorage, was selected as the central construction camp for the Alaskan Railroad. In a year's time, the site at the head of Cook Inlet was transformed from wilderness to a town of some 2,000.

Laurence

It might be said that Alaska's good reputation as a country of law-abiding people has been maintained during the first season of the railroad construction and even in the opening and boom days of Anchorage. The fact that the sale of liquor is prohibited in Anchorage, and that town lots there are sold with a prohibition clause attached, and delivery of title deferred five years, probably has had something to do with this condition, while the isolation of the country and the difficulty of escaping detection and apprehension has also doubtless had much to do with curbing lawlessness. A jail was built and a marshal appointed at the opening of the Anchorage townsite to settlement, but the jail has been empty most of the time and the marshal has had practically nothing to do.

December 1915, NATIONAL GEOGRAPHIC
from "Alaska's New Railway"
by The Editors

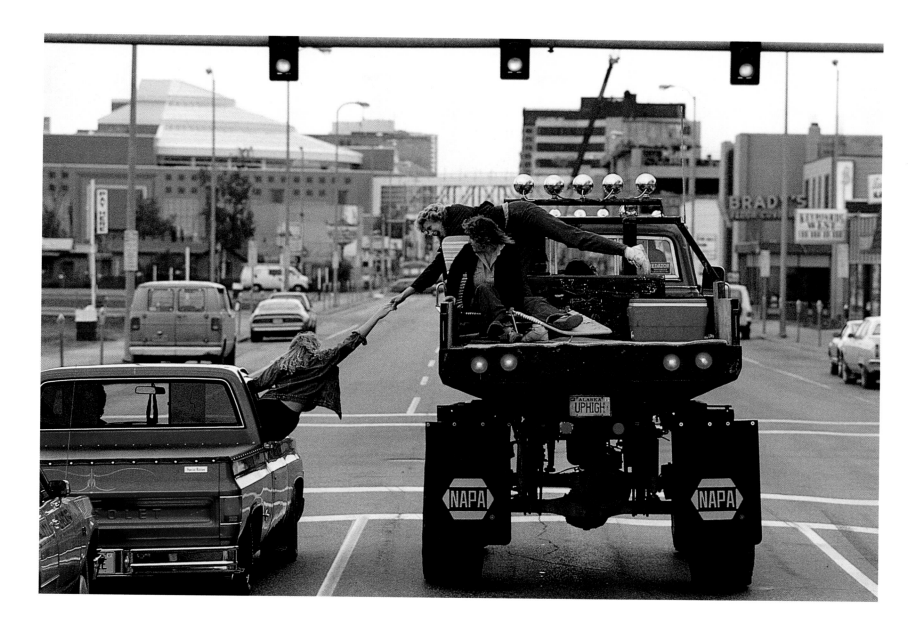

Mayor Knowles sees his city's number one problem as "how our people treat each other. We have our share of domestic violence and child abuse. Alcoholism plays a big part, as do our long, dark winters. One tough month is April. Expectations rise as spring approaches, but if it stays cold or snows…, people find that spring hasn't provided a cure-all. They go crazy." If one survives winter's gloom and a false spring, he'll witness nature's glory in bloom, bursts of happy optimism, and outdoor activities. "We're beautiful when it snows, beautiful in summer," says editor Howard Weaver. "Some people can't handle the cold and the dark. They come alive again when they can shake off their cabin fever." Anchorage's annual Fur Rendezvous…was begun with the hope that it might get residents out of their homes and help them shed the winter blahs.

March 1988, NATIONAL GEOGRAPHIC
from "Hello Anchorage, Good-bye Dream"
by Larry L. King

1988, Anchorage, Alaska
Spirits run higher than a jacked-up pickup as friends connect downtown on a Friday night. In this city of midnight sun—where the median age was 28 at the time of this picture—revelry is a staple of the summer months.
Chris Johns

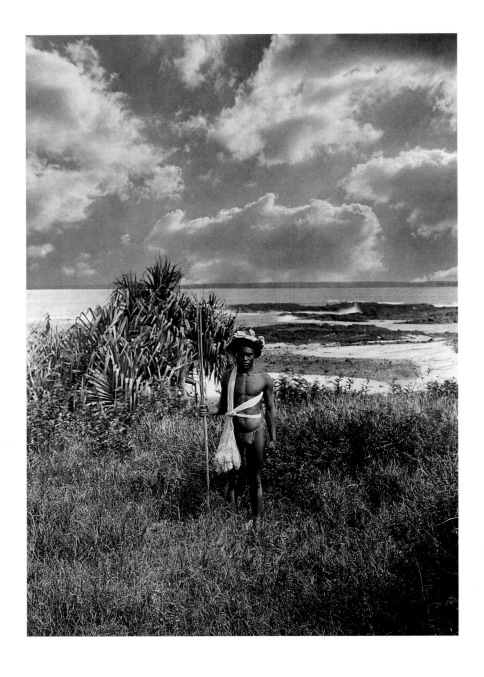

1924, Hawaii
Pacific water and sky frame a spear-fisher and his catch.
He wears the "abbreviated costume" reserved for native
fishermen.
Henry W. Henshaw

right:
1995, Maui, Hawaii
Kaleidoscope of neon sailboards festoons Maui's Hookipa
Beach during the Aloha Classic, a windsurfing competition
held on the island's breezy north coast.
George Steinmetz

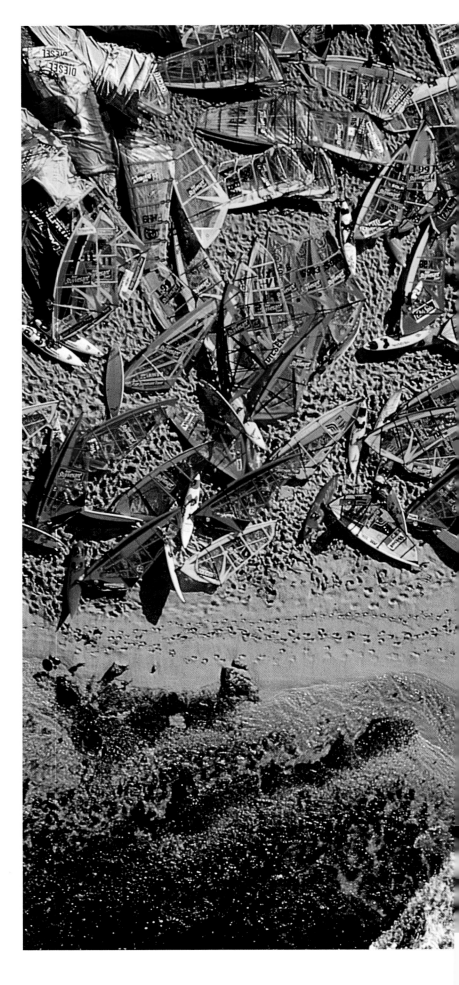

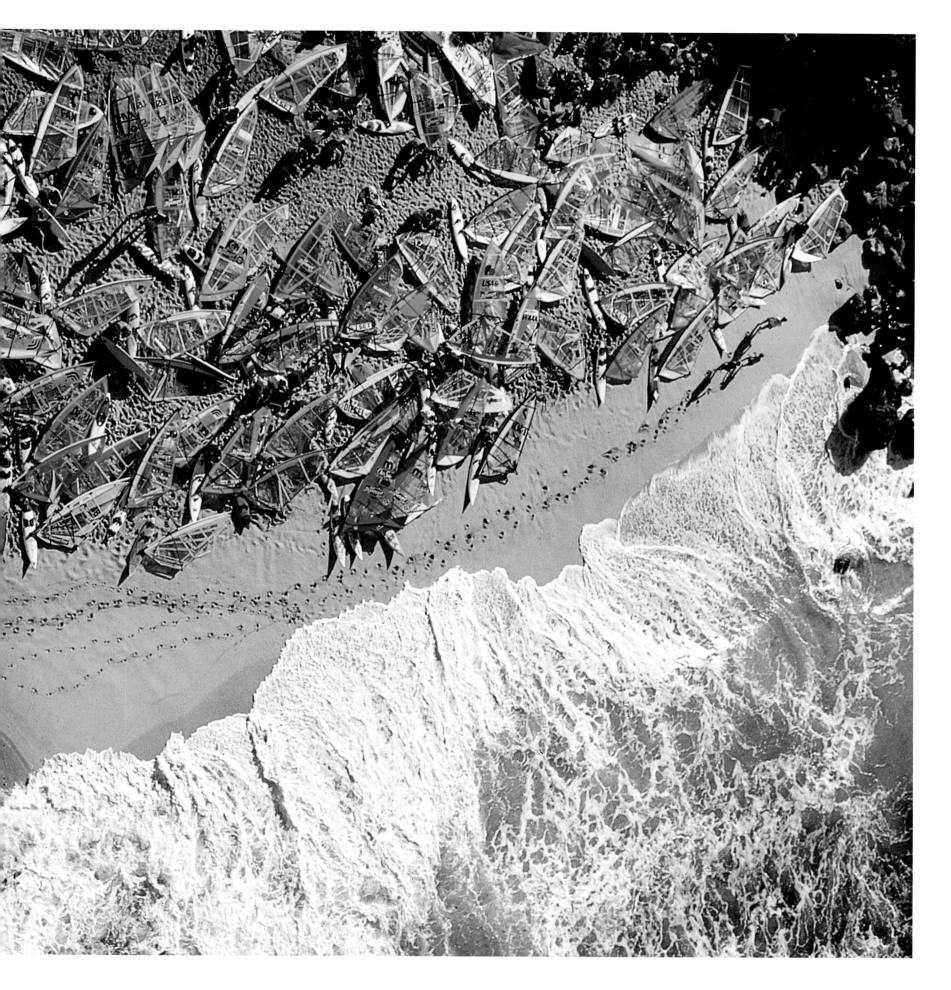

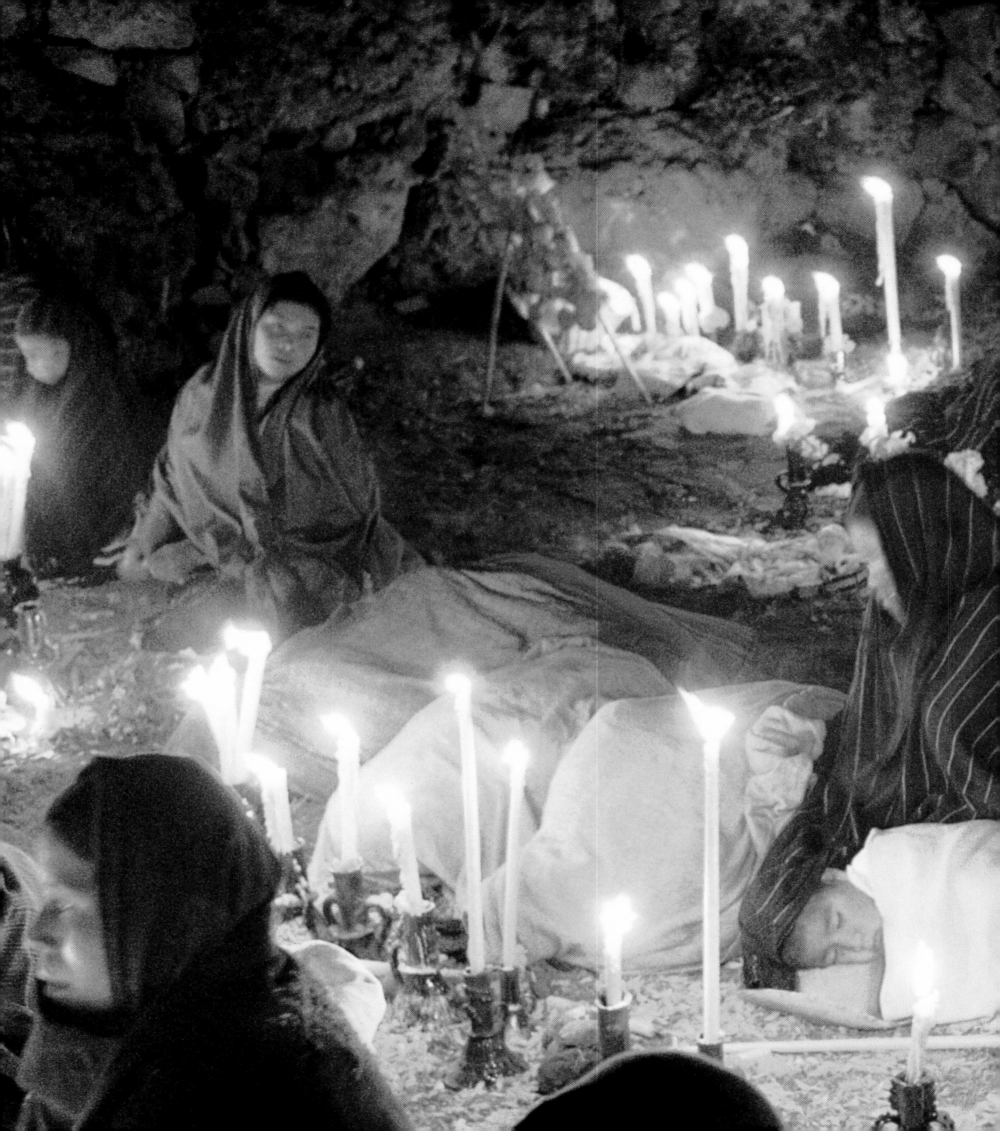

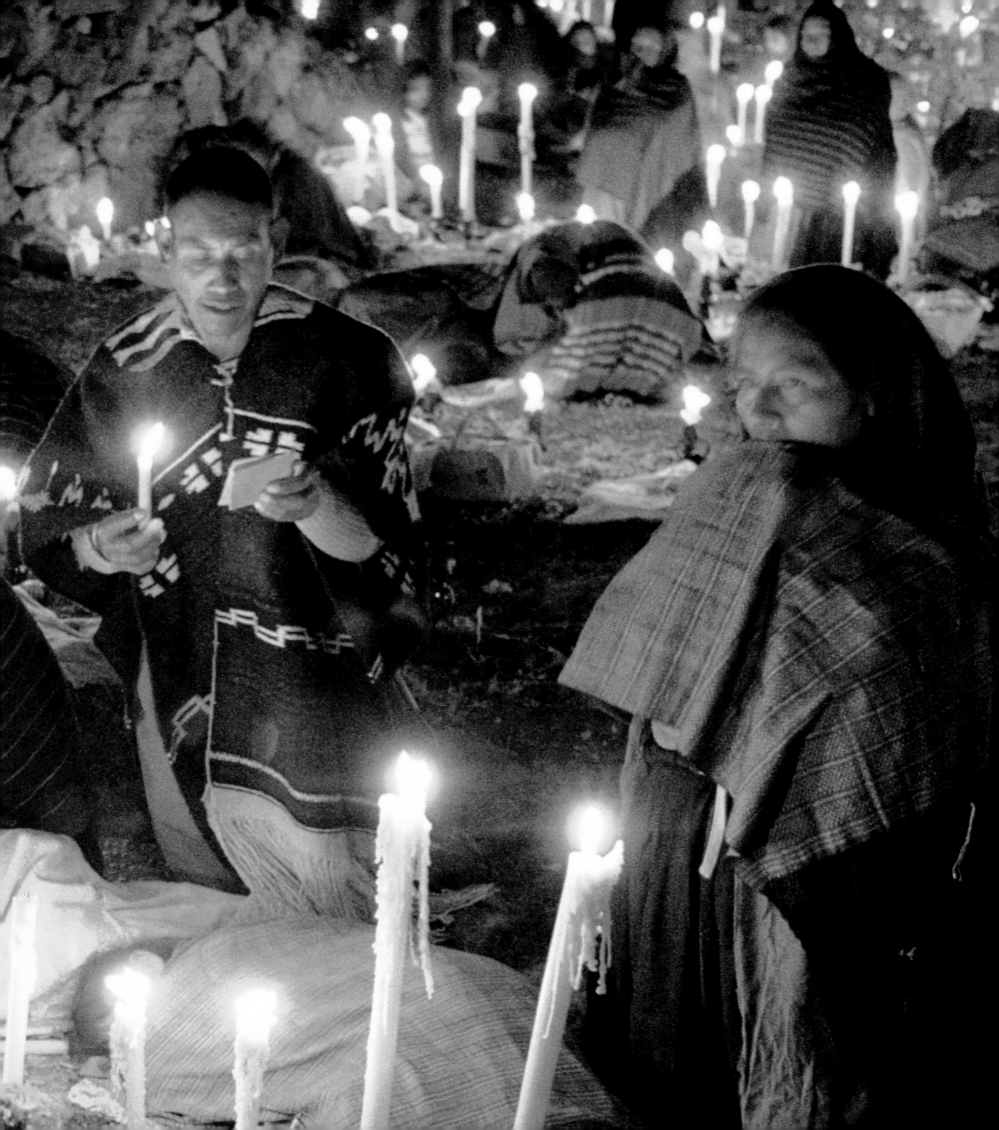

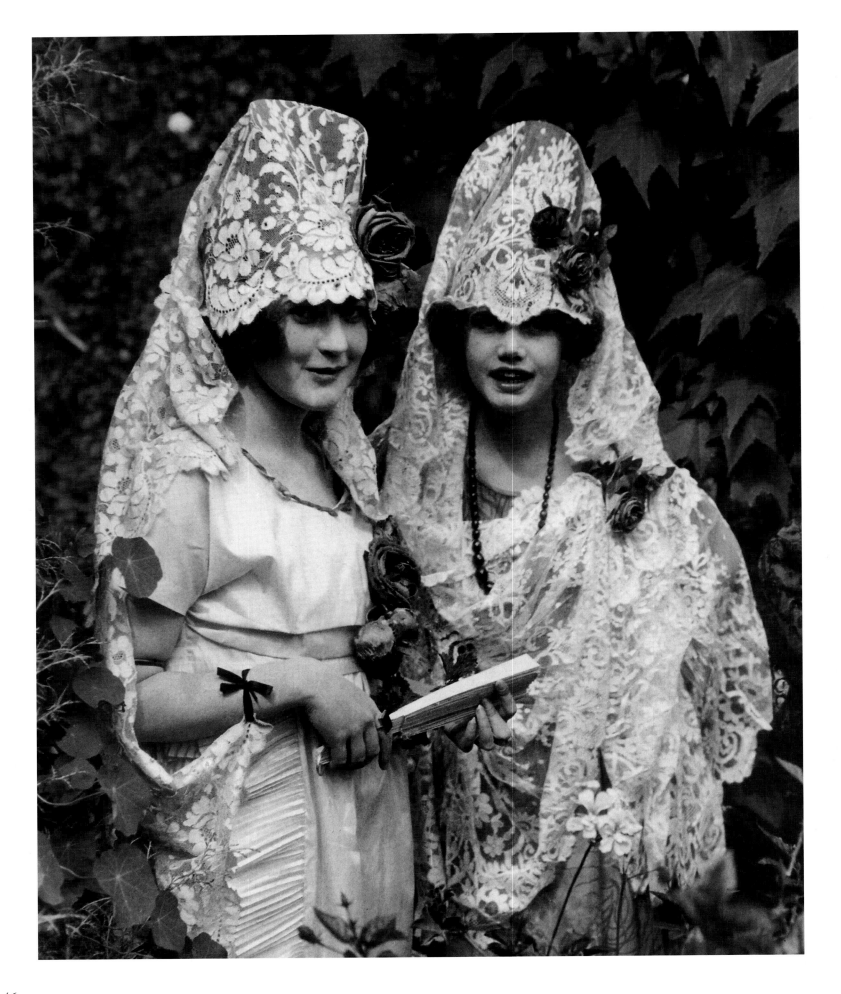

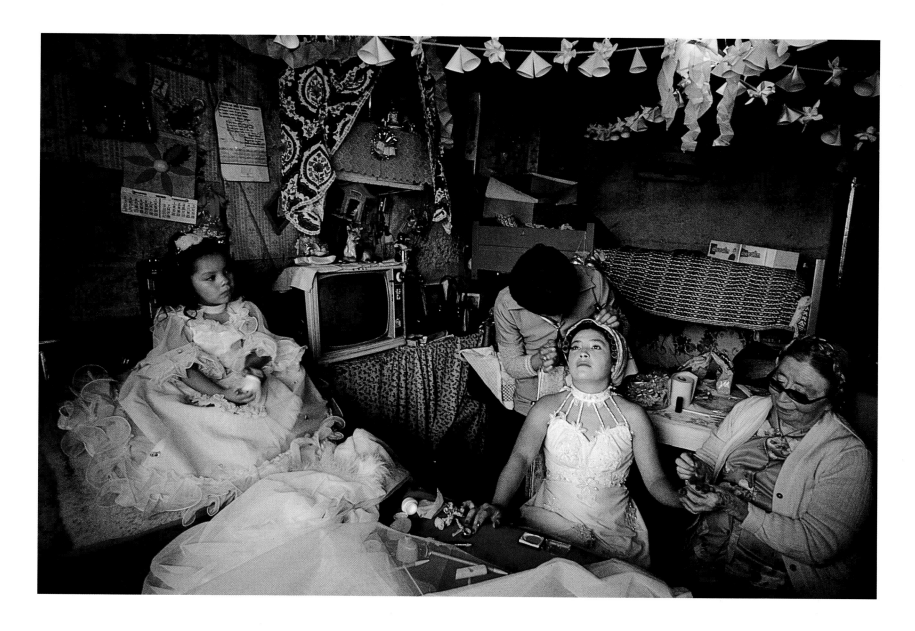

In the past it was obvious that fashionably dressed Mexican women preferred hats, clothing, and shoes imported from Paris. Now, to a growing degree, American styles, especially in sport and street clothes, are closely followed. This is an influence, no doubt, of the moving picture shows and increasing travel between the United States and Mexico. American style and influence are reflected again, not only in dress, but in the occupation of Mexican women. There is more social and industrial freedom. Now a growing number of Mexican girls are employed as stenographers, bookkeepers, clerks, and telephone operators, and have well proved their fitness for a place in the new world of Mexican economics.

July 1930, NATIONAL GEOGRAPHIC
from "North America's Oldest Metropolis"
by Frederick Simpich

1984, Mexico City
Flanked by her sister and grandmother, Patricia Perea is indulged by a hired beautician on her wedding day. Custom dictates that most other wedding expenses, including the cost of her gown, will be paid by the groom.
Stephanie Maze

left:
1930, Mexico City
Old-World lace mantillas adorn young "Queens of the Toros" who attend bullfights to cheer on and toss flowers to their favorite matadors.
Burton Holmes

previous pages:
1968, Janitzio Island, Mexico
To mark the Day of the Dead, November 2, Tarascan Indians maintain an all-night vigil at a family burial plot.
W. E. Garrett

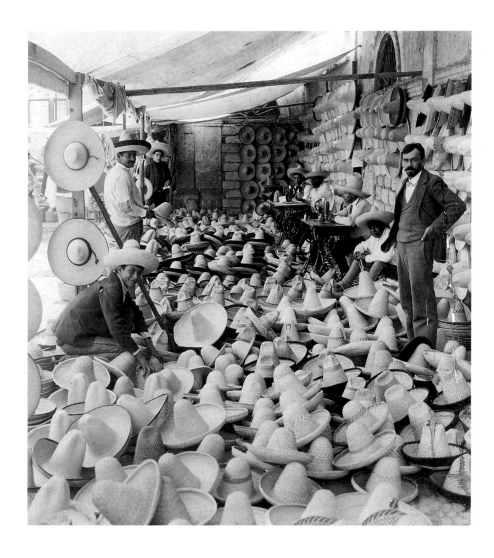

1911, Mexico City
Straw sombreros crafted by local milliners flood an
open-air store, beckoning customers with a variety of
patterns and weaves.

Underwood & Underwood

right:

1990, The Bajio, Mexico
Mountain of marigold blossoms inspires a grin from a work-
weary harvester. The flowers, which thrive on the verdant plains
of Mexico's heartland, are used in chicken feed.

Danny Lehman

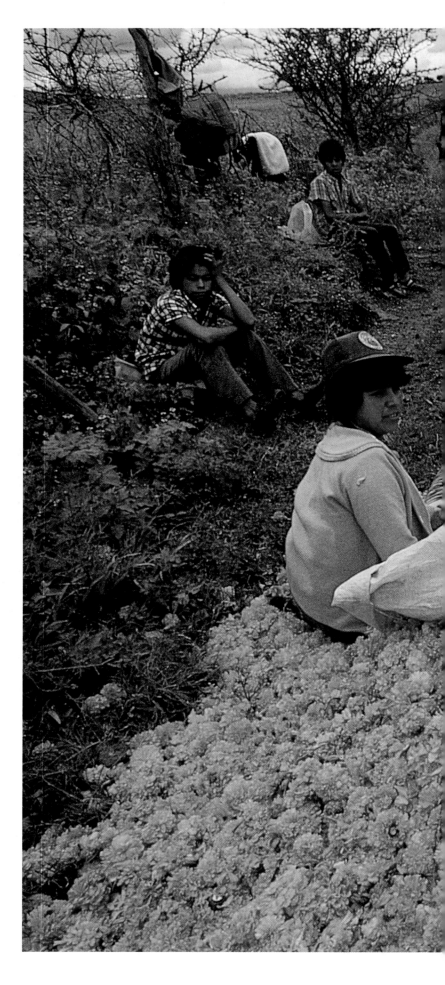

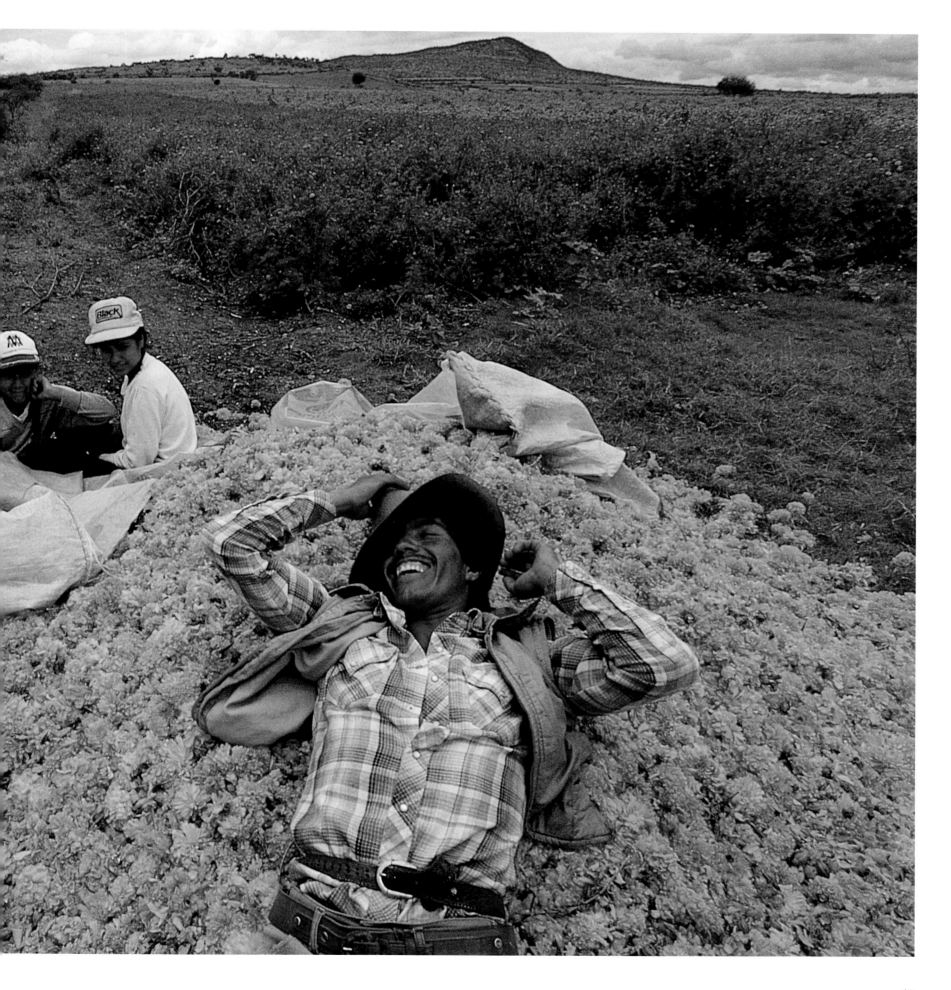

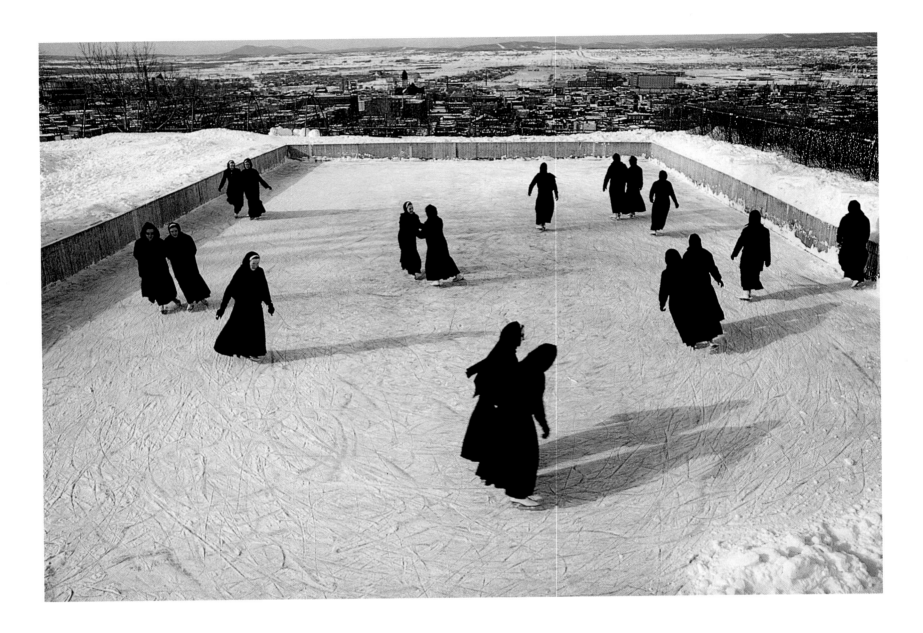

1967, Quebec City
Nuns glide around a rink near St. Joseph de St. Vallier girls school, where they are teachers catering to young members of Quebec's longstanding Franco-Roman Catholic population. The foothills of the Laurentian Mountains rise in the distance.

John Launois

Two centuries of separation from the mother country has not diluted Quebec's quintessentially French *esprit*. French language and attitudes still prevail, and the memory of its past enfolds the city like a dream. No matter how often I found myself in the sparkling buildings on the Chemin St. Louis or the handsome suburbs of Sainte Foy, I always returned to the city's old streets, gray and brooding beside the St. Lawrence…to the Ursuline Convent where Montcalm lies entombed…to the house built by explorer Louis Jolliet…. I would stroll…into the serenity of the Plains of Abraham. An ultimate calm envelops the old Battlefield. The grass seems greener, the breeze softer, the silence deeper. The peace has a quality of eternity, as though the anguish and bloodshed of the past has forever after exempted this plot of ground from violence.

May 1967, NATIONAL GEOGRAPHIC
from "The St. Lawrence, River Key to Canada"
by Howard La Fay

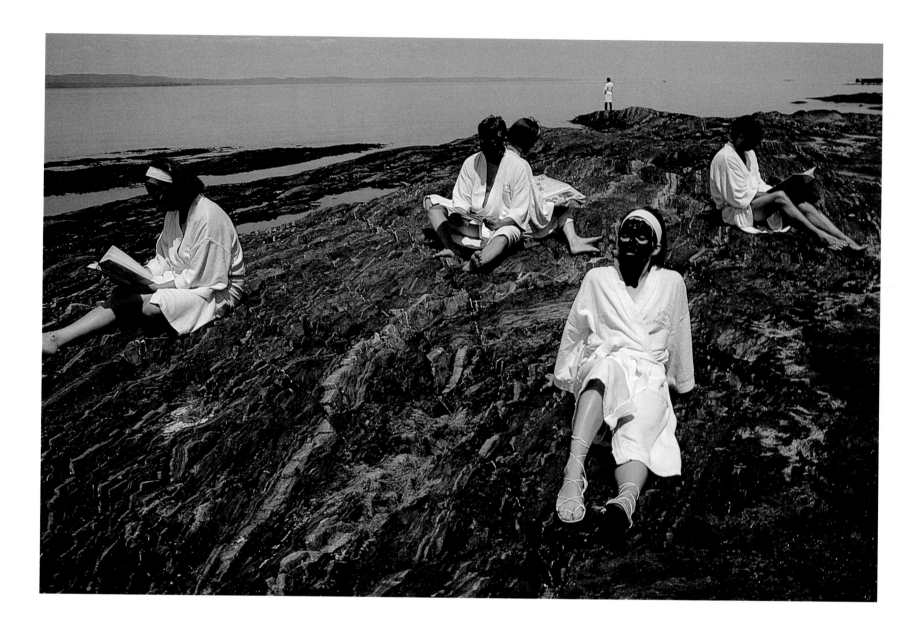

1994, Notre-Dame-du-Portage, Quebec
Complexion-enhancing masks of mud from a nearby bog
disguise health-spa clients lounging on the rocky banks
of the St. Lawrence River. The spa touted other mud
treatments for relief of rheumatism and arthritis.

Tomasz Tomaszewski

Entering Quebec province, the St. Lawrence becomes the Fleuve
St. Laurent, for this is the heart of French-speaking Canada. Guiding my cutter *Foxtrot* through the final locks of the seaway, I…followed the strong currents under arching bridges, noisy with trains
and traffic pouring into workaday Montreal. I tied up at the Club
Nautique at Longueuil, a trendy suburb just across the river, and
took the Métro into Montreal. Strolling among the chic office
crowds along Rue Ste. Catherine or sipping Campari at a crowded
café terrasse in the city's ethnically mixed *quartiers,* one tastes a European flavor. A 1977 law in Quebec Province requires that all outdoor signs be written in French. This was the reaction of some 6
million French Canadians surrounded by 225 million Canadian
and American anglophones.

October 1994, NATIONAL GEOGRAPHIC
from "The St. Lawrence: River and Sea"
by Thomas J. Abercrombie

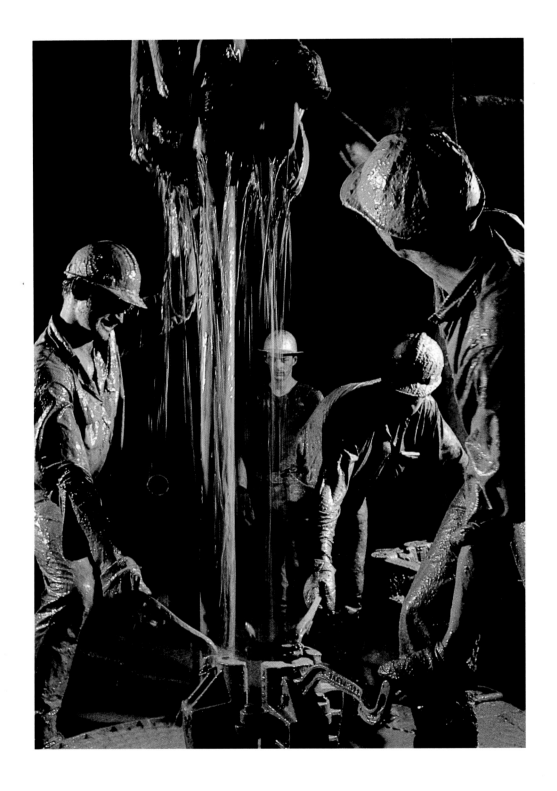

1968, Alberta, Canada
Drilling through the night at northern Alberta's Rainbow field,
mud-plastered oilmen pull pipe to change the bit.
David S. Boyer

right:

1992, Vancouver, Canada
Longshoreman leaps into a sea of barley as it is pumped aboard a cargo
ship; he will then spread the grain to keep it from shifting at sea.
Annie Griffiths Belt

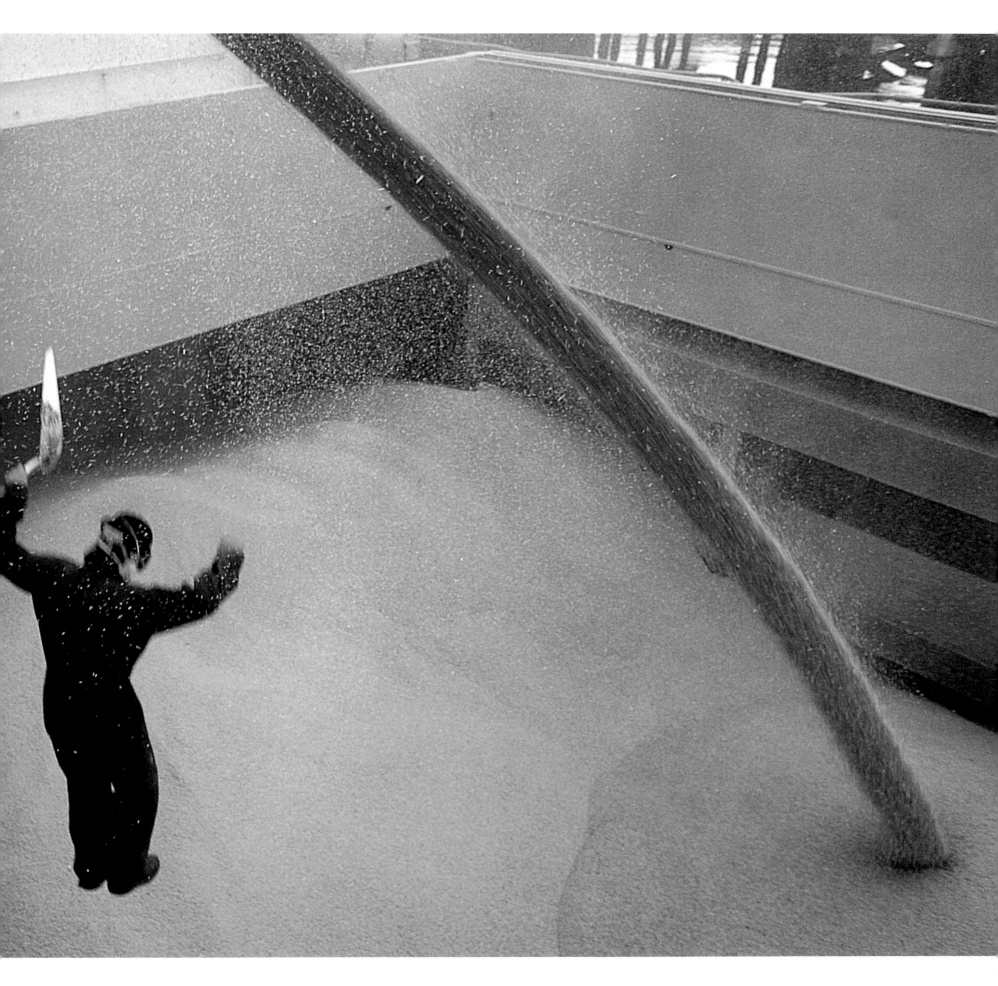

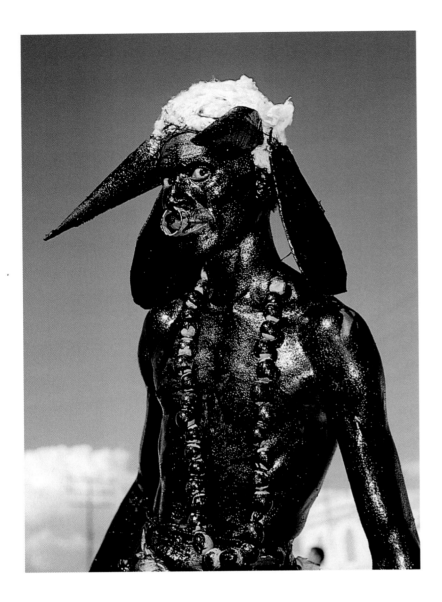

1961, Port-au-Prince, Haiti
Lacquered with grease paint and charcoal, a Mardi Gras reveler joins the pre-Lenten carnival. Cardboard horns and ears sprouting from a cotton toupee help distinguish him as a devil.
John Scofield

right:

1992, Port-au-Prince, Haiti
A young visitor to the National Palace sits before Haiti's great deliverer, Toussaint Louverture, who led the only successful slave revolution in the Americas.
Maggie Steber

following pages:

1967, Moore Town, Jamaica
Ancestral pride radiates from three Maroons, descendants of 16th-century slaves who escaped their masters and lived free in the hills. Their name derives from the Spanish *cimarron,* or runaway.
Thomas Nebbia

Back at Port au Prince, Audrey and I tackled the one thing that had so far eluded us: voodoo.

"You are here at the worst possible time," people told us. "Carnival, then Lent, then Easter. Everyone is too busy." But each Saturday night the drums gave a different answer, booming and throbbing from a dozen points. Voodoo was there if we could find it. Haiti's countryfolk see little conflict between Christianity and voodoo. The Great Master, they say, shouldn't be bothered with little problems. Reverently asking His permission before starting a Saturday night ceremony, they get down to cases with deities whose job it is to take care of everyday matters: crops, sickness, love, money.

The rites themselves are often colorful, noisy, and exciting—and as often boring and unintelligible to the outsider. Despite a government that eyes voodoo with surprising tolerance, visitors are seldom welcomed at important ceremonies; too many have taken home "eyewitness" accounts of blood-maddened orgies and mumbo-jumbo under the tropic moon.

February 1961, NATIONAL GEOGRAPHIC
from "Haiti—West Africa in the West Indies"
by John Scofield

As a people, black slaves drew upon their African heritage, their daily experience in slave quarters, their interaction one with the other, and the physical landscape to create a series of vibrant cultures uniquely their own. The new cultures afforded slaves crucial psychological space and helped preserve their identity in the face of the abuse and atrocity visited on them as human property.

The richness of those cultures can be observed in the contemporary societies of the Americas. The Caribbean islands with their black majorities bear an unmistakable African imprint in their styles of religious expression, art, music, language, culinary habits, dance, and folk beliefs. Haiti's voodoo, or vodun, has been characterized by Yale art historian Robert Thompson as "one of the signal achievements of people of African descent in the western hemisphere: a vibrant, sophisticated synthesis of the traditional religions of Dahomey, Yorubaland, and Kongo with an infusion of Roman Catholicism."

September 1992, NATIONAL GEOGRAPHIC
from "African Slave Trade: The Cruelest Commerce"
by Colin Palmer

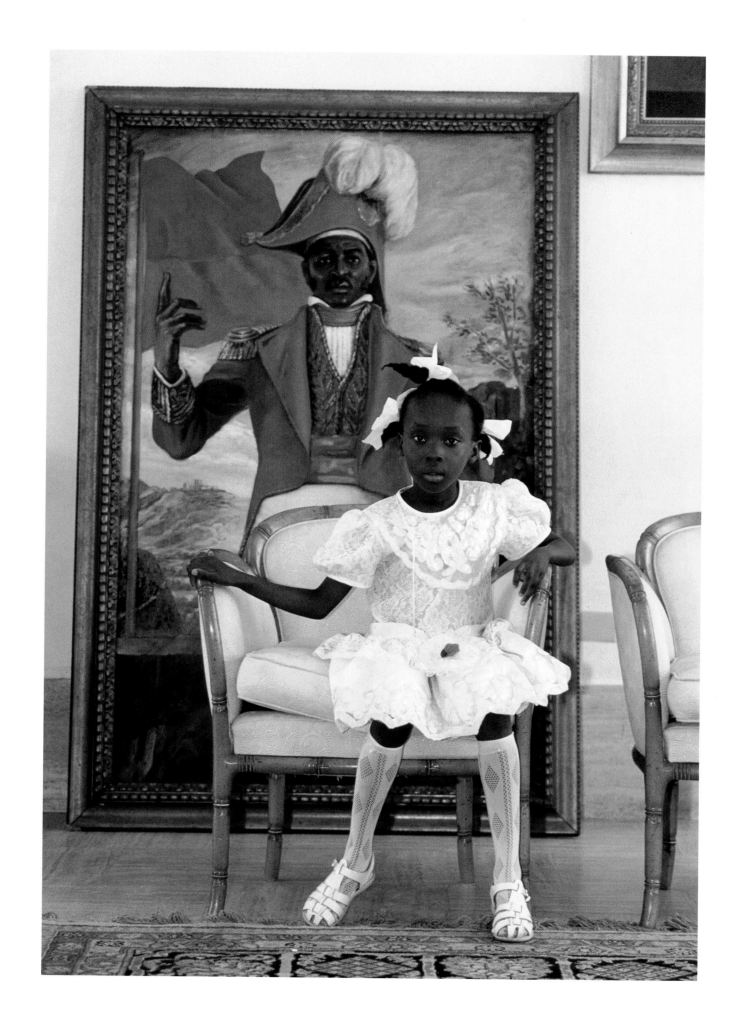

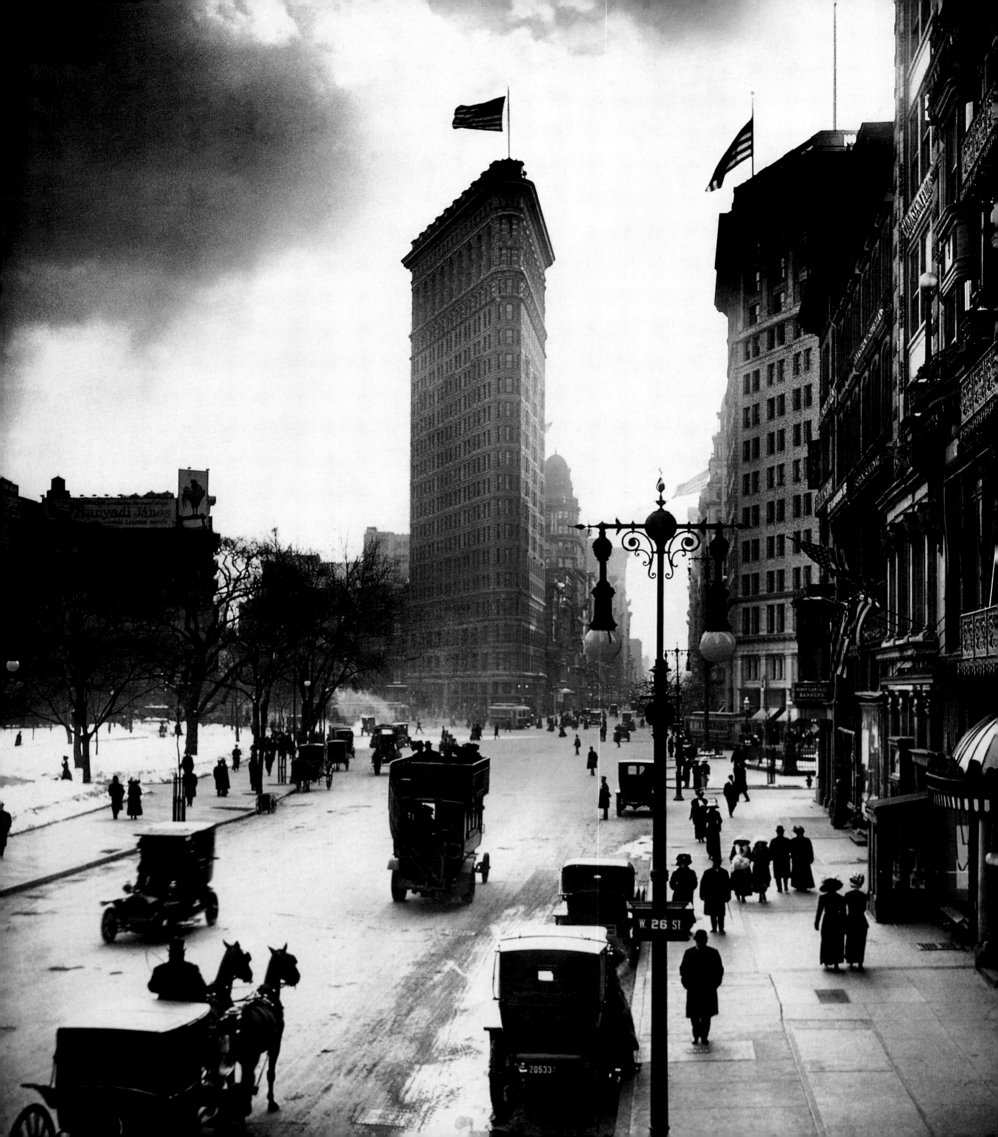

Featured Place

New York

"New York! Man's incomparable feat! As incredible, almost, as that ants should have built the Andes!" marveled Frederick Simpich in his 1930 article, "This Giant That Is New York." NATIONAL GEOGRAPHIC's love affair with the Big Apple began with its first visit there in 1918. Early stories praised the city's grandeur, explosive population, and economic stature, and regarded with awe—and not a little pride—its human achievements, from skyscrapers and bridges to public waterworks and transportation systems. Photographs provided appropriately impressive views of these monuments, as well as more intimate glimpses of the city's diverse inhabitants. Over the years GEOGRAPHIC writers and photographers have returned to New York some two dozen times, with a gradually less romantic but no less fascinated eye. They've taken us to the summits of Manhattan's tallest buildings and to tunnels 700 feet below the street; escorted us into Fifth Avenue penthouses and East Harlem tenements, into fur salons and fish markets; and brought us face to face with immigrants and blue bloods, Broadway stars and Brooklyn teens, Wall Street wizards and the homeless. With each coverage NATIONAL GEOGRAPHIC continues to show us a city that endures as an "incomparable feat."

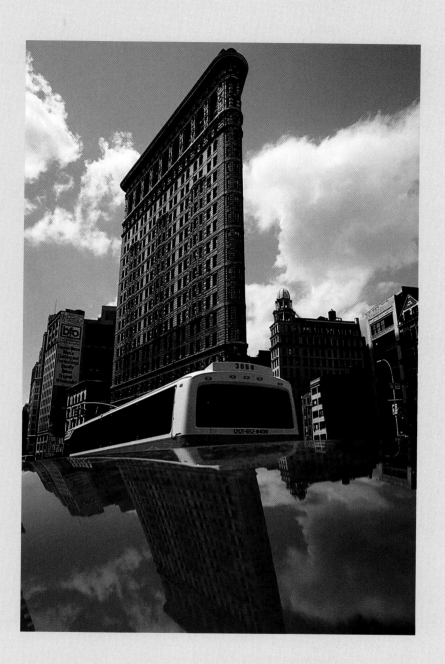

1990, New York
Manhattan limousine lends new dimension to the historic Flatiron.
Jodi Cobb

left:

1918, New York
Madison Square traffic passes the Flatiron and Fifth Avenue Buildings, "twixt the uptown and downtown business districts."
Norman Thomas and W. W. Rock

From whatever angle it is viewed, whatever facet throws back the light of its activities to the beholder, New York challenges one's interest and stirs one's imagination. Of all cities, it is the international city. In size, in wealth, in financial operations, in manufacturing, in international trade, in racial makeup, in a hundred ways it is the twentieth century Rome to which all roads lead—a city that does not belong to the New Yorker any more than Washington belongs to the Washingtonian. All nations have contributed to its population, and all America contributes to its financial, industrial, and commercial greatness.

July 1918, NATIONAL GEOGRAPHIC
from "New York: The Metropolis of Mankind"
by William Joseph Showalter

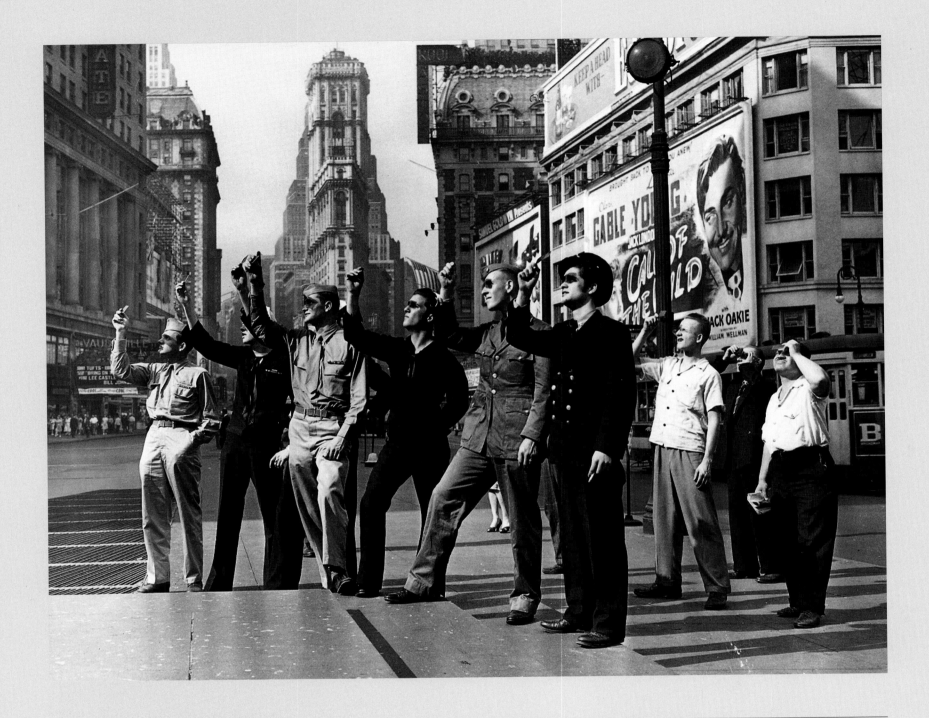

1945, New York
Broadway hit, a solar eclipse holds soldiers, sailors, and civilians at attention in the heart of New York's theater district.
Wide World Photos

The year was 1959. The year I first stepped foot on Broadway. My older brother Christopher and I had tickets to the hit musical *Gypsy*.... Halfway through the show the indomitable voice known as Ethel Merman broke into one of the musical's most stirring moments. "I had a dream!" she brayed, fighting tooth and tonsil with the orchestra's brass section.... "I had a dream!" Since that electric moment Broadway has always been the Street of Dreams to me.

September 1990, NATIONAL GEOGRAPHIC
from "Broadway, Street of Dreams"
by Rick Gore

1981, New York
Wall Streeters break from chasing dollars to catch some rays. Reflectors ensure even tans.
Jay Maisel

Mornings: Sometimes a yellow-brown haze, sometimes a metallic gray haze. Sometimes a sharpness of light and shadow that takes your breath, and you can smell the sea and see clear down the island. On such a day I headed down to Wall Street. I sought not change but abidingness. I was reassured when I met Bob Enslein, a member of the New York Stock Exchange, in the Stock Exchange Luncheon Club. There were wood-paneled walls, mounted moose and bison heads, a tobacco counter, a small room where members checked their street shoes and slipped into more comfortable shoes for the long hours of trading. We went down into the pit.

September 1981, NATIONAL GEOGRAPHIC
from "Manhattan: Images of the City"
by John J. Putman

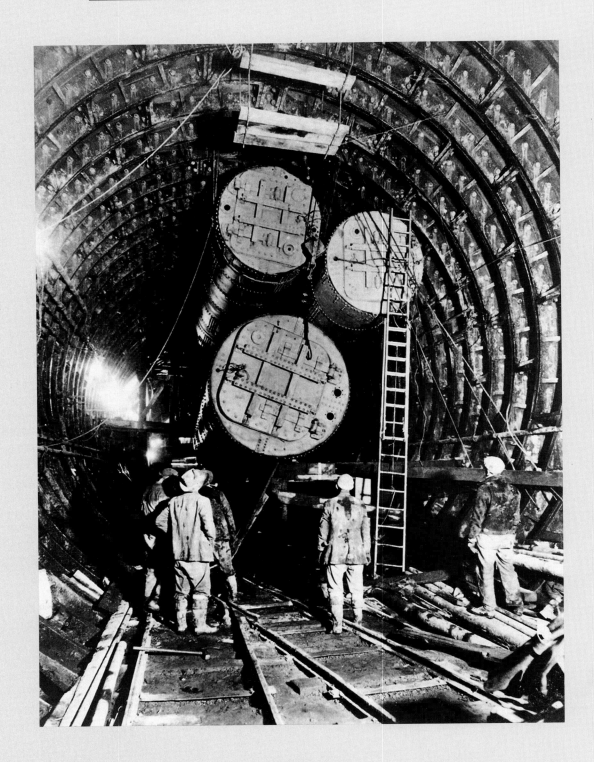

1936, New York
Through these airlocks, workers on the Midtown Hudson Tunnel will pass into pressurized chambers to stabilize their bodies for work below the river.
Wide World Photos

right:
1997, New York
Tunnel workers called sandhogs lower a 16-ton front-end loader into a water tunnel 670 feet below Queens.
Bob Sacha

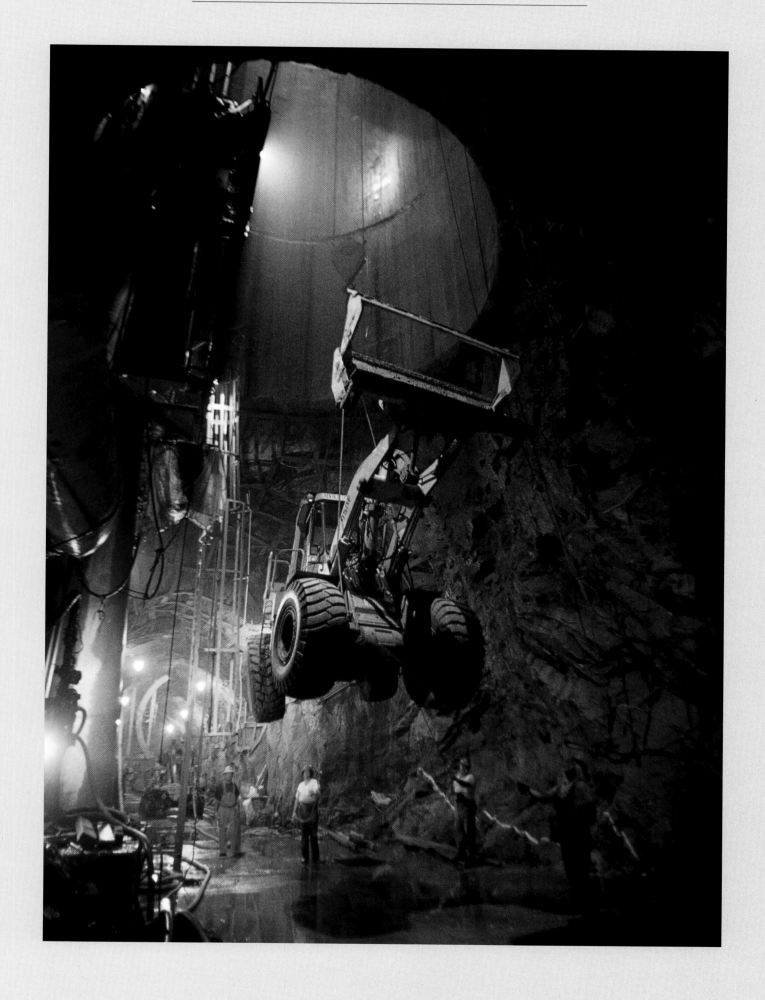

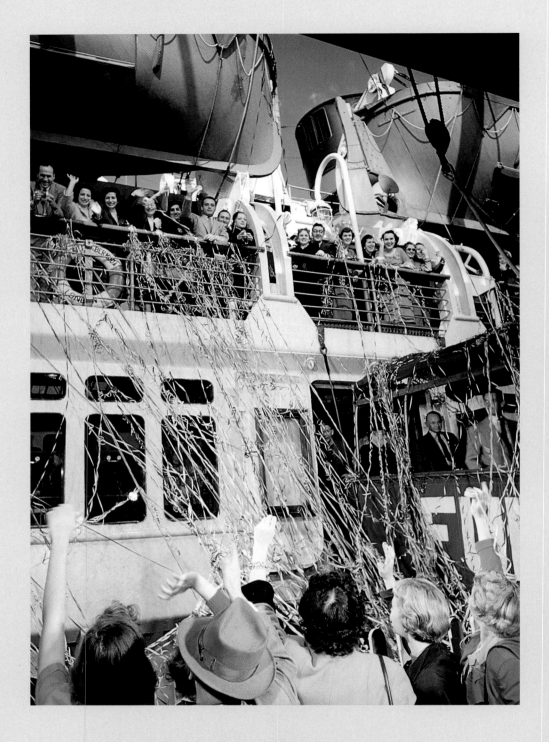

1954, New York
Dubbed the "Honeymoon Special" for the newlyweds that packed it
each June, the *Queen of Bermuda* departs New York Harbor in a
flurry of streamers.
David S. Boyer

right:

1986, New York
Ending its career in a Staten Island salvage yard, a tugboat awaits the
handiwork of metal cutter Charles Mead, who will reduce it to scrap.
Bruce Davidson

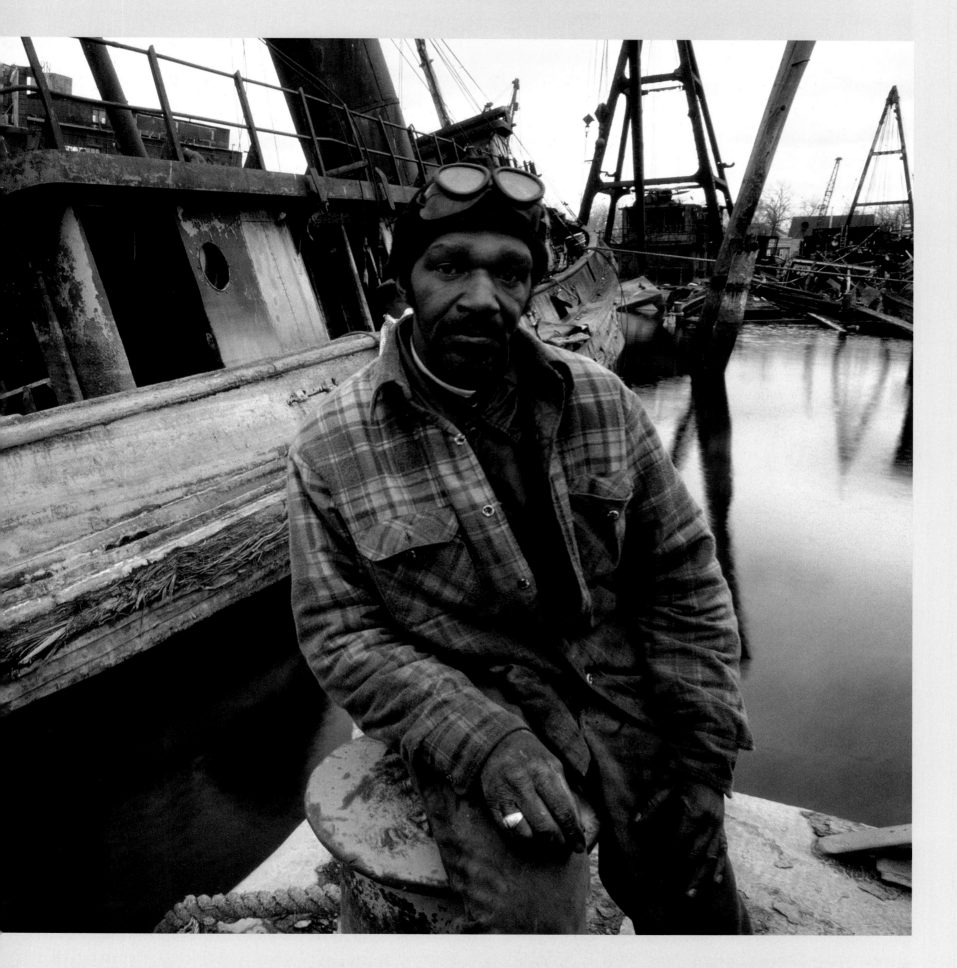

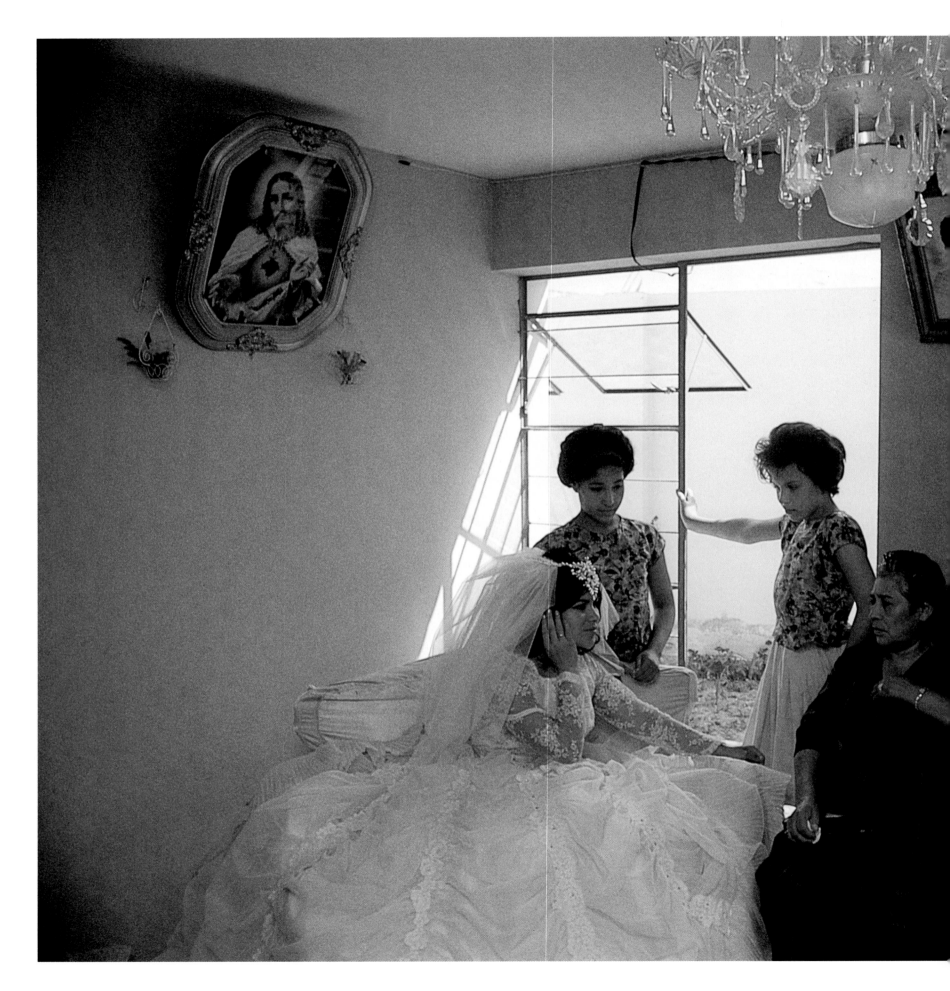

CENTRAL AND SOUTH AMERICA

By Loren McIntyre

1964, Lima, Peru
Princess for a day, a bride in rented finery accepts the admiration of her friends and the advice of her grandmother. The television, bought on an installment plan, identifies the family as part of the middle class that grew rapidly in Peru after World War II.
Bates Littlehales

following pages:
1993, Belem, Brazil
Love rules the ramparts that defended this major Amazon seaport from attack by European powers in the 17th century.
Alex Webb

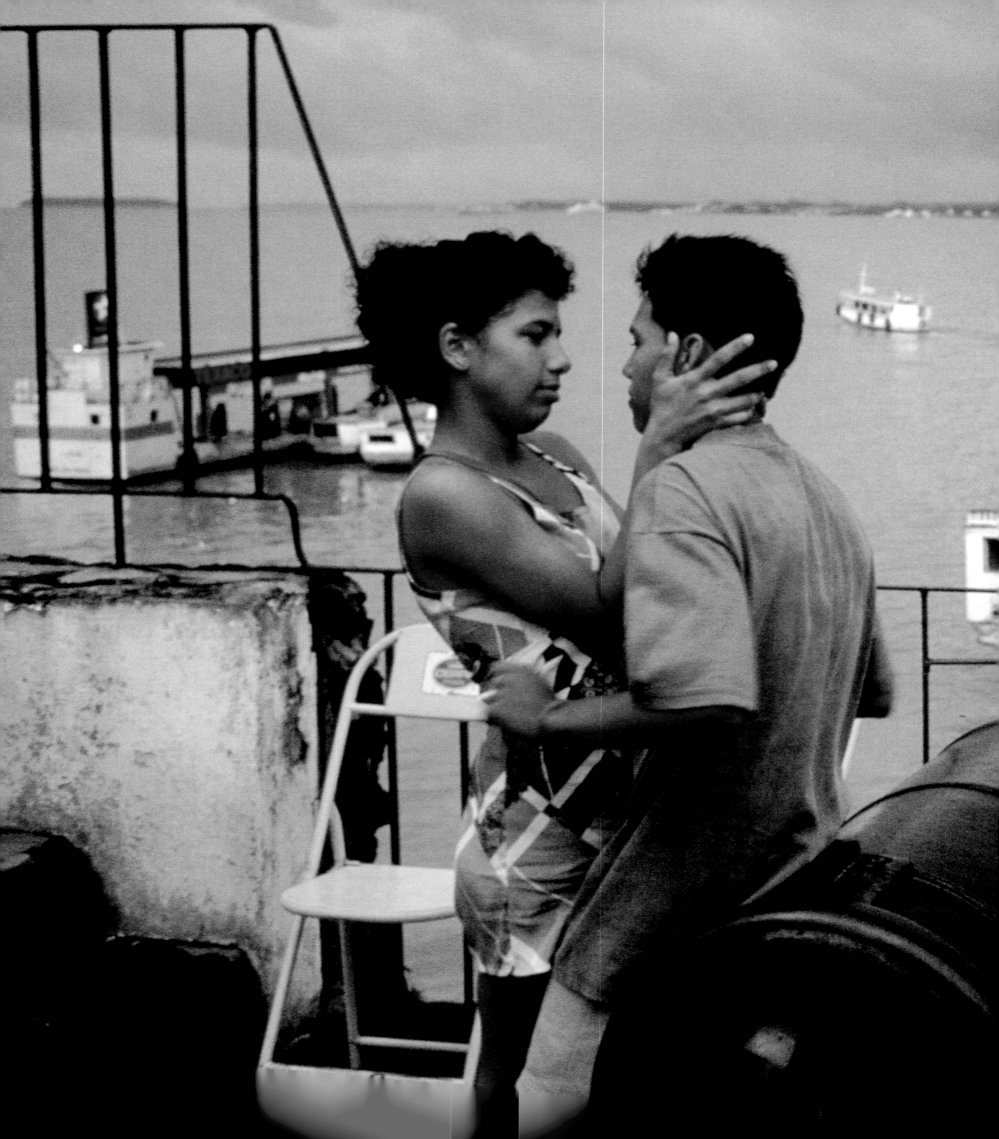

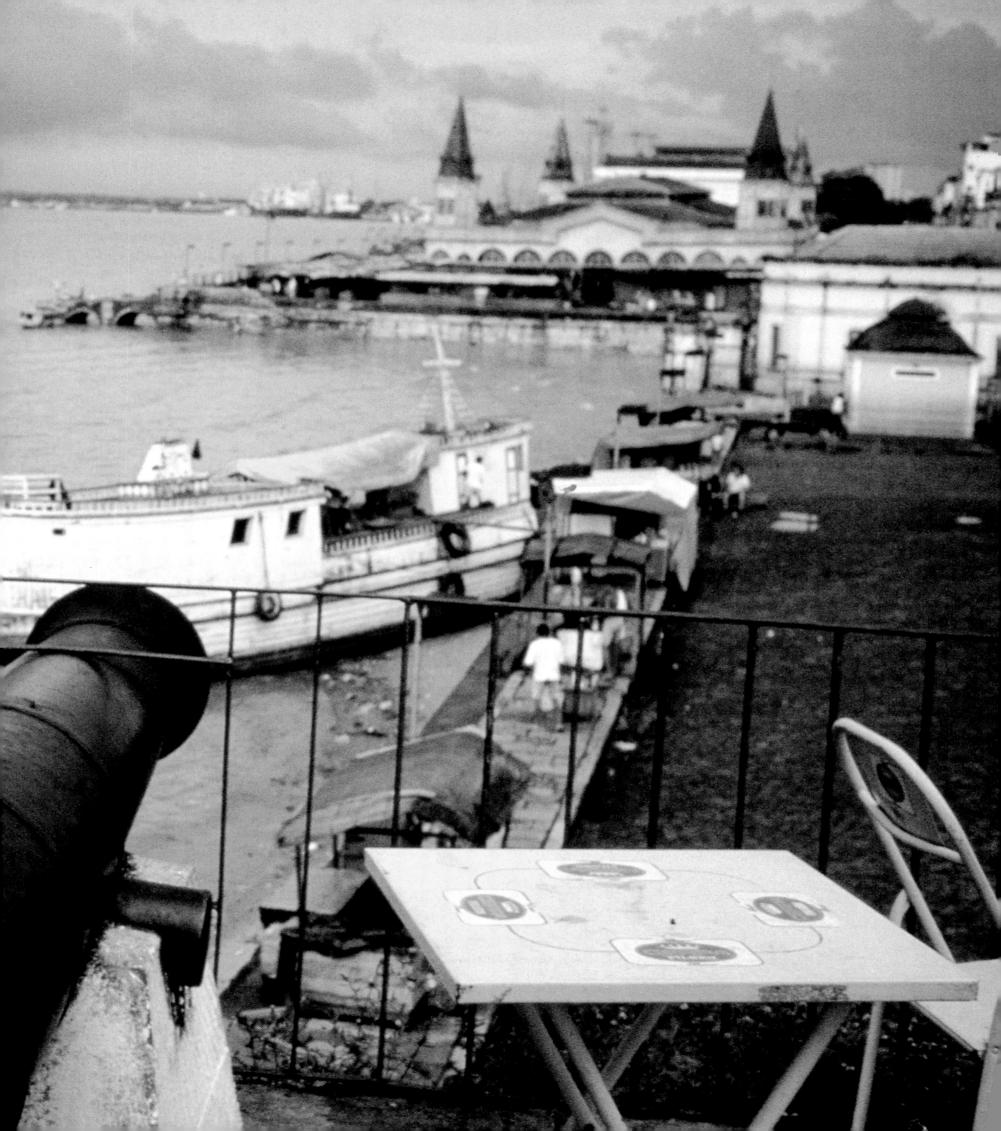

In the beginning there were no illustrations. Nor research staff to steer NATIONAL GEOGRAPHIC writers along the straight and narrow. So please excuse Gardiner G. Hubbard, founder of the magazine, for slipping up now and then in the first and only truly "continental" article on South America, March 1891. When Hubbard got to the Amazon River Basin (not in the field, of course, but engulfed in unverified data) he wrote: "Up from the ocean into this valley an immense tidal wave rolls, with a bore, twice a day, forcing back the current of the Amazon 500 miles and inundating a portion of the floodplain."

Some wave! Reversing a flow ten times greater than the Mississippi's! Racing an astonishing 80 miles an hour upstream! Then ebbing just as fast in order to repeat the tidal cycle twice a day! A whopper oft-repeated in print and sent flying even yet by the overdrawn longbow of Amazon storytelling. While most pieces like this were staff-written in the early years, many articles were borrowed from other publications. Sources improved after Mt. Pelé erupted on Martinique in 1902. Alexander Graham Bell, as Society President, ordered the editor to go there and "give us details of living interest beautifully illustrated by photographs." Not easy to do when the "details" are 30,000 Caribbean islanders immolated by incandescent ash. However, "You don't know if you don't go." Since my first voyage to South America in 1935 I've traveled the Amazon on countless trips by canoe, riverboat, and ocean liner, never troubled by towering walls of water. In fact, it took me years to find the tidal bore, as told and illustrated on the final pages of "Amazon, The River Sea," October 1972.

The "River Sea" assignment put my name on South American maps. I'd led an expedition to pinpoint the most distant source of the Amazon. It proved to be an ice-fed pond high in the southern Peruvian Andes, 4,000 miles from the river's mouth. The chief of nomenclature of the Inter-American Geodetic Survey later named the tarn after me. I had "been there and done that" as required of all NATIONAL GEOGRAPHIC photographers. Perhaps owing more to the magic of the name "Amazon" than to appeal of pictures and text, the story ranked high with the readership.

A lead picture shows the author seated on the continental divide. In the distant background rises a snowcapped volcano, Ampato, 6,310 meters. Recently, near Ampato's summit, Johan Reinhard found a frozen maiden sacrificed 500 years earlier by the Incas as described in the June 1996 issue—thus carrying on NATIONAL GEOGRAPHIC's reporting of human sacrifices at high altitude, which I began with "The Lost Empire of the Incas," in the December 1973 issue. My Inca story, also popular with GEO-

GRAPHIC readers, singed—but did not incinerate—repeated editorial assertions that readers are not ready for South America. A third article and survey winner in April 1987, "The High Andes," seemed to signify that South America was favored by yet another generation of readers. Or was it again merely the magical sound of names: Amazon, Incas, Andes?

In the field I enjoyed benefits denied photographers born too soon: Kodachrome film, more versatile cameras, ease of travel. But my main advantage over photographers of yesteryear came from readers' everlasting inability to part with *the magazine.* As if in a science-fiction movie, rectangular yellow-bordered motionless aliens full of unspoken wisdom keep multiplying weightily on bookshelves, invading waiting rooms and attics, and hiding in basements and barns throughout the English-speaking world—in such tonnage that the earth wobbles on its axis and science does not admit the real reason for such motion. Silently biding their time. Knowing that they will become, for GEOGRAPHIC writers and photographers, the greatest door-openers of all time.

As of 1968 no photography was allowed within the monastery at La Popa, atop a cliff overlooking Cartagena, Colombia. Yet when a priest noticed NATIONAL GEOGRAPHIC labels on my equipment, he invited me in, unlatched a crammed-full cabinet, and in his haste let hundreds of yellow-bordered treasures spill onto the ancient tiled floor. One was a bound copy dated October 1940, featuring "Hail, Colombia!" a country story written three decades earlier by legendary staff member Luis Marden (whose 61st article appeared in February 1998). Colombian President Carlos Lleras was also in love with the magazine. At a time when he refused to see a ranking news magazine correspondent, I was invited into his palace and offered a seat on his plane whenever he flew around the country on a reelection campaign.

It was a calm interval after the murderous civil conflicts termed *La Violencia* had ended and before the deadlier narcotics wars began. With the celebrity status accorded my Halliburtons labeled **National Geographic DO NOT X-RAY,** I stayed on in Colombia to do the Guajiro Indian chapter of a Geographic book *Nomads of the World;* a National Geographic lecture film; and documentary films for a world fair in Japan, for a Colombian airline, and for the city of Medellín—not yet the cocaine center it would become. No one else was covering Colombia in this way at that time. Or since then, because of recurring violence. A youth pictured with his family by their swimming pool in my August 1970 article was later kidnapped and held for ransom in a fetid hole in the ground near the Caribbean. After nine months he was "ran-

somed" by army gunfire. As he ran for freedom, an errant bullet tore out one of his eyes.

Yet half a century earlier, in October 1921, Frank M. Chapman had written, "As for risks to life and limb, I know of no safer country than Colombia." Curator of birds at the American Museum of Natural History, Chapman hoped to attract tourists to Bogotá, Colombia's capital city, that "with a population of 130,000 or more, seems as remote as Lhasa." He suggested a tour "on which anyone who can sit astride a mule may embark...." He went on to say that "the 'hold-ups' and other forms of highway robbery of daily occurrence in many large cities in the United States are practically unknown in Colombia."

Far less remote than Lhasa (only four hours by jet from Miami) and not as high, at some 8,600 feet, Bogotá now has nearly 40 times as many people as in 1921. Interurban buses have replaced mules. But I have never ridden one since a bus I missed by minutes in 1961 was ambushed near the capital and highwaymen arranged 32 passengers' severed heads in a row along the road. No such atrocity occurred in 1968 while I drove almost everywhere in Colombia. But during the next three decades of guerrilla and narcotics warfare, the GEOGRAPHIC stayed away from Colombia except to photograph survivors of an avalanche and Cartagena by night. Writers of two global articles, on emeralds and cocaine, felt endangered in Colombia because murder was so commonplace. That enchanting land is not yet as free of hazards as when Frank M. Chapman journeyed through "no safer country" with an army trunk of personal effects loaded on one side of his mule and a cot with blankets, mosquito netting, and overcoats on the other. It now seems old-fashioned for travelers to list all their gear, but I found it interesting and useful that Bernice M. Goetz detailed her preparations for a riverine exploration of eastern Colombian rain forests that few other "lone white women" would dare risk, even now. At that time, September 1952, GEOGRAPHIC picture captions still compared white folks with "simple Indians" in ways utterly unacceptable nowadays.

Little interest was paid to surviving aborigines of South America until articles by Harald Schultz about Brazil's naked tribes began to appear in 1959. By then, the construction of Brasilia, a new capital a thousand kilometers inland, had confirmed the nation's intention to colonize frontier territories whose two-per-square-mile population had remained largely indigenous. Schultz's articles were followed by five of Jesco von Puttkamer's dulcet Indian requiems. Jesco, until his death in 1994 an enthusiastic diarist and photographer of Indians, helped me with many

stories, including the Urueu-Wau-Wau tribe's "Last Days of Eden" and "The End of Innocence" in the centennial issue, December 1988. Every year since then I deliver to the tribe shipments of clothing and medicines donated by readers.

During Amazonian tribal adventures I often lived in a time warp. *Apollo* was circling the moon. Countless boats and bars

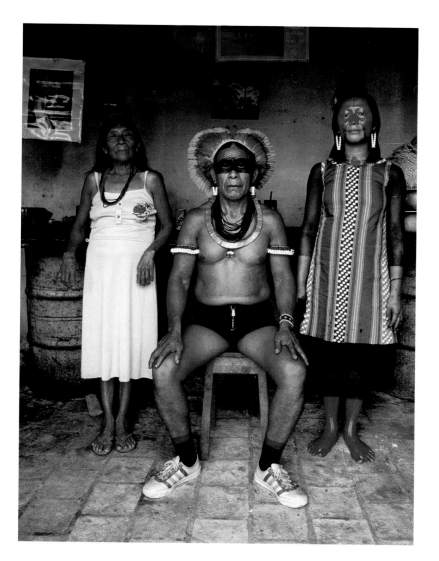

1984, Brazil
Kayapo headman flanked by wife and daughter wears a headdress of parrot feathers that denotes family origins.
Miguel Rio Branco

along the big river were being named and renamed "Apollo 8" and "Apollo 11." Meanwhile, far up one tributary, an Indian warrior would shatter my sleep with his shouts as he fired arrows into the night sky, sending ghosts that cause nightmares to the moon.

Youngsters often ask, "How did you get started at NATIONAL GEOGRAPHIC?" When I begin by saying I was 45 before someone at the GEOGRAPHIC saw my pictures of Bolivia and asked for more,

they wish they hadn't asked. I was living then in the high, thin air of La Paz, at 12,500-feet elevation. My pictures were okay but then nothing happened. The Supreme Court justice assigned to write the article had decided against a high altitude honeymoon with his bride of 23. Finally, Editor Melville Bell Grosvenor hired me to write "Flamboyant is the Word for Bolivia." Although other stories on the area had been done, this was the first full story of the country from Lake Titicaca to the Brazilian border. My chance shot of a woman weighing grapes—a pattern of ovals and angles—graced the cover of February 1966.

Because I am a generalist (one who knows very little about a lot of things) and by no means a specialist in anything South American, I began my freelance career at the GEOGRAPHIC writing wide-ranging stories about countries—Bolivia, Ecuador, Colombia, Argentina—and photographing geography in its universal sense; that is to say, almost anything concerning life on earth, whether high-born or low, as long as it was characteristic. Not having to stick to a particular subject as specialists must, I was free to follow wherever my fancy led. Later I turned to more adventurous themes: Amazon, Incas, Andes, and the travels of Alexander von Humboldt.

In 1982, in a cabin cruiser with five friends, I retraced the Prussian baron's expedition on the Orinoco River into a "lost world" where he said Indians call the morning dew "spittle of the stars." It was high water. We moored at dusk to the crowns of sunken trees and fell asleep to the pipe-organ bellowing of a million ardent frogs. Border guards grilled us at every riverine frontier post. Fearing they might arrest us "just for the hell of it," I spent one night making my exposed film look unexposed and vice versa. With double-sided tape I drew the leaders back out of my 44 used 35mm cassettes, wiped off their magic marker numbers with acetone, and put them back into cans and film boxes that I resealed to make them appear unopened. I then rolled leaders of 44 fresh films into their cassettes and gave them numbers. At daybreak a patrol boat found us. Police confiscated all the "exposed" film, disregarding the "unexposed" rolls.

For 13 jailhouse nights, confined in a six-by-nine-foot cell lacking even a bucket, we sweated on foul mattresses. We were thankful for downpours which cooled the air and hammered the sheet-metal roof, drowning out the sobs and screams of other prisoners. I would reach out through the window bars and fill my cup with rainwater, drinking to the wrongfully confined everywhere in the world and wishing them the priceless gift that prisoners never again take for granted. Freedom. Let it ring.

I contrived to swallow some anemia pills that turn the urine red. With theatrical groans I alarmed a jailor who witnessed a crimson splash when I relieved myself. He summoned a doctor. The *medico* secretly carried out a note that alerted the U.S. Embassy to our plight. When I eventually phoned the GEOGRAPHIC picture editor his first question was, "Did they seize your exposed film?" They had not, and I sympathized for an instant with some never-to-be-promoted technician unable to recover a single image from 44 rolls of confiscated film.

Having survived mad taxi trips along Avenida Infante Dom Henrique in Rio and Avenida Diagonal of Buenos Aires, as well as a less stressful 40 months on a warship in the Pacific during World War II, I came to believe that lady luck is my consort. She stood by when, at age 72, I was bloodily pistol-whipped by highwaymen on the desert coast of Peru while shooting chapter three of the Geographic book *The World's Wild Shores*. One fired at my face but he'd run out of ammunition. They drove off with my car and its trunkful of camera gear but luck saw to it that my exposed film had been safely stashed in a hotel refrigerator and even the rolls I'd been shooting had been dropped in the sand. Looking back, I realize I was lucky to have been born so long ago and to have started with the GEOGRAPHIC so late in life that I was able to take a longer view of the continent on which I was reporting. And lucky that my start at the magazine coincided with changes favoring widely ranging stories with pictures looking more profoundly into the heart of things.

In 1979 Director of Photography Bob Gilka awarded me a worldwide volcano story to photograph as soon as the assigned author, geologist David Johnston, returned from Alaska. When Mount St. Helens began to rumble, I phoned Gilka from Guatemala. He said, "Stay there. Finish up your national parks story. I'll hire a Pacific Northwest photographer, Reid Blackburn, to cover for you." When St. Helens exploded on May 18, 1980, with the force of 500 Hiroshimas, Johnston perished tragically in his observation site six miles from the mountaintop. Scalding gases ended all thought of the mountain's magnificence for Blackburn and 60 others. To quote Rowe Findley, author of the St. Helens article, January 1981, "First I must tell you that I count it no small wonder to be alive." Rowe had decided not to watch the mountain that Sunday, and I was shooting a religious procession with lady luck at my elbow. Rowe's 64-page St. Helens report, six months in preparation, with pictures by 21 photographers, was the most powerful article of the GEOGRAPHIC's first century and by far the finest of a hundred volcano pieces published since 1893.

The magazine has been less diligent at reporting cataclysms in South America. Although Peru has netted about 80 articles (more than Brazil, a country that embraces half the continent), a tsunami story was killed and little mention was made of the greatest natural disaster of the century in the Western Hemisphere, the Peruvian earthquake of May 31, 1970, which shook down half a peak of the highest mountain in the land and took some 66,000 lives. On Mount Ruiz, above Armero, Colombia, volcanic gases transformed summit snows and ice into a nocturnal mudflow that engulfed 23,000 residents. A May 1986 article told about it in 14 pages of text, maps, and pictures of daytime rescue operations.

The greatest then-till-now changes I have witnessed in South America during my own lifetime are the population explosion, motorization, and electronic communications. The continent holds more than three times as many humans as when I first went there at age 18. Travel now depends upon fossil fuels. There are few mules in the Andes and fewer sailboats on the Amazon. Chain saws have replaced axes. You can make the inhabitants multiply and sailing ships vanish before your eyes by leafing through some of the approximately 180,000 NATIONAL GEOGRAPHIC pages that can now be transferred from compact discs to your computer screen.

Early issues of the GEOGRAPHIC were not much given to aesthetically evocative pictures independent of time and place. In those days editors strove to find images that illustrated something specific in the story or at least hinted at the nature of the thing or place. Or sometimes just popped in a picture because it was pretty. When color arrived they tended toward "postcard" views of people—preferably dressed in "NATIONAL GEOGRAPHIC red" and "interacting" with one another.

In writing and illustrating two dozen freelance assignments, I learned that NATIONAL GEOGRAPHIC photographs were becoming more sophisticated than those that had enriched my childhood. No longer were they intended merely to bolster the text and limit the exuberance of writers such as Gardiner Hubbard. More and more they were chosen to create a world of their own in arousing reader response, be it wonder or simply a genesis of knowledge. To that end, I was constantly on the lookout for strong and enjoyable pictures that GEOGRAPHIC illustrations editors might term "stoppers" in the course of their examining thousands of slides from the field. About 300 of my pictures in the GEOGRAPHIC have been chance shots. Others, perhaps less eye-catching, had to be planned in advance. Many were "point pictures"—such as a portrait of a president interviewed for a country story.

Editors now publish pictures strong enough to stand alone, especially in National Geographic books bearing titles such as *Nature's World of Wonders*. Page 168 of that book holds the loveliest picture that ever came out of my camera, which I call "Death in the Rain Forest." I had been winging low in a small plane over a sea of green, the Amazon rain forest canopy of Brazil, at about 6° 30'S latitude and 56° 10'W longitude. While kneeling at the open door, camera at my eye, hoping to catch a glimpse of scarlet macaws, a pattern in white flashed before my lens. So swiftly was it gone that I did not remember snapping it. When published,

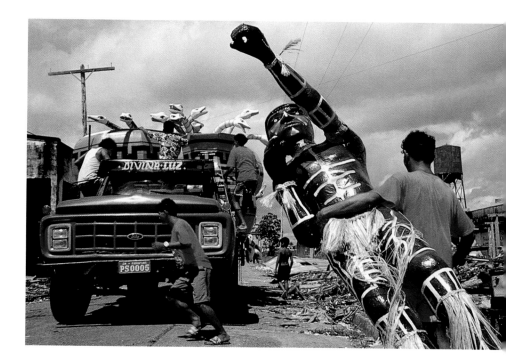

1993, Parintins, Brazil
Grass-skirted statue heads for a float in Boi-Bumba, the premier folk festival of Brazil's Amazon Basin.
Alex Webb

following pages:
1973, Curva, Bolivia
Timeworn terraces of pre-Inca farmers surround the home of Callawaya nomads, who were medicine men to the Incas.
Loren McIntyre

critics cited the haunting surprise of the skeletal tree, the elegant composition, the painterly qualities, "the kind of thing you could live with on the wall for a long, long time." And taken, they said, from the perfect distance. I had been quite unaware of such virtues while speeding above the treetops at 115 knots. Luck had let my camera capture a remembrance of Earth to hang, perhaps, in the wardroom of a future spaceship.

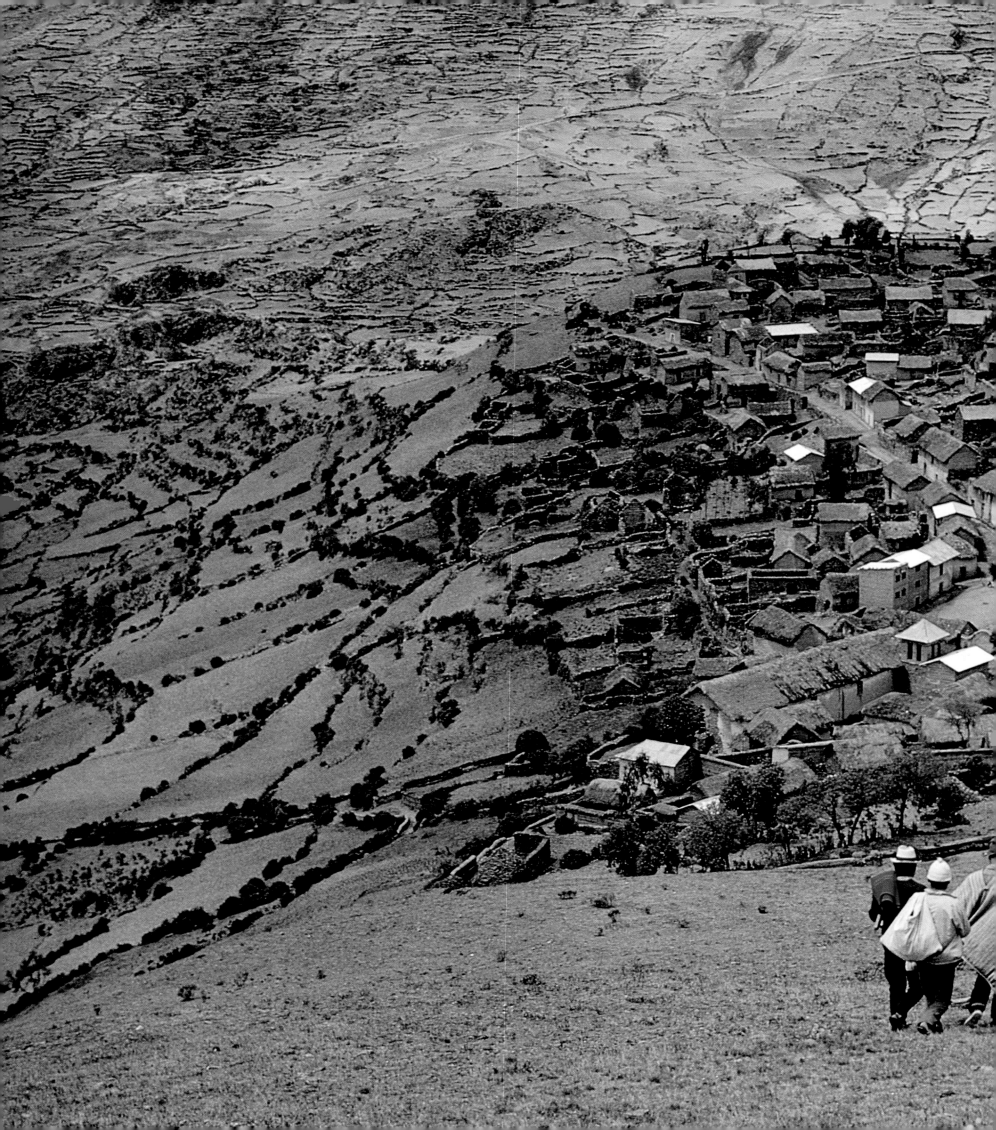

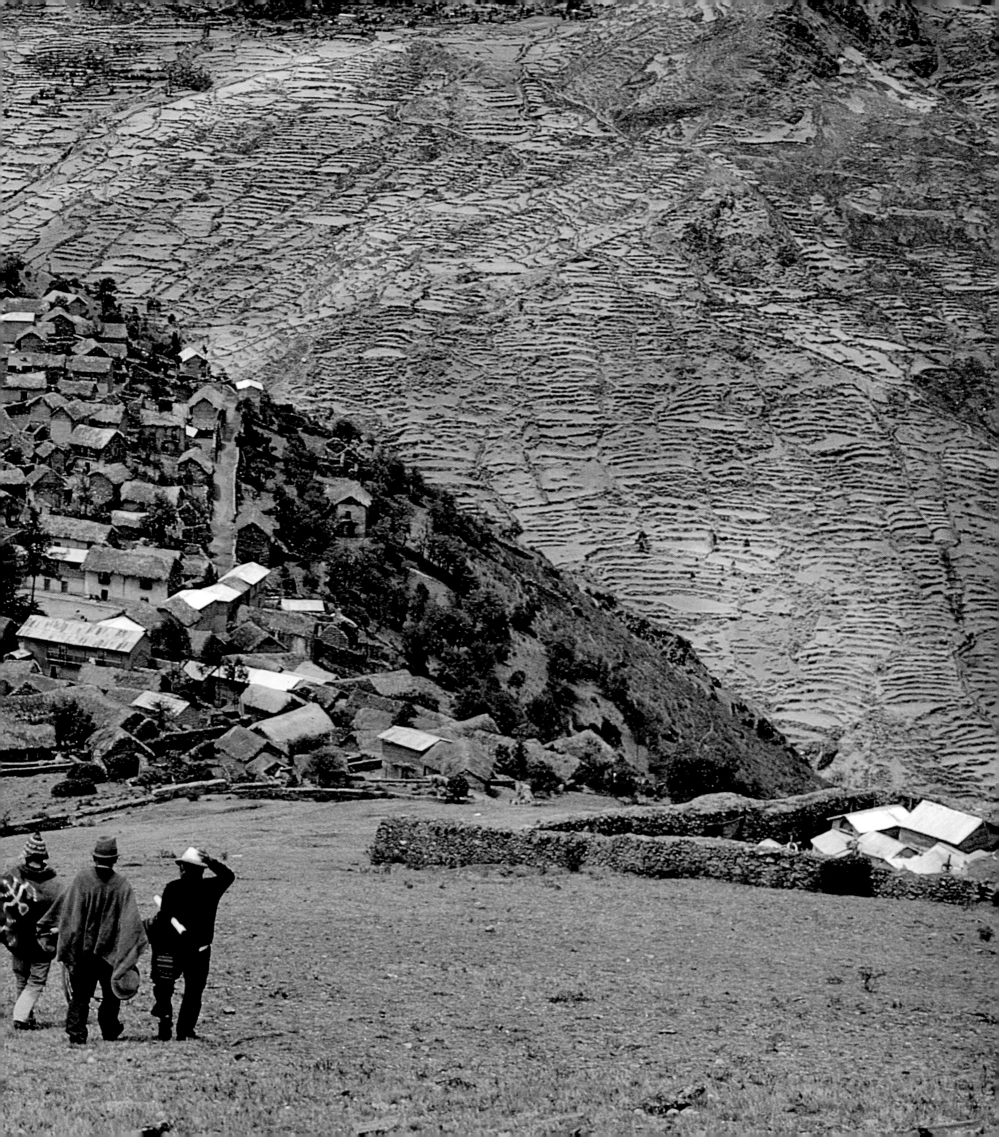

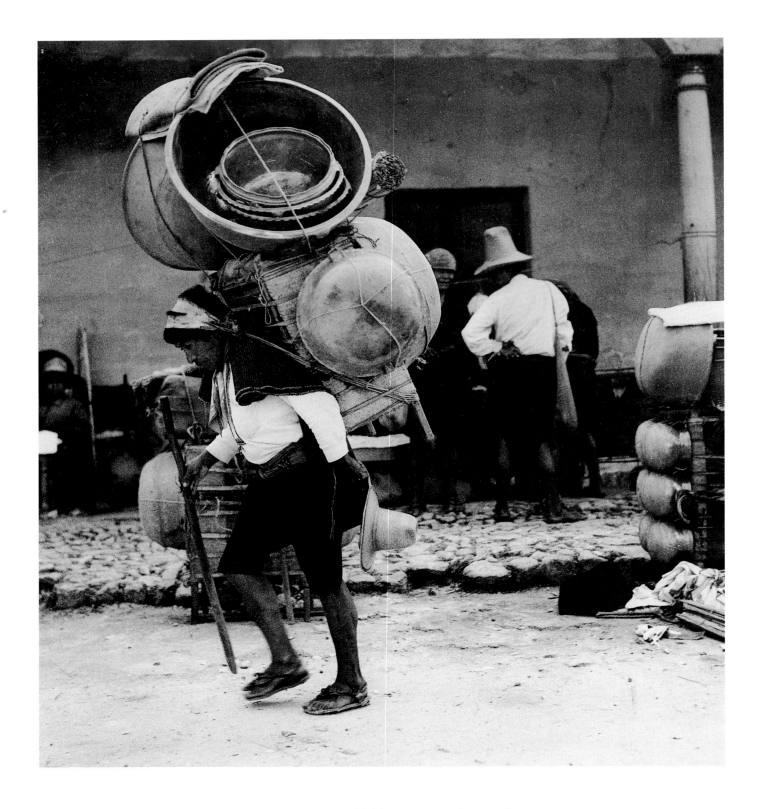

1936, Santo Tomas Chichicastenango, Guatemala
Pottery leaves the market on the back of a peddler. His successful trip hinges on the strength of his staff,
used for support on steep mountain trails. He will travel seven or eight miles before stopping to rest.
Henry Clay Gipson

right:
1974, Guatemala
Shower of gold, coffee beans pour onto a concrete apron during their five-day drying process.
Grant C. Kalivoda

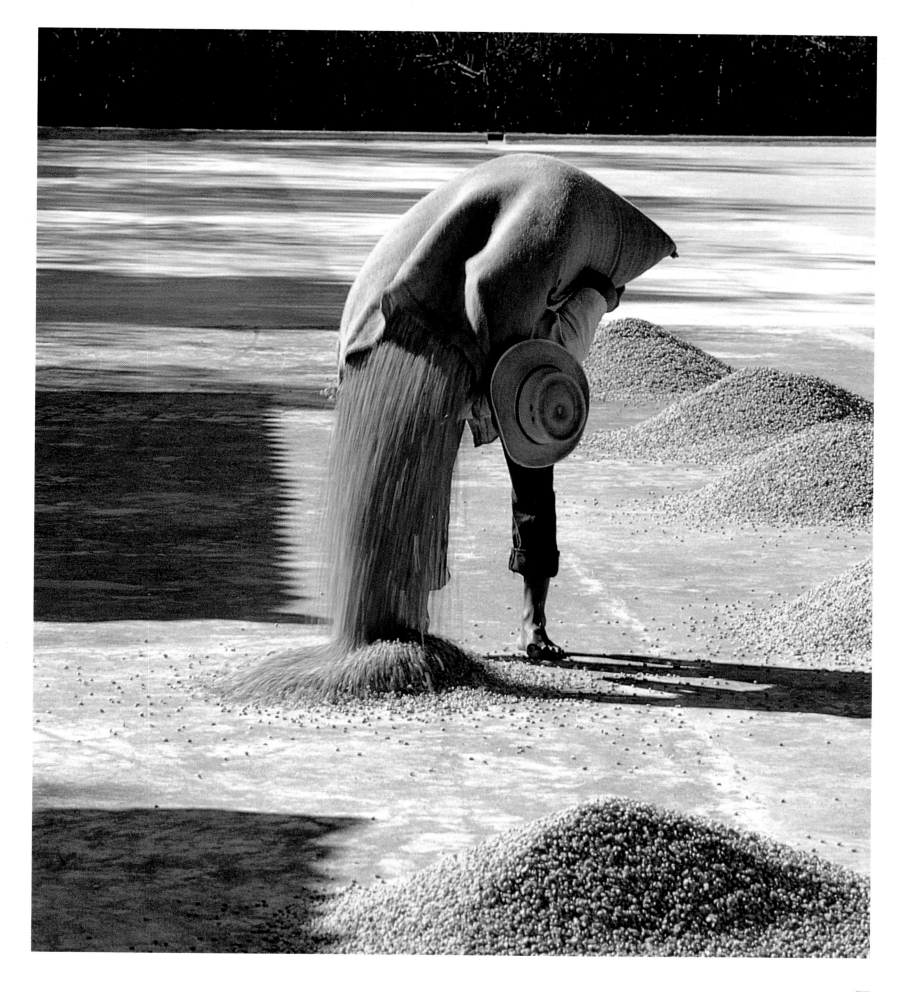

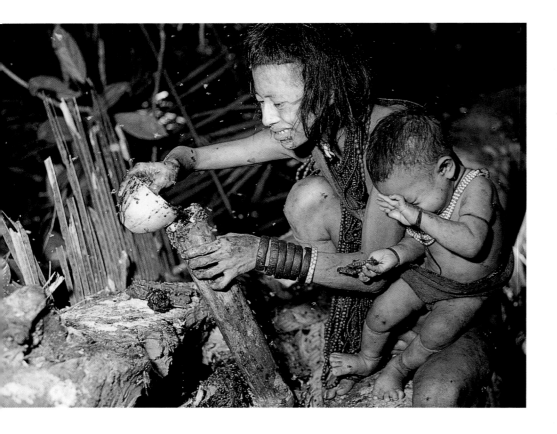

1964, Mato Grosso, Brazil
Sweet treat exacts a painful price as bees attack an Erigbaagtsa
mother and her daughter collecting wild honey along the upper
Juruena River.

Harald Schultz

right:

1992, Salvador da Bahia, Brazil
Heedless of history, four-month-old Samara Sampaio regards
this seaport's ancient Pelourinho quarter, where centuries ago
slaves from Africa were whipped and sold at public auction.

Maggie Steber

One afternoon two little [Erigbaagtsa] girls go into the forest, carrying
their baby sisters on their hips. At a shady spot in the forest, there are
three sandy open spaces—playgrounds. In one stands a palm-leaf hut,
just large enough for the little girls to crawl inside. In the sand lie small
baskets and paddles for fanning a fire—the girls' toys.

May 1964, NATIONAL GEOGRAPHIC
from "Indians of the Amazon Darkness"
by Harald Schultz

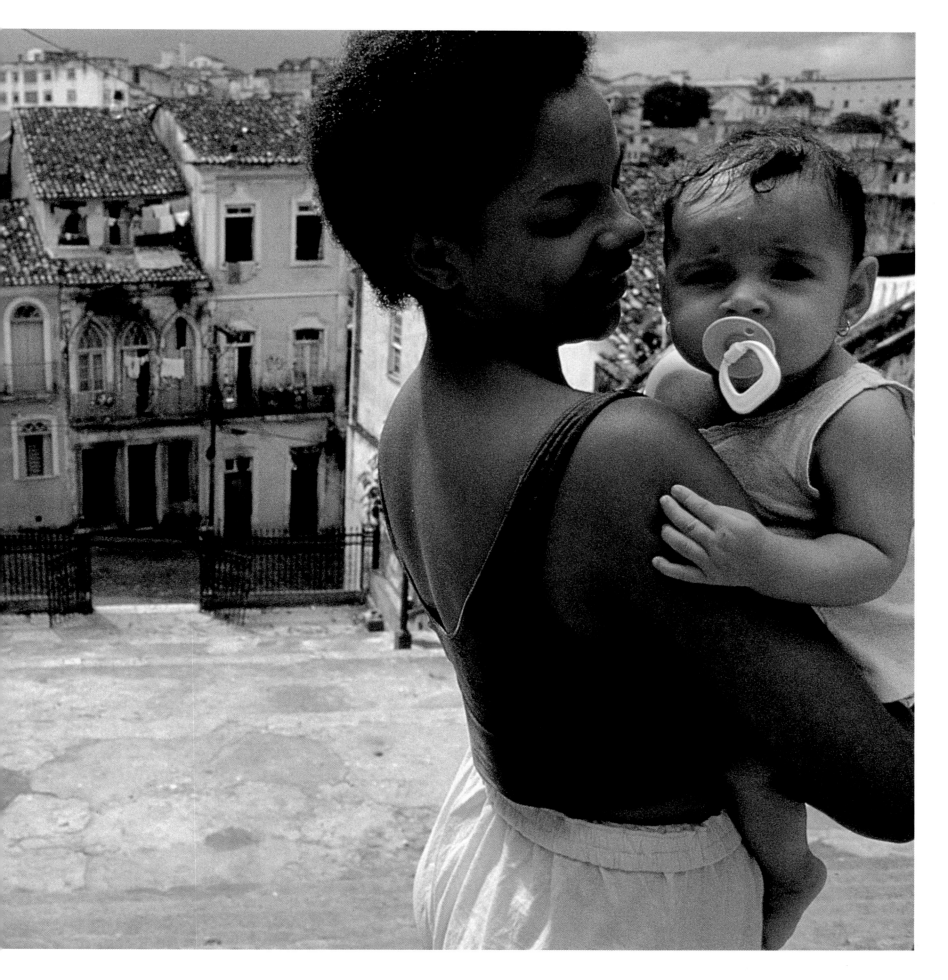

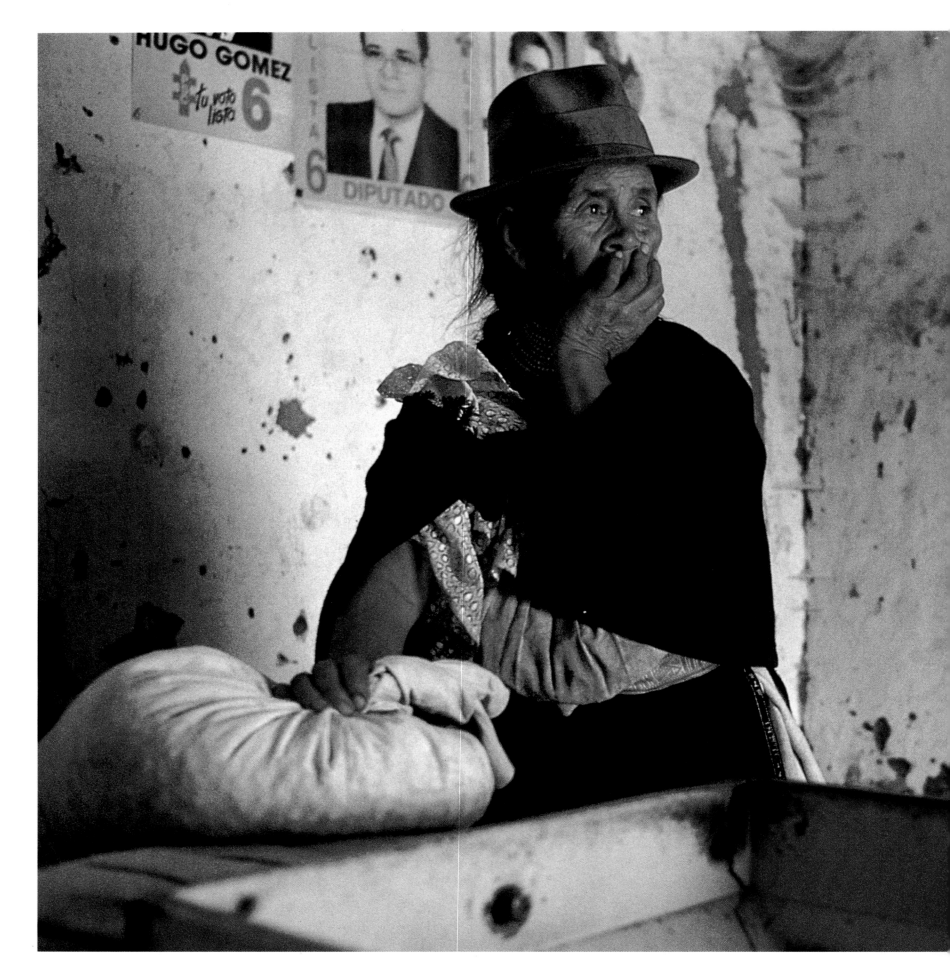

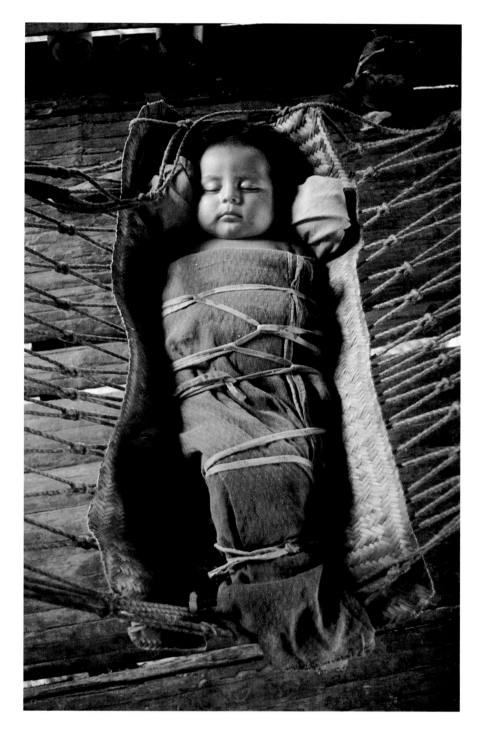

1968, Northwestern Ecuador
Soothed by the hammock's gentle sway, a Cayapa Indian baby
wrapped in a blanket bound with vegetable fiber succumbs to
sleep in her rain forest home.

Loren McIntyre

left:

1990, Barrio El Sagratio, Ecuador
Harvest time means lineup at the mill, where Doña Marta Cevallos waits to
have her corn ground into meal.

Chris Johns

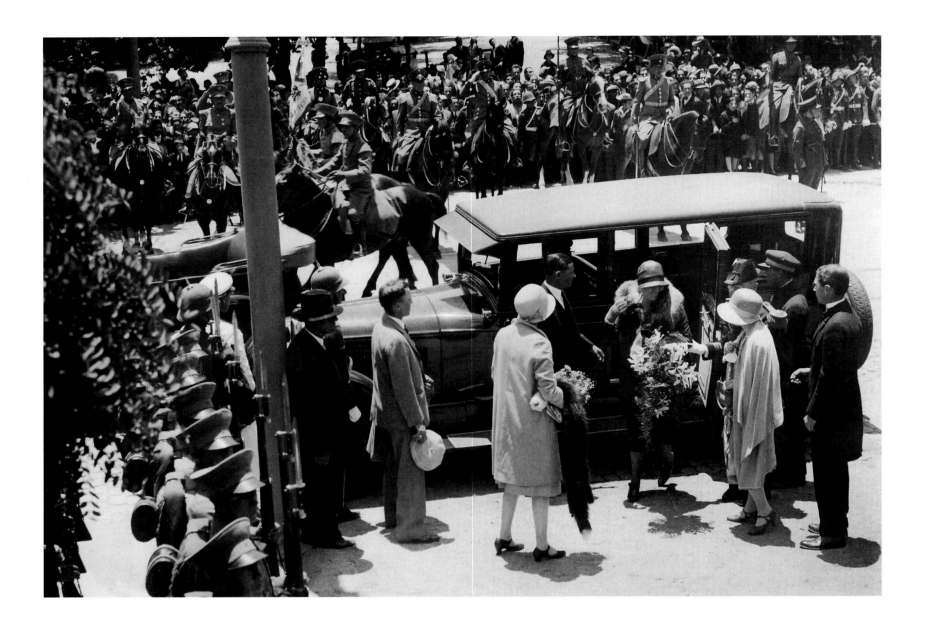

1929, Santiago, Chile
Horse guard and infantry welcome Mrs. Herbert Hoover, wife of the United States President-elect, as she arrives at the American Embassy. The visit to Chile was among several stops in the future first couple's goodwill tour of South America.
Pacific and Atlantic

The social life of Santiago is brilliant and vivacious. Most of the wealthier residents have vast haciendas, which yield large profits because labor costs are extremely low. Consequently, they are able to own city homes of the most luxurious type and to entertain with a lavish hand. The upper-class Chilean has traveled extensively, has studied abroad, and not uncommonly speaks both French and English fluently. Old Spanish conventions still control the relations between the sexes. The new Union Club has become the social center, and Santiago has much justification for the extravagant pride with which it contemplates its splendid new clubhouse. Dinners usually begin about 10 o'clock, and here one may see the debutantes and their younger sisters as perhaps nowhere else in the city.

February 1929, NATIONAL GEOGRAPHIC
from "Twin Stars of Chile"
by William Joseph Showalter

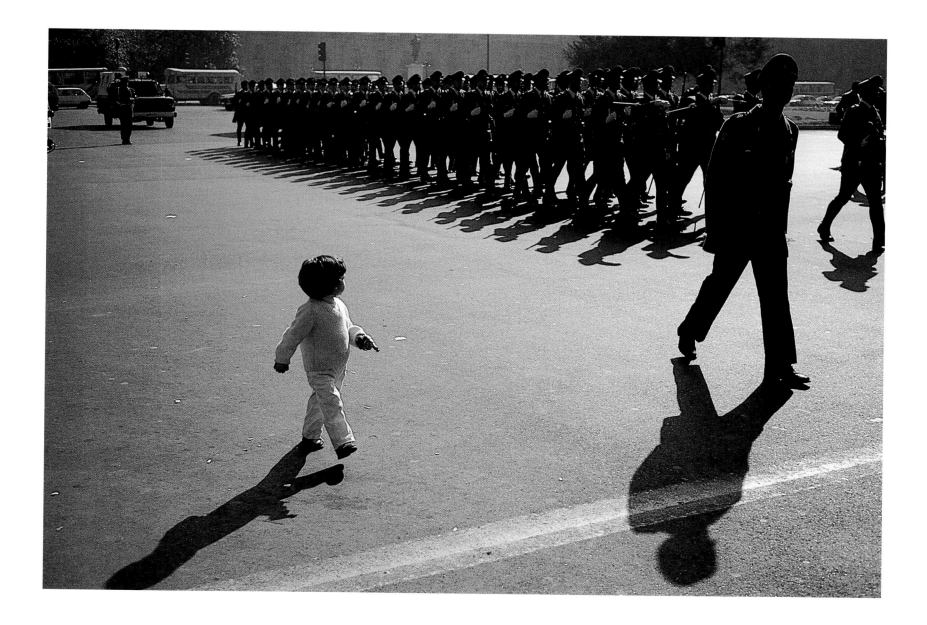

In August 1986 Chileans reacted with shock and disbelief to news that 80 tons of arms and ammunition had been uncovered…in the nation's north. Landed from Cuban trawlers? Cached by urban guerrillas of the Manuel Rodriguez Patriotic Front, or FPMR? More weapons turned up later in Santiago itself. I inspected the captured arms at a Santiago arsenal…. I hefted a submachine gun, its clip spent, and shouldered the scorched firing tube of an anti-tank rocket. In September 1986, FPMR guerrillas had used these and other arms to ambush President Pinochet's motorcade….Three cars were rocketed; five bodyguards died; only a bullet-pocked Mercedes Benz sped away. Inside, shielding his ten-year-old grandson, Pinochet kept low behind a window whose bullet cracks seemed to him to compose an image of Our Lady of Perpetual Help.

July 1988, NATIONAL GEOGRAPHIC
from "Chile: Acts of Faith"
by Allen A. Boraiko

1988, Santiago, Chile
Toy gun in hand, a child mimics the march of Santiago's palace guard unit during the regime of Captain General Augusto Pinochet Ugarte, who seized power in 1973 with the violent overthrow of President Salvador Allende Gossens.

David Alan Harvey

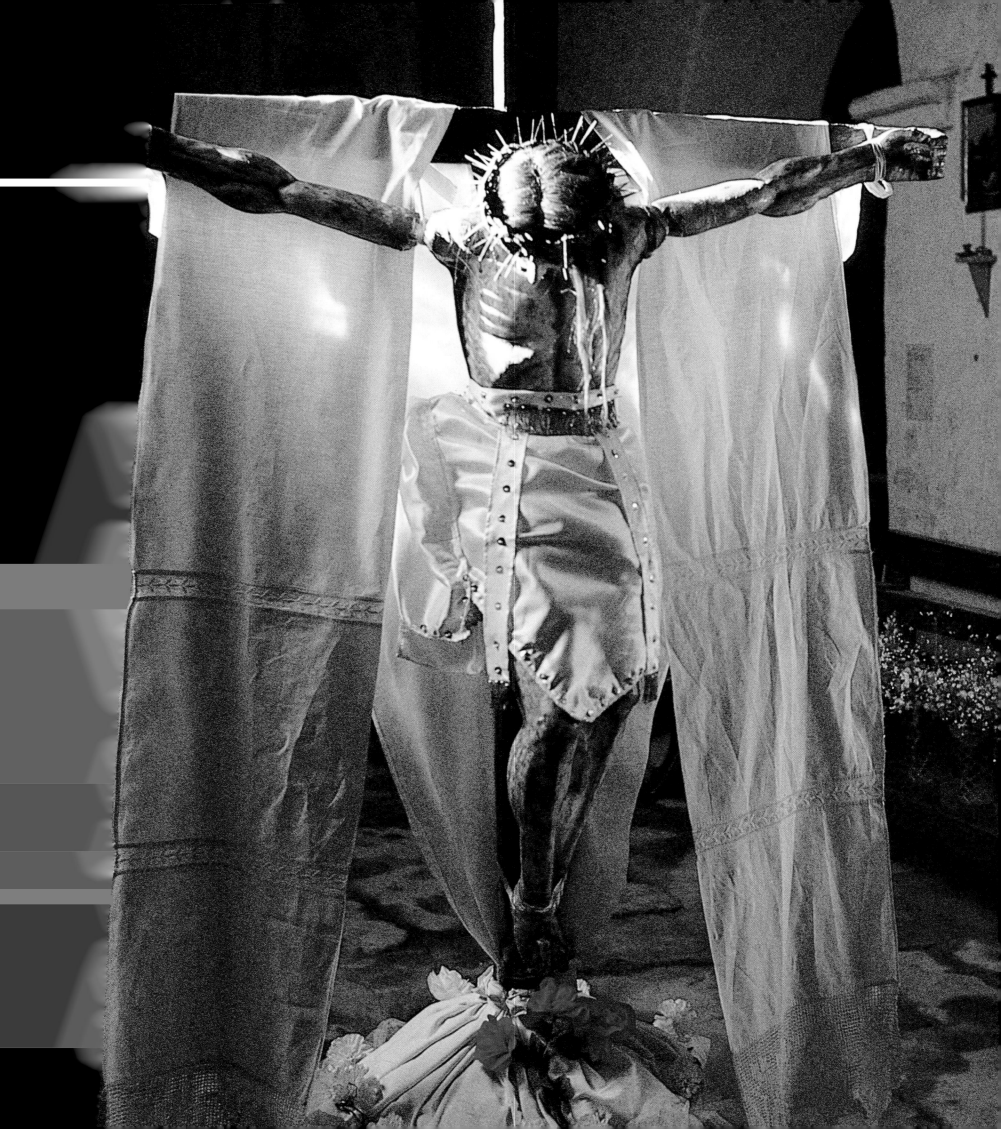

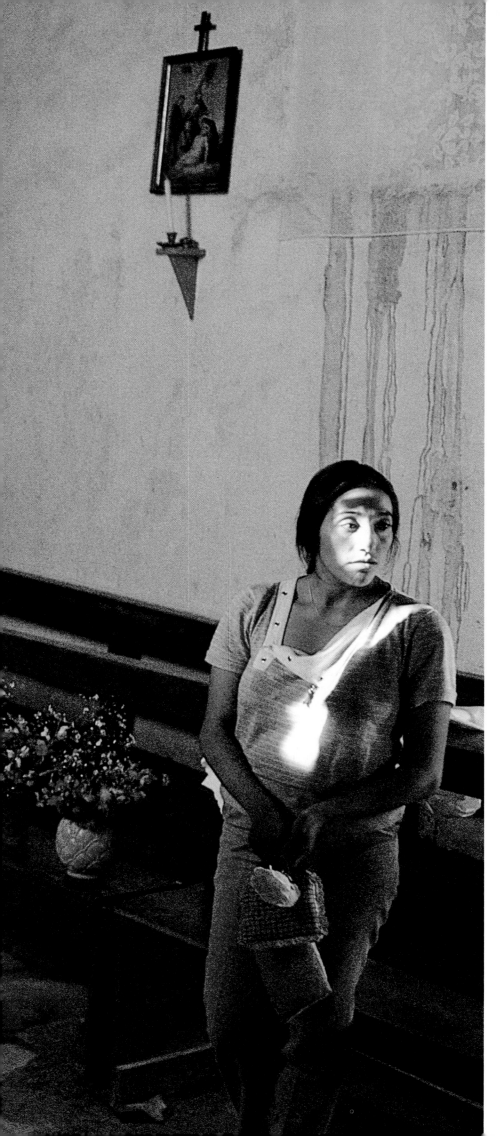

To a Mapuche shaman, or *machi,* the Lake District is a meeting ground between God and man, and a battleground between good and evil. "My life is always in danger," said José Gerardo Queupucura. "My greatest struggle has been to overcome a local male witch possessed by Satan, and Satan is very strong."

Machi Gerardo, 45, hardly seemed a match for Satan's surrogate: slender as a boy beneath a...poncho and with a...face as mild and untroubled as a child's set off by a purple bandanna. Still, we seemed safe enough in his *ruka,* a traditional Mapuche house, in the rolling wooded farmland outside Temuco....

How could Machi Gerardo divine and combat a witch? "My vision is different from yours," he said.... "This gift was revealed to me in a dream when I was eight. I was consecrated at 11. With passing years I have gained strength from the spirits above and from the earth, in which I root like a tree."

Some days as many as 60 Mapuche seek him out—to cure an ill, rescue a harvest, or pray for them at his *rewe,* an altar log incised with steps that symbolize a machi's power to elevate petitions to the land of the gods.

July 1988, NATIONAL GEOGRAPHIC
from "Chile: Acts of Faith"
by Alan A. Boraiko

1988, Chiuchiu, Chile
Reverence radiates from the face of a woman who has dressed the crucifix of Chiuchiu's Roman Catholic Church for Easter. The Church in this predominantly Catholic nation has long championed human rights and now provides help for growing social problems.
David Alan Harvey

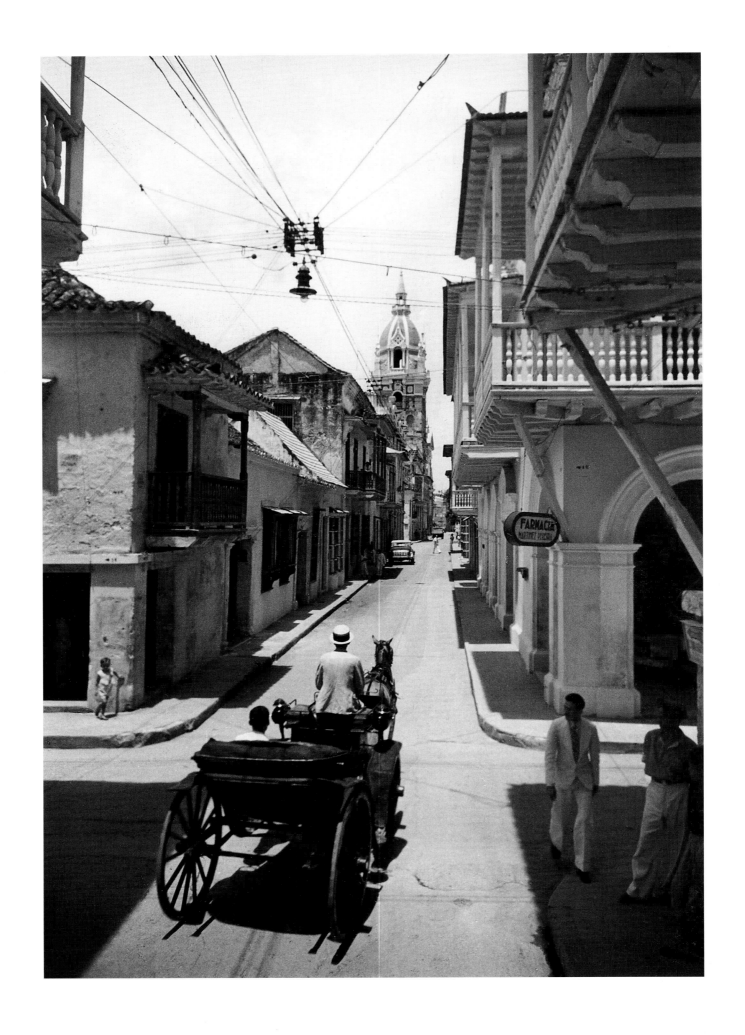

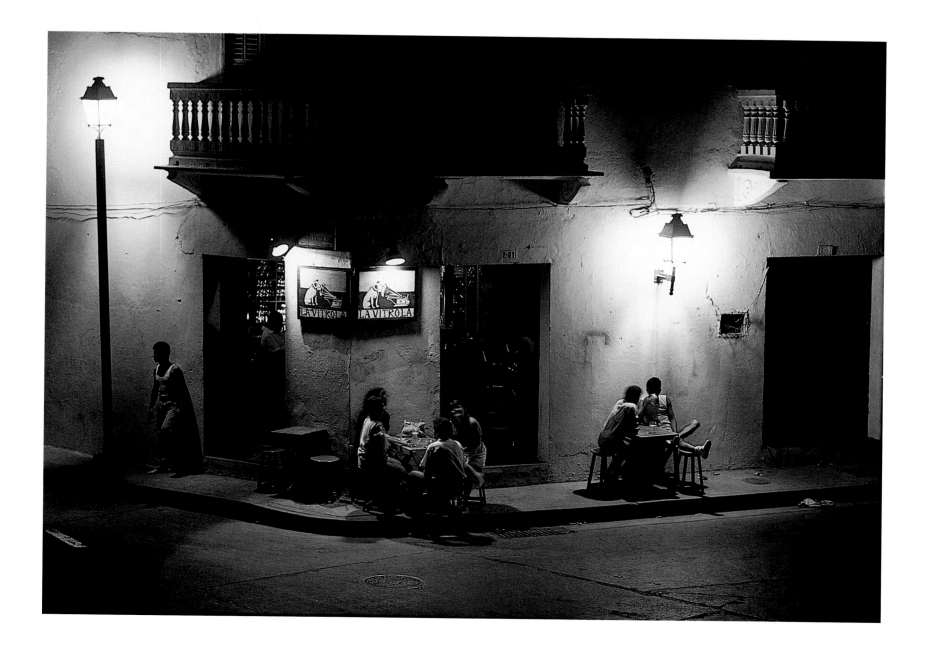

Galleons from Spain came regularly to Cartagena to take on gold and silver for the royal treasury. In their wake came Drake, Morgan, and the rest of the adventurers who for more than 150 years found Cartagena…a regular source of revenue…. The enclosed plaza, with its cobblestones, wooden-barred balconies, and open carriages, suggests the Cartagena of two centuries ago. Most of Cartagena's narrow, straight streets are partly shaded by wide overhanging wooden balconies that run along the upper stories of the houses. The balconies usually have bars of white-painted ornately turned wood. As the sun climbs higher toward the middle of the day, the intensely blue shadows retreat under the balconies, and each street is left deserted, with a line of white fire down the middle.

October 1940, NATIONAL GEOGRAPHIC
from "Hail Colombia!"
by Luis Marden

1989, Cartagena, Colombia
Lured outdoors by cool evening breezes, friends gather under antique balconies at La Vitrola, a streetside cafe frequented by the city's artists and intellectuals.

O. Louis Mazzatenta

left:
1940, Cartagena, Colombia
Clip-clop of a hired coach intrudes on the silence of midday, when blistering temperatures drive most Cartagenans indoors for siesta.

Luis Marden

following pages:
1975, Southwestern Bolivia
On a salt plain, once a prehistoric sea, llamas slake their thirst at a watering hole before carrying salt to market.

Loren McIntyre

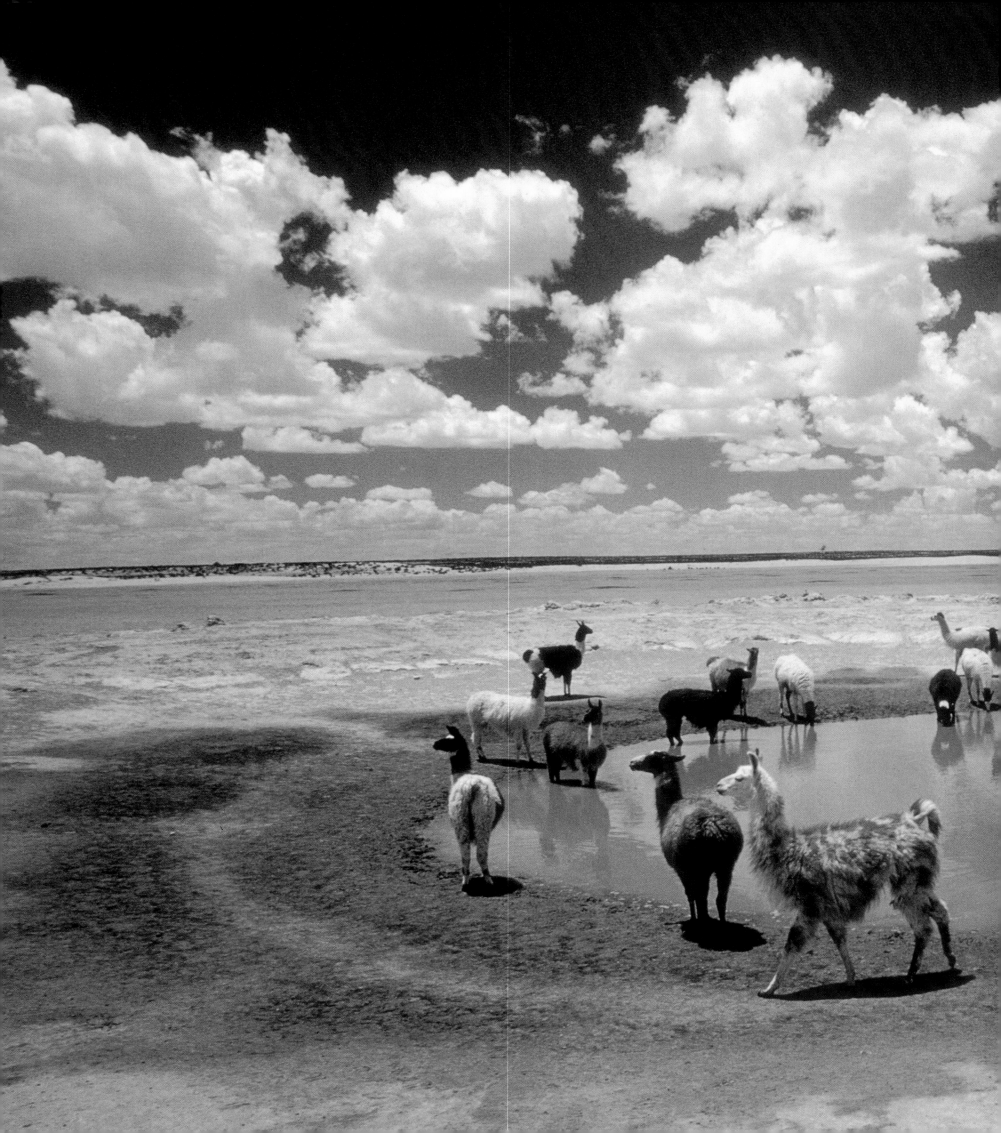

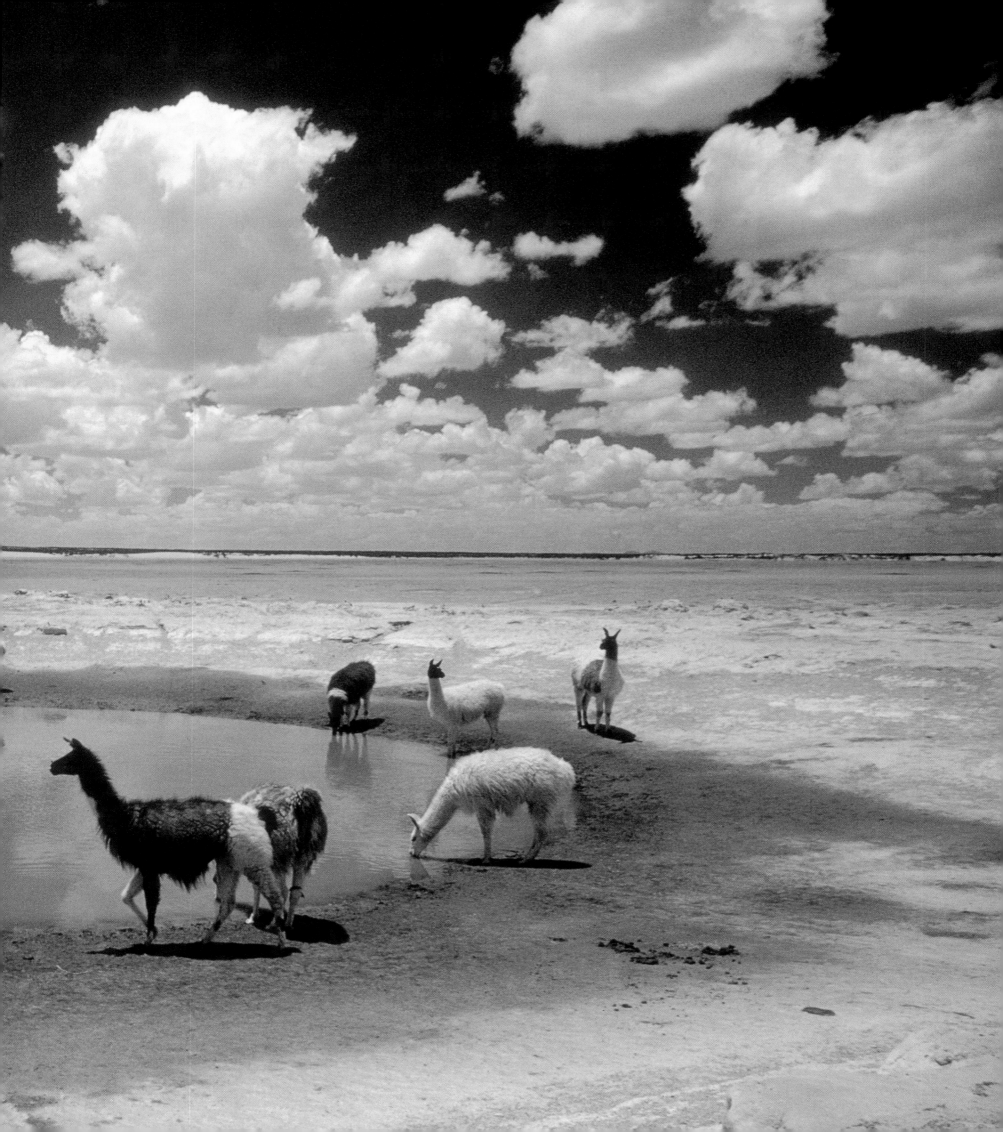

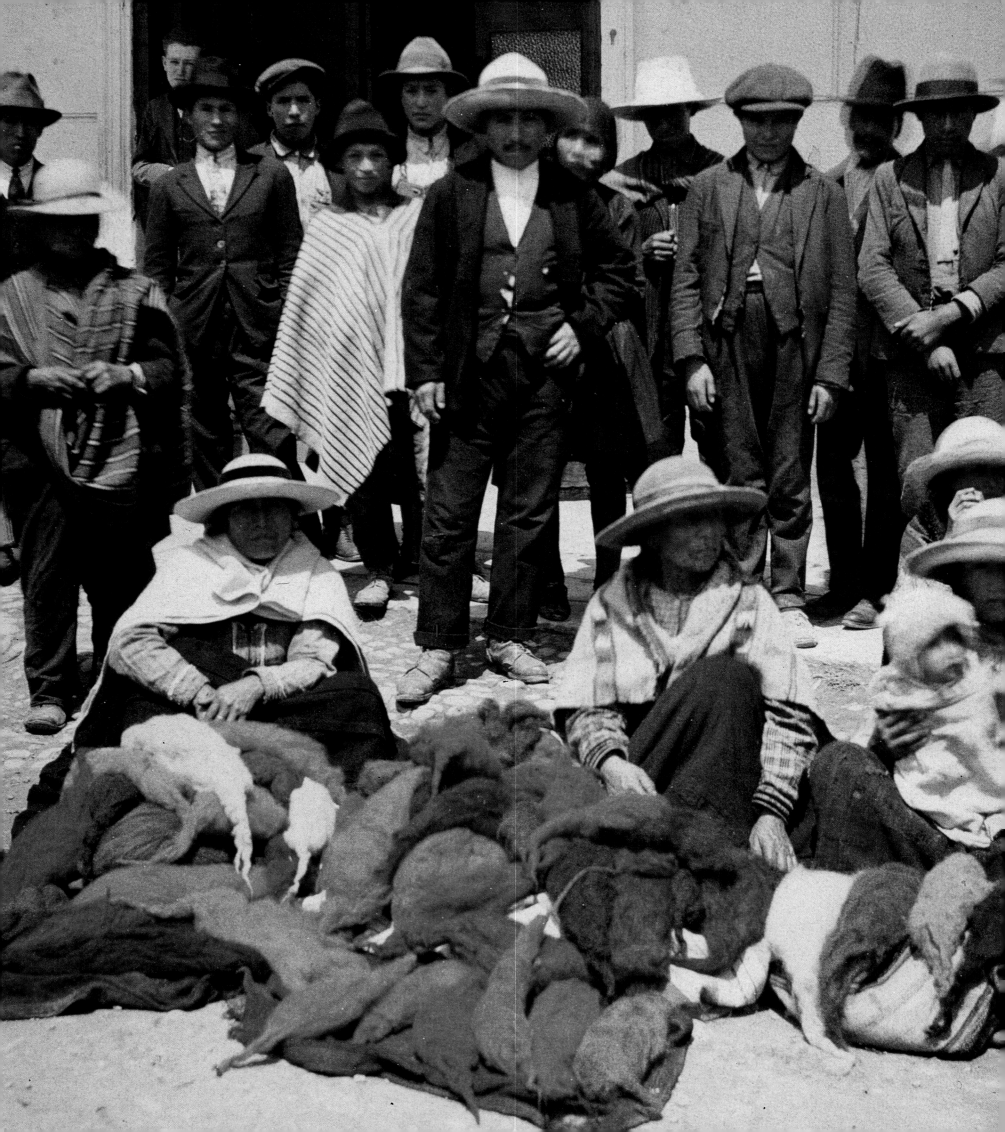

Peru

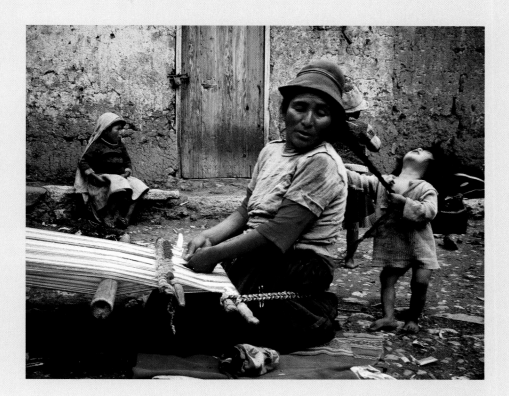

"With her worlds of mountain and jungle, desert and sea, and with Lima, her incomparable capital, Peru offers…an astounding variety," noted Kenneth F. Weaver in his 1964 article, "The Five Worlds of Peru." Such variety has lured NATIONAL GEOGRAPHIC to Peru time and again, with an eye toward documenting the Peruvian people, their customs and history, and especially their Inca heritage. Featured in more than a dozen stories, the Inca appeared first in Harriet Chalmers Adams's 1908 "Along the Old Inca Highway," and most recently in Johan Reinhard's 1998 "Research Update: New Inca Mummies."

above:

1992, Peru

Engaged in the craft of her Inca ancestors, a Peruvian weaver pauses at her backstrap loom to acknowledge a toddler's demand for attention.

Stuart Franklin

left:

1930, Huancayo, Peru

On market day Andean highlanders—distinguished by their broad-brimmed hats—peddle bouquets of spun wool ready for the loom.

Jacob Gayer

1964, Cuzco, Peru

In the ancient Inca capital, innocence confronts Spain's weighty legacy in the studded doors of La Compania de Jesus Church. Here stood the Inca Emperor's palace, overrun by conquistador Francisco Pizarro in 1533.

Bates Littlehales

left:

1982, Lima, Peru

Dressed to dazzle, a matador and his *cuadrilla* prepare to defy death at the Plaza de Acho, the oldest bullring in the Americas. Bullfighting invaded the New World with the conquistadores.

William Albert Allard

All night long the dogs barked in Ayacucho. An old saying has it that dogs bark the night before an earthquake—which added to my sleeplessness…. That evening…I attended Ayacucho's Good Friday night procession—highlight of the year in this Andean religious center. I elbowed my way into a dense crowd waiting for the life-size image of Christ to be borne out of a church. Just then—it was exactly 7:32 p.m.—there was a tremendous blast, as if two subway trains had collided beneath our feet. A terrorist bomb? I took three steps and froze. The man behind me broke into wailing prayer. For three or four seconds the old stone church towers swayed and shuddered. Then, a moment of eerie stillness, followed by a cacophany of screams. "¡Terremoto!—Earthquake!" And in fact…it was.

March 1982, NATIONAL GEOGRAPHIC
from "The Two Souls of Peru"
by Harvey Arden

1996, Ayacucho, Peru
Flames of faith light the way in a Good Friday procession. Introduced by priests who came with the conquistadores, Catholicism is practiced by most Indians of the Andes.
William Albert Allard

left:
1964, Ayacucho, Peru
Waving fronds bespeak the piety of marchers in the Palm Sunday procession. Many Indians walked from miles away to join the city's elaborate Holy Week ceremonies noted for rivaling those of Seville, in Spain.
Bates Littlehales

EUROPE

By Erla Zwingle

1928, Tuscany, Italy
Farmer and his tasseled oxen cultivate a field for grain and grapes.
In summer, pollarded trees serve as living supports for grapevines.
Hans Hildenbrand

following pages:
1992, Milan
Solitary scull glides through reflections on the Naviglio Grande
canal, which carried freight in the 13th century.
George Steinmetz

A few autumns ago, I went to Rome to write an article about the Roman Forum. I had spent months studying the subject, delving deep into the history, architecture, myths, and lore of the small but epic place. Late one afternoon, I came upon a quartet of young American college students. The blond girl had climbed onto the pedestal that had once borne the statue of a vestal virgin ("the most holy and blessed Claudia"), and was striking various poses for her friends to snap.

I drew near and launched a small conversation; I wondered what they thought of it all. To me, the Forum's battered remains still seemed to reek of life and death: Etruscan altars surrounded by mysterious offerings! The assassination of Julius Caesar! Blazing pyres of dead emperors! Processions of conquered kings!

"We were just saying," the blond girl promptly replied, "that it looks just like a picture in NATIONAL GEOGRAPHIC."

As a writer, of course I found this somewhat painful. But why didn't it surprise me? Pictures in NATIONAL GEOGRAPHIC have always had a strange kind of power over people. Now we had reached the point where four innocents abroad could be somewhere and be more aware of how it might appear on the printed page than how it looked right in front of them.

A NATIONAL GEOGRAPHIC photograph can do this because it has its own peculiar way of showing us the world: at the same time strange, beautiful, and accessible. While the magazine has long made a specialty of visiting, in the words of a Confederate soldier, "the damdest plases ever saw by mortal eyes," its photographs of these places have somehow managed to domesticate them. The best GEOGRAPHIC images show things you would probably never have found (or even noticed) on your own, and induce you to savor them in a way you never would have in person.

The magazine wasn't originally conceived as needing pictures. Yet after the overwhelming (and utterly surprising) success of the first illustrated articles, by 1908 more than half the pages were photographs. Some board members resigned, protesting that the publication was being turned into a "picture book." But Editor Gilbert Hovey Grosvenor was undeterred. "The illustrations made the NATIONAL GEOGRAPHIC magazine," he later wrote, "and the magazine's life depends on getting better and better pictures."

The GEOGRAPHIC turned its cameras early upon Europe. "The Dikes of Holland" appeared in 1901. Hundreds upon hundreds of articles followed; photographers have quartered the continent like so many indefatigable hunters, covering subjects ranging from the Rhine to Albania, from London to the "Iceman" mummy, Martin Luther to the entire Mediterranean. Erupting volcanoes in Sicily and Iceland, archaeology (on land and under the sea), plants, animals, minerals, people; from the obvious (Venice, Paris) to the hidden (Basques, illegal immigrants) to the historic (Vincent Van Gogh, Napoleon)—the inexhaustible sweep of civilization that has shaped our own and made us what we are.

"You're in a place where the culture is so rich and deep and plentiful," says freelance photographer Jim Richardson, who has photographed two European stories for the GEOGRAPHIC. He voices the discovery countless American travelers have made on first experiencing the Old World: "I was basically a farm boy from Kansas. I'd grown up with the sheltered view that the sun rises and sets in the United States. Suddenly there was a wider world."

William Albert Allard has photographed some 30 stories for the magazine, 6 of them in Europe. His first major European assignment was on the Basques. He recalls, "With the Basques there was a sense of antiquity, a sense of being exposed to this ancient breed of people. I liked being in the mountains, but it wasn't the same as if I'd been in Colorado."

Over time Europe has presented GEOGRAPHIC photographers with some very particular problems. As a place, of course, it has always fascinated Americans. Our roots, after all, strike deep into Europe. Other nations may be older, other traditions practiced by more people, but nothing touches our hearts and memories more strongly than the familiar resonance of things European: The Roman Empire, the glory that was Greece, the fairy tales of Grimm and Andersen, the Magna Carta and the Crusades and *Hamlet* and the "Mona Lisa." "C'est la vie." "Ciao." The audience is already hooked.

But the familiarity of Europe is in some ways its biggest drawback to photographers. We've seen most of it by now—Big Ben, the Colosseum, the Eiffel Tower. What is genuinely foreign is often subtle, elusive, hidden among the now ubiquitous artifacts of Western civilization—cars, TV antennas, cellular telephones, blue jeans. I've seen more Washington Redskins baseball caps in Venice than I have in Washington, and not always on tourists. So now photographs can't depend on the shock of the strange to create memorable images. The challenge therefore has been somehow to overcome the gravitational pull of the cliche: either to find something new, or to present the obvious in an entirely new way.

"In the early days photographers wanted a record that they were there," Robert Gilka, former Director of Photography at the Society, puts it. "These days that's not enough. Everybody's been there and taken photographs."

"These things have been seen so many times," agrees Jim Richardson. "In a certain way it's easier to go into the expanses of the Midwest and take a picture that surprises someone. If you come back with a wonderful picture of Paris, they say, 'Couldn't you do something better?'"

Richardson's photographs for the 1996 article "Scotland!" reveal his approach: His forthright image of a "brawny lad" wearing a "never-say-die grimace" during a Highland games tug-of-war gets to the heart of the people: This is Highland spirit. And the mystery of ancient cults turns New Age in his whimsical portrait of dawn worshipers at Stonehenge-like monoliths, their discarded costumes draped across the stones.

Europe, more than anywhere else, has always presented itself pictorially: first in paintings, then in photographs, ultimately in postcards. After all, photography was invented in Europe, and naturally found its first subjects there. Castles, cathedrals, costumes, customs—for many years our notions of Europe were very specific, and almost equally conditioned by pictures and by fairy tales.

GEOGRAPHIC readers have always been insatiably curious. But in earlier decades the world was still relatively innocent, and so were we; we were easier to entertain and easier to convince. Pictures were supposed to clarify, not confuse. There was a sort of calm in many European stories that now seems almost naive. Headlines contained words like "stroll" and "sojourn." The majority of photographs reflected this sturdy, confident view, and the technical skill that has always marked GEOGRAPHIC photography didn't draw attention to itself. The images were arranged on the page as carefully as in any family album.

Yet we did not, apparently, wonder very deeply about what we saw. An Italian farmer at his plow is dwarfed by his two massive oxen (Are they really so huge? Or is he unnaturally small? Why?). A car laboring up the foothills of the Alps bears a license plate from Naples (Is the driver lost? Or is he yet another poverty-stricken immigrant searching for work?). We see, as Sherlock Holmes was wont to say, but we do not observe.

Over time, Europe's once-simple fascination has become more complex, and the standard photographic approaches became "those pat answers," as one photographer put it, "that were so right at the time that they got worked to death." As Europe has changed, so has our view of it.

In the early years many photographers consciously wanted to make photographs that were "painterly"—but it was also something they couldn't escape. Photographers worked at the farthest edge of their technical capacity, striving against the limitations of their equipment. First there were heavy, boxy cameras and glass plates, then smaller cameras but with films that were still relatively slow. The equipment imposed a universe of restrictions and demands on what sort of subject you could photograph, and how.

Castles, vineyards, church steeples were classic favorites.

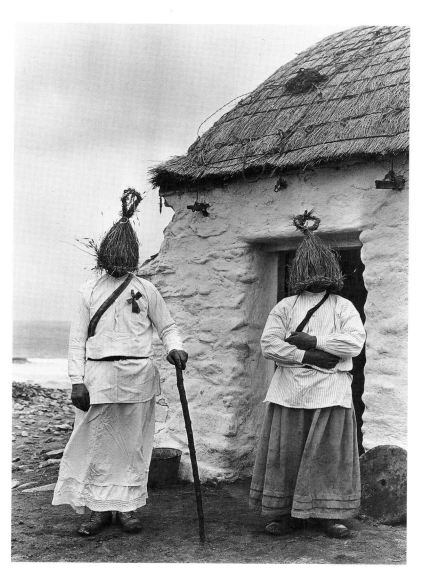

1924, Achill Island, Ireland
Descendants of the "Straw Boys" who terrorized Ireland some 100 years ago flaunt their ancestors' feared disguise.
A. W. Cutler

People in the early decades often had to be told to hold still—and looked it: the Netherlands maids poised on a brick square, conversing; the English lad perched on a fence rail beside his aesthetically-placed bicycle, deep in thought; Greek actors on stage at the ancient stadium at Delphi, wielding shields and swords, frozen in the eternal pose of war.

"In most close-ups you wanted pictures of people doing what

they do," Robert Gilka explains. "But in the early days photographers were limited by the film speed, so we had to pose people to show them doing what they do. In other words, 'candids' weren't really candids."

Now we're all keyed much higher, and faster cameras and films feed our craving for sensation—speed, blur, mood.

"Certainly the technique has changed," Robert Gilka states. "In the early work, the photographer's presence was overwhelmed by the big box. And if he used a flash, it could have been powder. There was nothing subtle about it. I always told photographers, 'I don't give a damn what kind of camera you use.' But I knew that to get mobile scenes, they had to have mobile equipment."

"I came in when they were still using flashbulbs," Bill Allard says, who has always done his utmost to work only with available light. "The faster films today will let you get pictures that you couldn't get before, or get in their natural state. In the earlier years you'd have to pump light into them—what today would be too much light. You've destroyed the environment." Allard became known early on for protecting his environment at all costs, to the point of improvising a tripod out of a beer bottle on a bar.

Compare his 1968 photograph of a Basque farm couple and their livestock to his 1989 portrait of models readying for the runway. Their composition and content are both distinctive, but the latter approaches another, more visceral plane, where there is blur, confusion, sweat, excitement. It makes us ask: how?

In 1962, retired Editor Gilbert Hovey Grosvenor said that his son Melville, then editor, "recognizes, as I have tried to, that as the years pass, a different…method of expression is necessary." The result is the eye on the world we now take for granted: intimate, fleeting, moody. Faster films and lenses, and the strobe light, have enabled photographers to reveal the myriad images that lurk within each instant.

The blur and confusion of the models backstage; the gloomy morning light filtering across a polluted village in Eastern Europe; the intense body language of two businessmen at a cocktail party; the dramatic curve of a hairstylist's arm at the height of her creation. The "different method" captures the new outlook of the post-Vietnam years: edgy, strange, ironic. We wanted to see the world in the same way we felt it—we didn't want it to be organized or frozen for us. Once we had glimpsed the mysterious world behind the obvious we couldn't get enough of it. By the sixties and onward, we were insatiable for intimacy, drama, the unpredictable, even the disturbing.

By the oddest chance, I discovered firsthand how drastically our expectations of a picture have changed. During one interminable week in Greece, I actually lived something akin to the olden days of photography. And it was hell.

In 1982 I was assigned by another magazine, also famous for its photographs, to write about the Easter celebrations on the Greek island of Pátmos. This being the island to which St. John the Divine had been exiled, and where it is said he wrote the Book of Revelation, it is famous for the particular richness of its religious and popular customs.

I was a fledgling writer, but not so green as not to expect that Holy Week would offer some spectacular visual opportunities. I was already ambitiously dreaming of the greatest NATIONAL GEOGRAPHIC pictures in the style of Bill Allard or Dave Harvey—intimate, vivid, surprising, moving. I thrilled to think of what someone of their caliber could make of the candlelit street processions, the monks washing the abbot's feet, old women devoutly kissing icons in the incense-laden shadows, the faces of awestruck, exhausted children, the slaying of the paschal lambs, the visible combustion of soul and ouzo.

I had never met, or even heard of, the young British photographer who arrived a day after I did. So I had no way of preparing myself for the fact that he worked chiefly with a 4x5 view camera—a splendid instrument, but one obviously more adapted to either studio or landscape work, places where environments and events can be highly controlled and patience is a virtue. It's heavy, it's sensitive, and it comes with all sorts of important and demanding accessories. He and his equipment were a vision from a hundred years ago.

That week was a sort of journalistic torture. It wasn't just that he had to hire a moth-eaten donkey to carry all his gear uphill and down; it wasn't the ages he spent setting it all up and then packing it away again. It was the agony of watching endless photographic possibilities shimmer past, unseized, lost forever. Didn't he see them? Didn't he care? There were places he couldn't go, developments he couldn't anticipate. Old men playing cards in the smoky taverna were perfect—but the only way to depict them was in a group portrait. Movement was forbidden. His most important tool? The phrase, "Please hold still." I lived in a fever of repressed hysteria, watching complex, dynamic moments unfold just beyond him. The moments he managed to catch he thoroughly killed, and then embalmed.

The Greeks regarded all this as pretty amusing and had more patience than even he. They seemed to find something endearing about watching him work so hard (no pretending to be invisible

for him), and they did their best to cooperate. GEOGRAPHIC photographers generally prefer that people don't cooperate—they'd rather be ignored altogether. "I found it difficult in England and Scotland to photograph people in their daily life," one told me. "They'd do what they thought they needed to do. And you could tell they were puzzling in their minds why anybody would want such a picture."

On Pátmos, the final result was a magnificent achievement—for the year 1890. It was like a NATIONAL GEOGRAPHIC story from the oldest of the olden days. And it obviously wasn't enough anymore. GEOGRAPHIC photographers have made us demand more. Grosvenor's "different method" is what we now consider normal. Trying to go back is worse than an exercise in nostalgia—it's essentially pointless. What baffled me about this British photographer wasn't that he was willing to endure aggravation and effort—clearly he had come to terms with that—but that he went through all this to make pictures that were so out of tune with the modern way of seeing. He clearly had his own reasons for this, but I couldn't understand them. If I hadn't been so distraught, I would have asked him why he was doing it. It was if I'd suddenly decided to write my article in heroic hexameters.

Today, the Old World is grappling with the new, wracked with problems, struggling to define its character. The GEOGRAPHIC has also had to grapple with new incongruities, new stresses, and the difficulty of coming up with a new way of depicting places that by now so many readers have seen in person. Above all, they are trying to enter more deeply into the spirit and soul of deceptively familiar places.

It is tempting to say that Europe has changed, and therefore the images have changed. But the deepest change has been in our expectations of the photographer. We hunger for intimacy and drama. We crave emotions as well as information. We want to find a deeper truth, a richer wonder. To see life not just as an assemblage of facts, but as experience. Now we are two inches away from the secret glance of a laughing couple in Naples, the fervent faith of Spanish women in a dusty procession, the fleeting fear in the eyes of East Berliners as the Wall crumbles. Even in its quieter moments, the reality of Europe today is gripping and contradictory, full of irony and tension, and the pictures show it.

What is the secret of confronting Europe? "It was a delight to see that what I had considered exotic was for somebody else simply the norm," one photographer says. "I'd go into a bar in Italy where all the old guys were playing cards. They were drinking wine instead of beer, and it wasn't 'pitch,' but otherwise it could

have been somewhere near home. The trick is developing a foreigner's eye at home, and a domestic eye in the foreign place."

"For me, there's so much more in Europe than I can comprehend," says Jim Richardson. "I was out walking around a town in Italy, and there was this Communist Party rally in the piazza. And I thought, 'This is neat. This is really a long way from Belleville, Kansas.' I find it tough to be jaded."

The result should be what we have come to expect when we open the page to a new NATIONAL GEOGRAPHIC story on Naples

1992, Madrid, Spain
Cigarette in hand, banking tycoon Mario Conde makes a point at a reception.
David Alan Harvey

following pages:
1995, the Pyrenees, Spain
Fashioned of stone from surrounding slopes, the cottage of a Basque shepherd is one with its mountain.
Joanna Pinneo

or Paris or Berlin: photographs that contain, as Jim Richardson says, "the sort of meaning that goes beyond being just records—that have that magical linking quality that jumps the gap between the person in the picture and the person who sees it." Beyond the myriad changes of taste and technique, that magical link is what we have always asked of NATIONAL GEOGRAPHIC photographs, and they have never failed us.

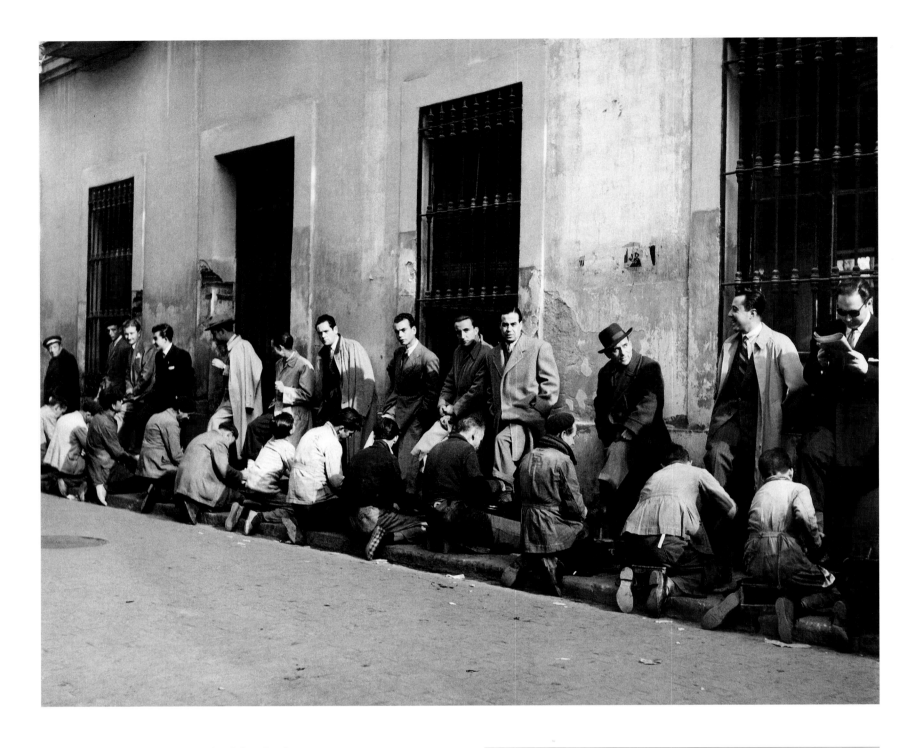

1959, Cordoba, Spain
Fashion lineup: Cordobans leave noon Mass for their
regular five-cent Sunday shoeshine.

Luis Marden

right:

1995, Bilbao, Spain
Trendy hairstylist Begona Alegria grooms a client in her
salon in the Old Quarter of this Basque city.

Joanna Pinneo

As the nights grew colder in Madrid, I began to see men wearing the *capa,* the typical coat of Spain.... One must know how to "carry the cloak," the Spaniards say, to wear it with grace and elegance.... It is cut full so that the wearer may throw one edge, lined with velvet or fur, round his neck in cold weather. Thus enveloped, a man is snugly warm, but as tightly confined as if rolled in a rug. I wonder how Spaniards of an earlier age drew their swords in a hurry."

April 1950, NATIONAL GEOGRAPHIC
from "Speaking of Spain"
by Luis Marden

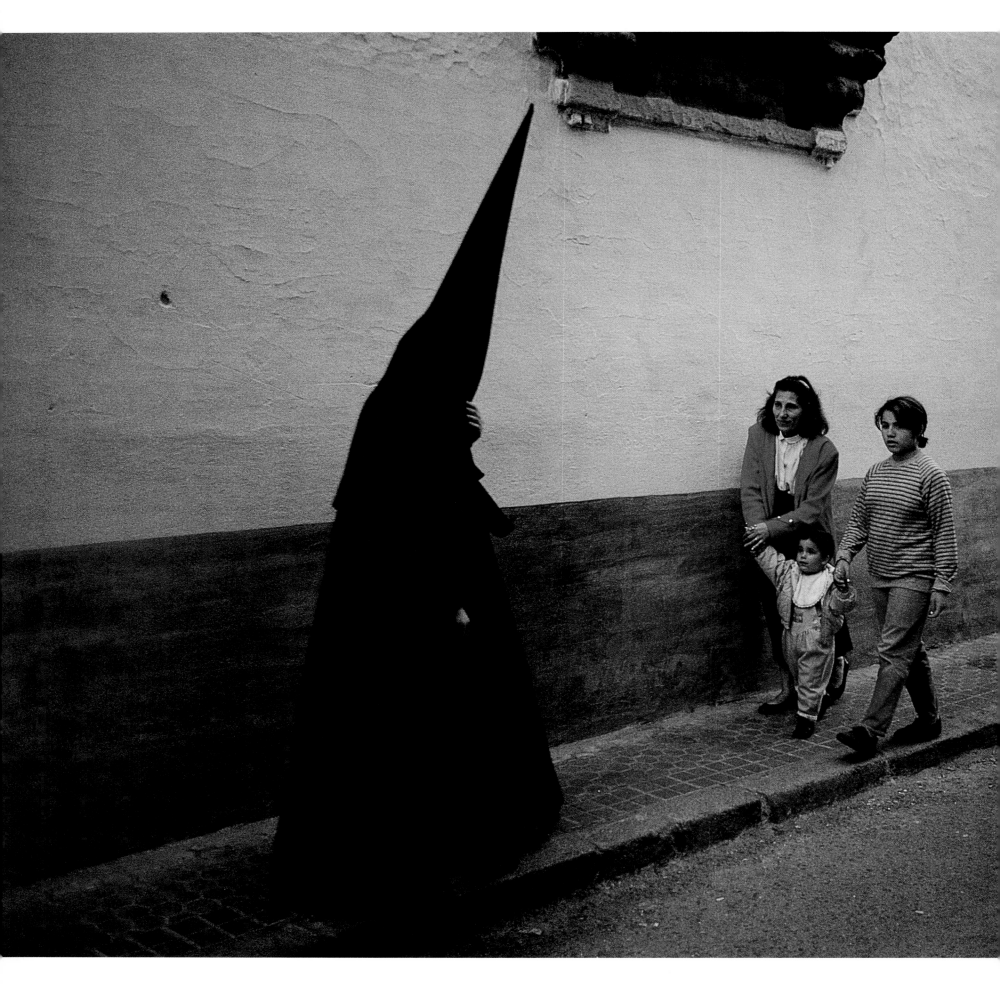

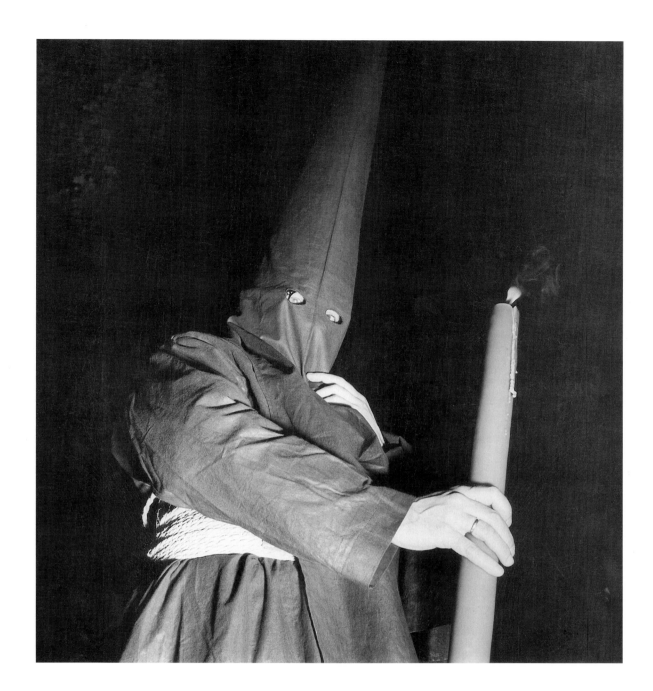

1951, Seville, Spain
Cloaked and candlelit, a solemn penitent emerges from church during
Easter Holy Week rituals.

Luis Marden

left:

1991, Spain
Brush with the present takes a traditional penitent toward Holy Week festivities, where
costumed thousands blend with statues and floats honoring Christ and the Virgin.

David Alan Harvey

1969, Berlin
Winter snow blankets the "death strip" along the Berlin Wall.
Howard Sochurek

right:
1990, Berlin
**First anniversary of the Wall's collapse unites Berliners under
fireworks to celebrate the rebirth of unified Germany.**
Gerd Ludwig

In East Berlin the people heard it first on television, as an item on the
evening news. You are free to go, the government announced. They could
travel to the West. For any reason. For no reason. After 28 years of virtual
imprisonment, the cage was open. The Berlin Wall had collapsed. On that
surreal, sleepless, Thursday night, November 9, 1989, joyous West Berlin-
ers popped champagne bottles and lit candles atop the despised Wall by
the towering Brandenburg Gate, symbol of the German nation.

April 1990, NATIONAL GEOGRAPHIC
from "Berlin's Ode To Joy"
by Priit J. Vesilind

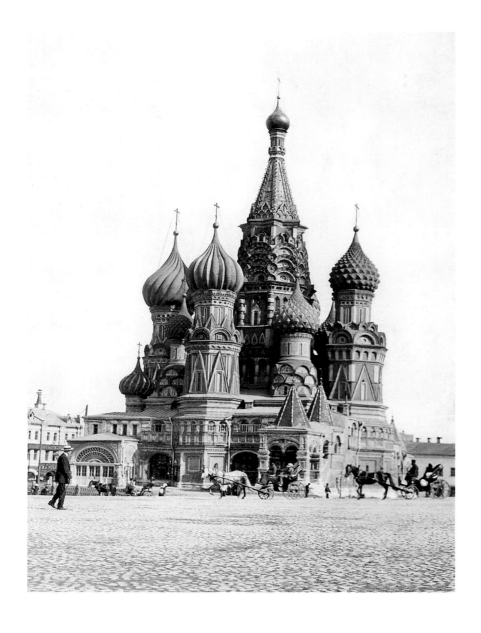

1914, Moscow
Magnificent as its builder Ivan the Terrible, 16th-century
St. Basil's Cathedral eclipses neighboring structures.

Gilbert H. Grosvenor

right:
1997, Moscow
Across Red Square, onion-domed St. Basil's stands sentinel
over an old Russia beseiged by newly capitalist Moscow.

Gerd Ludwig

following pages:
1992, Boldino, Russia
Frozen lands once owned by beloved 19th-century poet
Alexander Pushkin are traveled in the age-old manner.

Lynn Johnson

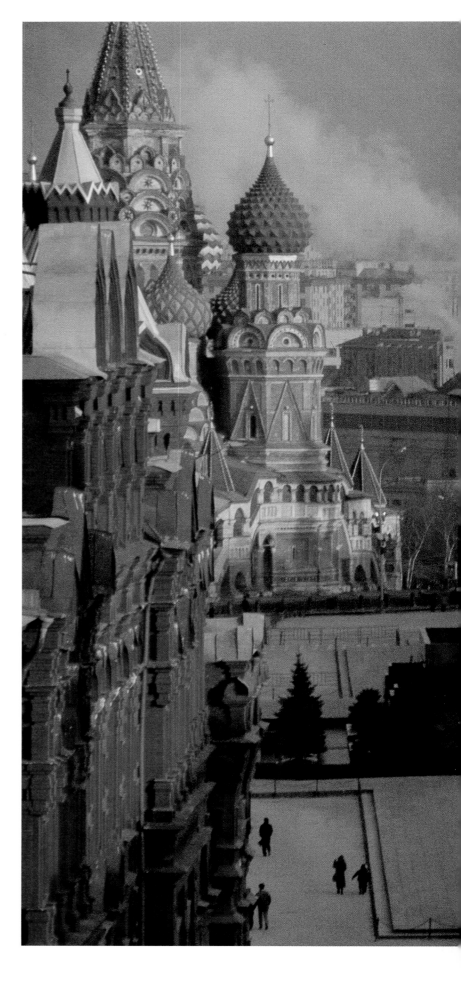

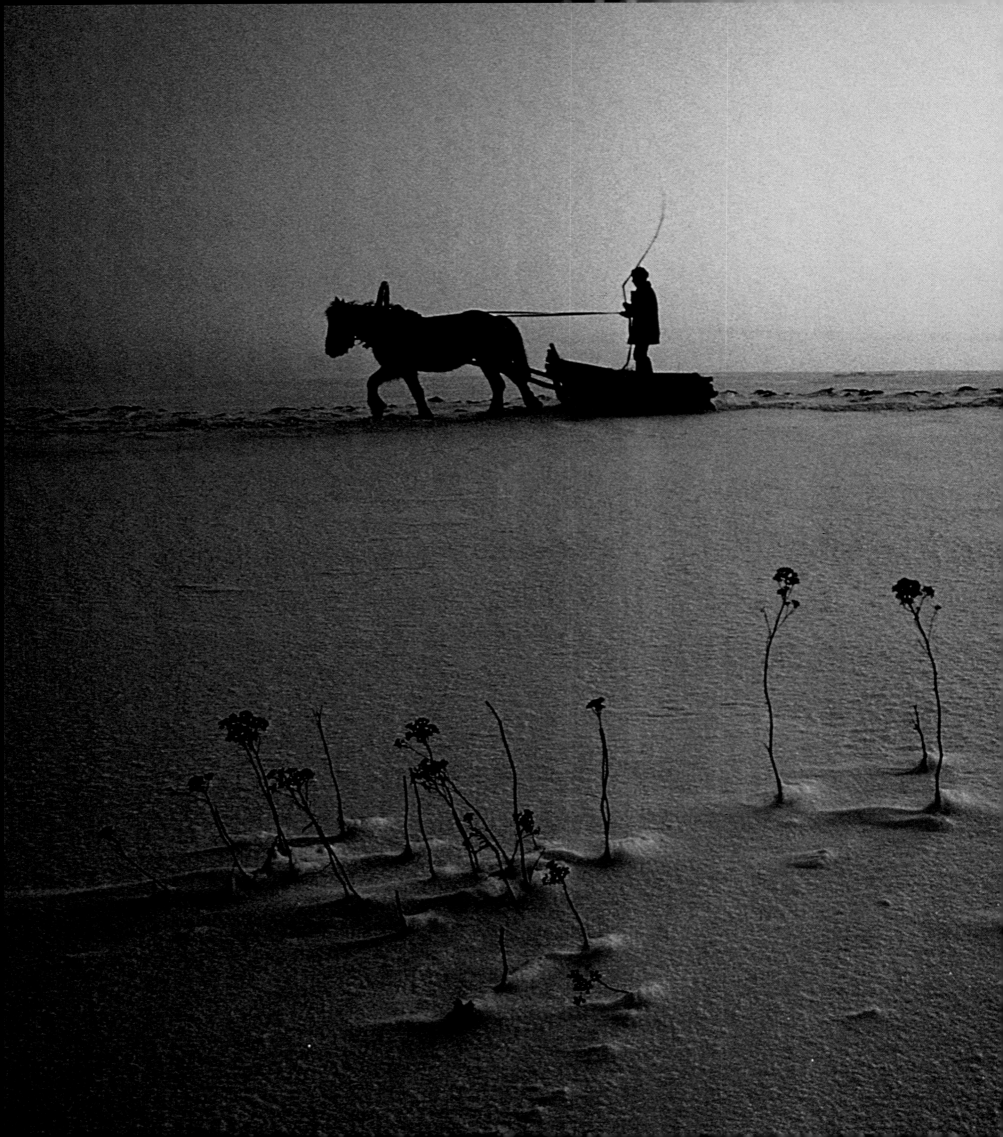

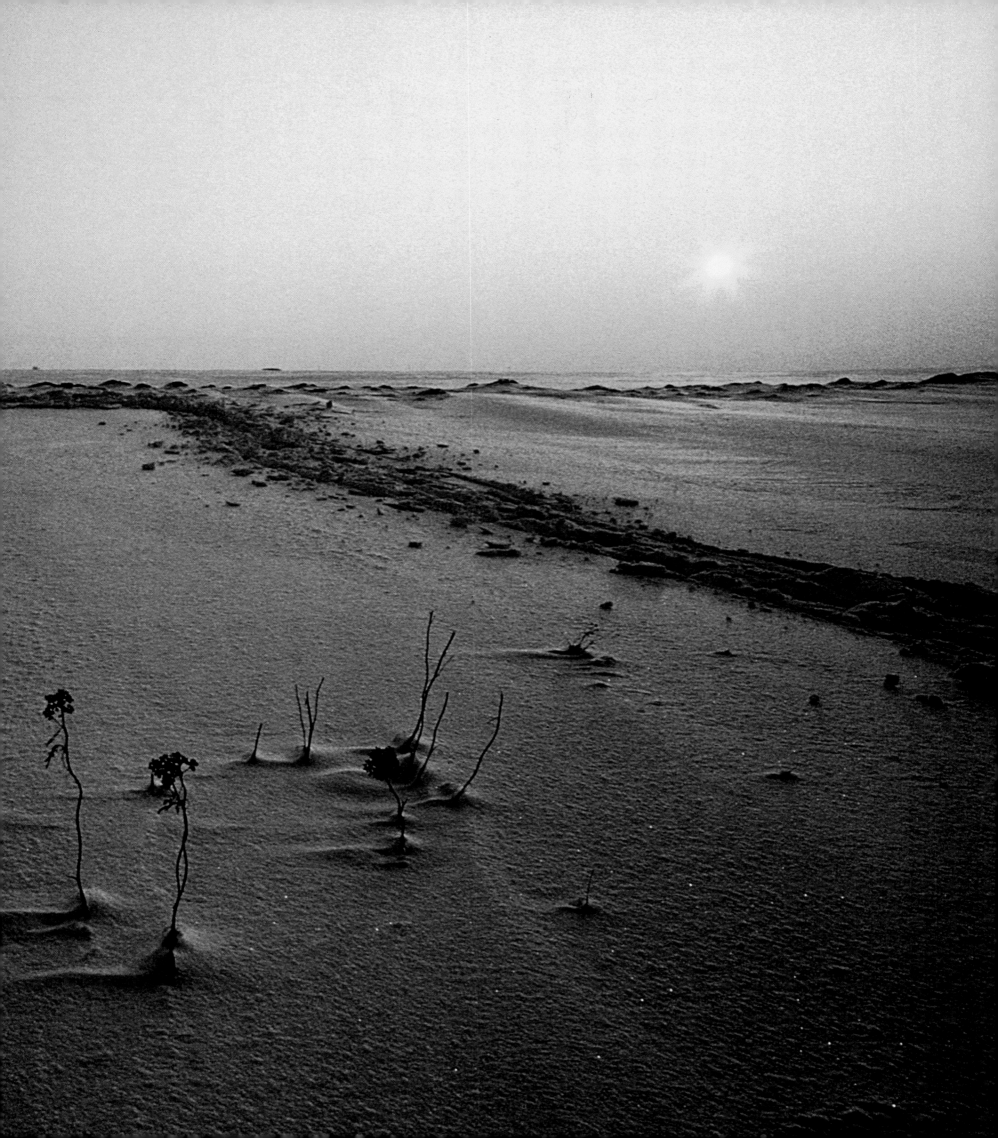

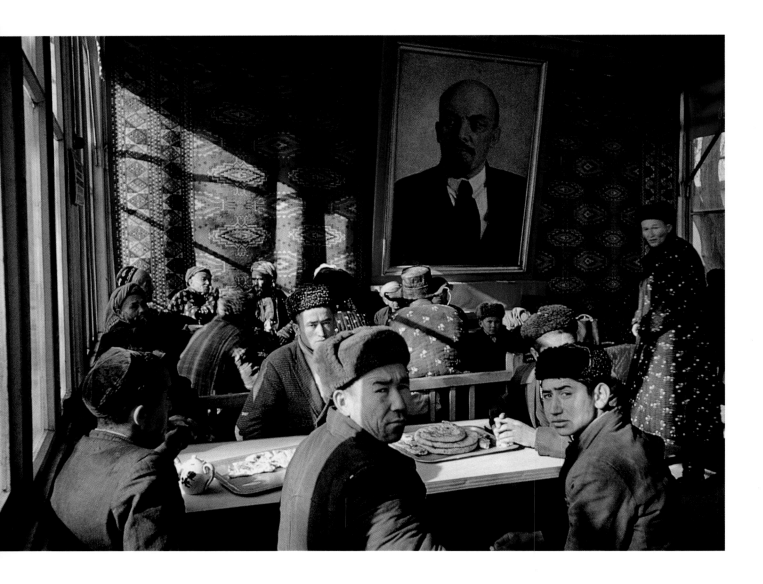

1968, Samarkand, Russia
Beneath Lenin's watchful gaze, Communist Turkoman and Uzbek workers
break for the noon meal.

Frank and Helen Schreider

right:

1992, Moscow
Days ended as a film prop, tsarist poet Pushkin heads for a new job: inspiring
children in a Sunday school classroom.

Lynn Johnson

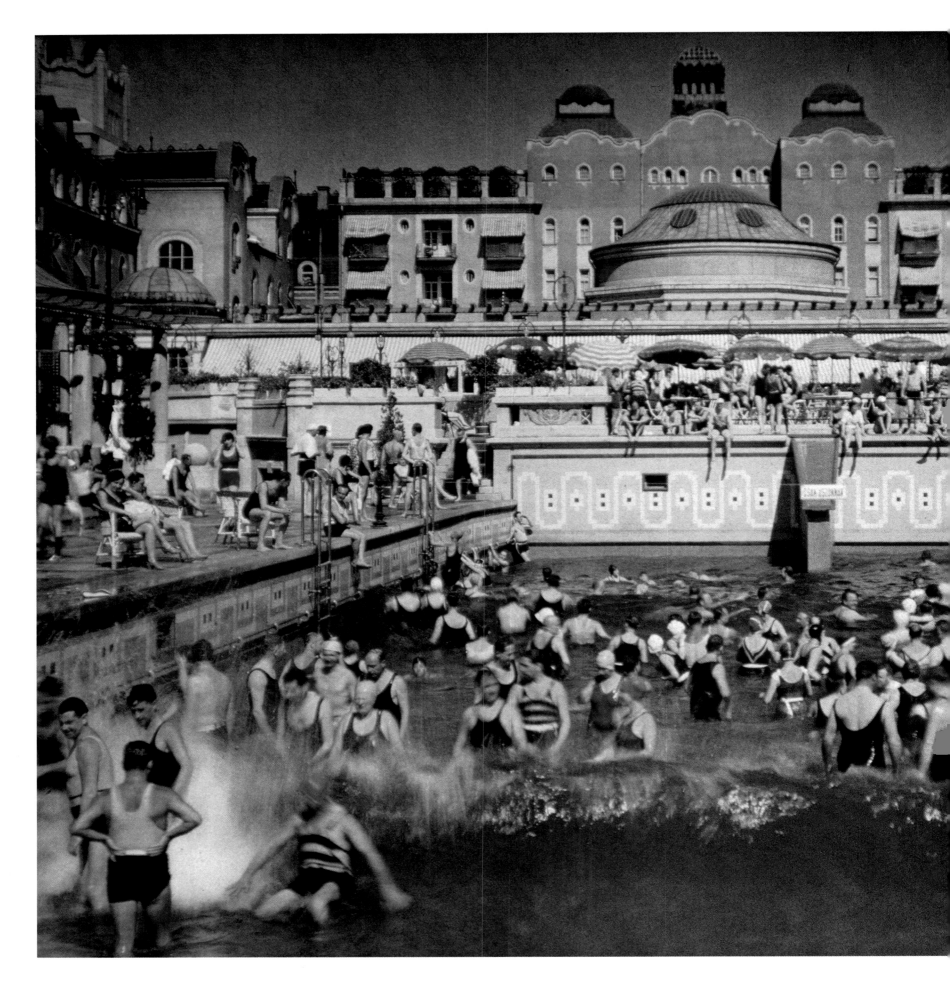

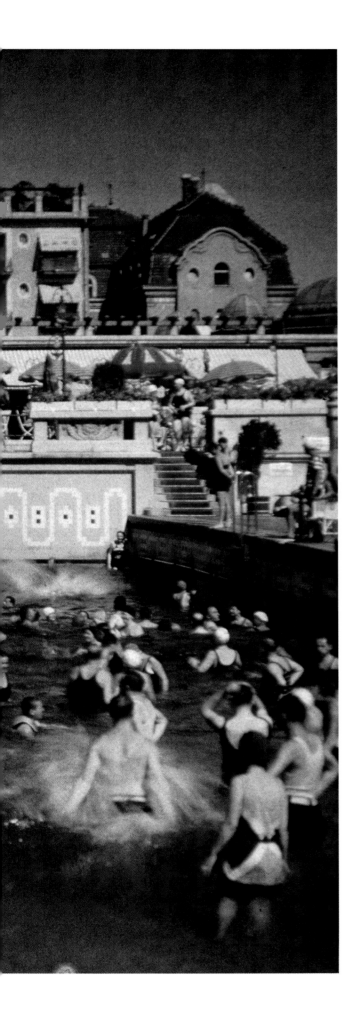

1991, Copsa Micã, Romania

While citizens labor in plants that produce carbon black for tires, a community shepherd leads their sheep to pasture. Carbon black rains continually from the factories, coating houses, streets, and sheep, which graze on carbon-coated grass. Short of drastic measures, cleanup is near-impossible in Copsa Micã.

Jim Nachtwey

left:

1930, Budapest, Hungary

Wave pool at state-of-the-art St. Géllert Hotel was touted as part of this municipal building's "very active contribution to modern Budapest." Every 15 minutes a whistle signaled for a new set of artificial waves, initiated from an underground spring and set rolling to the strains of a gypsy band.

Hans Hildenbrand

1962, the Riviera, Italy
Bound for the vintner, grapes make the venerable trek down a mountain.
Albert Moldvay

right:

1992, Milan, Italy
**During a soccer match, San Siro stadium seethes with cheers and the
mist of smoke bombs set off by rowdy fans.**
George Steinmetz

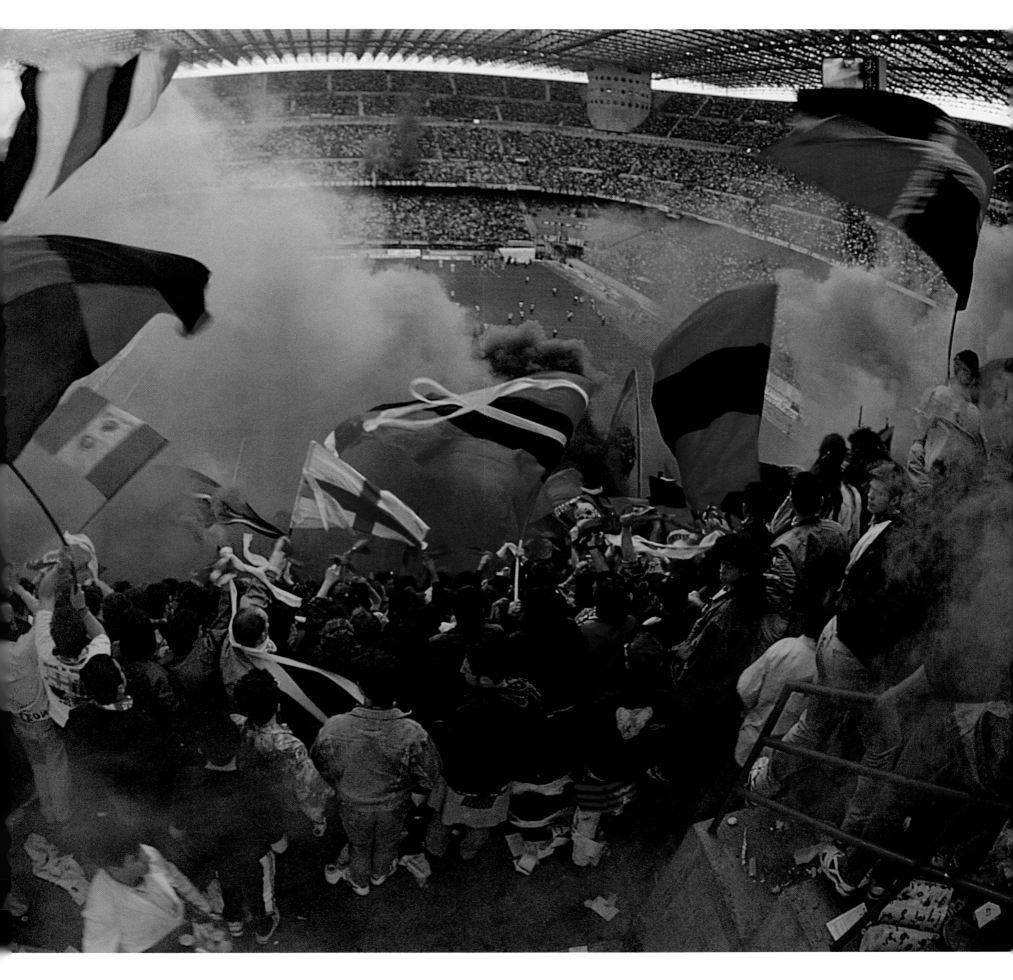

1917, Herefordshire, England
Cyclist pauses in pastoral England "of the loved
and familiar, of village and countryside...," noted
an early article.
A. W. Cutler

right:

1996, Selkirk, Scotland
Admiring bakers frame baby Mairi Chisholm, who dozes
as her mother runs errands. While cities such as
Edinburgh and Glasgow burgeon around them, small
towns retain their charm and sense of safety; mothers
often leave infants unattended for brief shopping forays.
James C. Richardson

There is an old English saying, "As sure as God is in Gloucestershire." Indeed, aged church towers and spires, enduring monuments of faith, rise from even the tiniest Gloucestershire villages. Here, I do believe, God must have been practicing for the larger handiwork of paradise when He fashioned the Cotswolds, gentle little prominences mostly, hardly worthy to be called hills but worthy of every superlative for beauty. Scattered through them, hidden in their folds beside meadow, woodland, and stream, lie postcard-pretty villages seemingly built of quarried gold, the natural hue of Cotswold stone. No longer am I young, but how effortless my footsteps seem when treading the rural pathways of England. When you walk with beauty, the miles are shorter, the paths less steep.

October 1979, NATIONAL GEOGRAPHIC
from "Two Englands"
by Allan C. Fisher, Jr.

1960, Amsterdam, Netherlands
Eclectic row of houses enlivens a canal's still surface. In the old tradition, many homes still have windows with mirrors, called "spies," angled to give a one-way view of passersby or unexpected guests.

Adam Woolfitt

The Hague is neat and stuffy. Amsterdam is untidy and self-indulgent—with much to indulge: museums, concerts, theaters, piety, and sin. The oldest church in town abuts the redlight district. Antique houses slouch, and the city rings with secular bells: bicycles, streetcars, striking clocks. Restaurants offer menus for pet dogs, and dogs offer hazards for strolling the streets.

October 1986, NATIONAL GEOGRAPHIC
from "The Dutch Touch"
by Bart McDowell

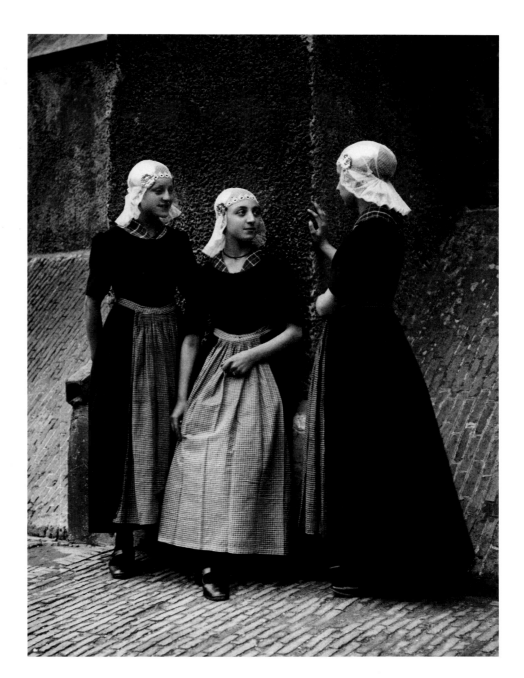

Continuing our walk into the country, we soon met a young woman supporting a wooden yoke on her shoulders, from which hung two pails. While her appearance plainly indicated her object in coming to this particular field, where several beautiful black and white cows patiently awaited her arrival, instinctively the lines came to mind, "Where are you going, my pretty maid?"

January 1915, NATIONAL GEOGRAPHIC
from "Glimpses of Holland"
by William Wisner Chapin

1923, Netherlands
Maidens in lace "helmets" converse in "the old Frisian tongue," noted a 1923 article, which prevailed in language districts in Holland and Denmark. Their headgear, of thin-beaten silver or gold covered with lace, often included earrings that dangled to the waist.

Donald McLeish

1951, Iceland

Silent tourist mecca, water-filled Keridh Crater, one of thousands of volcanic craters pitting Iceland, was shaped by violent subterranean explosions.

Göran Algård

left:

1987, Iceland

Big as a city block, a sorting pen holds one million sheep driven down from hillside grazing at summer's end. Called a *rettir,* the drive lasts several weeks, with much festivity.

Bob Krist

"You'll need a passport, a cocktail dress, a dinner gown, a raincoat, galoshes— and a boundless capacity for astonishment!" The airline executive briefed me as I asked about the trip I planned to Iceland.

I found he was right, especially about the last.

November 1951, NATIONAL GEOGRAPHIC
from "Iceland Tapestry"
by Deena Clark

1963, Delphi, Greece
Impersonating their Macedonian ancestors, members of the Salonika YMCA stage
a mock battle in the ancient stadium at Delphi.

Maynard Owen Williams

right:

1994, Greece
Mirror of Hera, goddess of marriage, a bride glows before the camera. Ancient Greeks
are thought to have honored Hera at this temple in the 5th century B.C.

Sisse Brimberg

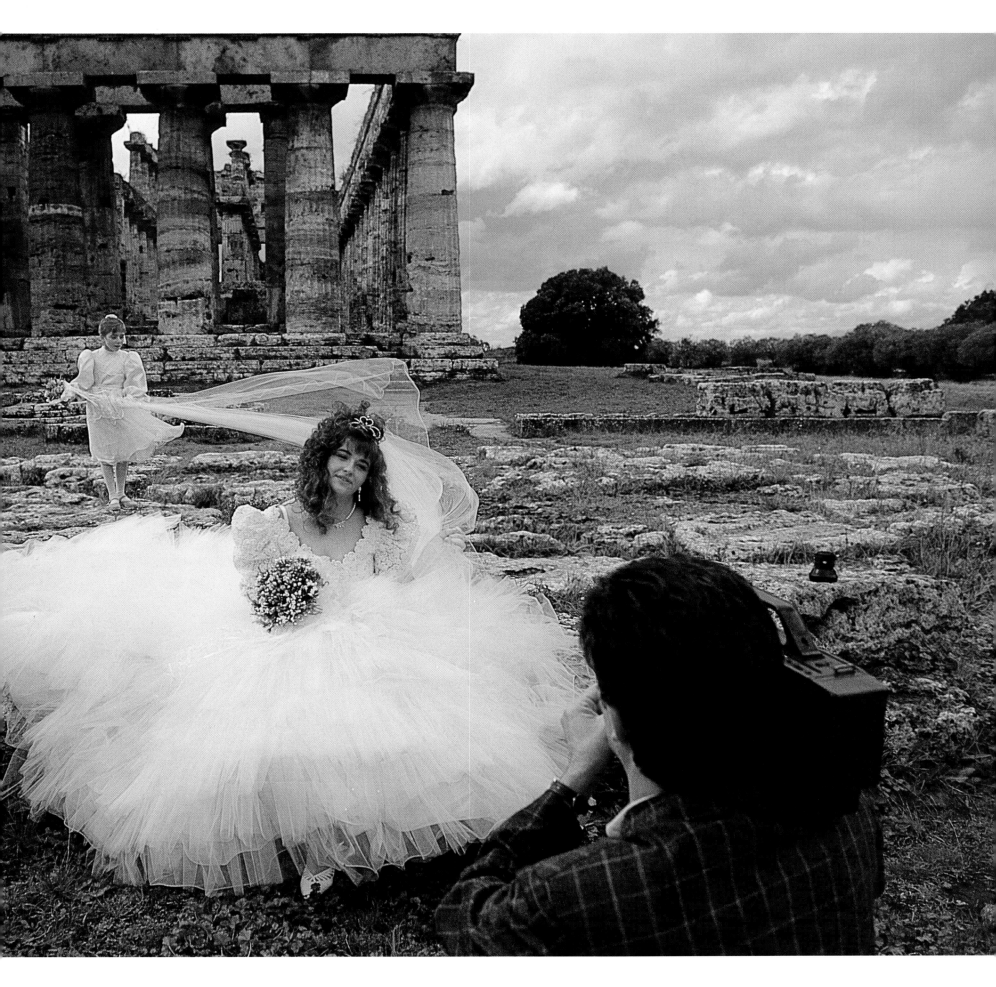

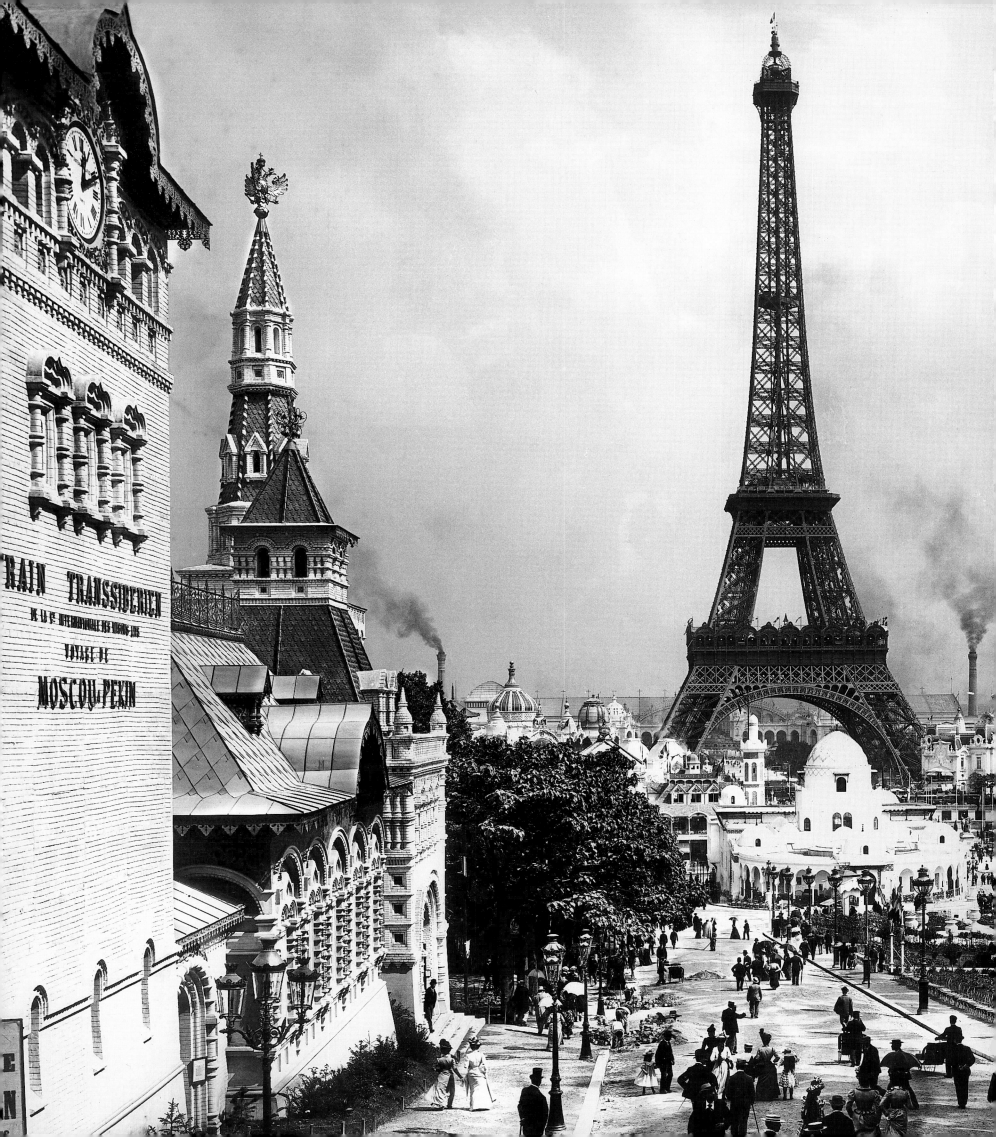

France

"An article on all of France? But impossible! We have more than 300 different kinds of cheese alone!" After leading with these words of French painter Jean Lurcat, Walter Meayers Edwards promptly addressed the whole of this varied land in his 1960 article, "Eternal France." France has netted more coverage in NATIONAL GEOGRAPHIC than any other European country. Most of the articles, however, focus on a distinctive region or city, searching for the essence of the place, including its local cheese or wine. Indeed the magazine's first feature on France was "Brittany: Land of the Sardine," in 1909. Paris alone has garnered over a dozen articles. Highlighting the coverage of France is the July 1989 issue devoted entirely to that nation in honor of its bicentennial.

above:

1989, Paris

Above the City of Light, the Eiffel Tower crowns France's bicentennial celebration.

James L. Stanfield

left:

1900, Paris

Dedicated in 1889, the Eiffel Tower commands center stage at the International Exhibition of 1900, where it drew more than a million visitors.

Roger Viollet

1918, Northern France
In the waning days of the Great War, coffee and companionship unite three women awaiting the return of loved ones.
Gilbert H. Grosvenor

How adaptable is the social quality of the French! How it makes pleasant the rough road of life! It lends a personal grace not only to the necessities, but even to the very hardships, of life. During this war I have taken dinner in the homes of French families where the bread was distressingly scarce and pitiably poor, the sugar limited to one cube per individual, butter entirely absent, and the quantity of meat so small that only the national optimisim could magnify it into a square meal, and yet the bon mot flourished upon this very poverty of food.

November 1918, NATIONAL GEOGRAPHIC
from "Our Friends, the French"
by Carl Holliday

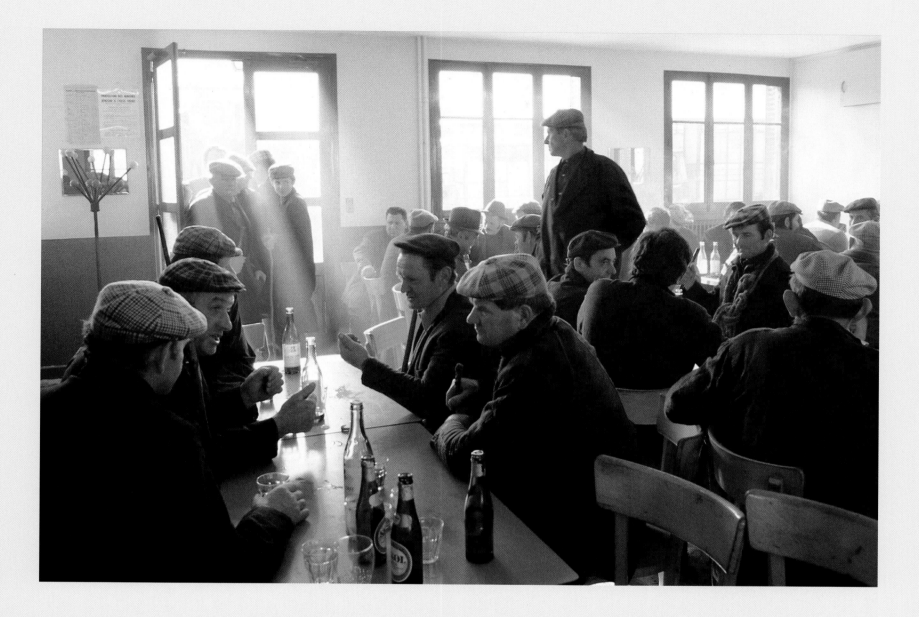

1978, Burgundy
Cattle traders in a café at Saint Christophe en Brionnais
market compare notes after early morning sales.
Robert Freson

Pierre Arbey mourns the loss of companionship that binds best in a café where the *vin ordinaire* is tolerable and the talk is a blend of gossip, wit, and cynicism. It is not civilized, a village without a café, Arbey said. He was a retired farmer and a postman, and after he retired he spent his time tending his grapevines. Now 82, he longs for someone to come and reopen the café…. There has been considerable speculation as to why the last owner of the café failed to make a success of the business. Some say that he didn't understand the nature of Darcey and its people. Being Burgundians, they like a rich sauce with their food, not sparse fare set adrift in a sea of spriggy garnishes. It was rumored too that he sometimes used a microwave. *A microwave!*

July 1989, Nᴀᴛɪᴏɴᴀʟ Gᴇᴏɢʀᴀᴘʜɪᴄ
from "Darcey: A Village That Refuses to Die"
by William S. Ellis

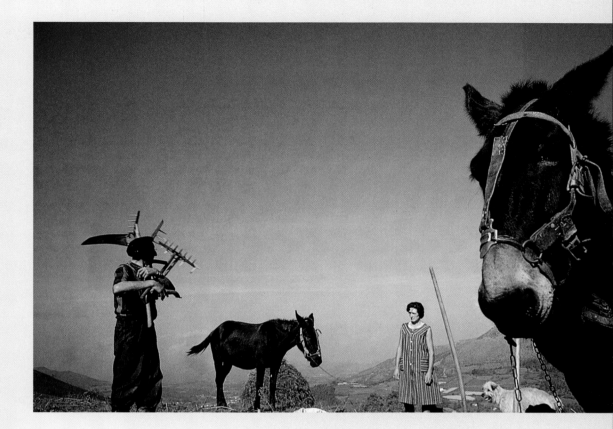

1968, the Pyrenees, France
**High in Basque country, a couple gather bracken to line
the stalls for their livestock.**
William Albert Allard

left:
1989, Paris
**Sheathed in silk, runway-bound models prepare to unveil the
new art of Yves Saint Laurent.**
William Albert Allard

Beneath the cool disdain, imperious as the withering look of a maître d', there is warmth. As disarming as the delight of the Renoir-like child at the next table tasting her first artichoke. Beneath the stiff formality, fussy as a Louis XIV armchair, there is earthiness. Blunt as the tight-lipped housewife trudging crosstown to a *boulangerie* where loaves are a centimeter longer.... How endearingly French....

July 1989, NATIONAL GEOGRAPHIC
from "Letters from France"
by Don Belt, Cathy Newman, and Cliff Tarpy

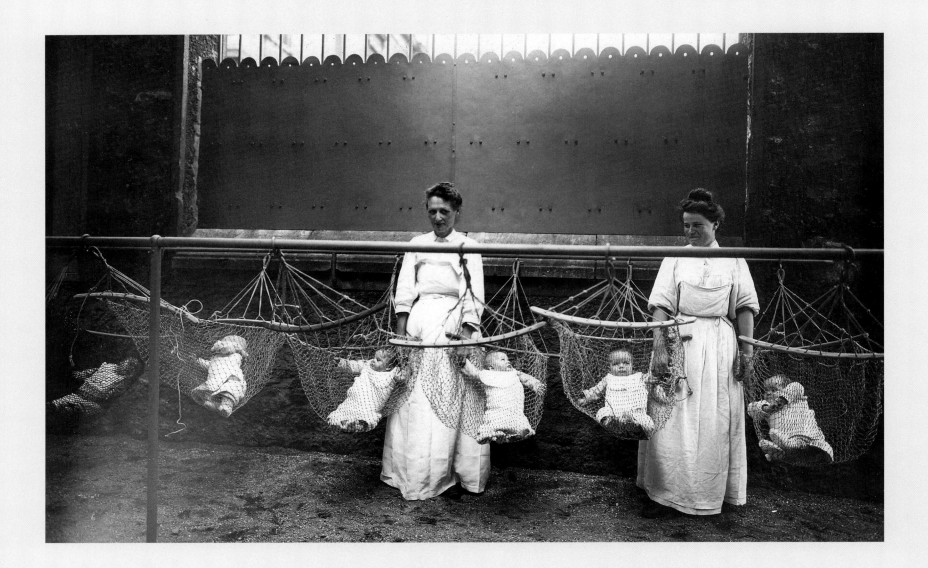

1918, France
Babies pass the time in hammocks at a public nursery while their mothers work in a government factory.
H. C. Ellis

right:
1997, St. Remy, France
In his pursuit of "light that rises from the darkness," artist Vincent Van Gogh made more than a hundred paintings in the asylum at St. Remy, where this sunny art therapy studio has since opened.
Lynn Johnson

In France, social welfare is not a charity but a right of citizenship as inviolable as the August vacation. Though rooted in the social reforms of the 19th century, its soul reaches back to Rousseau and ideals of the French Revolution: *liberté, egalité, fraternité*. "Security is liberty," says the modern system's architect, 81-year-old Pierre Laroque. "Equality: Everyone benefits. Lack of money is not a barrier to health care." Then there's fraternity, the Gallic sense of community that says we're all in this together, *mes amis*, so we'd better take care of one another. In France that sentiment burns so bright you can go to jail for failing to aid a drowning man. "Naturally, that doesn't obligate us to simpler civilities, like giving you the time of day," says a Paris lawyer.

July 1989, NATIONAL GEOGRAPHIC
from "The Fine Feathered Nest—La Protection Sociale"
by Cathy Newman

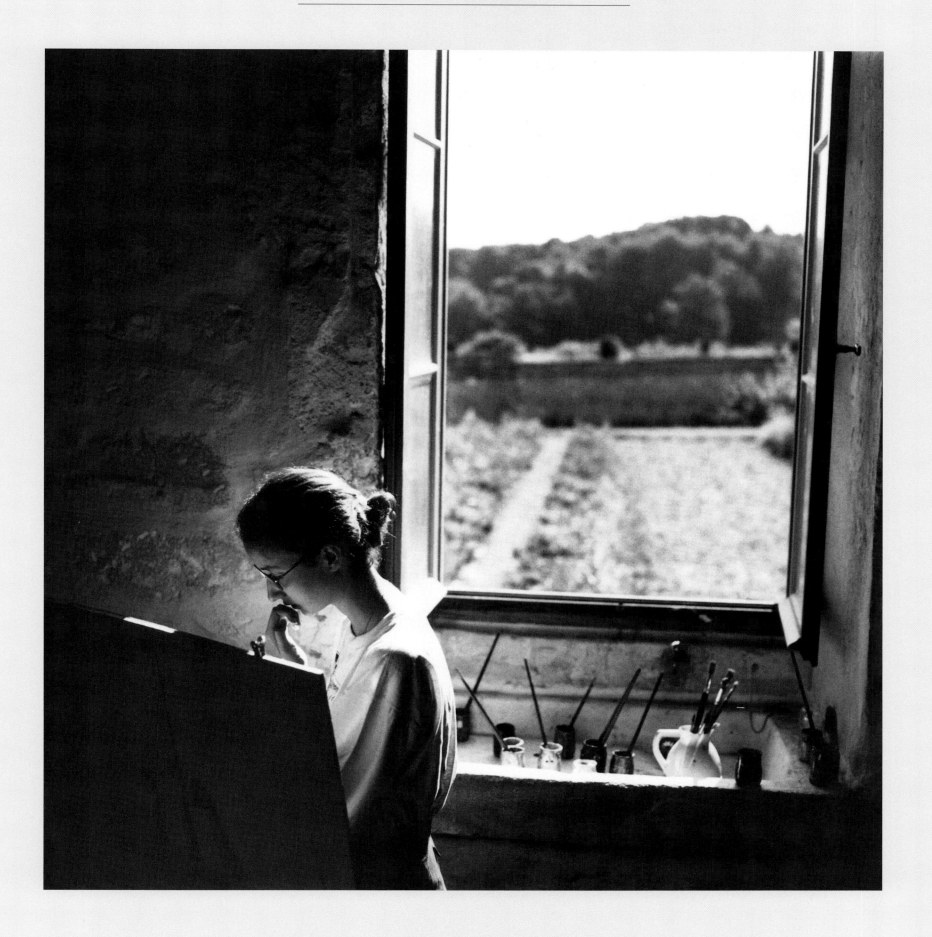

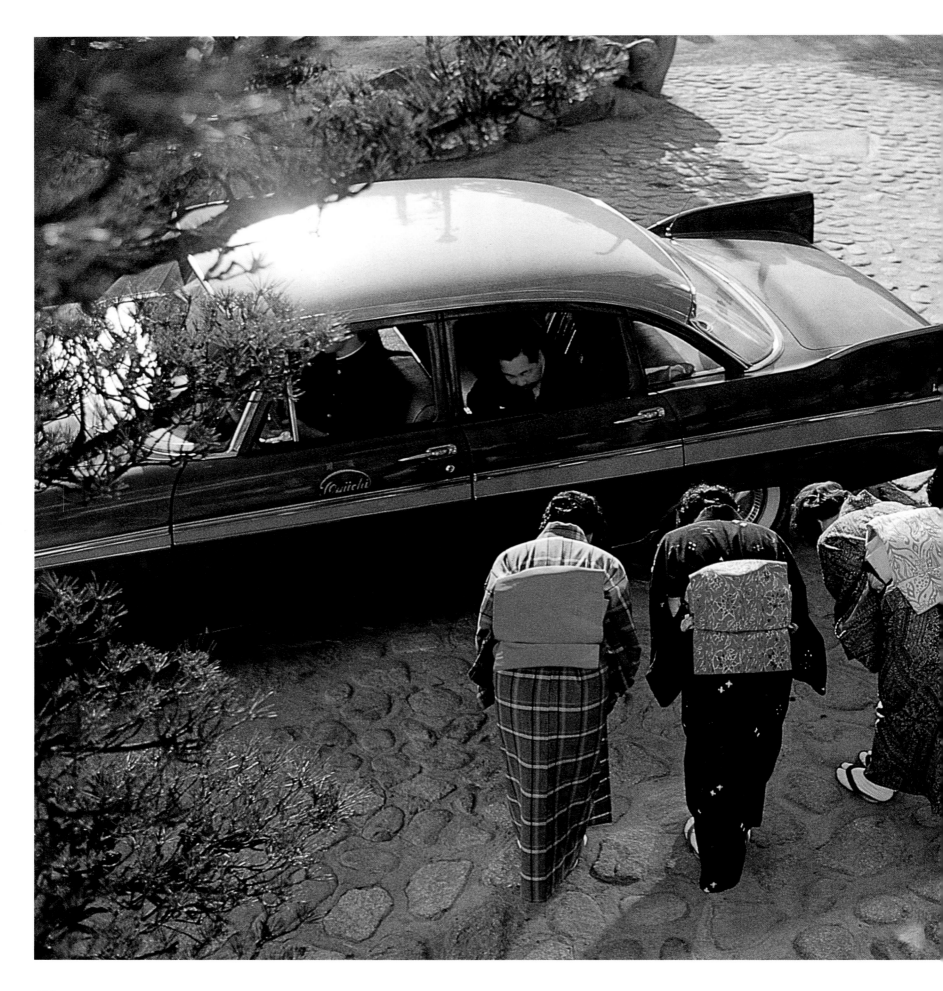

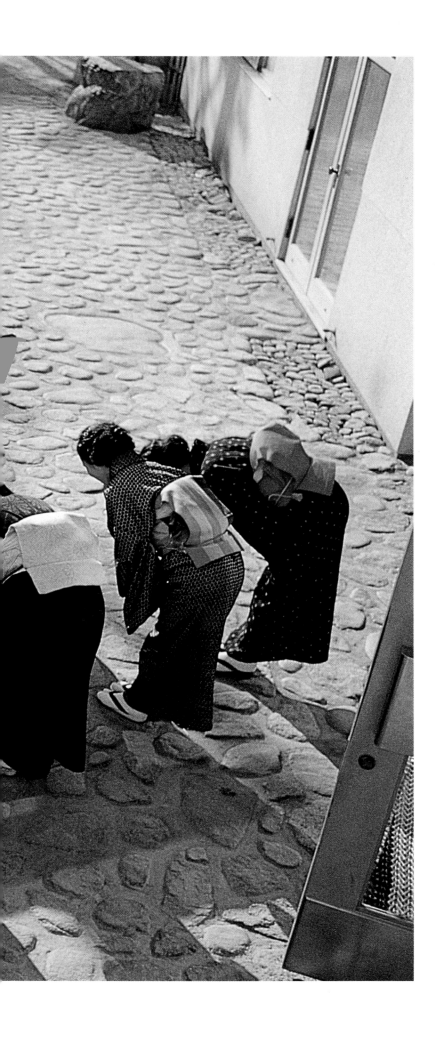

ASIA

By Thomas B. Allen

1960, Matsuyama, Japan
Hotel maids in traditional attire bow low as they bid farewell to
a departing guest.
John Launois

following pages:
1991, Tokyo
Wrapped in thought, a 20-something Tokyoite—member of the
richest generation yet in Japanese history—pauses amid
pedestrian-thronged streets.
Karen Kasmauski

Asia, said the NATIONAL GEOGRAPHIC magazine in 1901, is the cradle of humanity, the birthplace of mathematics, chemistry, and astronomy. But the peoples of Asia are a mystery. It would be "easier to deal with the human affairs of all of the rest of the world together than with those of Asia alone," wrote W. J. McGee, Vice President of the National Geographic Society.

Those days were like our own days, for one century was giving way to another, and in America there was a sense of great change in the air. But what of Asia? McGee gravely traced the cultural march of humankind from savagery and barbarism to civilization and enlightenment in the Western world, except for Asia. Unlike noble Europe and progressive America, Asia still harbored savages and barbarians and, although achieving some degree of civilization, still lacked the enlightenment that shone upon the West. So GEOGRAPHIC coverage of Asia became a search for signs of enlightenment in a faraway land pulsating with mysteries.

The magazine's first photo story—in the January 1905 issue—was about Tibet, the most mysterious of Asia's strange realms. With the photos were captions that would be a GEOGRAPHIC trademark, giving the reader a bonus of facts far beyond what the image showed. Two smiling Tibetan women going to market, for instance, had a caption that noted, "Women enjoy perfect freedom and independence and take an active part in business affairs, often managing extensive enterprises unaided." A photo of the Dalai Lama's magnificent palace in Llasa went beyond architecture: "The unequal distribution of wealth and the subservience of poverty to wealth are conspicuous throughout Tibet."

Facts helped to dispel mystery, and so did an understanding of geography. From the beginning, the magazine used geography and photography to show how the lay of the land shaped lives. An early article explored Korea "the hermit nation," and readers could begin to see what geographic isolation meant to people. Another article pointed out that the mountains of Central Asia blocked communication between eastern and western sides of the continent. Societies in the mountains evolved more slowly than those on plains and rivers, where "commerce and cultivation" flourished. Cultures that could communicate across terrain tended to resemble each other, so that "from western Asia Minor to the north of eastern Tibet the same Turkish language may be heard, the same tents seen, and the same tribal customs studied under the scattered and isolated conditions of nomadic life."

More than 90 years after that was written, I went to Central Asia to write a magazine story about Xinjiang, a remote province of China. The Turkic-speaking people still were there, and so were the tents I had seen in early images. The territory belonged to China, but the soul of the land still belonged to the nomads.

Looking at the photographs in GEOGRAPHICS of the 1920s and 1930s, I see what I found in the mountains of Xinjiang in 1995. Here still were the nomadic families, riding their horses. Here still were their circular white tents called yurts. Here still, in the high meadows, were the sheep being driven to the new grass of spring. Little had changed, including nomadic hospitality.

But lenses and film had improved, and photographic sensibilities had changed. My friend Reza, the photographer on the Xinjiang assignment, had learned photography in his native Iran (and had been imprisoned for photojournalism unappreciated by officials). Guided by a deep understanding of the people he visits, he aims his camera at moments of reality.

In 1936 a writer-photographer had written that wherever he had gone in Central Asia, a sheep had been sacrificed in his honor. Numerous sheep also died for Reza and me as we traveled.

One day, after leaving our four-wheeler at a rickety bridge, we hired a donkey to carry Reza's equipment and began walking a few miles to a Tajik farm in a high valley of the Pamirs. About 30 people fell in behind us, some on horseback, one man pounding a drum, another playing a flute. None of them had ever seen a foreigner. We were led to a house near a stream, and the women of the farm immediately began preparing a feast. Reza, hardly noticed by the women, moved quietly, capturing vivid, richly colored images far from the bleak portraits of 1936. The women's pillbox-shaped brocaded hats were draped with white veils that framed their lively faces. Their jet-black hair hung in long braids intertwined with bits of silver and plastic jewelry. As they worked by the oven's light, he caught reflections from their spangles, dancing like tiny moons along the smoke-blackened walls.

The feast culminated in a rite that by now Reza and I well knew, a sheep was brought to us and blessed. Reza pleaded for the sheep's life, saying we could eat from the farm's ample larder. Our host looked quizzically at our Chinese interpreter, then turned, unsmiling, toward Reza. The Tajik could not understand why his gesture of hospitality was being rebuffed.

Reza graciously gave in, and the sheep was led away. An hour or so later, the boiled head was presented to me, as the elder guest, and I had the honor of slicing off a piece of the cheek and eating it. Next came round after round of "black and white"—mutton meat and mutton fat—and brittle pieces of unleavened bread called *nam*. Tea laced with sheep milk washed it down.

When Reza later photographed a 3,000-year-old mummy in

a Xinjiang museum, he noticed that its deerskin boots resembled those of an old horseman of the valley. And designs on the horseman's saddlecloth traced back to ancient times. Change does not come quickly there. We realized that what does change is how we see people and photographically record their lives for the world.

Eastern tradition, to Western eyes, can seem quaint. In the 1930s a condescending tone at times crept into the magazine. Nomads were "childlike" and without "ambition enough" to grow wheat. They were ignorant, too: "To them, the world is flat and no amount of explaining can alter their conceptions."

But, as the Chinese discovered long ago, "One picture is worth more than a thousand words." Even if the words in articles about Asia were smugly Western, the reader could find moments of eastern reality in the photos that increasingly filled the pages of the GEOGRAPHIC: Smiling young men floating on sheepskin buoys on the Yellow River. Korean bakers kneading bread with huge mallets. Blind street musicians forlornly playing in old Peking, China.

Asia came alive even more in 1910 when the GEOGRAPHIC printed a series of color photos—"Glimpses of Korea and China," 24 pages of black and white photos "Kodaked" by William W. Chapin and tinted by a Japanese artist. A Chinese family ride in a wooden-wheeled cart pulled by a white horse. A Korean man garbs for rain in a coat of long grass and a basket hat. A bare-breasted Korean laundress stands beside a naked "street baby." A Chinese prisoner wears a *cangue,* a wooden yoke, around his neck.

Shocking images appeared unexpectedly. In China in 1901, an executioner raises his sword to behead a prisoner. A woman's head and arm stick out of a box in a 1922 series of color photos. The caption tells us: A Mongolian Woman Condemned to Die of Starvation. A 1921 article on headhunters in the Philippines shows a headless body being carried to a grave. Its 97 pages provide detailed descriptions of headhunters' grisly rituals.

In head-hunting country, the report says, women's "upper garments are practically unknown," a fact that is repeatedly illustrated. By then, it was no surprise to see in the GEOGRAPHIC images of women naked from the waist up. An early photo appeared in a 1903 story on the Philippines, where, it had been noted, "Young girls are frequently possessed of considerable comeliness."

No one made Asia more exotic than Joseph F. Rock, a botanist turned author-photographer. Hired in 1921 to write about a plant seen as a possible cure for leprosy, Dr. Rock became the GEOGRAPHIC's man in China. In the wildest of places he managed to live a civilized life. He bathed in a fold-up bathtub, listened to opera on his phonograph, and had baffled Chinese cooks prepare

him Viennese dinners. On the trail of a story, however, he stoically endured heat and insects, bureaucrats and bandits to get pictures of a China never seen before. In a mountainous realm near Tibet—"hitherto a blank on the map"—Rock faced down an outlaw chief and his band, "their sullen faces hinting of loot and murder…all

1935, Tibet
Splendid robes were believed by Tibetan lamas to endow
a shaman with superhuman strength and agility.
Joseph F. Rock

armed with rifles and pistols looted from Chinese soldiers in the north." He came away with astonishing images, photos whose colors were seen rather than imagined: a monarch resplendent in regal robes, tribal wizards performing in purple costumes, a mountain tribesman in a green coat trimmed with leopard skin.

Photographing in color on glass plates, he produced images

as vivid as the scenes limned by his words: masked lamas, women in embroidered satin jackets, mountain farms with golden corn drying on pine-log racks. In those times, photographers did their developing wherever they were. Rock notes how he did it: "Tying our black developing tent to the branches of rhododendrons…I started developing the plates. We had to filter the water through clean absorbent cotton to eliminate impurities…. I ordered one man to keep a cardboard waving over the plates to drive the insects off, but the air currents dislodged tiny specks of humus or moss from the rhododendron trunks, often spoiling the results."

Expeditions in the 1930s took readers to many blanks on Asia's map, such as the Gobi, the realm of Roy Chapman Andrews, an explorer whose paleontology was enhanced by the stunning images of photographer J. B. Shackelford. The pistol-toting Andrews once drove off brigands by telling their chieftain that his expedition included 30 men armed with rifles and a machine gun. "We didn't have a machine gun," he admitted to GEOGRAPHIC readers, "but the word went out, and we were not attacked that year."

Andrews's tales of derring-do were often eclipsed by Shackelford's photos, made while windblown sand sifted into the camera housing and primitive lenses had to outwit the glare of the desert sun. He brought back color photos of Mongol women who "wear every color of the rainbow." More routine photos portrayed Andrews, holstered gun on hip, examining 95-million-year-old dinosaur eggs, found when he discovered "one of the richest and most important fossil fields in all the world."

Those photos and words chronicling Andrews's expeditions helped half a century later, when GEOGRAPHIC photographer Dean Conger and I traveled to Mongolia for a story. The United States did not diplomatically recognize the communist nation, so Dean and I had to go to Moscow, get visas from the Mongolian Embassy there, and enter Mongolia through Siberia. Once we reached Mongolia's capital city, however, officials treated us like suspected spies. Dean was even grabbed off the street by security police who wanted to know why he was taking so many photographs.

The communist official who controlled our travel turned down request after request. Then, during one of the many interminable meetings, we mentioned the Gobi and Roy Chapman Andrews. A rare smile cracked the stern face of the official. He remembered the dinosaur eggs. Yes, we could go to the Gobi. Slowly, day by day, we convinced our suspicious escorts that our journalistic curiosity was benign. We got into schools and hospitals. We visited nomads and were invited into their tents. I would see identical yurts years later in the pasturelands of Xinjiang.

By the time Andrews's Gobi explorations were published in 1933, war was ending the era of Asian expeditions. The GEOGRAPHIC, meanwhile, continued to look at Asia as it always had, telling about places and people, but never telling about politics or war. The issue of February 1938 carried an article on "bustling Nanking" with typical photographs—alligator skins hanging in the apothecary shop, a shadowy pagoda, street urchins—and only glancing mention of the unpleasant fact that Japanese troops had taken the city the previous November. There is not even a hint of the invaders' notorious rampage of killing and raping.

After the Japanese attack on Pearl Harbor on December 7, 1941, the GEOGRAPHIC described the Pacific theater of war—but not the war itself. Readers saw elaborate maps of the theater, read and saw geographic facts about it (Luzon is "almost exactly eight times the size of Connecticut"), and learned that Japan's Emperor Hirohito was a "gentle soul" and "an ardent zoologist." Look for coverage of the bloody battle of Guadalcanal, and you find one photo—a Marine taking an outdoor shower between battles.

While GEOGRAPHIC staffer Volkmar Wentzel served on Okinawa, he decided that an Army ambulance would be a good vehicle for a traveling photographer. After the war, he returned to his job and, in 1946, was given a legendary two-word assignment: "Do India." He bought a used ambulance in Bombay, had "National Geographic Society U.S.A." painted on it in English, Hindi, and Urdu, and began a 40,000-mile odyssey across the subcontinent.

As he did India, Wentzel became one of several photographers of that postwar era who gave GEOGRAPHIC photography a new focus. No longer was Asia only a stage for tableaux of stone gods and people in colorful costumes. The pages began to have a new vibrancy. There still were snake charmers and topless maidens in grass skirts. But there were also British paratroopers hunting down guerrillas in Malaysia, where "Security forces kill about 150 guerrillas a month." And there were French paratroopers on patrol in Indochina. ("Indochina's Red guerrillas seem everywhere and nowhere, threatening sabotage, ambush, and sudden death.")

War in Indochina changed the GEOGRAPHIC, just as it changed America. A 1954 article by W. Robert Moore read: "As I write, the flimsy building shudders with the heavy explosions of sporadic mortar fire." Photos show French troops fighting in Indochina. In one, a jungle patrol passes a slain communist guerrilla.

When Americans began fighting in Vietnam, Dickey Chapelle, who had been a war correspondent in World War II, went back to battle. Covering the Vietnam War for the GEOGRAPHIC, she waded in waist-deep swamps, carried a carbine, and

once leaped out of a U.S. helicopter as it landed in pursuit of a fleeing Viet Cong. She recorded his capture in words and photos.

In November 1965, on patrol with Marines, she was killed when she tripped a Viet Cong booby-trap mine. She was that war's first woman correspondent to die in action. The GEOGRAPHIC posthumously published her last report about gun battles in the U.S. Navy's river war against the Viet Cong. "She lived the hundreds of lives of the men she wrote about and photographed," said Associate Editor Bill Garrett in tribute. Garrett had also covered the war for the magazine, and he brought to it his zest for "I am there" photos when he became Editor in 1980.

Throughout the Cold War, Chinese officials had shut the GEOGRAPHIC out of a country that since 1900 had been widely traveled by magazine photographers and writers. A thaw came in December 1971, when writer-photographer Audrey Topping produced a sweeping report on China including banquets with Zhou Enlai. Officially, she was traveling with her father, a retired Canadian diplomat who had known Zhou in the 1940s. In fact, the GEOGRAPHIC trip was part of Zhou's quiet diplomacy. For, even as Zhou was opening China to the GEOGRAPHIC, he was secretly negotiating with President Nixon for his historic 1972 trip to Beijing.

Audrey Topping later aided Geographic Book Division editors in the long negotiations that led to the publishing in 1982 of *Journey Into China,* an unprecedented panoramic report on the country by teams of Geographic writers and photographers. Many of us went to places where people had never seen Americans.

Like the other teams, photographer Jim Brandenburg and I were closely monitored. Officials laid out our itinerary, which invariably consisted of visiting factories and having tea with the manager, who gave us little more than statistics. We kept insisting that we wanted to see people in their homes. We asked for schools and hospitals, a chance to see the real China.

Finally and inexplicably, we won liberation from official itineraries. Through a young, fascinated interpreter (who later became a Chinese journalist), I interviewed and Jim photographed real people. While I talked to a woman proud of her new television set, Jim took photos of her spic-and-span apartment. My pencil and Jim's camera recorded a man building his own house, workers in an oil field, teachers and their pupils, doctors and their patients. Our official babysitters, as we called them, even gave in and let us ride on a "hard-seat" train that they considered too Spartan for Westerners. Onboard, people at first shyly turned away. As the miles clicked by, some started singing, and one urged us to join in. I tried "Home on the Range," with Jim chiming in on his

harmonica (between candid photo-taking). After our interpreter explained that this was a cowboy song, the audience demanded endless encores. The song fest continued until the train leader appeared and sternly ordered us all to go to sleep.

Looking back to that wonderful night on the hard-seat train and leafing through the book we helped to produce, I see again the singing passengers, the oil workers, and the other Chinese we showed to readers, and I wonder how many of the people in those photos are now capitalists playing the stock exchange in

1996, Xinjiang, China
In the Altay Mountains a lissome dancer performs before nomadic herders gathered for a rite of circumcision.
Reza

following pages:
1950, Nepal
Stripped of wheels and bumpers, a Mercedes bound for trade-in is carried from Katmandu to India.
Volkmar Wentzel

Shanghai. Westerners now look to Asia not because of its mysteries but because of its role in the global economy. Asia isn't remote anymore. Recent GEOGRAPHIC photos show not only stock exchanges but also Western-style clothes on Chinese who once knew only drab Mao jackets…kids in cool sunglasses…skyscrapers in Shanghai. As a Shanghai eel skinner said in a GEOGRAPHIC story about that city's booming 1990s: "I feel like something good is going to happen, that I am going to become part of the world."

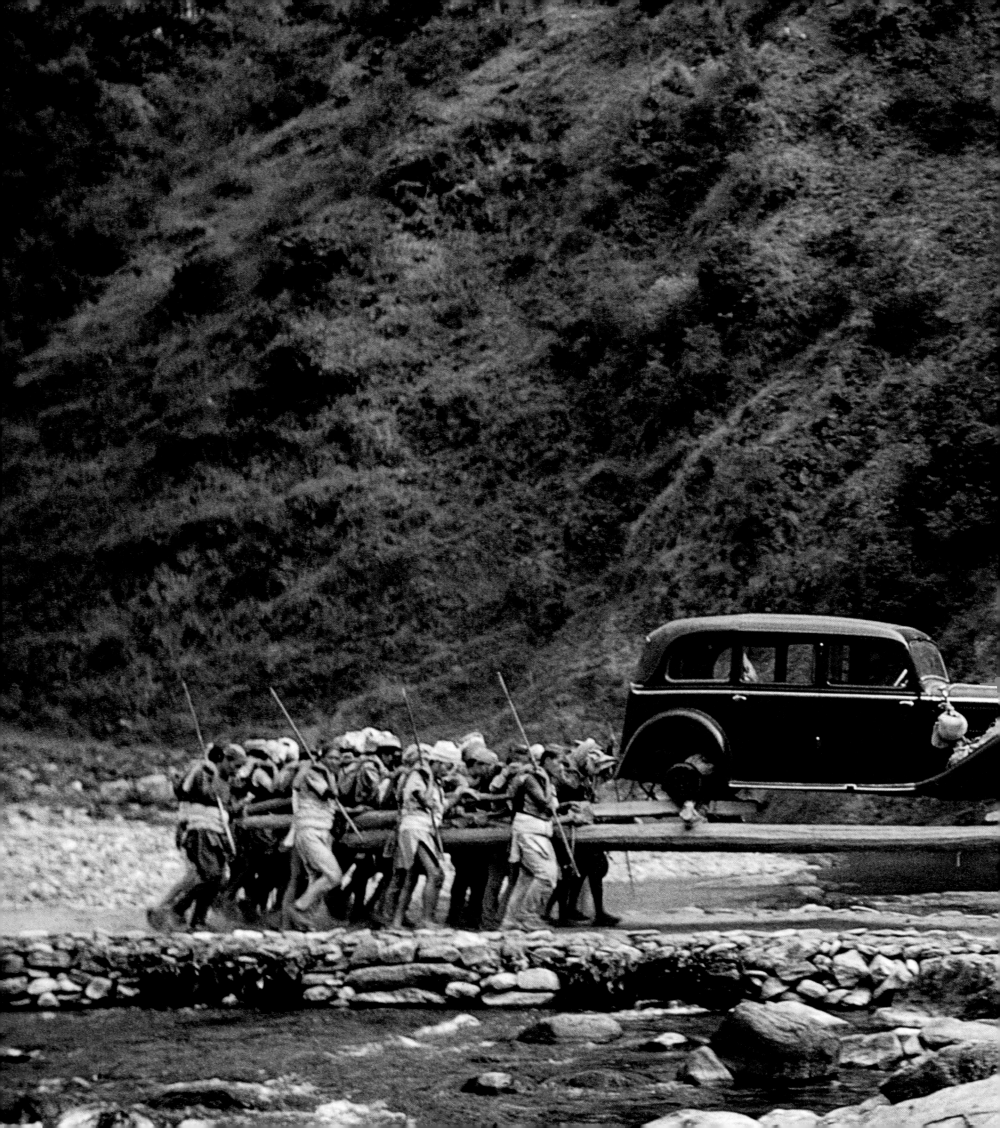

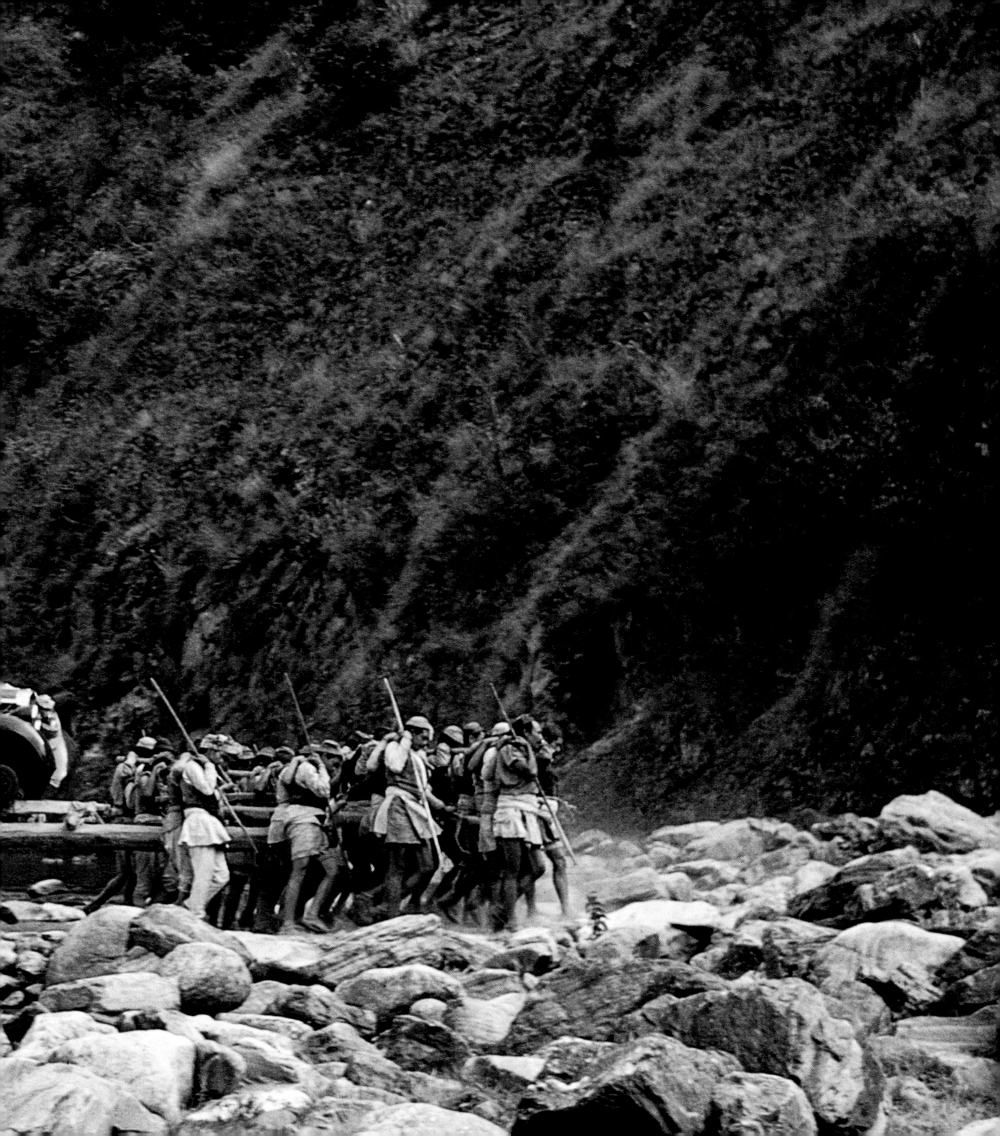

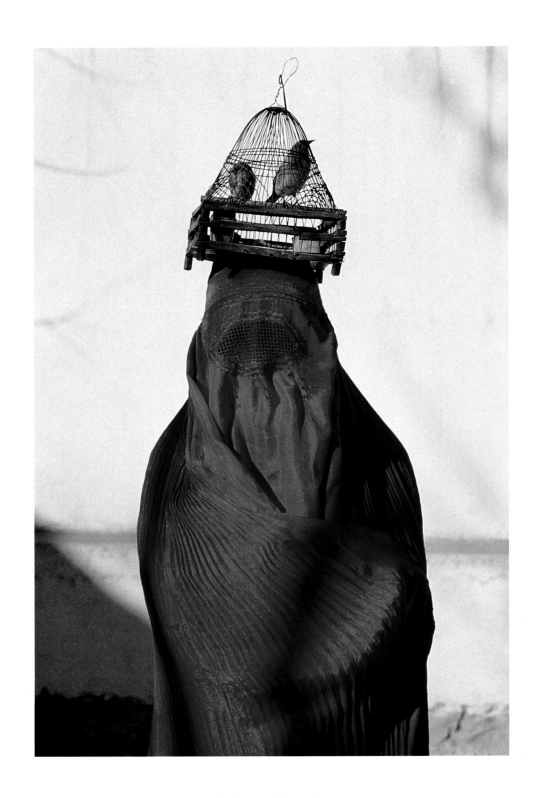

1968, Kabul, Afghanistan
Songbirds ride home from market on the head of a woman concealed in
a traditional *chadri*.
Thomas J. Abercrombie

right:

1993, Kabul, Afghanistan
Two-year-old Muhammad Abdul Waheed, grazed by a bullet during factional
fighting, sobs in sympathetic arms.
Steve McCurry

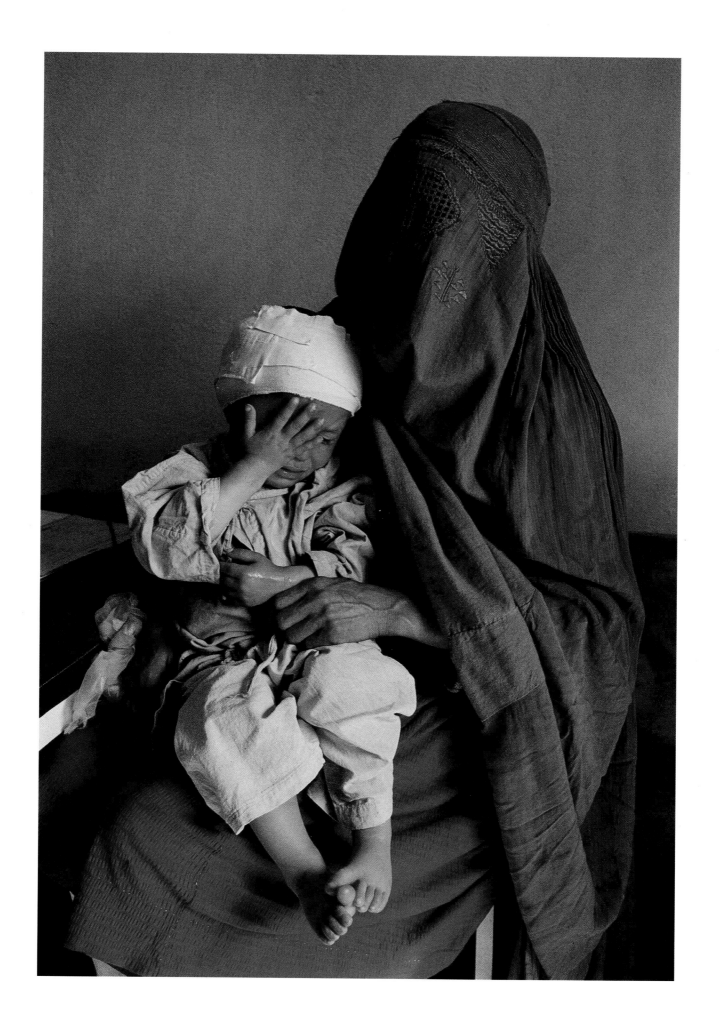

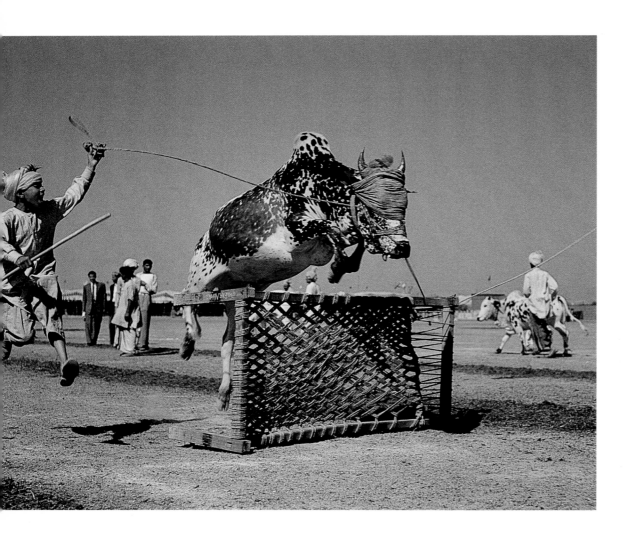

1960, Lahore, Pakistan
Cattlemen goad a blindfolded bovine over a hurdle during the National Horse
and Cattle Show, where pageantry included trick riding, camel acrobatics,
and even a police tattoo.

Schuyler Jones

right:
1997, Pakistan
Stick-wielding Pakistani guard scolds Afghan boys at the Nasir Bagh refugee
camp. More than three million Afghans fled to Pakistan during the Soviet
occupation of their country from 1979-89.

Ed Kashi

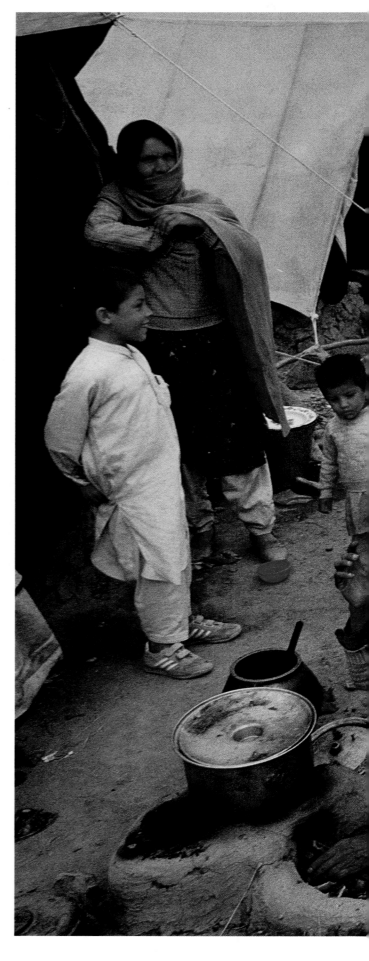

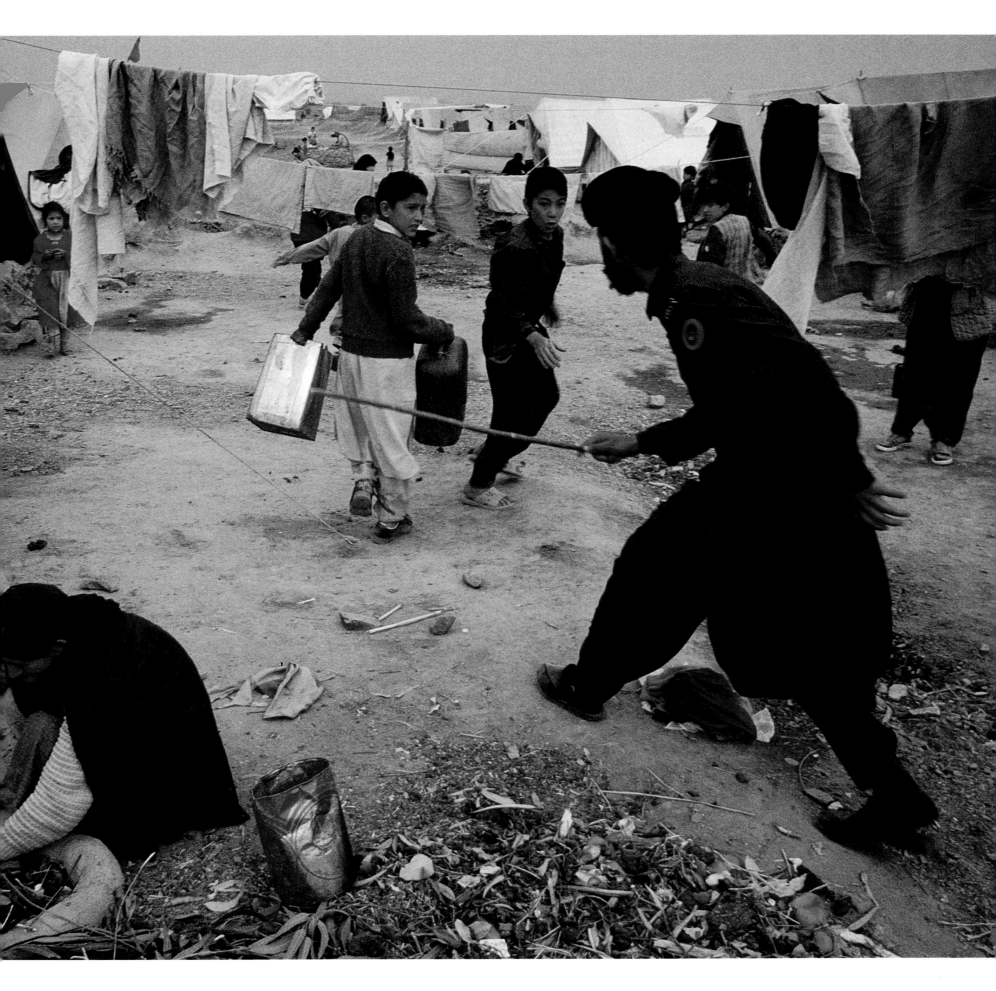

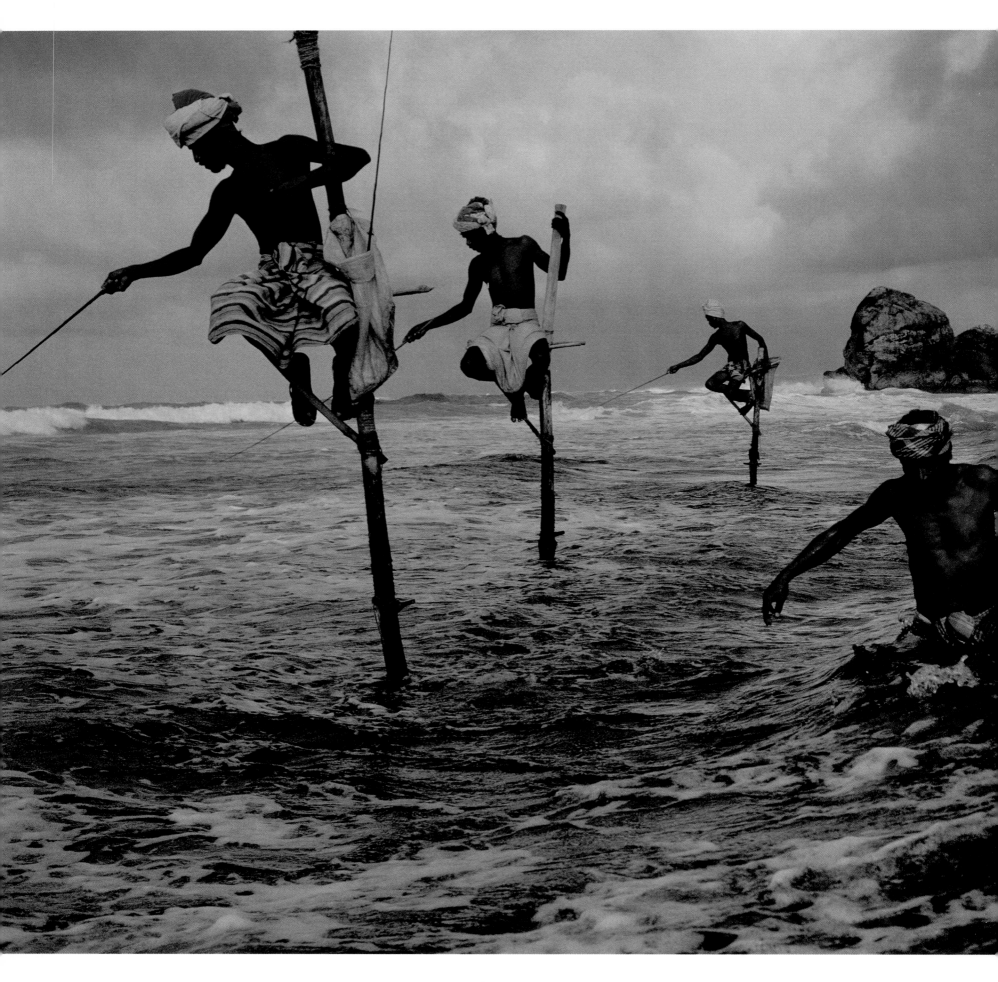

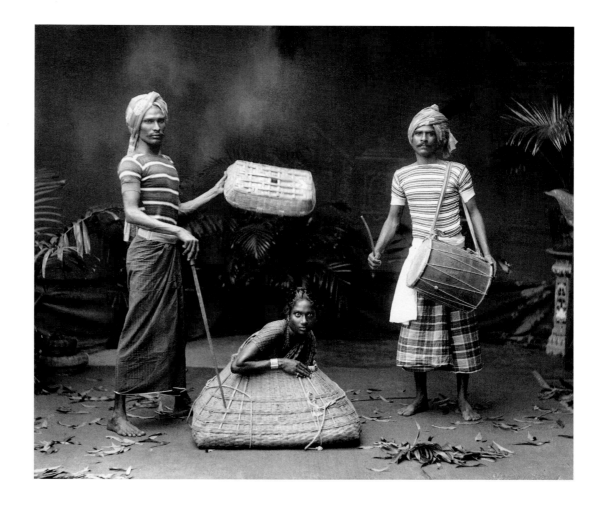

1912, Ceylon
Magician's assistant emerges unscathed from a basket through which swords
have been repeatedly thrust.
Alexander Graham Bell

left:
1997, Sri Lanka (formerly Ceylon)
Perched on wooden stilts, fishermen work the shallow coastal waters in the
manner of their ancestors.
Steve McCurry

Probably the most beautiful stretch of the island's coast is around the palm-fringed area of Tangalla. Buddhist fishermen brave the deep to battle shark and swordfish, but they are loath to kill even an insect. In their profession they claim they do not kill—they merely remove fish from the water. My Sinhalese cook would not break an egg. Yet they do not hesitate to murder when provoked!

July 1948, NATIONAL GEOGRAPHIC
from "Ceylon, Island of the 'Lion People'"
by Helen Trybulowski Gilles

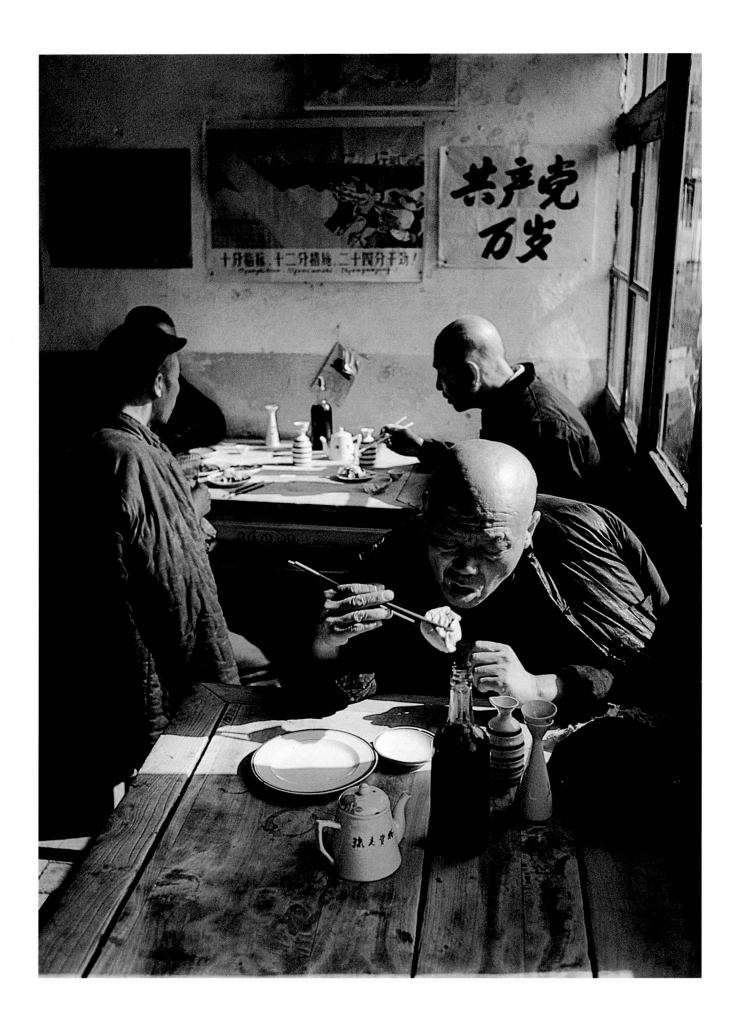

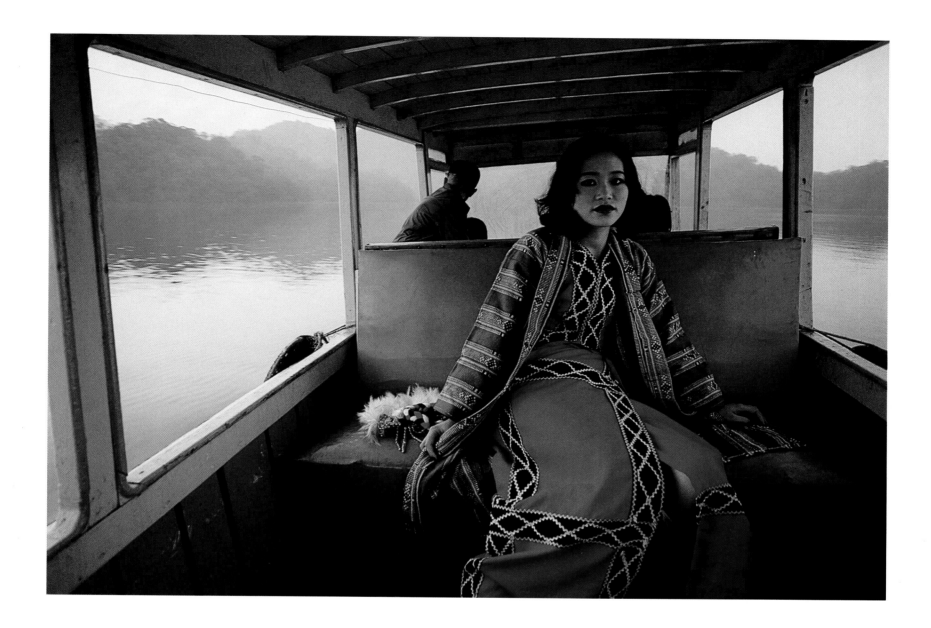

You won't see any ricksha boys in these pictures. The Communists have banned them. It is undignified, they say, for one man to pull another in a cart. Perhaps it is. There are people, on the other hand, who hold that no occupation is undignified if a man does it proudly and of his own free will. I know only this, that the ricksha boys of Peking were proud of their strength and of their jobs, and that they had as much human dignity as any group I have ever known. Some of them were my friends; my last dinner in Peking was in the home of a tall, blue-gowned man named Liu who had taken me about the city for years. It was a simple meal, and Liu's home had only two rooms, but he and his wife and two children were a loving, happy family, and I think he would have fought anyone who told him he should be ashamed of his work.

August 1960, NATIONAL GEOGRAPHIC
from "The City They Call Red China's Showcase"
by Franc Shor

1982, Sun Moon Lake, Taiwan
After entertaining tourists at a lakeside resort,
a young dancer of aboriginal descent returns by boat
to her village.

John Chao

left:
1960, Peking, China
Patrons dine on traditional *chiao-tzu,* dumplings,
at a restaurant frequented by laborers, pedicab drivers,
and merchants.

Brian Brake

following pages:
1990, Southwestern Thailand
Nest gatherer shins up bamboo and vines to a lofty sea
cave where he will collect swiftling nests, the key
ingredient of bird's nest soup, a Chinese delicacy.

Eric Valli and Diane Summers

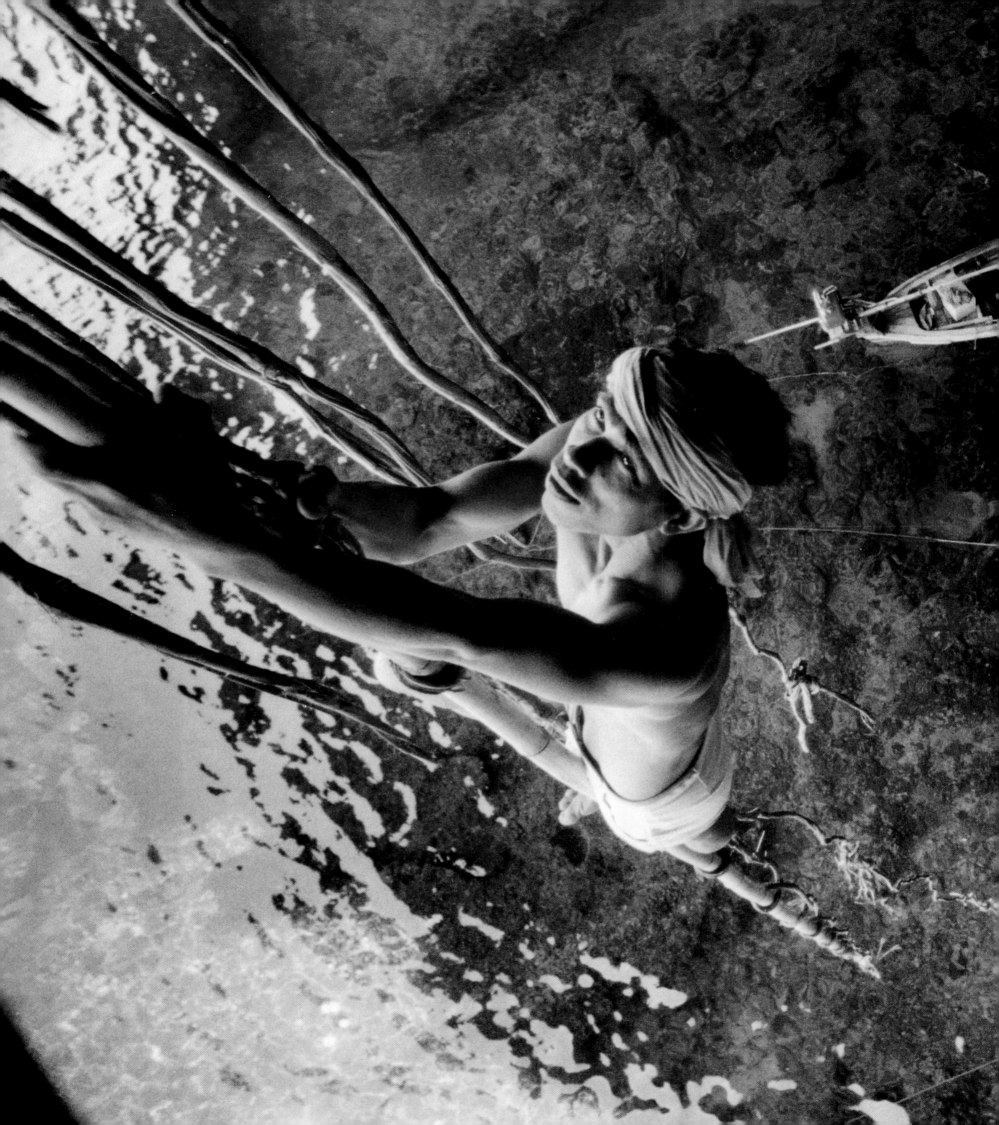

In all the swift, significant changes wrought by white men in the East, no one event stands out more conspicuously than the rapid rise of Singapore. From a jungle isle, where tigers ate men at night, to a magnificent city, tenth among the ports of the world, in less than a century! A boomtown record this might be, even in new America, but striking indeed when one thinks of the remote geographic position of Singapore and the many centuries which other oriental cities have taken in the building.

Now it is a wonder city, with marble bank buildings of singular beauty and great stone law courts and government edifices and Christian churches—all striking contrast to the ornamental Malay mosques, the carved temples of the Hindus, and the fantastic joss houses of the Chinese. Through the thick jungle, where once led only the elephant paths, wide, level roads have now been built, and the hoarse squawk of the motor horn has drowned the fierce growls of the tiger.

March 1926, NATIONAL GEOGRAPHIC
from "Singapore, Crossroads of the East"
by Frederick Simpich

His [Buddha Shwethalyaung's] mood seemed to suffuse the land. Pony carts and trucks shared the highway companionably. Water buffalo wallowed luxuriously in algae-green pools.... Here a wheelwright cheerfully sweated red-hot iron tires onto intricately carved rims....

Of houses there was need. Everywhere small children scurried like chipmunks, their faces striped with a yellowish bark powder, called thanaka, to preserve their young complexions. I shared with them my roadside snacks of bright yellow watermelon that tasted pink, peanuts spiced with garlic and chili, and candy called jaggery, fresh from boiling caldrons of toddy palm juice....

There were many signs of prosperity, and a farmer named U Aung Kyaing gave us some reasons. He'd borrowed $1,000 from the government to install a 110-foot well and a diesel-powered pump. It had paid for itself in a year, allowing him to irrigate profitable dry-season crops of corn, chili peppers, and tomatoes. Now he could afford to hire laborers and send his three sons to school.

July 1984, NATIONAL GEOGRAPHIC
from "Time and Again in Burma"
by Bryan Hodgson

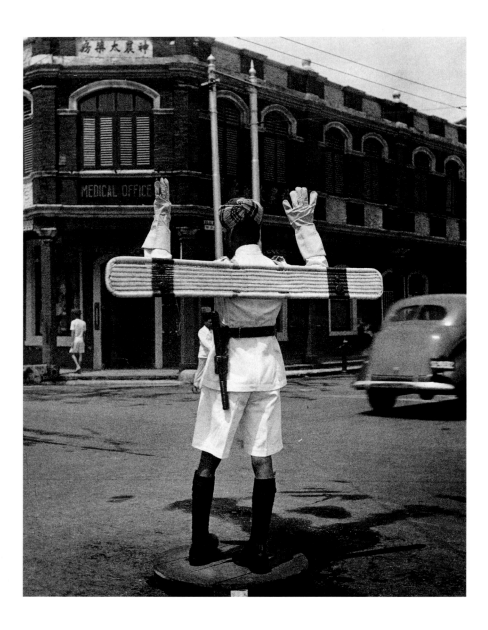

1939, Singapore
Human semaphore, a policeman directing traffic in front of the city's medical office wears a board on his back to supplement his arm signals.
Pierre Verger

right:
1984, Burma
Too young to begin the 11-year mandatory schooling at age five, a child passes time swinging in the folds of his father's *longyi,* the tube of fabric traditionally worn by Burmese men and women.
James L. Stanfield

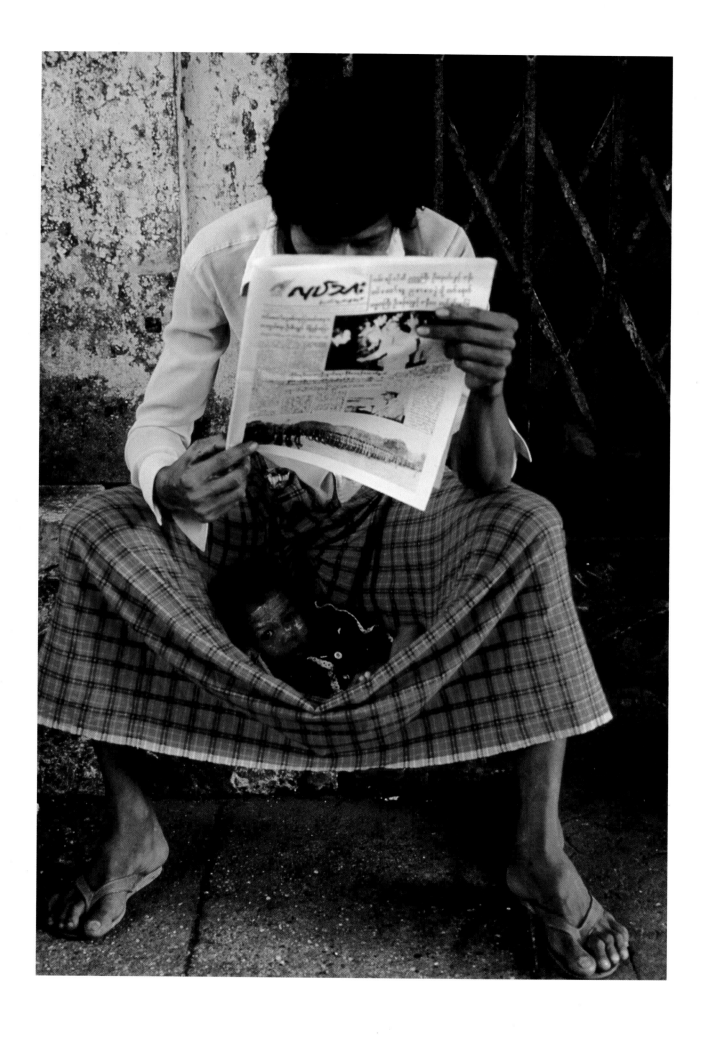

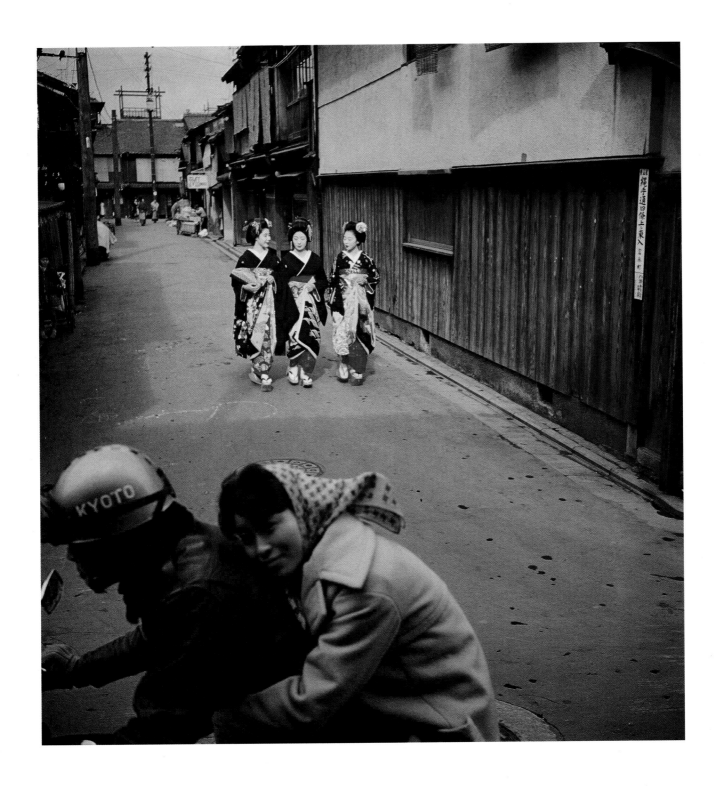

1960, Kyoto, Japan
New meets old in Gion-machi entertainment district as Western-togged motorcyclists roar past a geisha and her apprentices swathed in silk kimonos. Their gei, or art, of music, dance, and conversation has been practiced for more than two centuries.
John Launois

right:
1995, Kyoto, Japan
Today barely a thousand strong, the geisha's "flower and willow world," as the community is known, is more closeknit than ever. Here two *maiko,* or apprentice geisha, relax between dance performances.
Jodi Cobb

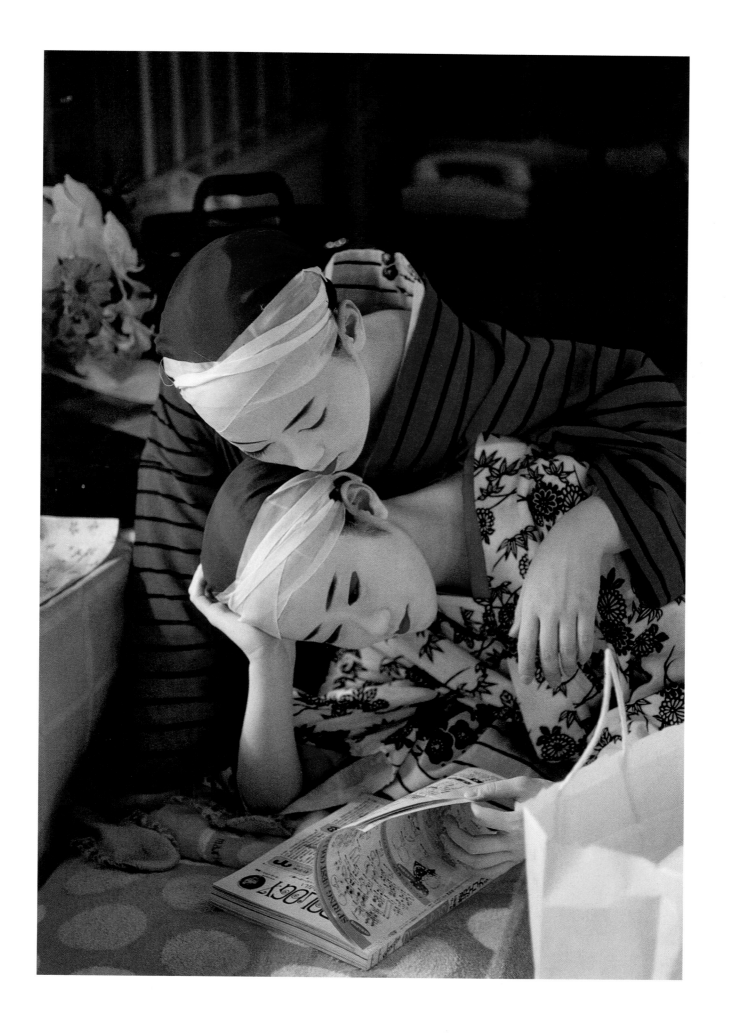

As Arab oil wealth was the money phenomenon of the 1970s, so in the '80s was the Japanese money machine.…

And then came *zaiteku*.

"Zai"—the Japanese word for the Chinese character for wealth—was combined with "teku," a word borrowed from English that represents technology. Zaiteku means financial engineering—"new ways of making money with money," I was told by Haruhiko Kuroda, a senior official in the Ministry of Finance. And who was the biggest practitioner of zaiteku? Toyota. They were earning 2.9 billion dollars from cars and 1.2 billion from financial operations in 1989.

How? "Rapid currency trading," said Mr. Kuroda, "and issuing securities, say 5 percent bonds, that will be bought by Belgian dentists.…" I must have looked puzzled. Mr. Kuroda smiled—he'd meant to say affluent people who are financially unsophisticated, looking for investments that seem safe and yield good returns.…

January 1993, NATIONAL GEOGRAPHIC
From "The Power of Money"
by Peter T. White

1993, Tokyo, Japan

Inside the world's largest trading room, 350 employees of Sanyo Securities play the stock market.

Charles O'Rear

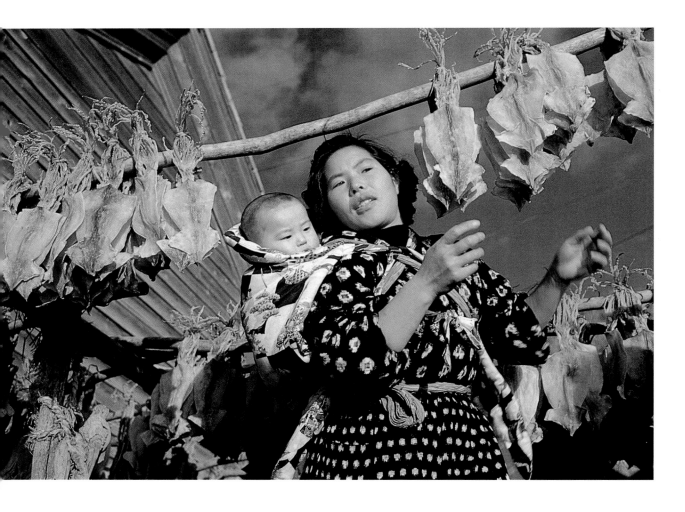

1960, Japan
A young woman with her baby strapped to her back hangs up cuttlefish to dry
in the sun.

John Launois

right:

1994, Nezugaseki, Japan
Squid destined for snack food dries on lines strung across the beach of this west coast
port, which still subsists on the commerce supplied by a handful of fishermen.

Peter Essick

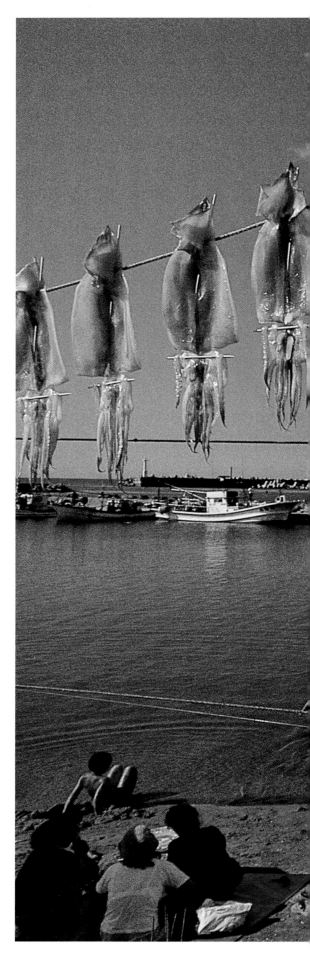

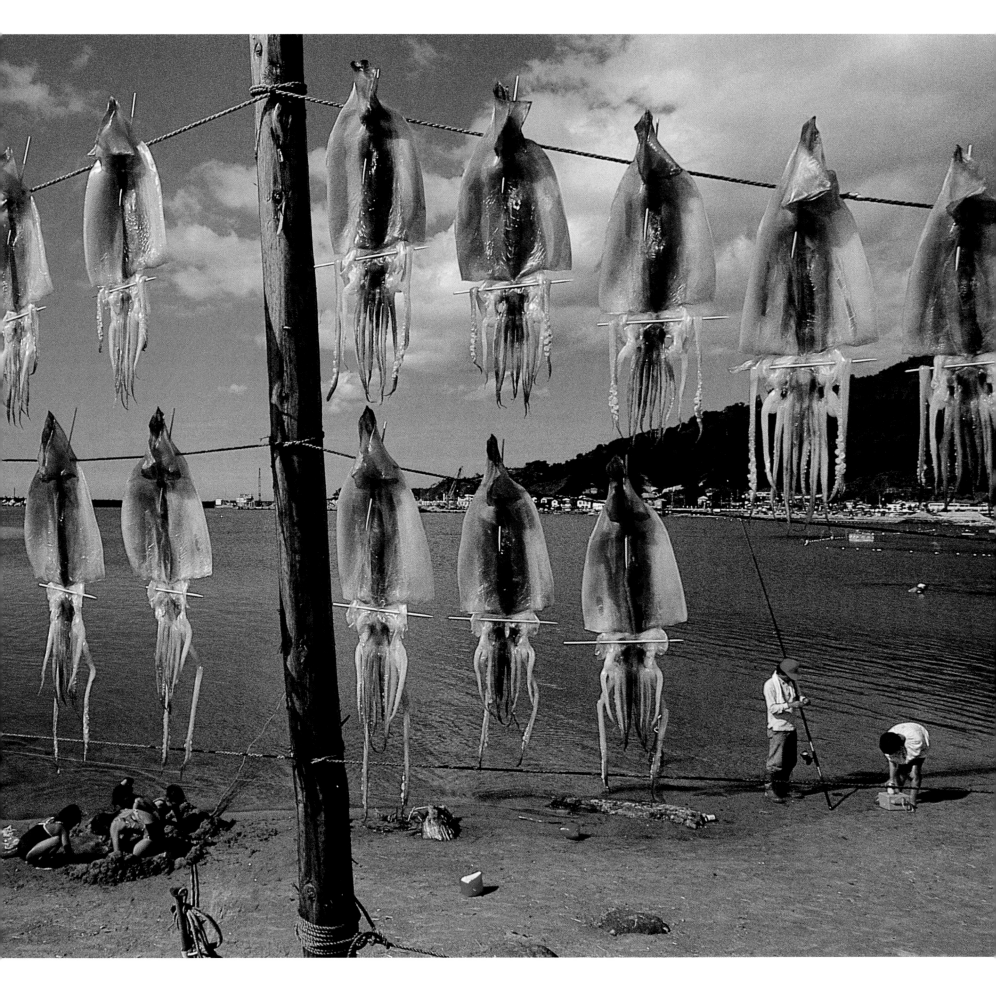

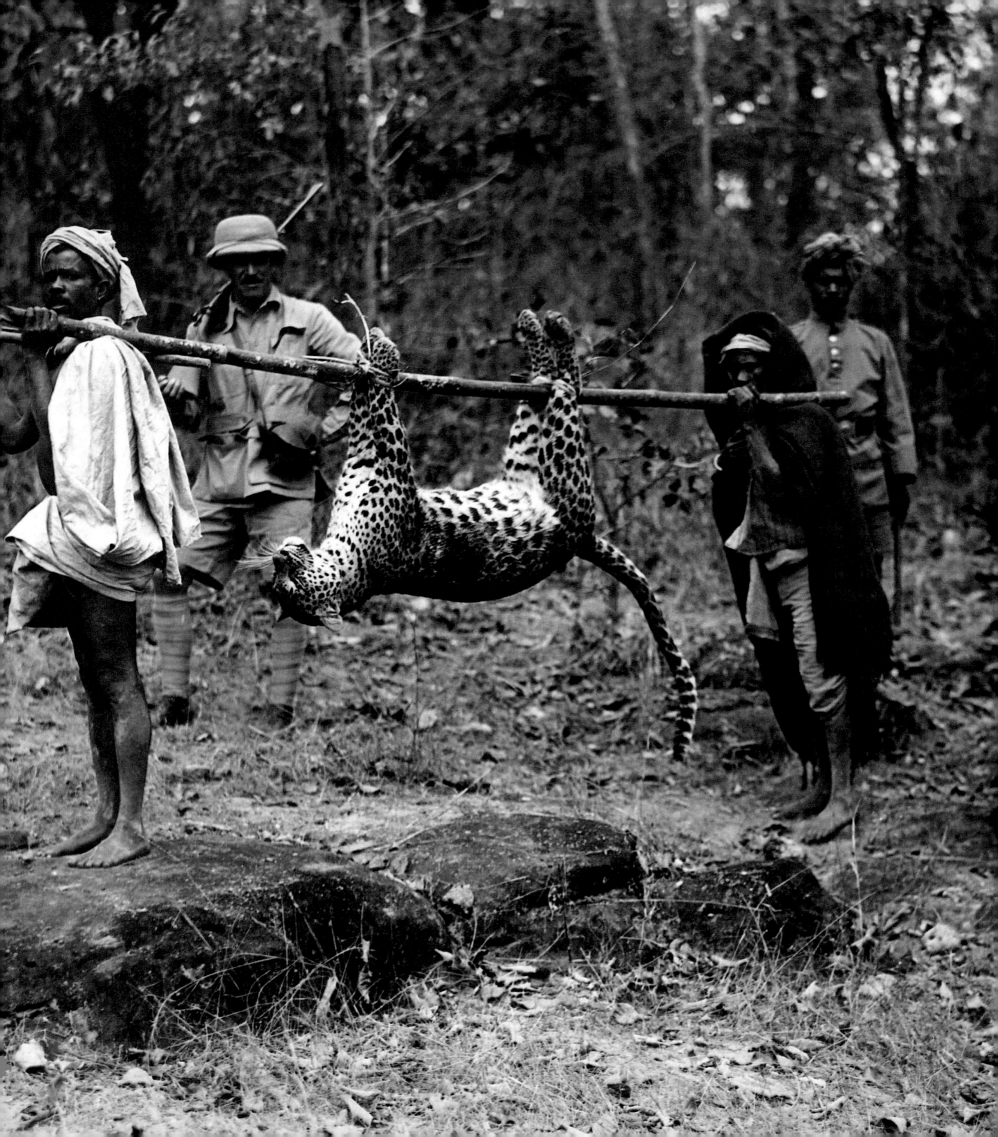

India

In his 1924 article "Tiger-Hunting in India," William Mitchell noted that a hunter who bagged a tiger or panther was "looked upon as a public bene-factor, for the number of people killed each year by wild animals…in India is appalling." Peter Muir, posing with a tiger he felled, reiterated the point in "India Mosaic," in 1946. By the 1970s, however, NATIONAL GEOGRAPHIC was covering India's wildlife—many species of which now faced extinction after a century of hunting and habitat destruction—with an eye on preser-vation rather than sport. In 1992 "India's Wildlife Dilemma" reported on "a new kind of Indian conservation effort, aimed at restoring the relative har-mony that once existed between the forests and those who live around them."

above:

1992, India
Drugged by game wardens after it attacked two villagers, a leopard is readied for transport to a wildlife sanctuary.
Raghu Rai

left:

1875, Shikar, India
Gun-toting hunters admire their prey as porters hoist a dead leopard to haul back to camp.
Indian State Railways

1970, Shirala, India

In ancient ritual, Hindu women prostrate themselves within striking range of a cobra, symbol of fertility. They do not fear attack from *Nulla Pambu,* "good snake," which is known for its peaceful nature.

Naresh and Rajesh Bedi

In Benares we suffered a grievous disillusionment. The town was crawling with snake charmers and their lethargic, tame, defanged cobras. Larry wanted to stage a fight between the two traditional enemies, the cobra and the mongoose. He insisted on having captured a…six-foot king cobra as big around as your wrist and black as night. When [a] corral had been made…and the two contestants had entered the ring, what a disappointment. There was not even a preliminary skirmish. There was a three-second approach, a flash of brown lightning, and the great snake lay thrashing in its death agonies, its spade head crushed in the inexorable jaws of its furry adversary. We began to have profound respect for Rikki-tikki-tavi.

October 1940, NATIONAL GEOGRAPHIC
from "In the Realms of the Maharajas"
by Lawrence Copley Thaw and Margaret S. Thaw

Perhaps Bombay is a city where people are simply too busy to care what others are up to. For an Indian woman this is especially liberating.... [A] career woman is generally free to live alone, to drive her own car, to marry the man she loves rather than the one her family has chosen for her. "Eve teasing"—an expression used...to describe the act of harassing women on crowded streets—is a chronic problem elsewhere in the country but...rare in Bombay.

This blasé indifference to others... can be summed up in a word constantly heard in the rough-edged Hindi of Bombay streets: *bindaas*. Although the word can be translated as "I don't give a damn," it corresponds almost exactly to the American "cool."

March 1995, NATIONAL GEOGRAPHIC
from "Bombay: India's Capital of Hope"
by John McCarry

1995, Bombay
Rain pelts a woman and child seeking coins from passing motorists. Half of Bombay's 13 million people live on the streets or in shanties; for thousands, begging is the sole means of income.
Steve McCurry

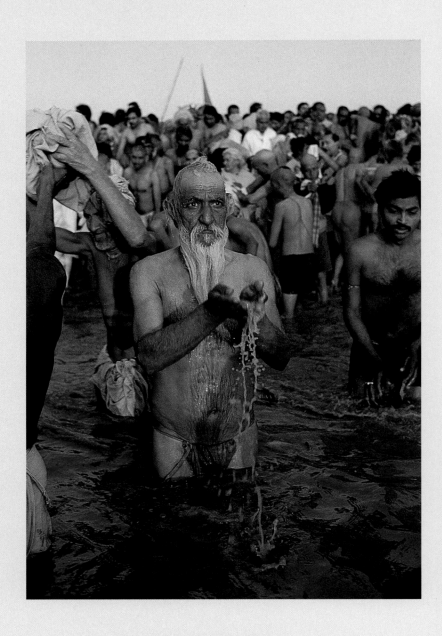

1990, North Central India
**During Maha Kumbh Mela, India's largest religious
festival, pilgrims bathe in the sacred river, the Ganga
(Ganges), at dawn.**
Raghubir Singh

right:
1958, Kashmir, India
**Team of fishermen on Dal Lake hurl tent-size nets over
a prospective catch.**
Brian Brake

MIDDLE EAST AND NORTH AFRICA

By K. M. Kostyal

1958, Southern Iraq
Marsh dwellers known as the Ma'dan frame an arched hut with
bundles of reeds. Mats laid across the ribs formed the walls and
roof of the collapsible dwellings, which migratory Ma'dan families
carried as they roamed.
Wilfred Thesiger

following pages:
1985, Baghdad, Iraq
Symbolizing half grief, half pride, 150-foot-high Monument of
Saddam's Qadissiya Martyrs honors Iraqi soldiers killed in the
1980s war with Iran.
Steve McCurry

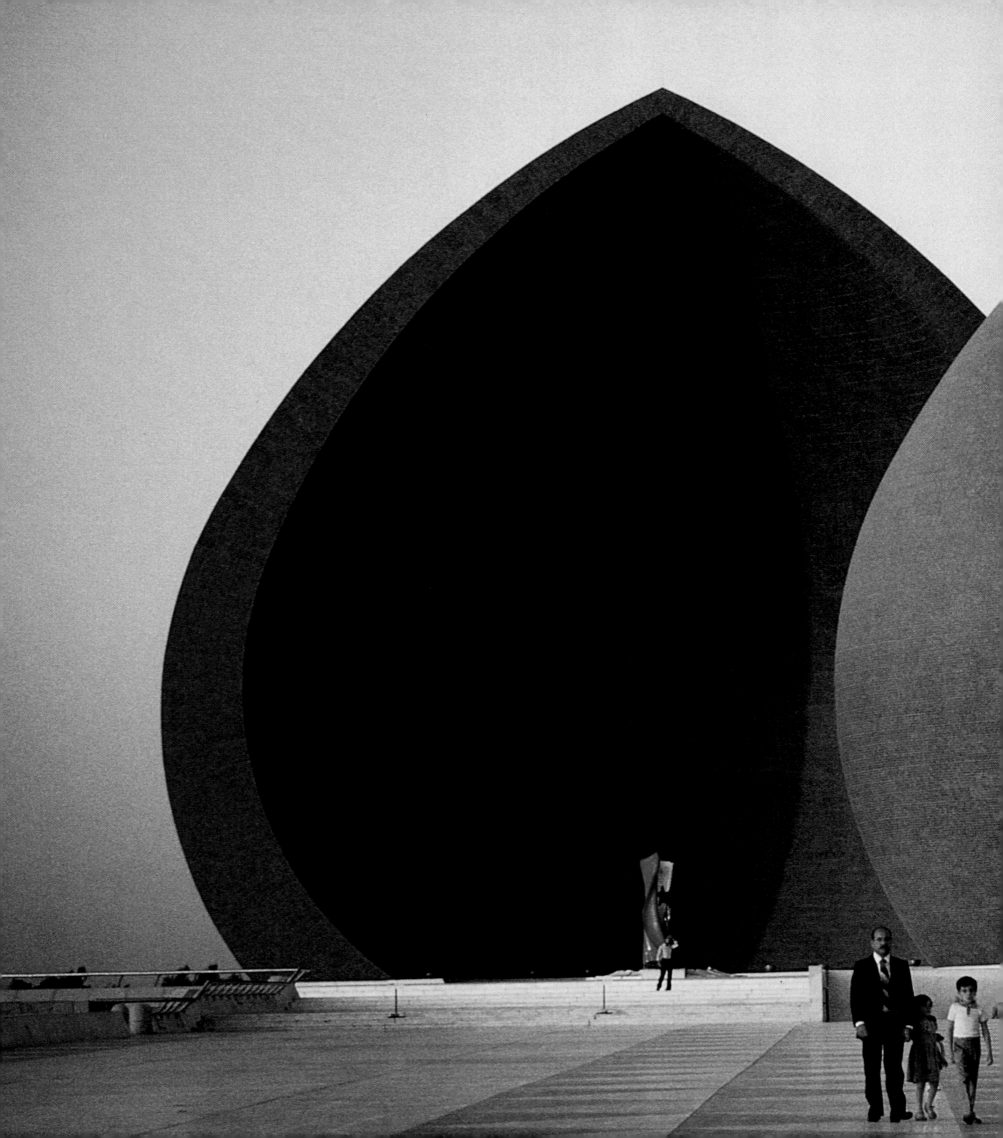

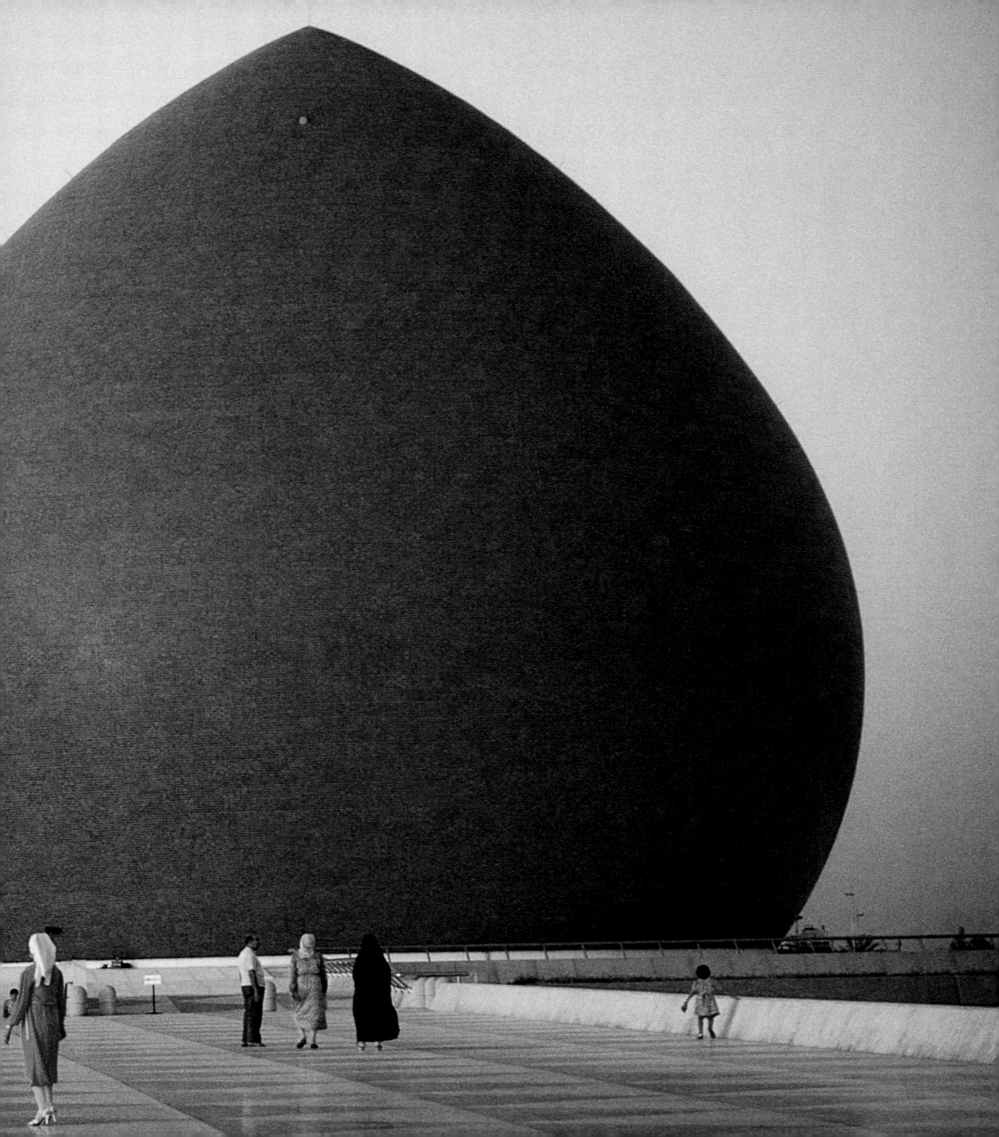

The Middle East and North Africa. A world of oil sheiks and desert nomads, of passions and pyramids, of prophetic potentials and apocalyptic problems. Ancient and modern seem to morph in and out of one another here in ways that boggle the Western mind. If you look back through a century of NATIONAL GEOGRAPHICS, you can trace a strange, almost circular history happening in this part of the world. The tides of modernization sweep across its deserts, and Arab women are suddenly unveiled, Bedouins trade their camels for Land Rovers, and peace between Arabs and Israelis seems possible at last. But then the tides recede and history circles back on itself. Arab women return to the veil, ultra-Orthodox Jews return to millennia-old traditions, and peace talks become little more than failed seeds cast into the desert sands. Of course, the tides will change direction again. And when they do, GEOGRAPHIC photographs will record the change.

Early in the century, when the Society began covering this area, the Middle East as a major flash point on the globe wasn't even a concept. Back then, Muslims were "Mohammedans"; Saudis were Arabians; the 600-year-old Ottoman Empire was still alive, if not well; and the Holy Land was more often viewed as the Christian heartland than as a smoldering political hotbed. Pictures in the magazine featured Arab dhows in full sail, tribesmen drawing water from coveted water holes in the Sudanese sands, and camels—always camels—laden with everything from bridal trousseaus to tented palanquins filled with whole families. Whatever the country, whatever the culture, though, in those imperialist days, each was seen as benefiting from the guidance of the Western world's colonial benefactors. In a 1909 article in the magazine, a British geographer wrote glowingly of "Civilized French Africa." Thanks to the French colonialists in Tunis and Algeria, he assured us, "the Dark Continent has its light spots," one of them being Algiers, a city, "more French than Marseilles." Not exactly a fitting characterization for the Algiers of today.

In the same year, the president of the American College for Girls in Constantinople reported to the GEOGRAPHIC readership on the "Emancipation of Mohammedan Women." Overnight a new constitutional government had "liberated" the women from tradition. "Their lives have been shrouded in mystery," Mary Patrick wrote. "In the streets they have been concealed behind thick veils and flowing draperies, and hidden behind heavy curtains and latticed windows in their homes." Not a single image of a Turkish woman appeared in her story, though there was a memorable shot of the bearded Sultan of the Ottoman Empire in his fez and open, horse-drawn carriage. It was the day the constitution had been signed and a sea of anxious male faces backed him. The sultan's harem alone, Dr. Patrick wrote, usually contained several hundred women, closely guarded by eunuchs. He could not have been happy with the march of progress.

On a recent lecture tour to the Middle East for the Society, I saw that early "liberation" reversing itself. In Istanbul ardent young Muslim women wore pious floor-length coats, their hair swathed completely in scarves. "Islamic fundamentalism is being embraced again by some Turkish young people," Nurdan Saracoglu told me. "It worries me. They want a return to my grandmother's time." Formerly a World Bank official and the wife of a government minister, Nurdan was as Western in her viewpoint as I and wanted Turkey to avoid the Pan-Islamic movement that has swept the Middle East. In the living room of her home in the hills of Asian Istanbul hangs a framed, 1940s *Time* magazine cover featuring her father-in-law, Sükru Saracoglü, former prime minister of Turkey. He had been a freedom fighter in the early 1920s with Mustafa Kemal—later known as Atatürk—the father of modern Turkey, and Nurdan showed me faded black-and-white photographs of him as a proud young Atatürk partisan. Within a decade Atatürk moved Turkey away from age-old traditionalism and orthodox Islamic beliefs into the 20th century. In a part of the world where established religions have historically dominated human lives, he made secularism the unofficial religion. To Nurdan's generation, the very soul of modern Turkey is based on Atatürk's progressive vision. Time and again I saw middle-aged women reverentially wearing lapel pins with images of Atatürk—dead now 60 years. But to the young women in the floor-length coats or to the schoolgirl pictured wearing the traditional black shroud in the May 1994 issue of the magazine, Atatürk is passé, or worse. He foisted Western culture on Turkey, and they want to turn about and face into the Islamic past.

In Saudi Arabia Islam has always defined life, and such conflicts don't exist, at least not overtly. Saudi women have worn the veil for hundreds of years and to this day show no agitation toward change. But veils, though they may outwardly confer anonymity, do not thwart individuality. In a rare look at the "Women of Saudi Arabia," photographer Jodi Cobb brought back images of real individuals and the diversity in the lives they lead. Individuals like the Bedouin woman, most of her face masked by a veil, but her eyes laughing as she climbs into the driver's seat of the tribe's water truck. Or the Western-educated aerobics instructor wearing only leotards in the welfare center where she works. On the street, of course, she would have to be well swathed. The article's writer,

Marianne Alireza, former wife of a Saudi official, could report first-hand that under those veils "might be a high-society lady in haute couture, a high schooler…in blue jeans and T-shirt, a villager in colorful cotton, or an old-time lady in her old-time dress."

As guardians of Islam's most holy cities, Mecca and Medina, Saudis consider themselves twice blessed. Until the mid-20th century, these were the only true blessings they could justifiably claim. Photographs of the vast, sterile Arabian desert haunted the pages of past GEOGRAPHICS. Not even desert-bold Bedouins braved the brutality of the Rub al-Khali, or Empty Quarter—the largest sand desert in the world. Even in the country's less forbidding deserts, life for centuries revolved around a perpetual thirst for water. And then came oil. Alireza reported in her article that in the 1930s, when King Saud's drillers began prospecting for oil, the monarch "hoped in his heart for water." He shouldn't have despaired at oil; that black gold has allowed the Saudis to compensate for any lacks. Saudi desalinization plants, prohibitively expensive for most countries, now produce about 30 percent of the world's desalinized water. And their state-of-the-art technology can access aquifers so deep that the "fossil water" is actually from an earlier geologic age.

In the last half century, GEOGRAPHIC photographs have often captured the conflict between oil wealth and traditional Saudi values. A 1980 article began with the poignant self-doubts of the Saudi deputy minister of planning. Ethnically a Bedouin, he should have become the leader of his tribe, rather than what he called an "American-educated technocrat." "Sometimes I think that I am the greatest failure in the world…." he confessed. "Trying to find a way to spend a five-year-plan budget…that will only speed up the disappearance of the nomads. I act against all the forces that created me." The photograph beside his words showed a Saudi woman, obscured by the conventional black veil, and her small son in overalls emblazoned with the word JAWS and a shark's fin.

Despite the pressures exerted by oil wealth, much of Saudi Arabia seems itself out of another geologic age, particularly when the *hadj,* the annual pilgrimage to Mecca, is in progress. Every Muslim is urged to make this pilgrimage once in a lifetime, and the GEOGRAPHIC has never tired of covering the mass of humanity streaming toward Mecca. A 1930s writer-photographer, Owen Tweedy, joined the faithful journeying from Khartoum in the Sudan. On that long pilgrimage, he reported, "babies are born, elders died, and families may halt for a year to earn funds in distant lands." The photographs reveal camel caravans plodding across desert; boats filled with a press of variously turbaned men; white-robed Javanese Muslims staring solemnly into Tweedy's lens. As

an unbeliever, Tweedy was forced to stop, too, in Jiddah, because only Muslims are allowed to continue to Mecca. The article did feature a rare picture, by another photographer, of pilgrims at their destination: the Kaaba, Mecca's and Islam's most revered shrine.

In later decades GEOGRAPHIC readers got a look at Mecca

1954, Syria
Besides lifting water for a nearby town, a 64-foot waterwheel offers a lift for daring divers.
David S. Boyer

through the eyes of an American Muslim—writer-photographer Tom Abercrombie. After years of covering the Middle East, the boy from the Minnesota heartland converted to Islam. In a now classic picture, he captured the swirl of a quarter of a million humans circling the Kaaba. In a later article, he wrote of his own spiritual sense of that experience: "We orbited God's house in accord with the atoms, in harmony with the planets."

Harmony has often been a commodity more precious even than water in the Middle East. A well-known Arab saying actually celebrates conflict: "My brother and I against our cousin; my cousin and I against the alien." The alien, it seems, is forever being redefined in this contentious corner of the globe. Sunni Muslim against Shiite, Christian against Muslim, Arab against Jew, Iraq against Iran, and the Kurds, well, forever fighting against a world that seems bent on their destruction. Though tensions here remain high, there have been rare pockets of peace in the past. In 1959, with classic fifties optimism, Supreme Court Justice William O. Douglas set out for NATIONAL GEOGRAPHIC on a "Station Wagon Odyssey: Baghdad to Istanbul." There he is, cameras dangling from his neck, posed with a Kurdish prince. Though "Kurds and Arabs hated each other for centuries…," he reported, "times are changing. The Kurds are more and more civilized, more contented." He also mentioned, without note, that at the border between Iran and Iraq, "There was no guard…no building, no gate or barrier." And no Khomeini, no Saddam Hussein, no radical nationalism or religious zealotry. Perhaps after the wrenching wars earlier in the century, even the Middle East had grown temporarily tired of the fight.

I, too, had a brief taste of Middle East peace in 1971, when I spent a few days in Beirut. The city was still the Paris of the Middle East. The bazaars were a riotous display of exoticism—rich pastries, spices, gold; high-rise hotels backed boisterous beaches; and people reveled in a Mediterranean-style joie de vivre. Four years later, the city was being mauled by civil war, and the nightly news brought so many scenes of devastation in the fighting between Christians and Muslims that I couldn't react to them after a while. In 1983, with a fragile peace finally brokered, writer Bill Ellis and photographer Steve McCurry went back to watch the city rebuild itself. McCurry's picture of the bomb-gutted but once elegant Summerland Hotel seemed to symbolize wounds that might never heal. Ellis was guardedly hopeful: "It is good to be able to walk by the sea now and not fear death by a sniper." Fourteen years later, in 1997, the magazine returned to Beirut, and the opening shot showed beachgoers tanning themselves unafraid by the sea. But behind them yet another war-ravaged hotel still stood gaping.

Terrorism and death are a daily counterpoise to life in many parts of the region, and nowhere more than Israel. Such a small country, 8,019 square miles, smaller than the state of Vermont. Yet so much passion and history compressed into that small space. Time and again the GEOGRAPHIC has gone back to Israel. In recent years the coverages have been filled with barbwire barricades coiled like wounds on the desert, the fresh faces of boy soldiers, families grieving for relatives lost to terrorism. But the photographs also show that the land itself doesn't change; somehow it remains raw, ageless, unforgettable. Over and over writers invoke the word "biblical" in trying to capture the almost ineffable atmosphere that presses against the Israeli desert. Israeli author David Grossman is more brutal. He describes it as a country "hard and twisted, like scar tissue on a bone that was broken and badly set."

On my recent lecture tour to the Middle East, I traveled across the northern half of that enduring land, from the Mediterranean port of Haifa east across the crumpled, sun-bleached Galilean hills, dropping down to the sapphire blueness of the Sea of Galilee. On its far side the Golan Heights reared up in austere, contested emptiness. We—my driver and I—continued south, following the West Bank of the Jordan River down to the eerie, muffled silence surrounding the Dead Sea. Along the way, road signs pointed to Nazareth, Canaan, Jericho as nonchalantly as if announcing Poughkeepsie or Peoria. But the names held so much scriptural resonance that I found myself as confused as the elderly American cited in a 1909 GEOGRAPHIC article. When confronted by a young friend who was about to visit the Holy Land, the old woman declared, "Well, now, I knew those places were in the Bible, but I never thought of their being on earth."

Had she been a Society member, she *would* have thought of it, for the Holy Land had then figured prominently in the pages of the magazine. But even GEOGRAPHIC pictures can't quite convey the intensity of a firsthand experience of Israel, on so many levels—biblical, historical, political. In the sere Judean hills, the landscape seems motionless, unchanged. Here and there, nomadic tent camps and wandering camels add a touch of life to the desert, but they give no sign of knowing that the 20th century exists just beyond the bare hills of their world. For where the Judean desert ends, the suburbs of modern Jerusalem begin.

That day, we circled around Jerusalem and headed first for Palestinian-controlled Bethlehem. My driver, a Jew, was on his cellular phone, calling ahead to an Arab friend to see if all was quiet. Violence erupts so quickly here that the apparently normal street bustle can transmogrify into rock-throwing hatred in moments. But like most Israelis, the driver had learned to live with the uncertainty. "You have to keep your eyes open, yes, but it's crazy, this idea that Israel isn't safe. It's plenty safe." On that day, Bethlehem was indeed plenty safe, and we made the pilgrimage to the Church of the Nativity without incident. That favorite idiom of his, "it's crazy," he said all day until I realized that the world he had lived in was crazed—plagued by war, age-old hatreds, unpredictable vio-

lence. I thought of the June 1995 picture in the magazine of a young Israeli soldier guarding pre-schoolers on an outing in the bright Galilean sun. My driver was too right. It was all crazy.

At sunset, we were in Jerusalem, and I left him to doze in his car as I walked toward the Temple Mount and joined dozens of Jews hurrying across the long stone courtyard that fronts the Western Wall. The last remaining bit of the Temple destroyed in A.D. 70 by the Romans, the Wall is Judaism's most revered shrine, "from which the Divine Presence never moves, which was not destroyed and never will be destroyed." On one end of the wall, women, some with babies in strollers, prayed. On the other side were the men, small groups of them clustered together, praying in low Hebraic chants. Hovering behind them at a distance, the golden sheaf of the Dome of the Rock mosque caught the last rays of sun. Muhammad, it is said, ascended into heaven here from the same rock upon which Abraham almost sacrificed his son, Isaac. Suddenly, the high singsong Muslim call to prayer arced out from the mosque's minaret, trailing above the Jewish worshipers at the Wall.

In the words of a former official of Jerusalem, the Temple Mount, a plot of land some 30 acres across and fraught with the collective tensions of 2,000 years, is "a time bomb…of apocalyptic dimensions." Yet, like Jerusalem itself, it continues to survive, perhaps too timeless to be destroyed by the bombs of any age.

Timelessness is a forgiving shroud spread across the problems of the Middle East and North Africa. In 1941 a magazine article on Egypt declared with unapologetic hyperbole that "the Egyptian of 1941 is to all intents and purposes the same man as the Egyptian of 1941 B.C." Obviously, no GEOGRAPHIC writer would say that now. Still, the photographs seem to substantiate that agelessness: ancient statuary baking in the desert heat, waterwheels creaking in the Nile, Moroccan oases little changed by centuries. As a Moroccan architect said in a 1996 article, "Here time isn't money yet."

In fact, time, on some level, seems beside the point. How, for example, to understand the Egyptian tombs, temples, and pyramids in temporal terms. Again and again their images, blurred by wind-whipped sands, have captivated readers. The photographs in the magazine confirm the monumentality and drama of the architects, but its age—measured in millennia, not centuries—is simply too monumental to grasp. Whether or not their builders, the ancient pharaohs and queens, attained immortality in the afterlife, as they so ardently hoped, they surely attained it in their buildings. Even the march of 20th-century progress pauses when confronted with their works. In the 1960s, when the new Aswan High Dam threatened to inundate the great complex of

Rameses II at Abu Simbel, the world watched—and the GEOGRAPHIC photographed—as the 3,300-year-old structures were cut into pieces and reassembled on higher ground.

Though Rameses has now entered the realm of the timeless, in his own time war plagued him, and he indulged in the kind of vaingloriousness still favored by some of the region's modern leaders. Having won a decisive victory over the Hittites, he had accounts of his bravery incised on temple walls across Egypt. He would surely be gratified to know that even today his square-

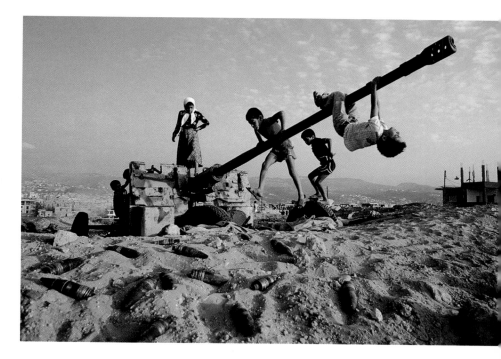

1983, Beirut, Lebanon
War in recess, children clamber over an abandoned antiaircraft gun; some of the discarded shells were live.
Steve McCurry

following pages:
1992, Panjwin, Iraq
Bitter cold and snow deepen the misery of a Kurdish family camped in the ruins of Panjwin—laid waste by Iraqi troops—as they flee their own war-torn home.
Ed Kashi

shouldered, ever-victorious likeness appears over and over in the pages of the GEOGRAPHIC.

Grandiose rulers, cults of personality, and political conflict, it seems, have a long legacy in the Middle East. As do the religious conflicts that perpetually threaten to ignite a consuming conflagration. An Israeli Arab, quoted in a 1995 article, put the problem simply, "Because God is mostly silent, some think they can do anything they want in his name."

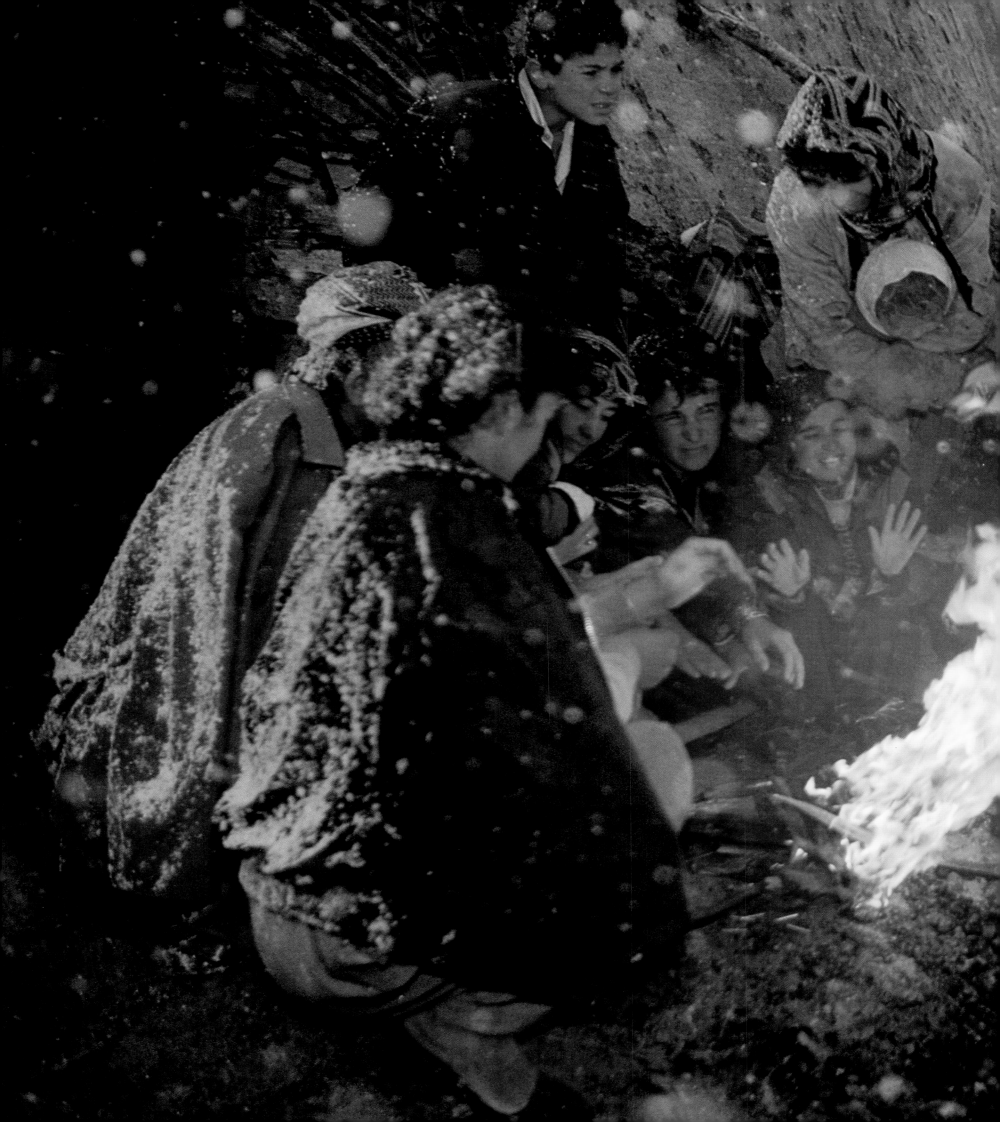

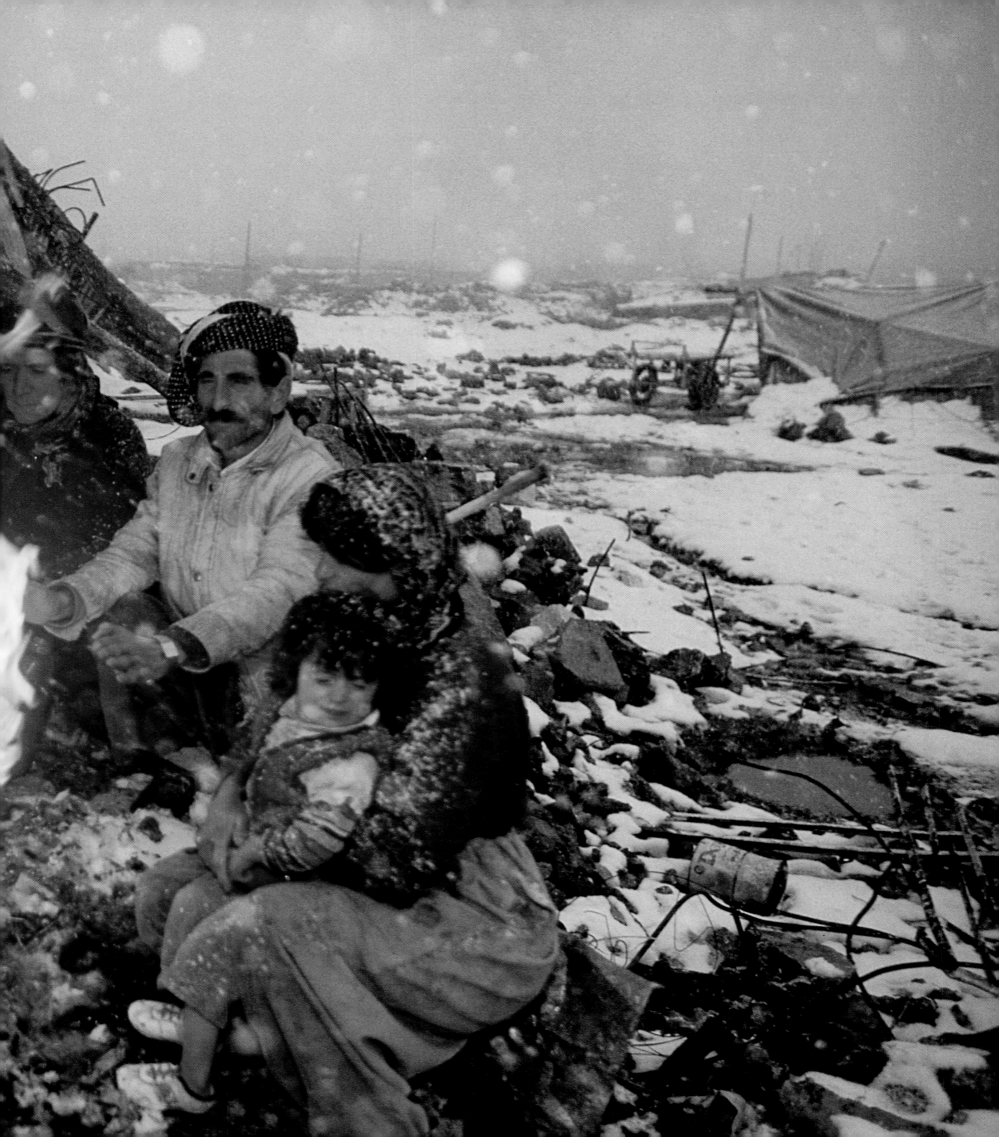

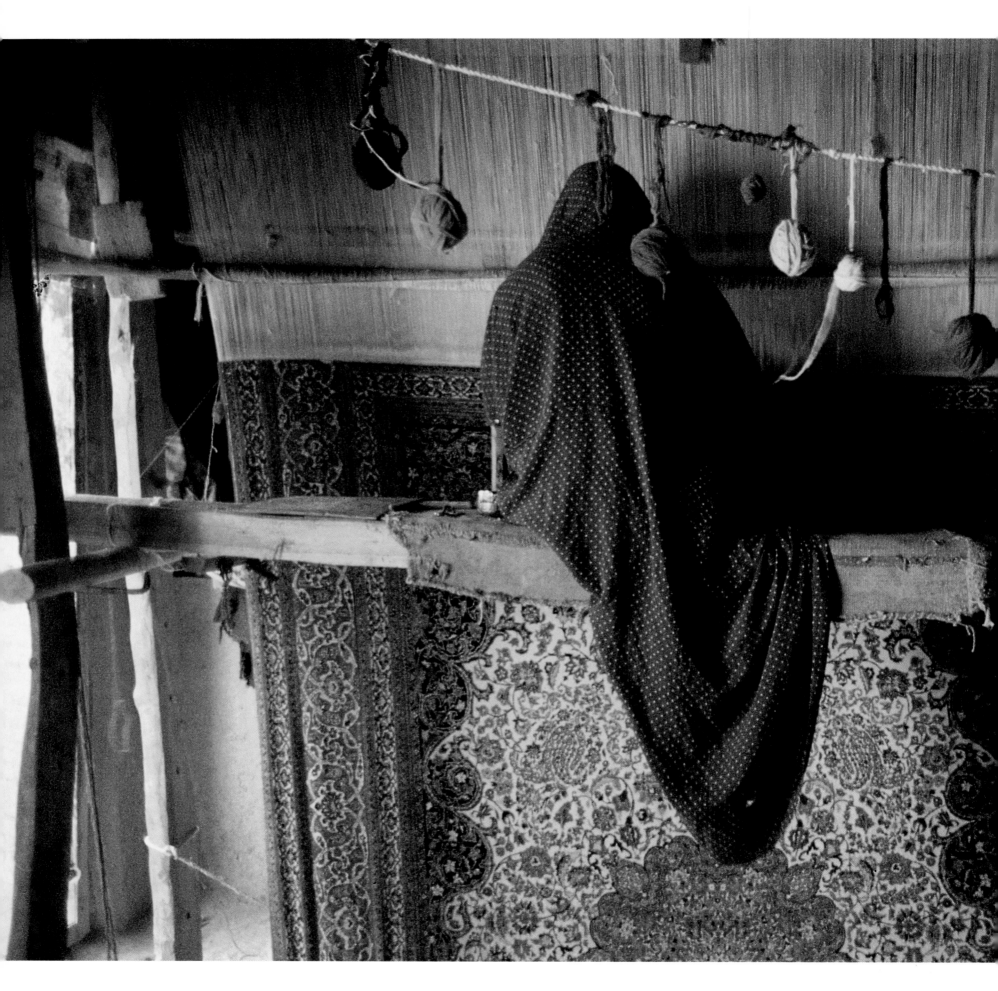

1985, Esfahan, Iran

Shoppers browse through dresses to wear under their chadors, or in the privacy of their homes. Being caught chador-less on the street is serious business. Punishments for first offenders have ranged from arrest and lecture to mandatory religious classes; repeaters have been whipped or jailed. The bold have expressed dissent in public by wearing a bright scarf or displaying a lock of hair.

Michael Coyne

left:

1961, Na'in, Iran

Graceful as a bird on a branch, a girl balances on a ten-foot scaffold to weave an intricately patterned Persian rug that can take months or even years to complete. Her agile fingers, which may tie 3,000 knots of the wool or silk a day, are concealed by the folds of her chador. "Most girls pulled the concealing chador over their heads as soon as they saw my camera," noted the photographer.

Thomas J. Abercrombie

1938, Deir-ez-Zor, Syria
Stubborness incarnate, a mule balks at an automobile sharing a narrow bridge across the Euphrates—the only one in this part of Syria. In the next minute the animal turned and sat on the car's running board. "Even the muleteer laughed," wrote the author.
W. Robert Moore

Past windowless beehive villages, we rode to Aleppo. Old almost as time itself is this route. At one spot the modern metaled road cuts across and for a short distance runs parallel to a Roman highway whose stone blocks are almost perfectly in place. That, in turn, was laid over a still earlier pavement, with deep ruts which may have been worn by the wheels of the Hittites. Wander through Aleppo's miles of tunnels or arched *souks,* lighted only by shafts of sunshine that stab through small holes in the roofs, and you turn time back to the Middle Ages. Your only traffic problem is how to flatten yourself against a wall to avoid a string of camels with bulging saddlebags.

August 1941, NATIONAL GEOGRAPHIC
from "Bombs Over Bible Lands"
by Frederick Simpich and W. Robert Moore

It costs 65 pounds, less than $1.60, to take the bus from Aleppo to the city of Hamah. The buses used to be old and dusty, and having to buy a seat a day in advance was an ordeal. I recall over-hearing, in 1989, a Syrian in line at a bus station window mutter to his wife, "It would be easier to walk!" But now there are dozens of private bus companies operating out of Aleppo, and the smooth ride is enhanced by free chocolates, cups of water, and an Egyptian video shown on a television bolted to the front of the bus cabin. As the rows of poplars rushed by outside the window, we watched *Al-Munsi, the Forgotten,* featuring the comedian Adel Imam and the music of the American rap duo Kriss Kross.

July 1996, NATIONAL GEOGRAPHIC
from "Syria Behind the Mask"
by Paul Theroux

1995, Damascus, Syria
Gaze of President Hafez al-Assad studies a bustling roundabout. His likeness appeared on buildings throughout Syria after he seized power in 1970. "On the surface, little [here] has changed...since I first visited in 1979," writes author Paul Theroux. "Traffic still clogs... streets, though I notice a few more Mercedes-Benzes."

Ed Kashi

following pages:
1993, Syria
Drilling for water replaces roaming in search of it for Bedouins east of Aleppo in the arid northern steppe.

Ed Kashi

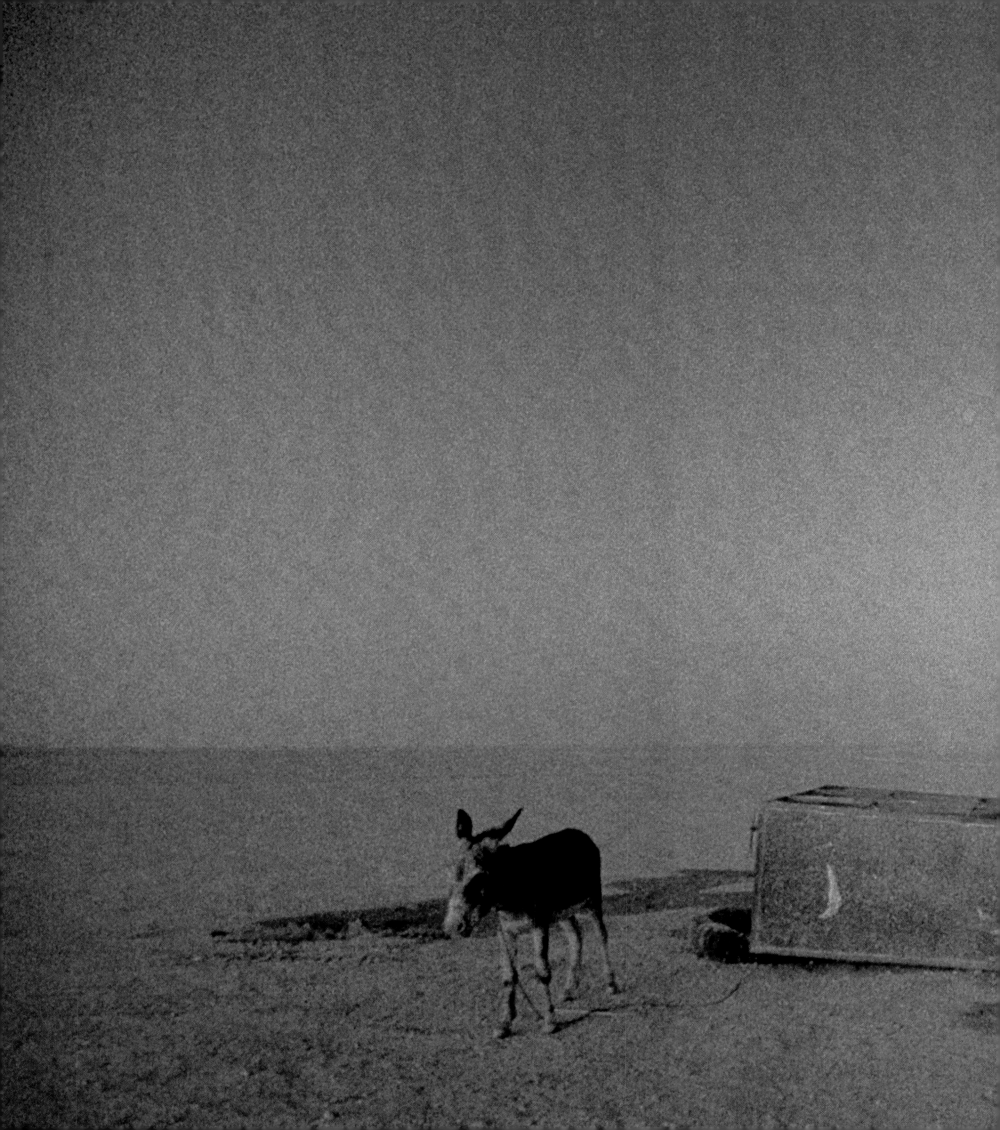

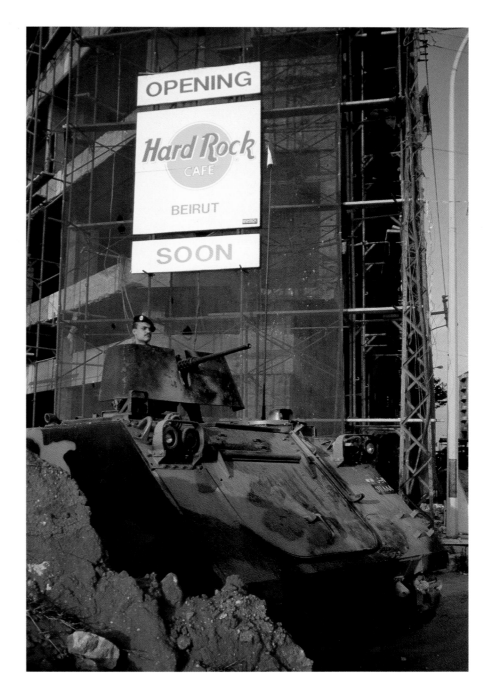

1996, Beirut, Lebanon
Betting on Beirut's future, the trendy Hard Rock Cafe stakes its claim on a battle-scarred building next to an army checkpoint.

Ed Kashi

left:

1950, Beirut, Lebanon
Enterprising young Beirutis run a car-polishing business on one of the bustling, palm-lined avenues legendary for their cafés, nightclubs, and markets. Before war erupted in 1975, Beirut's reputation rested on its Mediterranean vitality and the allure of its boutiques. "No businessman ever visited Beirut without his wife's shopping list," wrote an Arab poet.

Maynard Owen Williams

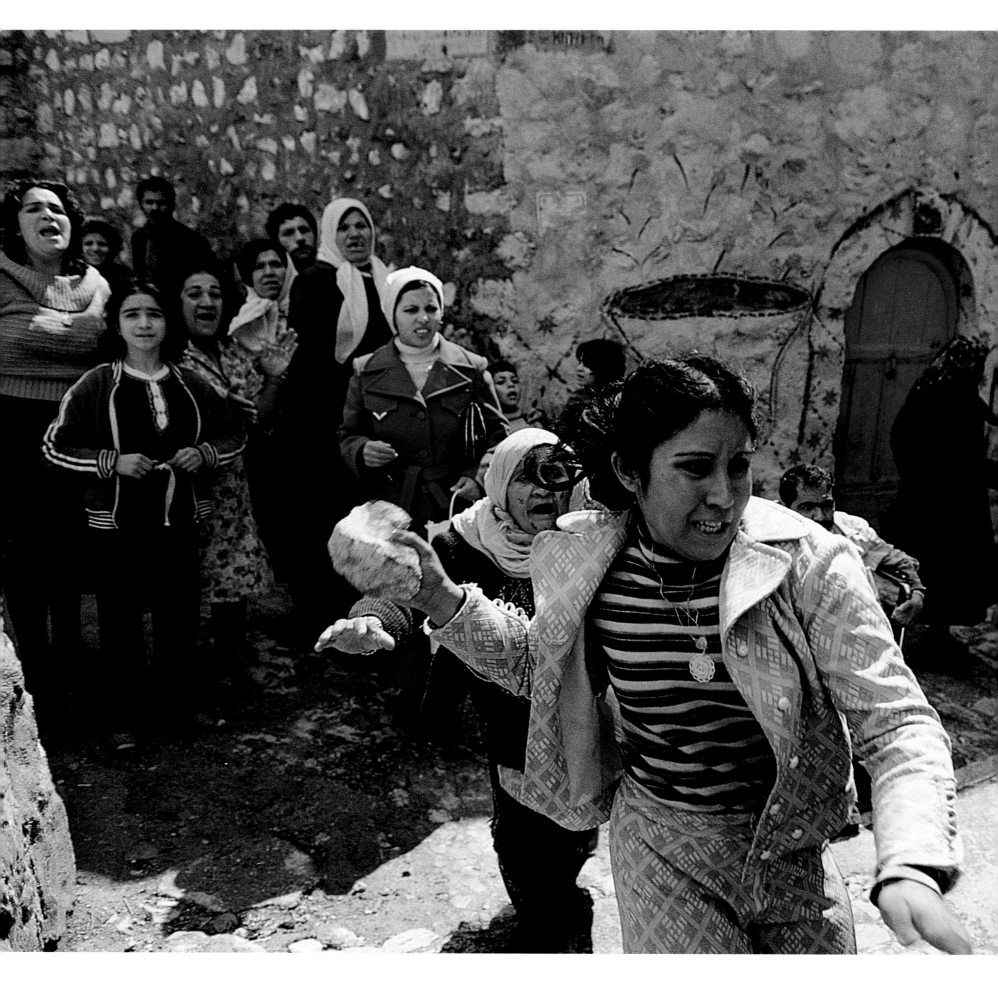

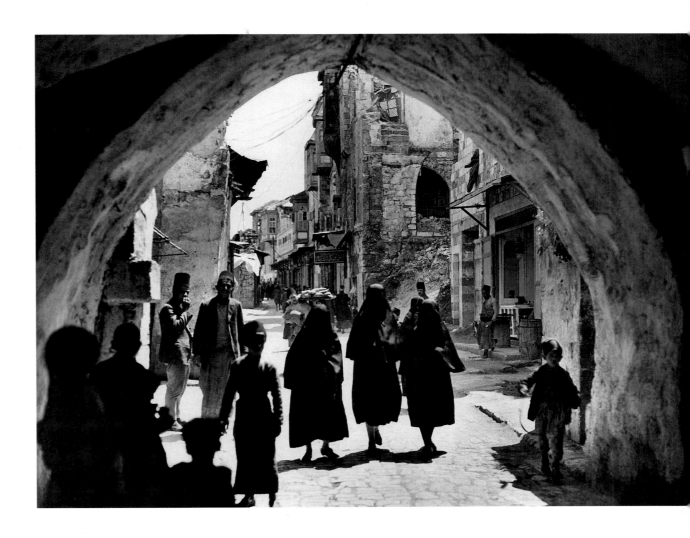

1938, Nablus, Palestine

After an outbreak of feuds between Arabs and Jews, residents of Nablus walk in temporary peace through tunnels connecting the marketplace of this 4,000-year-old town to the Samaritan Quarter, home to descendants of the biblical Samaritans. Sites of the Bible abound in this city once called Shechem. Here under an oak Jacob hid the idols his family had brought from Haran, and here Joseph came hunting his brothers.

Maynard Owen Williams

left:

1983, East Jerusalem

Enraged by the arrest of a fellow Palestinian during a shopkeepers' strike, a woman hurls a stone at Israeli police. Tensions between Israelis and Palestinians boiled over a few weeks later when an Israeli soldier opened fire in the Dome of the Rock, killing two Muslims and wounding many more.

Jodi Cobb

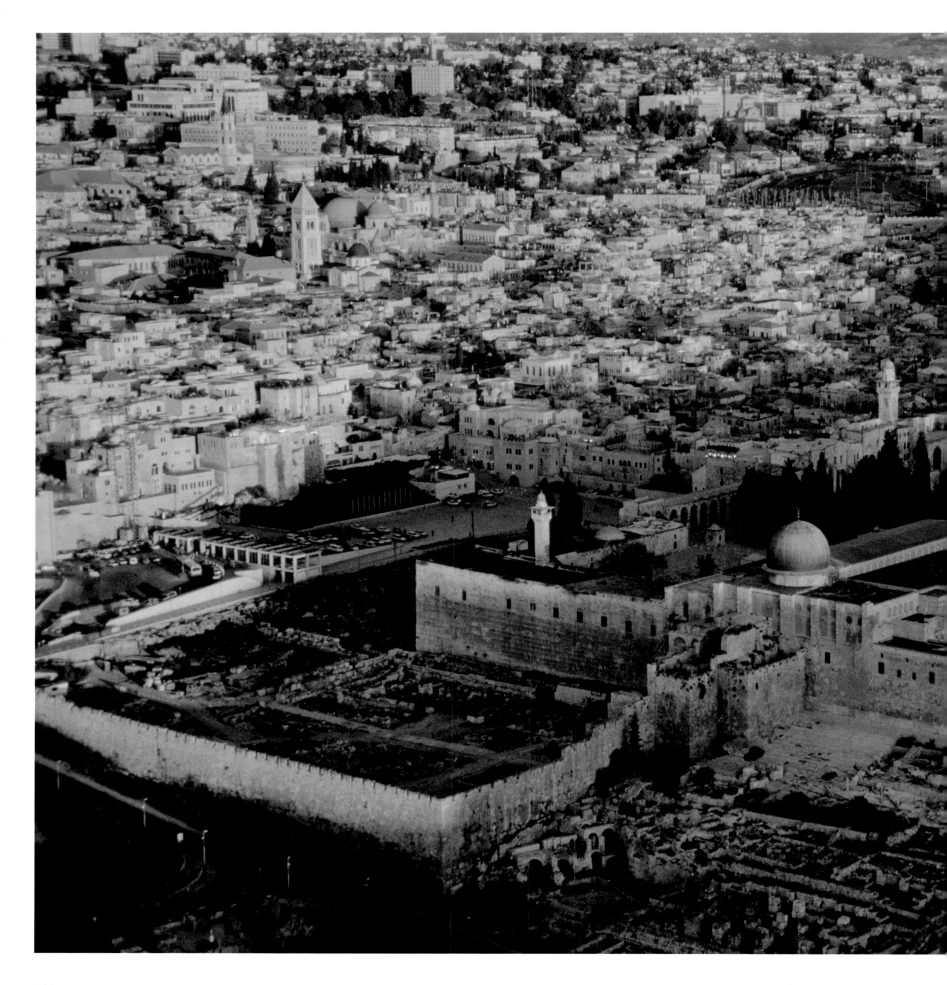

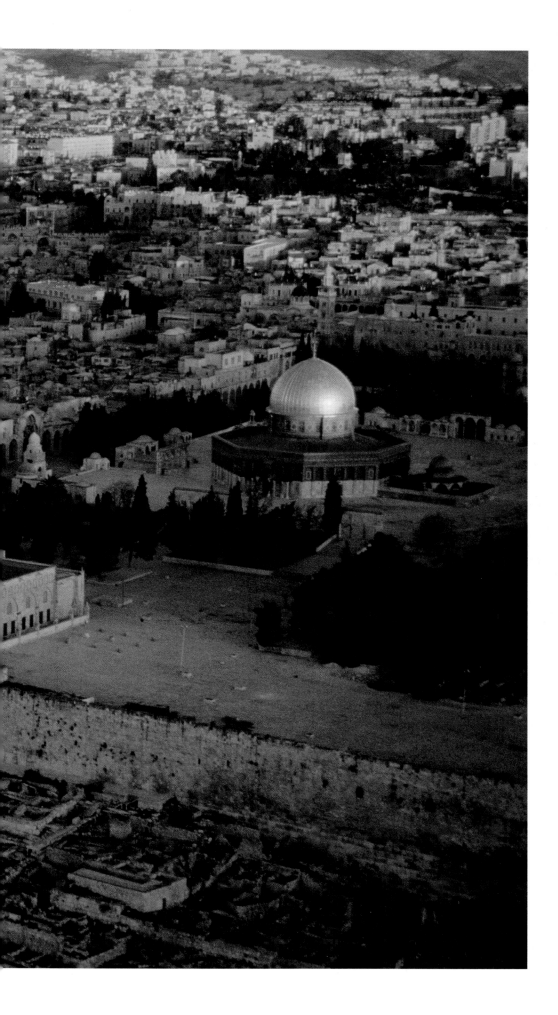

1996, Jerusalem
Required to wear his weapon at all times, an
off-duty Israeli soldier shares telephone time
with other Jews in conservative attire.

Annie Griffiths Belt

left:

1996, Jerusalem
Serene in the golden light of dawn, the walled
Old City—sacred focus of Christianity,
Judaism, and Islam—simmers with age-old
religious rivalries.

Annie Griffiths Belt

193

1966, Saudi Arabia

Heavily veiled in tradition, a Bedouin sheikh's wife peers from behind the hand-woven drapery that partitions the harem, where daily housekeeping includes preparing food over a brushwood fire. She may be one of as many as four wives, the maximum allowed one man—on the condition that he treat them equally.

Thomas J. Abercrombie

right:

1986, Wadi Nissah, Saudi Arabia

In a luxurious tent complete with battery-operated television, Bedouin women check their veils. Veiling became fashionable during the time of the Prophet Muhammad, perhaps in imitation of his many wives, who covered themselves in public at his request.

Jodi Cobb

following pages:

1991, Kuwait

Legacy of the Gulf War, plumes of smoke from oil fires set by retreating Iraqi troops streak the wings of a research aircraft. It flies above the infernos to assess their chemical makeup and effect on the environment.

Sisse Brimberg

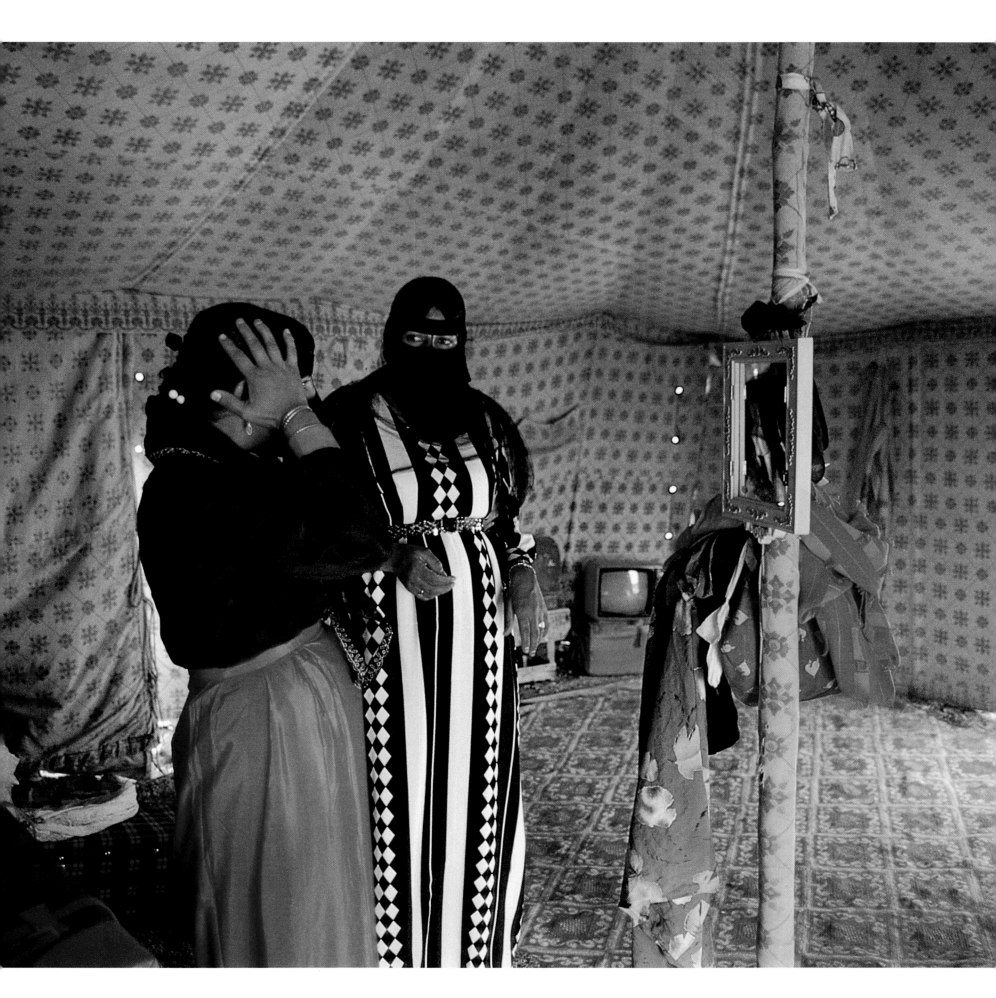

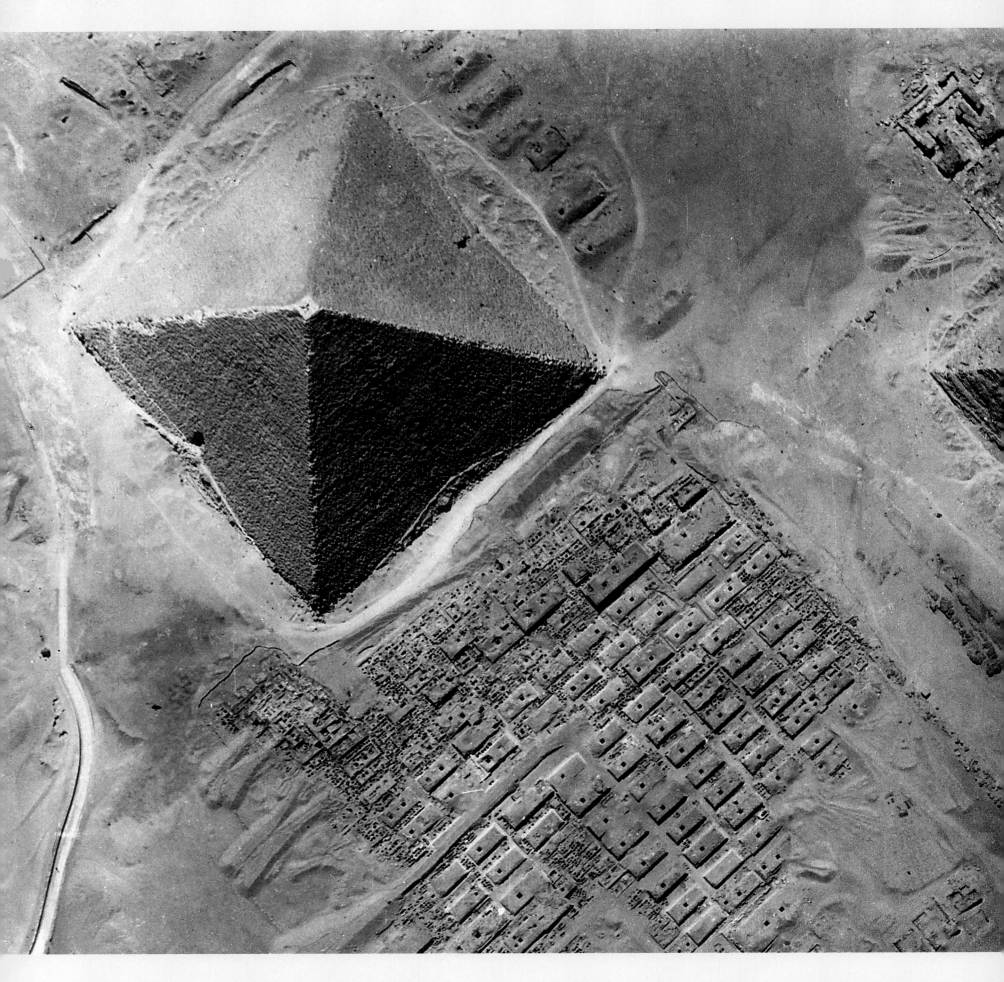

Egypt

Writer-photographer Tom Abercrombie mused in a 1977 story that "Egypt seems always to have been…overshadowed by the power of her past." Indeed, in the GEOGRAPHIC's early decades, there were two articles on the wonders of ancient Egypt for every one devoted to the modern land. And in the 1923 picture essay "Egypt, Past and Present," only 3 of its 16 photographs featured the present, including a shot of five donkey drivers, said to "reap a harvest from tourists who visit Tutankhamen's tomb." Contemporary Egypt appeared increasingly from the mid-1920s on, as contributors reported their adventures on the River Nile and through the Holy Land. Not until 1993, however, did Cairo, the "Clamorous Heart of Egypt" earn an article of its own.

above:

1993, Cairo, Egypt

Gallery at Giza: arches of a businessman's posh villa frame the eternal pyramids.

Reza

left:

1925, Cairo, Egypt

Bird's-eye view of the wind-scoured Giza plateau accents the perfect symmetry of the great pyramids of Khufu and Khafre. Rectangular tombs of nobles, commanders, and engineers lie between the royal monuments.

J. Blackburne

Traveling in the Western Desert, I often feel I am on another planet. It is so desolate that I have driven more than 300 kilometers between signs of life. After joining me for such a drive, an American colleague exclaimed: "This is a real desert! Now I know why some people call the U.S. Southwest a jungle." South of Qattara begins the domain of sand. Beyond the depression more than 20 belts of dunes flow southward toward Sudan on a course that roughly parallels the Nile. However, this mighty river has nothing to do with dune orientations. In this sea of sand the wind controls all. I have often sat nearly mesmerized, watching the wind move sand southward across the desert. As the wind gusts, it hurls the finest sand particles upward. The heaviest, largest particles remain earthbound, forming a protective armor of large grains across the surface. It is the mid-size particles that become agents of the wind, bouncing across the surface, accumulating into dunes.

February 1982, NATIONAL GEOGRAPHIC
from "Egypt's Desert of Promise"
by Farouk El-Baz

1982, Western Desert, Egypt

Shade cast by a boulder of chalk—remnant of an ancient seafloor—shelters a geologist breaking from his study of the desert's features. The morning sun is relentless in this driest part of the Sahara.

Georg Gerster

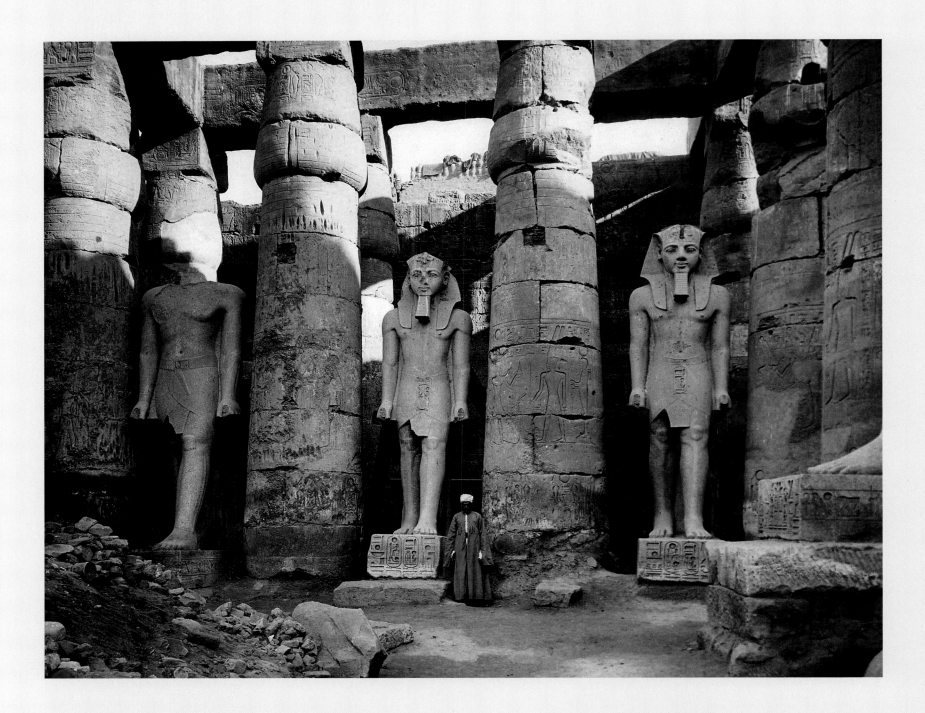

1923, Luxor, Egypt
Gigantic portrait statues proclaim the might and godliness of Ramses II, who, stated one article, "has been facetiously called the 'father of mural advertising.'" He left behind more monuments to himself than any other pharaoh during his nearly 70-year reign.

Elmendorf

It is only within the…present generation that…we have begun to pass from the stage of mere wonder to…coordination of the facts disclosed by excavation. The science of Egyptology…is…reconstructing for us the ordered history of the 3,000 years before Christ, and enabling us to see the types of men, the manner of life, the forms of government, the religious customs and beliefs…from the very dawn of Egyptian nationality.

September 1913, NATIONAL GEOGRAPHIC
from "The Resurrection of Ancient Egypt"
by James Baikie

On my last day in Egypt I finally receive permission from the Egyptian Antiquities Organization to see Ramses' mummy. At the Egyptian Museum in Cairo…I behold the face. Browned and chisel sharp. Arms crossed regally across his chest. A long neck, a proud aquiline nose, and wisps of reddish hair…. Ramses' mummification and burial rites likely took the traditional 70 days. Embalmers [placed] the liver, lungs, stomach, and intestines in sacred jars. His heart was sealed in his body. Egyptians believed that it was a source of intellect as well as feeling and would be required for the final judgment. Only if a heart was as light as the feather of truth would the god Osiris receive its owner into the afterlife.

April 1991, NATIONAL GEOGRAPHIC
from "Ramses the Great"
by Rick Gore

1991, Cairo, Egypt
Ribbons of traffic bind a towering Ramses in the present.
This one of the king's colossi was transplanted from
Memphis to the capital in 1955. Its body, carved of hard
granite from Aswan, takes a beating in Cairo's dense
air pollution.
O. Louis Mazzatenta

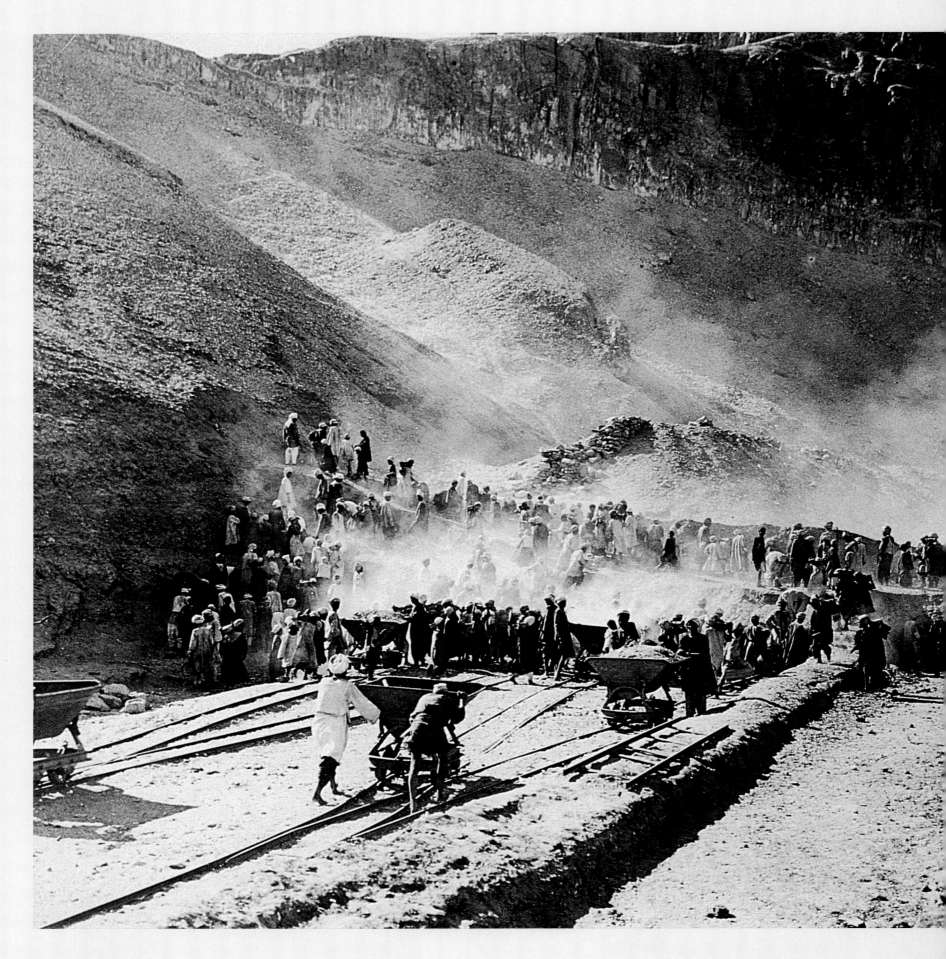

1997, Egypt
Stacked 12 or more to a board, newly minted bricks travel from kiln to truck via the heads of women workers at a factory near Zifta.
Reza

left:

1923, Deir el Bahri, Egypt
Debris goes hand to hand down the line as laborers excavate limestone cliffs to reveal the terraced temple of Queen Hatshepsut, built about 1500 B.C. Not far from this site in ancient Thebes rose the temple of Mentuhotep II and other splendors of the legendary city.
Wide World Photos

1940, Egypt
Village child rides aloft in the traditional method used for carrying
food and water jars.
B. Anthony Stewart

right:

1995, Saqqara, Egypt
In a whirl of color, women whisk through a marketplace. Balanced
on their heads are trays of dates to sell in Cairo.
Kenneth Garrett

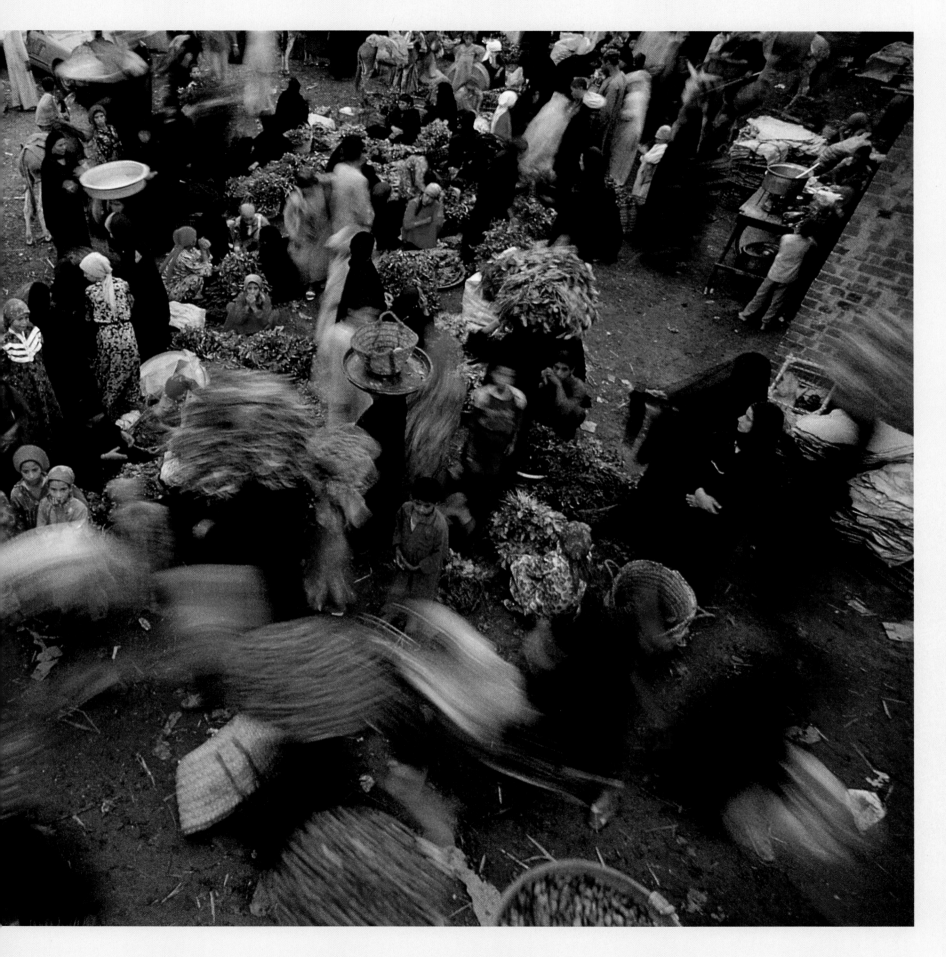

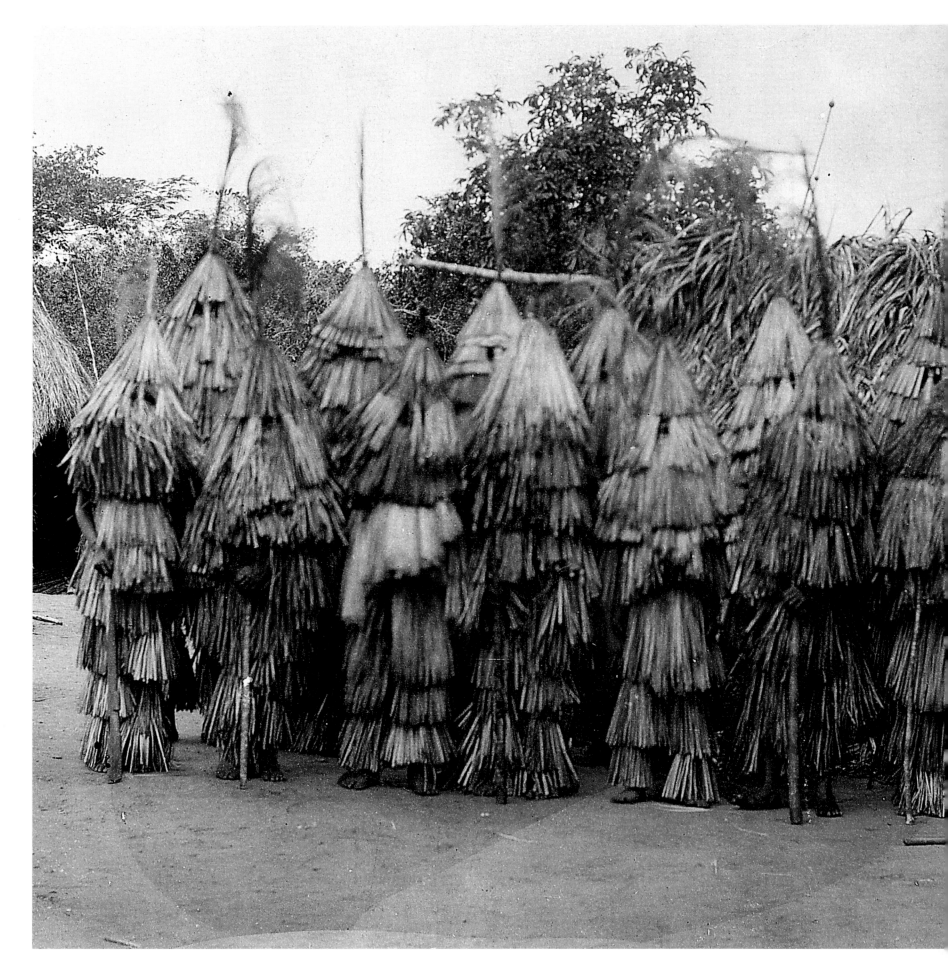

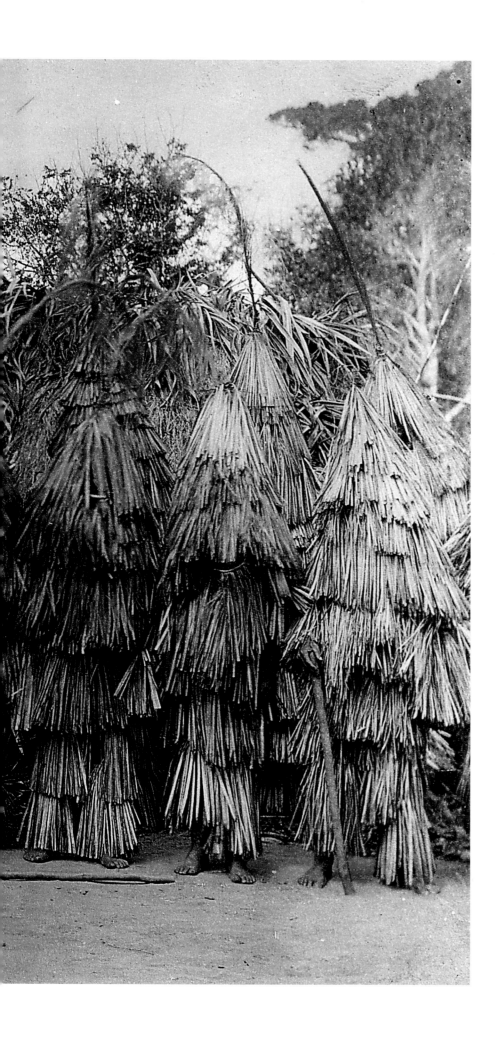

AFRICA

By Robert Caputo

1910, Mozambique

Shields from feminine eyes, rustling layers of grass and
palm lend anonymity to recently circumcised M'chopi
boys. During their coming-of-age ritual, a woman's glance
is thought to bring misfortune.

O.W. Barrett

following pages:

1982, Ivory Coast

Brightly-patterned costumes — indicating tribal ties —
unite a chapter of a nationwide women's association.
More than 60 distinctive tribes inhabit this West African
country, which gained independence from France in 1960.

Michael and Aubine Kirtley

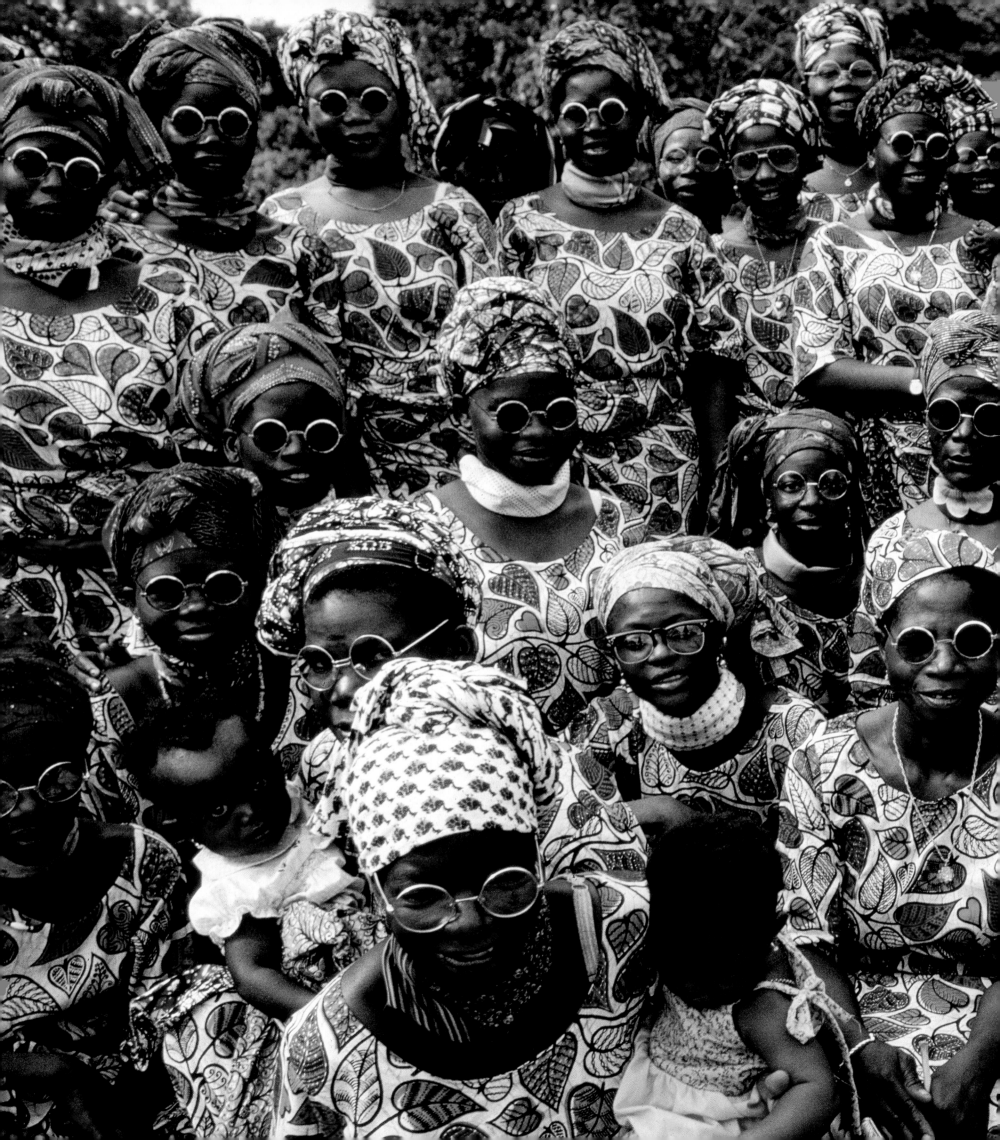

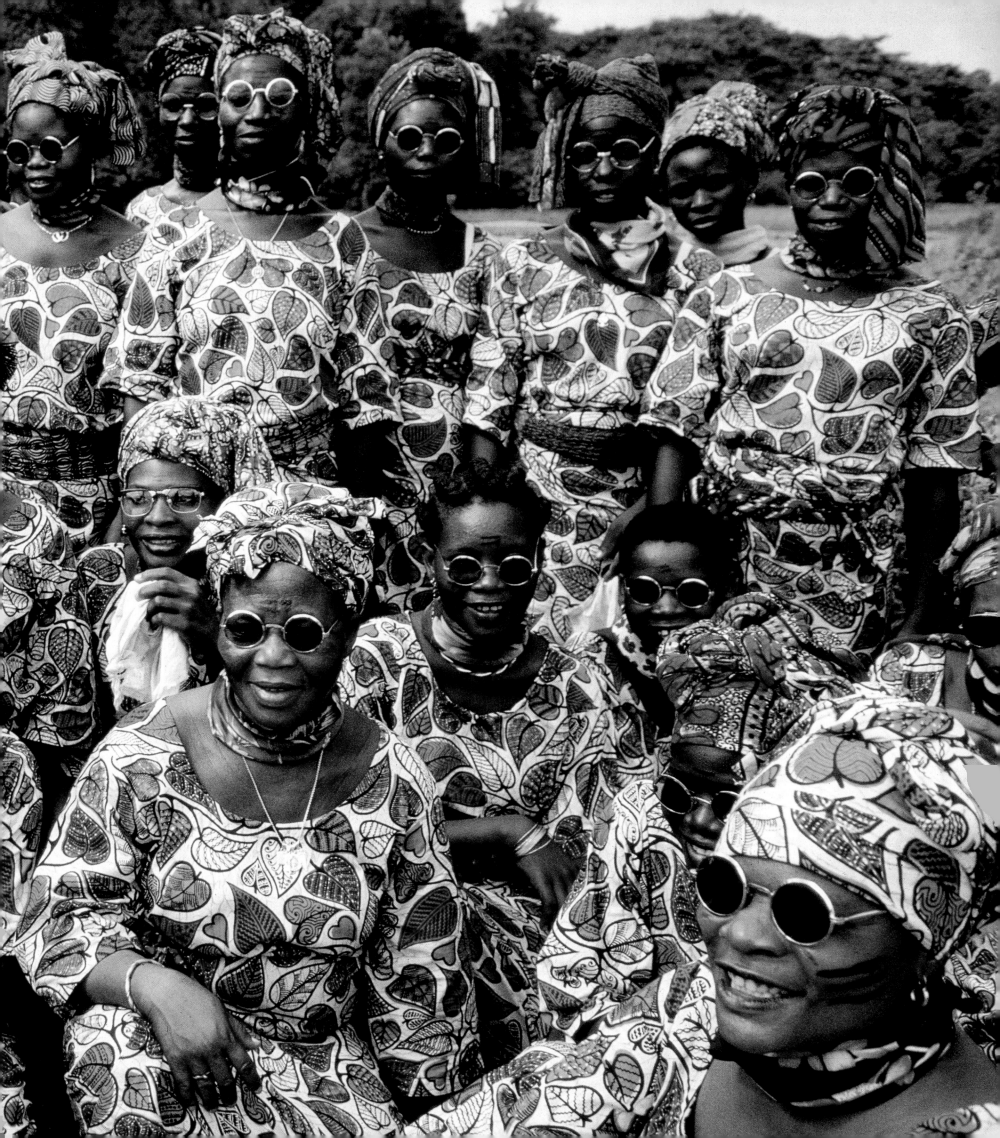

Exhausted, I climbed into the little tent atop my four-wheel-drive car. I was very fond of my roof-tent: I usually camped in the bush, and found it a great comfort to be beyond the reach of the myriad creatures that slithered, crept, and crawled through the African nights. Often I'd been awakened by the snuffling and scratching of critters milling about the car, trying to determine with noses, paws, and teeth whether it might be edible. They could smell me, but were confused by the unfamiliar odors of gasoline and oil which tainted the scent of dinner. I lay happily and safely above them, worried only by elephants, to whom I was about eye-high, and who sometimes investigated the tent with their trunks.

On this particular night, though, I wasn't worried about animals. I was camped in a village in a cluster of hills near the border between northern and southern Sudan, the territory of the Nuba people. I had arrived in the Nuba Mountains at harvest time—quite by chance—and had spent the day watching and photographing the festivities. About 2,000 people gathered in a clearing near the village to dance, sing, and drink large quantities of *marissa* (sorghum beer). The main event: to watch wrestlers from different communities vie with each other and impress the girls. The wrestlers had smeared their bodies with light gray ash and wore Day-Glo shorts, striped knee socks from which the feet had been cut, anklets and bracelets of bells, and necklaces of animal and bird claws. They strutted about the open circle formed by the crowd, emboldened by songs of their prowess sung by the girls. The girls wore beads—bead belts, necklaces, headbands, short flaps that shielded their loins, and bandoliers across their bare chests. Patterns of small beadlike scars embellished their torsos and foreheads. Hoops and plugs of gold pierced their ears, noses, and lower lips. Their oiled bodies glistened in the sunlight as they danced and sang for their champions.

A dozen or more wrestling matches went on simultaneously. Circles formed around two combatants, dissolved, and reformed for another bout. I was in a sea of whirlpools, pulled from one match to the next by the swirling crowd, driven back by leather paddles, and sucked forward into the wake of victory parades.

The wrestling ended at dusk, and everyone retreated to the village for more drinking and dancing—a long snake that folded back in on itself and was lost in the dust raised by pounding feet. Around midnight, the drummers and dancers tired and dispersed for the night. Or so I thought.

Deep in slumber, I slowly became aware of thunderously loud drums. The earth under the car shook. Dazed, I peered out through the mosquito netting. A three-quarter moon in a clear sky shone on about 300 Nubas dancing in a circle around the car. The white-painted wrestlers and oiled girls shimmered as the drums drove them around and around, feet stomping, bells jangling, voices soaring.

Farouk, a young lad who had been taking care of me during my visit, was standing just below the tent. "Come," he said. "Come, they want you to dance."

That scene took place in 1981, during my first assignment for NATIONAL GEOGRAPHIC. Like many other Americans, I had grown up with the yellow-bordered magazine, and my images of and conceptions about faraway places like Africa were shaped by its photographs and stories. What amazed me, when I was able to visit some of those places myself, was how closely what I experienced fit with what I had seen and read: the scene above (with only the minor exception of the shorts and socks worn by the wrestlers) could easily have been part of a 1951 story about the Nuba Mountains, or even one that appeared in 1924. And there are many others: A picture in a 1934 article, "Three-Wheeling Through Africa," shows the author riding his motorcycle on railroad tracks in western Sudan because there was no road and the sand was too soft to support the vehicle. There is still no road, and when I made the same journey in the 1980s, I rode those same rails in my car. Ferries across rivers are often still planks across a couple of dugout canoes that come awfully close to swamping under the weight of a car, and I have often, like earlier NATIONAL GEOGRAPHIC travelers, had to hack away at fallen trees to clear a track no other vehicle has passed in months.

In going through old issues of the magazine for this essay, I was struck again and again by how familiar the scenes in many of the pictures are: A photograph in 1926 shows fishermen with their traps at the falls above Stanleyville on the Congo river (a scene Stanley himself described in 1877, when the town was known as the Inner Station). A photograph I made at the same place, which appeared on the cover of the November 1991 issue, shows exactly the same scene, though the town is now called Kisangani. Many pictures of the people, their villages, and their land that have appeared during the magazine's 110-year history could be run today with no lack of veracity. Even in Kenya, one of Africa's most "developed" countries, pictures of Masai people taken now would differ very little from those published in the teens and twenties. It is astonishing to realize how little some things have changed.

But not, of course, everything. Nairobi, which President Theodore Roosevelt described in a 1911 article as "a town of per-

haps 5,000 or 6,000 people," is now a bustling city of more than 1.5 million. Countless other cities have grown in the same way, as have the networks of roads, schools, clinics, and other parts of modern infrastructure begun by European colonialists and extended by independent nations since the 1960s. Africa today has its factories and skyscrapers, sprawling suburbs, traffic jams, and briefcase-toting businesspeople rushing along crowded streets. Most of the peoples who appear in the early editions of the magazine have long since abandoned their traditional ways and moved onto at least the fringes of the modern world. But not all. One of Africa's unique features is that the old and the new coexist in such proximity: Masai warriors in full regalia walk the busy streets of Nairobi, and leopards snatch dogs from verandas in the suburbs.

I was struck too by how recent Western knowledge of the continent is, and the fact that NATIONAL GEOGRAPHIC has existed for so much of that time and disseminated so much of that information. The magazine was first published in 1888, only 30 years after the discovery of the source of the Nile in central Africa, an era dominated by the names of great explorers like Livingstone, Stanley, Burton, and Speke. In fact, the first story about Africa, in 1889, was published while Stanley was on his great trek to rescue Emin Pacha and, the author notes, "We have not heard from Stanley for a year and a half." Though the European powers had begun to colonize Africa with trading stations and missions, they were mostly confined to the coastal areas. Much of the interior of Africa remained a blank on the maps. Largely unknown, and with evils like the slave trade still active, Africa, the same author wrote, "remains today the dark continent."

Perhaps what has changed most over the last 110 years is our own perception and reporting of Africa. The early stories were either general ones lamenting our lack of knowledge of the continent, like "Geographic Progress of Civilization" (1894), or reports of adventurous expeditions: "Recent Explorations in Equatorial Africa" (1897), "Across Widest Africa" (1908), "Trans-Africa Safari: A Motor Caravan Rolls Across Sahara and Jungle Through Realms of Dusky Potentates and the Land of Big-Lipped Women" (1938). Even Stanley himself wrote a story that appeared in 1902.

These great adventure-travel stories have always been a mainstay of NATIONAL GEOGRAPHIC, and remain so today; my own articles about the Nile and Zaire Rivers (1985 and 1991) fall easily into this category. But, as might be noted from one of the titles above, not only our methods of travel have evolved.

The language used in some of the early stories, and the attitudes it expressed, were like those in other publications of the day.

Descriptions of African peoples were usually patronizing at best, and often just plain racist. It is shocking to realize how long such attitudes were held and freely expressed.

While such statements and attitudes are today banished from the printed page, they are a reminder that the authors were products of their time: Western civilization was on the march. Nature was there to be conquered, Africa to be "civilized." Caught up in the fever of adventure and exploration, the early stories were mostly about the physical characteristics of the land and the difficulties

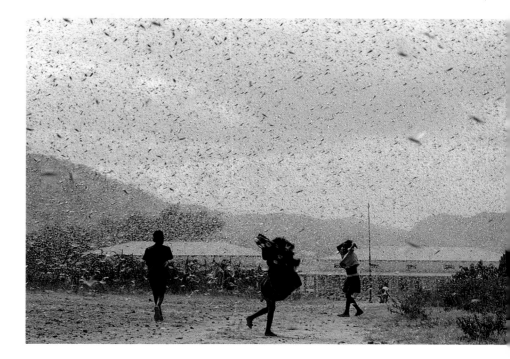

1969, Keren, Ethiopia
Blizzard of locusts wreaks destruction on crops and lives.
Gianni Tortoli

of travel: crossing deserts, swamps, forests, and mountains. We see pictures of the cars and motorcycles—even the sedan chairs in which the authors, usually in pith helmet and khaki shorts, were carried by Africans. Not that these travels were easy or unimportant, or that the stories were not worth telling. These men (few of the authors were women) faced conditions and obstacles almost unimaginable today, and their photographs and articles conveyed information unavailable to most people anywhere else. But like the weird baobab trees, African people were usually just another picturesque element of the exotic landscape through which the intrepid photographers and writers adventured.

The animals too. It seems odd now, when NATIONAL GEOGRAPHIC is so widely known for its studies of animal behavior and

beautiful wildlife photography, to look at the early pictures of African wildlife. They're all dead: Elephants, rhinos, zebras, the lot—and often with the gun-toting author standing over the carcass. This was the age when the collections of the great museums of Europe and America were being put together, like that for the American Museum of Natural History by Carl Akeley, described in his "Elephant Hunting in Equatorial Africa with Rifle and Camera" (1912). Roosevelt's "Wild Man and Wild Beast in Africa," (1911), says, "We brought back, I think, all told some 14,000 specimens of mammals, birds, reptiles, fish, etc." Only much later did the magazine become known more for intimate behavioral stories like those by Jane Goodall and Dian Fossey, and articles concerned with the threats to wildlife, such as "Wild Cargo: the Business of Smuggling Animals" (1981).

Like the culture of which it is a part, NATIONAL GEOGRAPHIC evolved with the times. Story titles like 1941's "Dusky Tribesmen of French West Africa" gave way to "Africa: The Winds of Freedom Stir a Continent" (1960). As independence was achieved in the 1960s, Africa, once dealt with pretty much as a single mass, began to be covered in greater detail: Some stories profiled the emerging countries, others documented African art, both ancient and modern, and the discoveries of early man by Louis Leakey and others that were changing our ideas of our own past. The environmental issues that have become so important to our time were reflected in stories about the spreading Sahara and the fate of the rain forests and wildlife. Coverage of South Africa moved from an uncritical "Natal: The Garden Colony" (1909), to a sympathetic description of life under apartheid in "Pioneers in Their Own Land" (1986).

Most important, perhaps, was that during this evolution the voices of the African peoples themselves slowly emerged. The photographs, even from the earliest stories, are not much different from ones that might be taken today—let's not forget that Africa *was* very exotic, and that parts of it remain so, to us, today. Those early portraits, scenes of daily life, festivals, villages, and scenics convey a feeling of the continent and often of the humanity of the people that still ring true. They were straightforward documents of what the expeditioners met along their way. Only the captions, at times, betray the era in which they were made. The texts of the stories, however, reveal not only our growing knowledge of the continent, but also our increasing ability to let the African people speak for themselves.

The first stories (without photographs) were generally descriptions written by geographers or officers of the National Geographic Society, who had not actually been to Africa but who compiled information from various sources. The succeeding adventure and hunting stories rarely quoted Africans, though the authors often visited and described many villages, where they were invariably hosted by the local chief. Language was, of course a problem—it still is. I have traveled in areas where every day I was encountering a different language, spoken only by that one, often quite small, tribe. Though there is usually someone who speaks English, French, or some other mutually intelligible language, this is not always the case. I've often been hosted, sometimes for days, by people with whom I could not converse at all, which makes quoting them rather difficult.

But as the adventurers evolved into journalists, African voices became more prevalent in the magazine. Africans became individuals, whether presidents of newly independent states like Senegal's Leopold Senghor, featured in "Freedom Speaks French in Ouagadougou" (1966); the Ndebele woman Mtazi Mtsweni whose forced relocation by South Africa's apartheid government was so touchingly told (1986); or the numerous farmers, herdsmen, fishermen, and urbanites who have revealed their lives to us.

The articles, like our own relationship with Africa and other far-flung parts of the world, have become increasingly intimate. As have the photographs.

The early pictures of people were often portraits taken at middle distance, in order to show the exotic dress, scars, or other decorations of the subject. Over the years the photographers, like the authors, moved closer to the people and into their homes, to convey more of a sense of their daily life: the exotic scars, costumes, dances, and rituals are a part of life, but not the only part. I feel that it is my responsibility to make photographs of the exotic: the dances, rituals, and forms of beautification like the intricate cicatrix on the face and around the naval of the Mondari woman who appeared in the 1982 story "Sudan: Arab-African Giant," which is not unlike a picture that appeared in 1909. But it is equally important to show people at work in their fields, as in "Eritrea Wins the Peace" (1996), or to sit in a hut with a patient who is dying of AIDS as portrayed in "Uganda: Land Beyond Sorrow" (1988).

In recent years, NATIONAL GEOGRAPHIC articles about Africa have become a blend of the old-fashioned adventure stories with ones about individual countries, regions, or tribes; wildlife and archaeology stories; and, increasingly, ones about the many challenges facing the continent. The adventure of traveling there (and believe me, it can still be quite an adventure) becomes combined

with the beauty of its uncommon landscapes and wildlife, with portrayals of the dignity of its people, and with a growing understanding of its economic and political troubles.

NATIONAL GEOGRAPHIC has always been, and continues to be, unique. The wide scope of subjects, length of the texts, and number of photographs devoted to a story give it the opportunity to explain and show Africa in ways few other publications match—whether it is adventuring into the forbidding rain forest at the continent's center, ("Ndoki," 1995), living for months amid teeming herds of animals ("The Serengeti," 1986), facing environmental issues ("Africa's Sahel: The Stricken Land," 1987) or political ones ("Tragedy Stalks the Horn of Africa," 1993).

I have been working in Africa for 27 years. During that time, I've slept under The Tree Where Man Was Born with an old Nuer man in southern Sudan, interviewed the Emir of Kano in Nigeria, climbed to glaciers on the Equator, dined with countless hospitable people around campfires and in huts, and drifted over great herds of wildlife in hot-air balloons. I've also visited the Nairobi Stock Exchange, toured factories, stayed in five-star hotels, and been shot at. Though many of the peoples and places I've visited over time have stayed the same, much has disappeared, and continues to do so every day.

The photographs in NATIONAL GEOGRAPHIC are documents of the passage of time. Inevitably, as the world grows smaller, it becomes more homogenized. The younger people of many African tribes no longer wear the traditional clothes of their parents or sport their tribal scars. Knowledge of the lore and rituals is lost as they move to the cities in search of jobs and a life in their modernizing nations. Plains once teeming with wildlife are now covered with small farms. In the early 1970s, I took rhinos for granted—in practically any national park I could find lots of them, easily, every day. Today they are on the brink of extinction, and you have to be very lucky to see one in the wild.

Covering these changes—and the things that haven't—has occupied most of my adult life. As a photographer and writer, I hope that my stories present an honest, accurate, and fair image of the places and people I am privileged to visit. It is my job—the job of all those who set out on assignments for the magazine—to be the eyes and ears for those who are not able to go there themselves. I have a responsibility: To convey the infectious joy of the Eritreans rebuilding their country after 30 years of war, and the heart-rending sorrow of the Somali famine camps; the tranquillity of a Dinka cattle camp in Sudan and the bustle of Kinshasa, the capital of the Democratic Republic of the Congo.

One more thing struck me as I perused the 110 years of NATIONAL GEOGRAPHIC stories about Africa: I wondered, as I gazed at a particularly good photograph or read a well-turned sentence in an old copy of the magazine—and also when I came across a picture or line that would be out of place in any publication today—what will the judgment of the future be of the work we are doing now? I imagined someone like me sitting down in the year 2098 to write an essay for volume two of *Then and Now*. Would that person be glad that NATIONAL GEOGRAPHIC had doc-

1993, Baidoa, Somalia
Sleep of death awaits a young girl ignored by other famine victims.
Robert Caputo

following pages:

1991, Southwestern Ethiopia
Wielding staffs with carved phallus tips, Surmas vent their hostilities in the annual *donga*, a stick-fighting duel with one regulation: A fighter may not kill his opponent.
Carol Beckwith and Angela Fisher

umented those long-lost places and cultures? Would they think my stories quaint, that I and the magazine were obviously products of that interesting time around the turn of the millennium?

And I wondered, too, how big Nairobi would be in 2098, if Jane Goodall's chimpanzees would still be romping around Gombe, if the fishermen would still be setting their traps on the Congo River, and if the Nuba would be dancing around some future photographer's car.

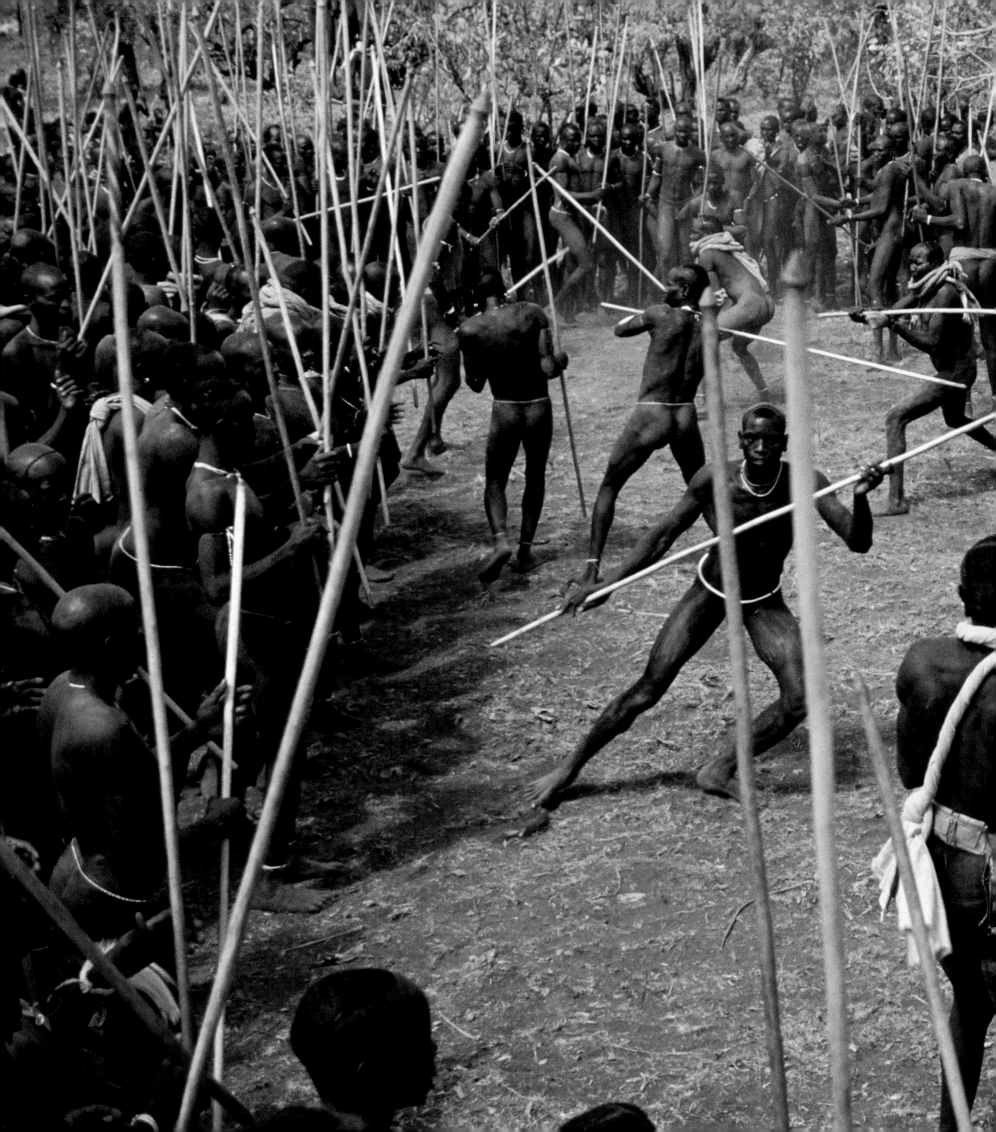

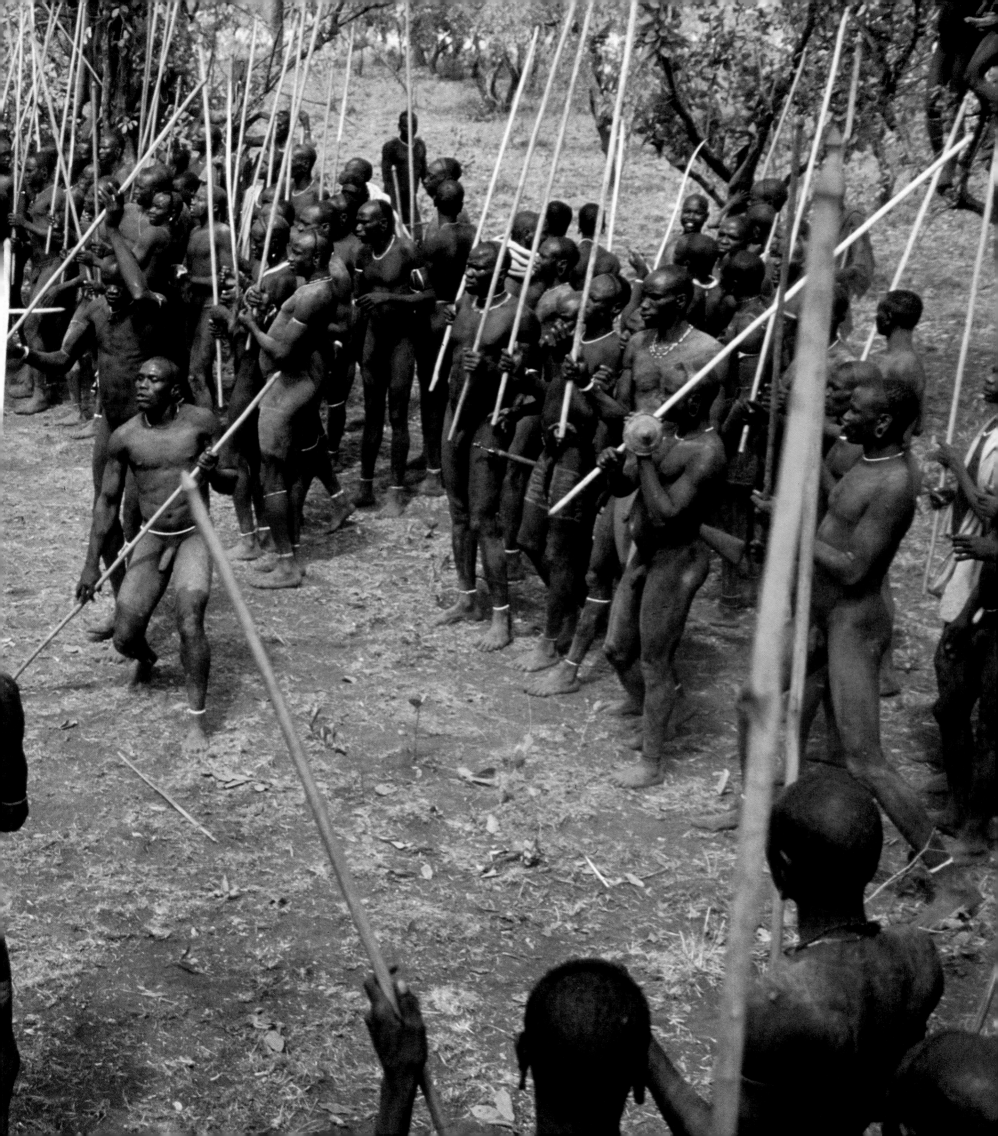

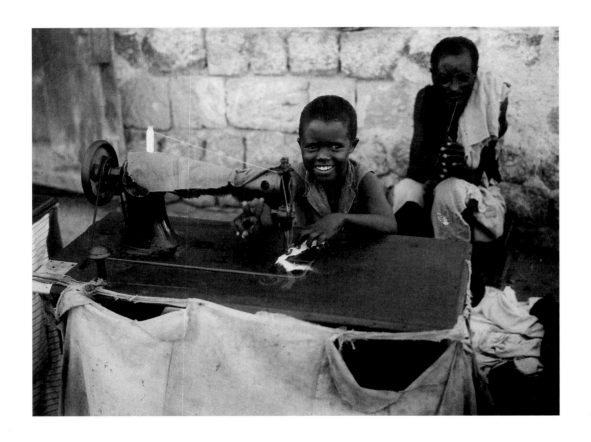

1931, Djibouti, French Somaliland
An elder's pride beams on a young tailor plying his trade on an American-brand sewing machine of the "portable variety," which reportedly "found its way all over the East, both in cities and in villages, and sometimes in nomad tents."
Burton Holmes

right:
1990, As Ela, Djibouti
Armed with an imported rifle and the traditional dagger of his warrior ancestors, an Afar chieftain trains a wary eye on the parade of humanity outside his home: tourists from France, refugees from Ethiopia and Somalia, and any possible smugglers. France ruled Djibouti until the African nation's independence in 1977.
Chris Johns

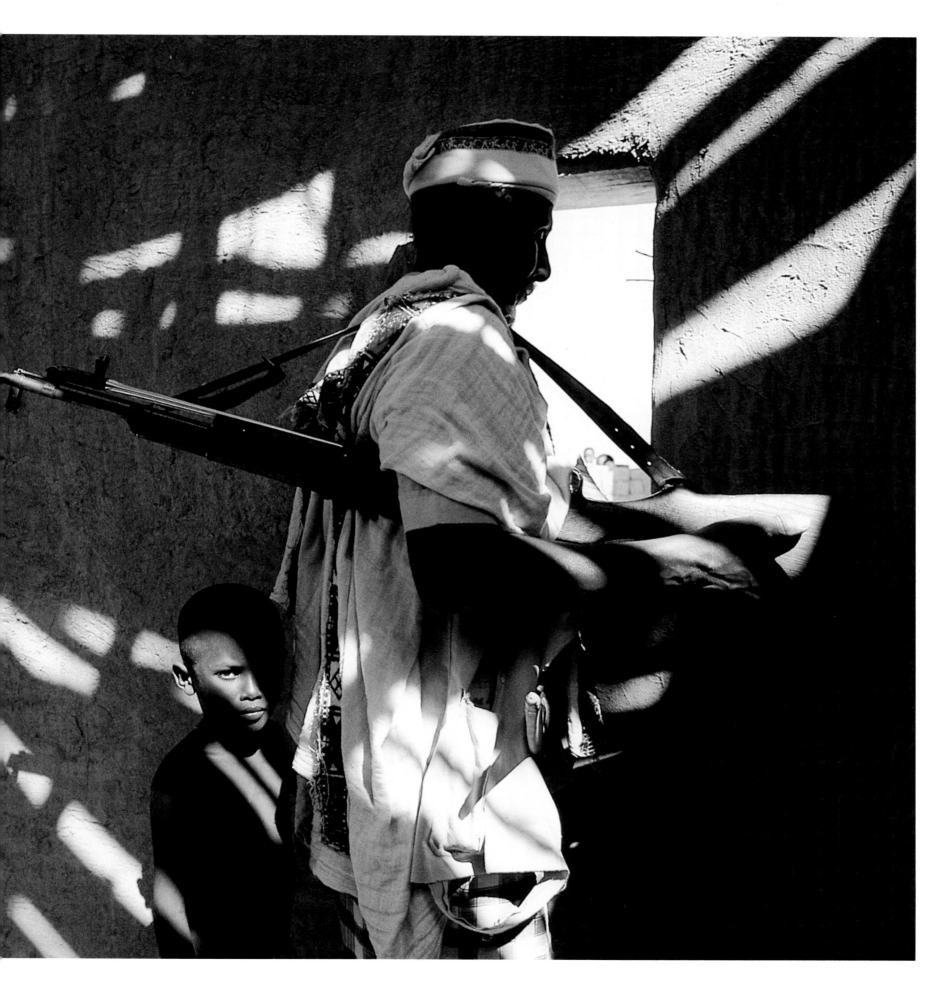

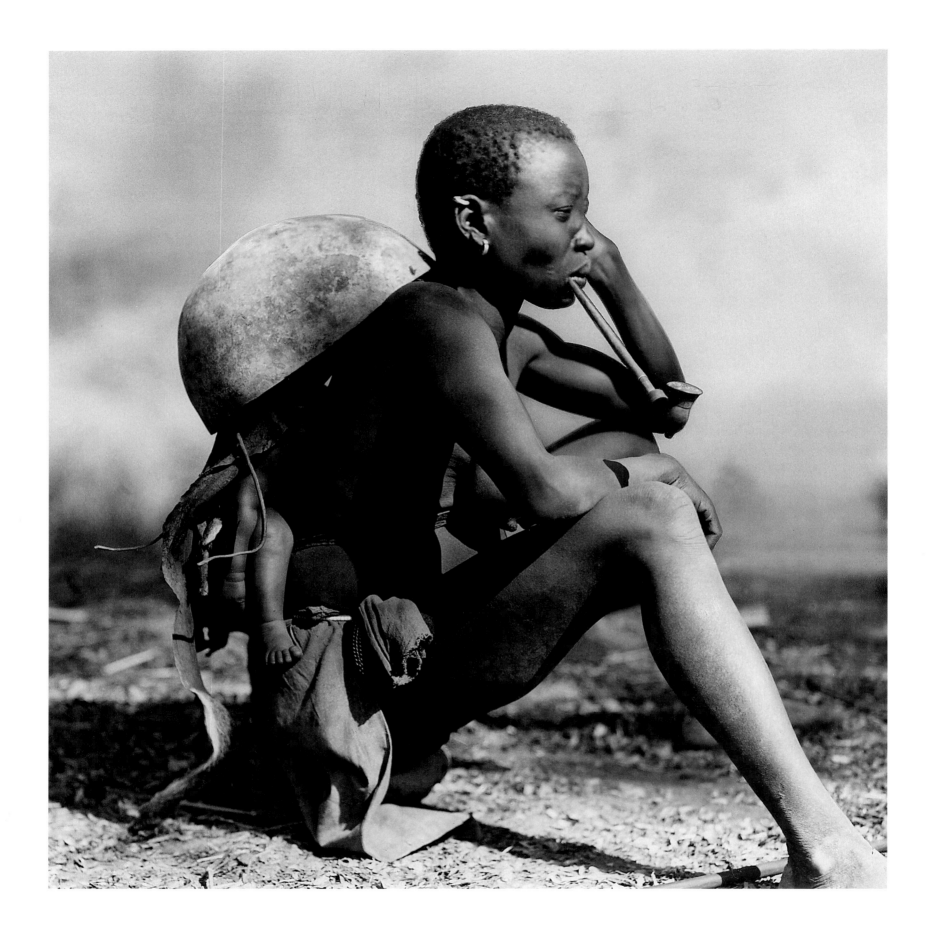

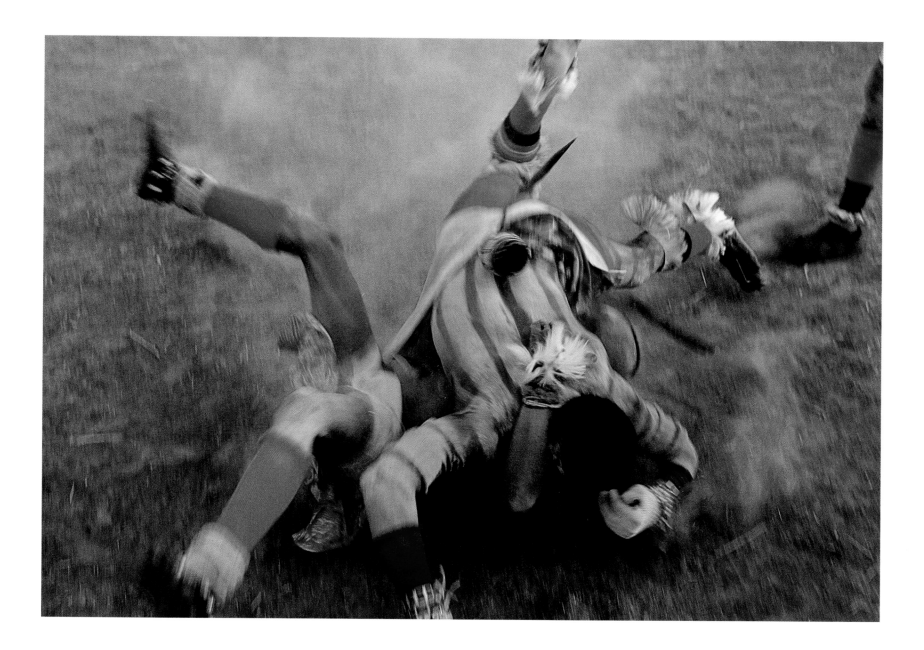

We learned local folklore from helpers who skinned specimen animals. Around campfires these boys sang chants and humorous extemporaneous ditties. In their clever pantomimes we sometimes figured as conquering heroes and at other times as bedraggled hunters of fleas. Few outsiders have had intimate acquaintance with southern Sudanese tribes. One was an English-born ecologist from New Zealand, Dr. John Golding Myers, who…explored agricultural possibilities of southernmost Equatoria Province. Another, best unnamed, was an American ivory poacher. Shortly after the century's turn he caused so much havoc that an expeditionary force was sent against him. The report read: "Accidentally shot while trying singlehandedly to disarm pursuers."

February 1953, NATIONAL GEOGRAPHIC
from "South in Sudan"
by Harry Hoogstraal

1982, Eluheimir, Sudan
Colorful combatants lock limbs in a Nuba wrestling match, part of the festivities of a harvest celebration that continued into the night with dancing, singing, and drinking *marissa*—a beer of sorghum, the staple food of Sudan. The Nuba people share their name with the mountains of their homeland, in central Sudan.

Robert Caputo

left:
1953, Sudan
Gourd parasol shades a napping Lotuka baby while his mother enjoys a pipe—a pleasure relished mainly by women of the tribe. Inhabiting the grasslands of southern Sudan, the Lotuka at this time lived by their skill as hunters, farmers, and herdsmen.

C. P. A. Stone and Harry Hoogstraal

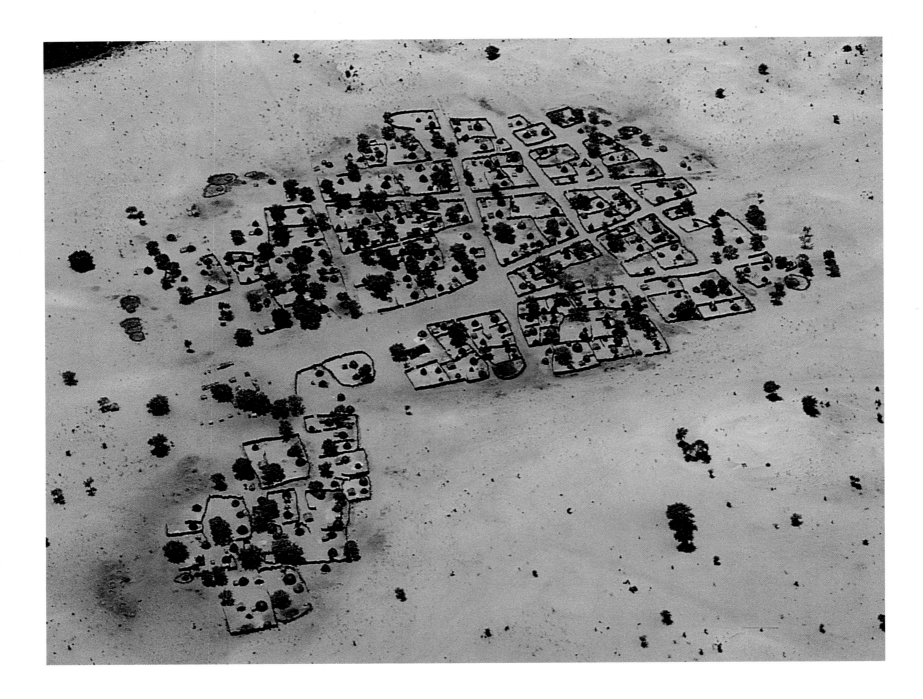

1966, Chad
Tidy islands clustered in a sea of sand, village compounds in central Chad define their borders and defend their privacy with tightly woven brush fences.

John Scofield

right:

1979, Nouakchott, Mauritania
Legacy of the drought spanning 1968-73, a sprawling shantytown—peopled by refugees from the desert—spills from the edge of the capital city's orderly streets. The years after the drought saw nearly half of Mauritania's nomads abandon their ancient lifestyle for settlements.

Georg Gerster

In the past 65 million years, the borders of the Sahara have expanded and retreated many times. Oak and cedar trees once grew in the Saharan highlands, and rock paintings portray abundant wildlife. But about 3000 B.C. the current desiccation began setting in, and man, a relative newcomer to North Africa, had to contend with desertification of the worst degree.

Yet in only a few places is the desert advancing like an army of sand. The war is being lost in patchwork battles from within. A piece of land goes here, another dies there. The enemy is no longer just the climate. It is ourselves and our animals....

November 1979, NATIONAL GEOGRAPHIC
from "The Desert: An Age-old Challenge Grows"
by Rick Gore

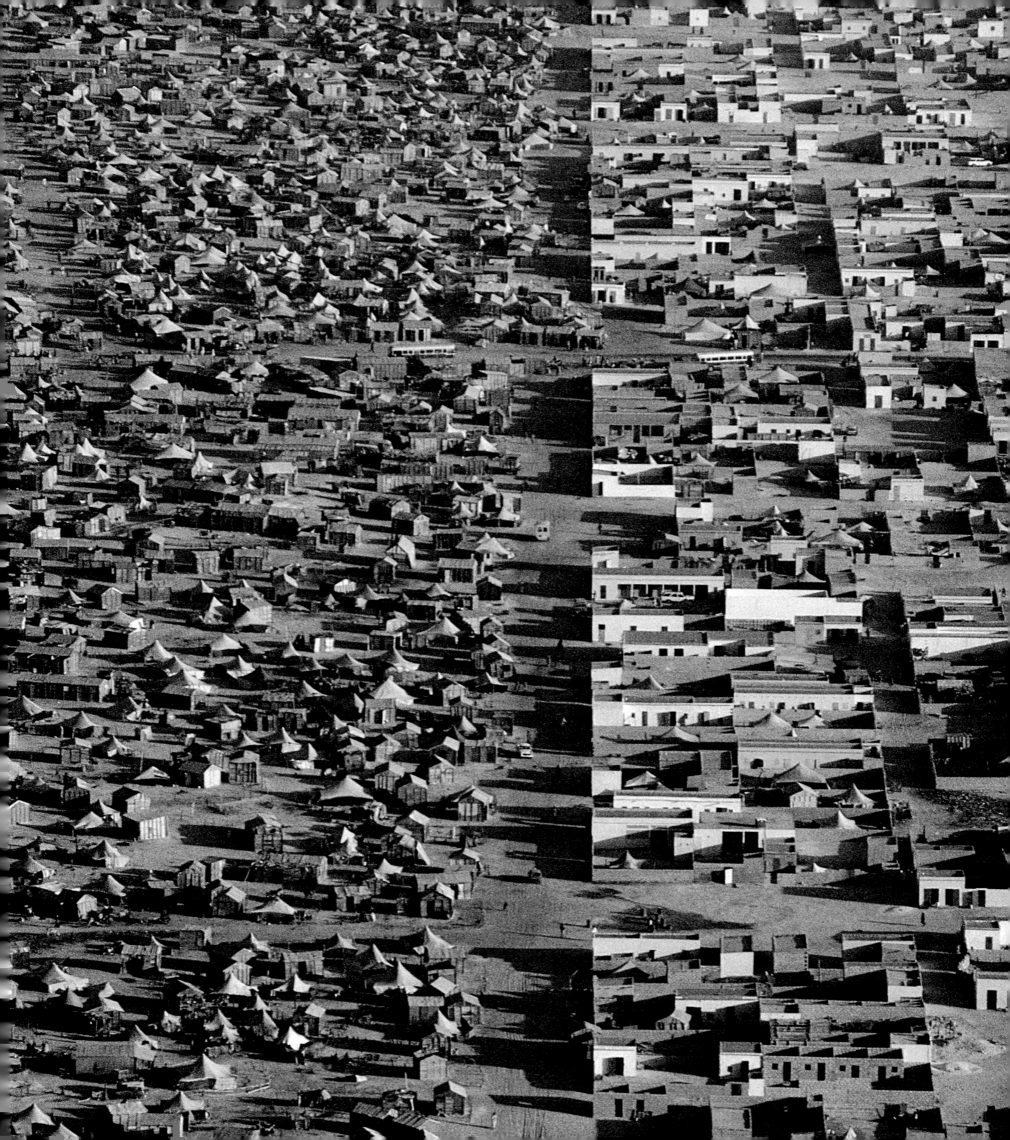

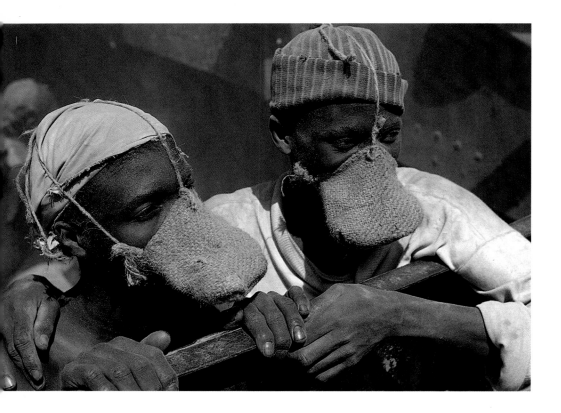

Gambling 90 percent of its annual income on groundnuts, the Gambia joins half a dozen other African nations whose economies can wax or wane at the whim of world peanut prices. Major importers such as France and Britain subsidize purchases. But in the glutted market, prices may still fall. And nations may suffer.

Food experts try to liberate African agriculture from the soil-exhausting crop. The Gambia, embracing an area little wider than the banks of the Gambia River, has experimented with rice, poultry, and shark oil. Disease, pests, the oppressive climate, and a fondness of Gambians for growing peanuts have hobbled every effort.

August 1966, NATIONAL GEOGRAPHIC
from "Freedom Speaks French in Ouagadougou"
by John Scofield

"Development has hurt people more than it has helped [said anthropologist Peter Weil]. The life expectancy of certain Mandinka women has dropped from 45 to 38 years because peanuts have replaced the traditional crops. The planners, strangers to Mandinka customs, called for men to grow peanuts—women were left to raise rice…. They labor in very unhealthy conditions. Is this progress?"

Sophisticated Dakar confronts these problems at long range. Cool ocean breezes and affluence buffer it from the desiccation and poverty of the countryside. Dakar combines the elitism of Paris with the partying atmosphere of a Riviera resort, yet also is a haven for…beggars and pickpockets.

Dakar is the capital of African chic. When Aubine, a smart Parisian, first arrived in the city, she felt like a hayseed amidst the exotic billowing robes and ornate tresses of Dakar women. An important measure of a man's status, she was informed, is the beauty of his wife. But I couldn't discern a wealthy socialite from a secretary. They all were elegantly garbed—and beautiful.

Fatou Sow, a researcher at the University of Dakar, noted that Senegalese women are encouraged to obtain an education. "We have excellent examples to follow—women jurists, doctors, professors, merchants, and even female members of parliament, and ministers. Of course, especially in the villages, the role of women is still greatly controlled by men."

August 1985, NATIONAL GEOGRAPHIC
from "Senegambia—A Now and Future Nation"
by Michael and Aubine Kirtley

1966, The Gambia
In the hold of a Gambia River peanut boat, stevedores wear burlap "duckbill" masks to filter out the dust stirred up as nuts are offloaded for transport to an oil-pressing plant.
John Scofield

right:

1985, Dakar, Senegal
Elegant gowns of Senegalese secretaries relaxing beneath the stern gaze of a marabout, or holy man, bespeak the emphasis on clothing in this French-influenced culture. "Downtown Dakar is a living art show of femininity," noted author Michael Kirtley.
Michael and Aubine Kirtley

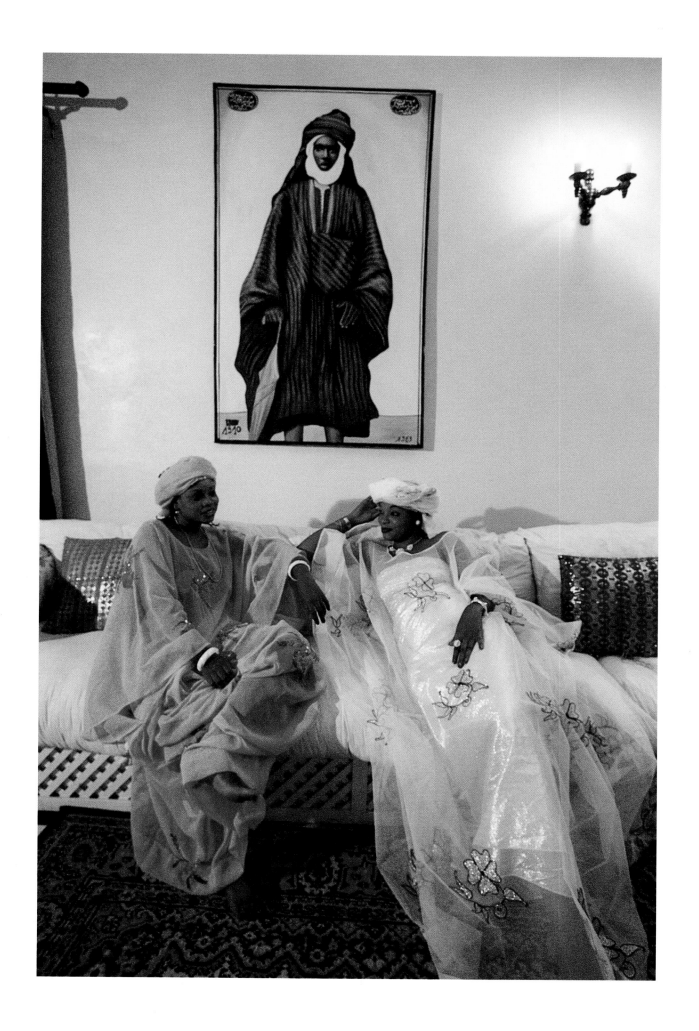

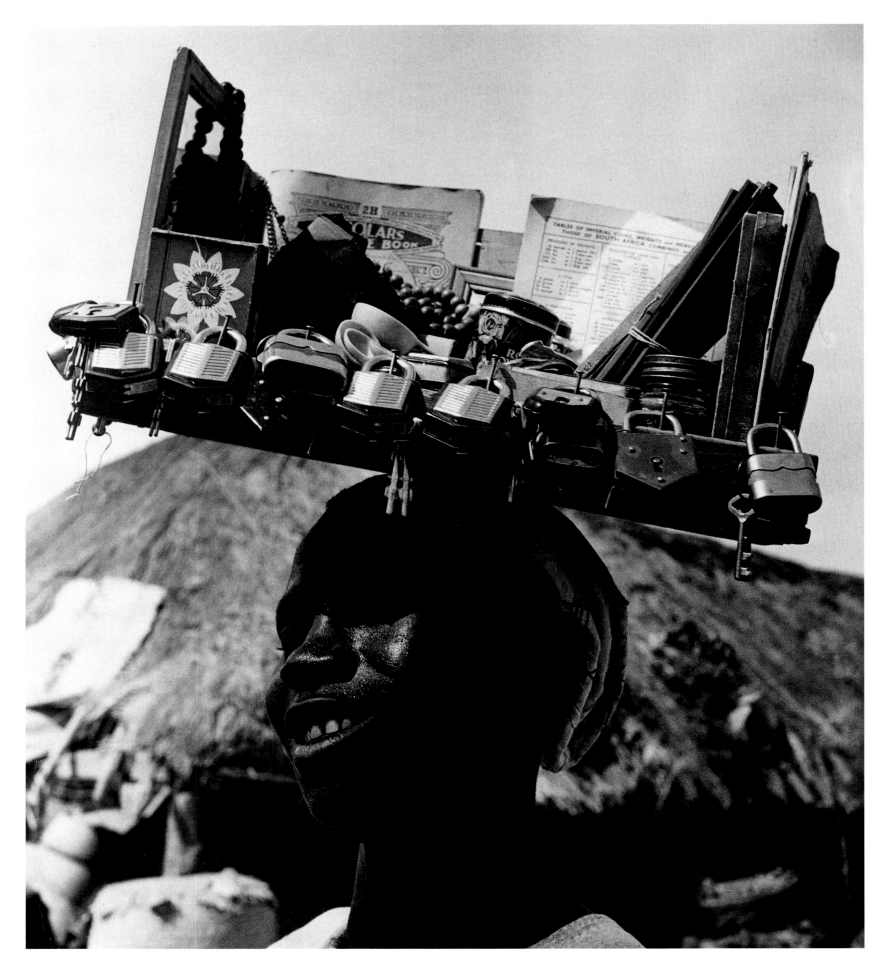

226

Oil-rich Nigeria is booming, and its rapidly changing populace sees both the good and the bad in national growth…. Throughout my visits I talked with Nigerians who are buoyed by the new opportunities and new prestige but irritated by the problems. They accept the frustrations of an evolving society, however, with remarkable insouciance. I watched reactions one afternoon as a Lagos businessman complained that his contract for five thousand pairs of shoes had been rejected by a local firm in favor of a foreign contract. "I found a factory in the north that would make them, out of Nigerian leather," he shouted. "Instead, they bought the shoes from London." Incredibly, other Nigerians in the room laughed to tears at the absurdity of it. "It is crazy," said one, wiping his eyes. "Someday we will learn to trust ourselves."

March 1979, NATIONAL GEOGRAPHIC
from "Nigeria Struggles With Boom Times"
by Noel Grove

1956, Kano, Nigeria
Cornucopia of goods crowns a smiling Hausa peddler as she wanders through the marketplace. Among her wares are locks and keys, lemon drops, glue, a watch chain, rosaries, and an astronomy book.

George Rodger

right:

1991, Nigeria

Folk remedy or wonder drug? A leaf from the "headache plant" treats a Nigerian woman. Traditional healing methods such as this may help identify plants useful in producing new drugs.

Lynn Johnson

following pages:

1986, Tanzania

Striped minority, zebras find safety in numbers by joining a herd of wildebeests in their spring migration across the plains of Serengeti National Park.

Mitsuaki Iwago

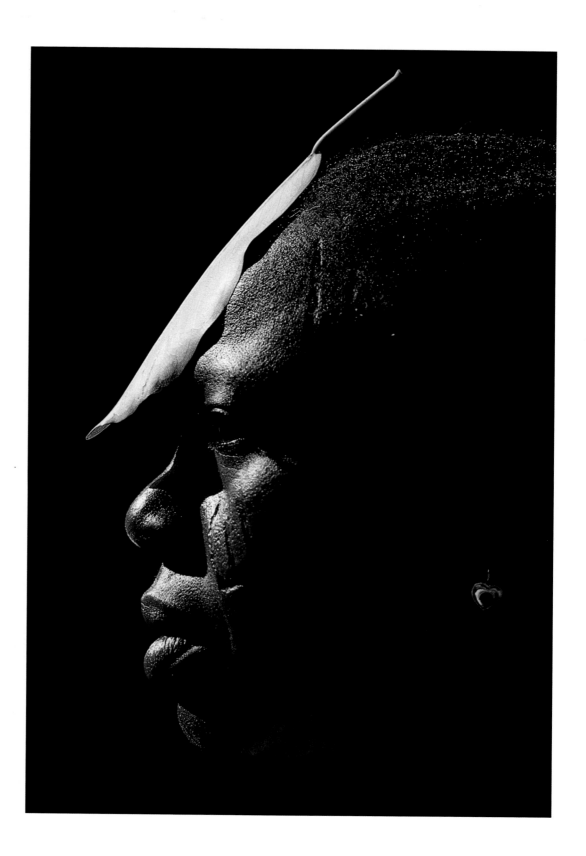

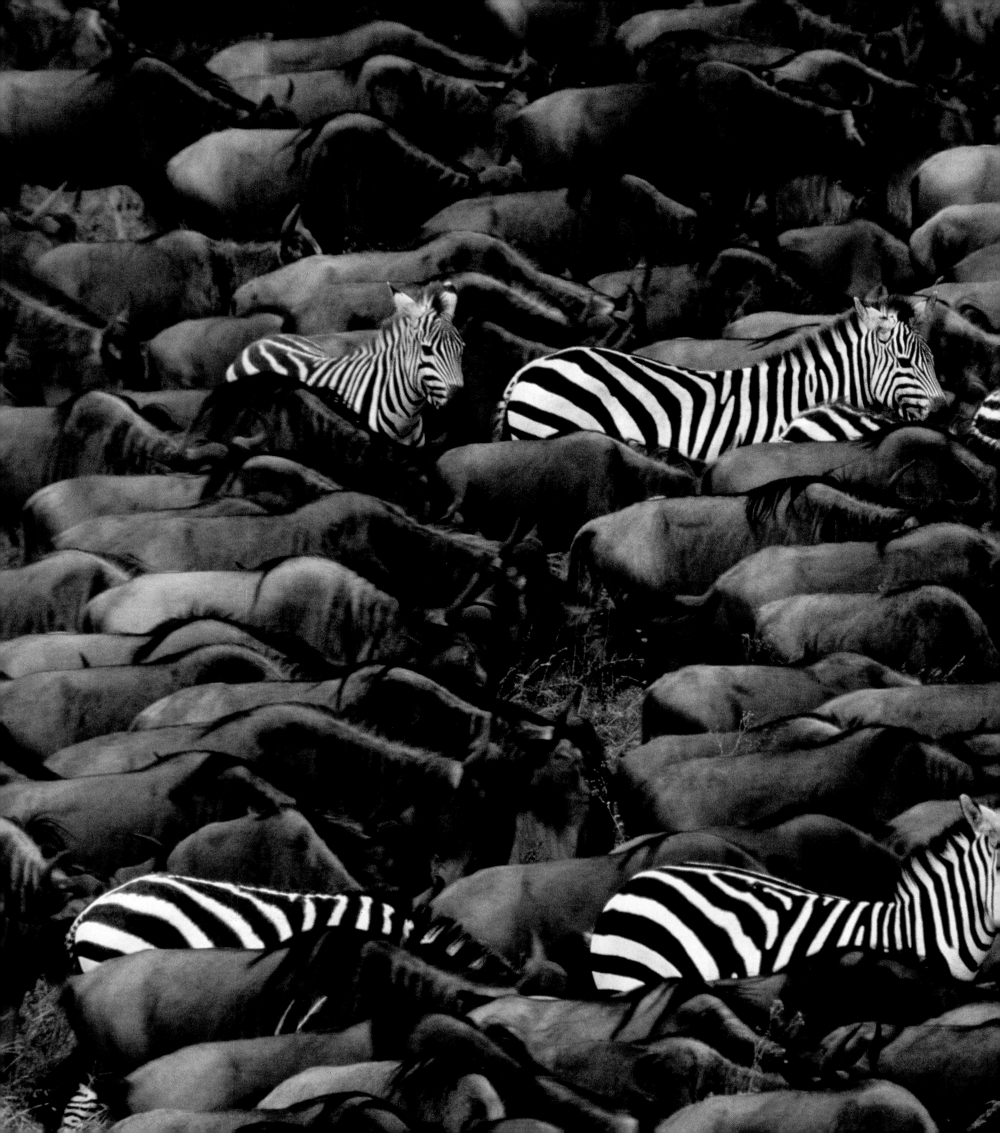

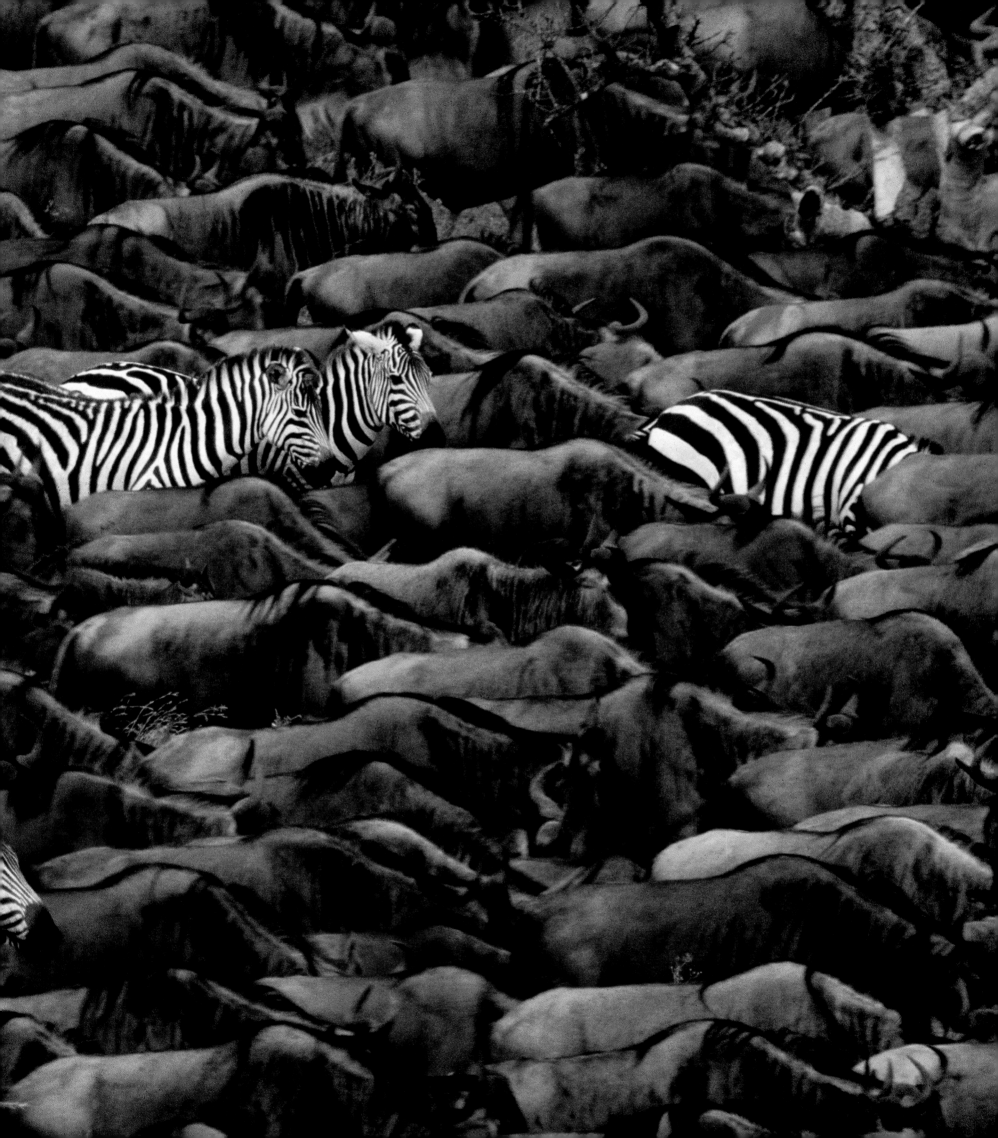

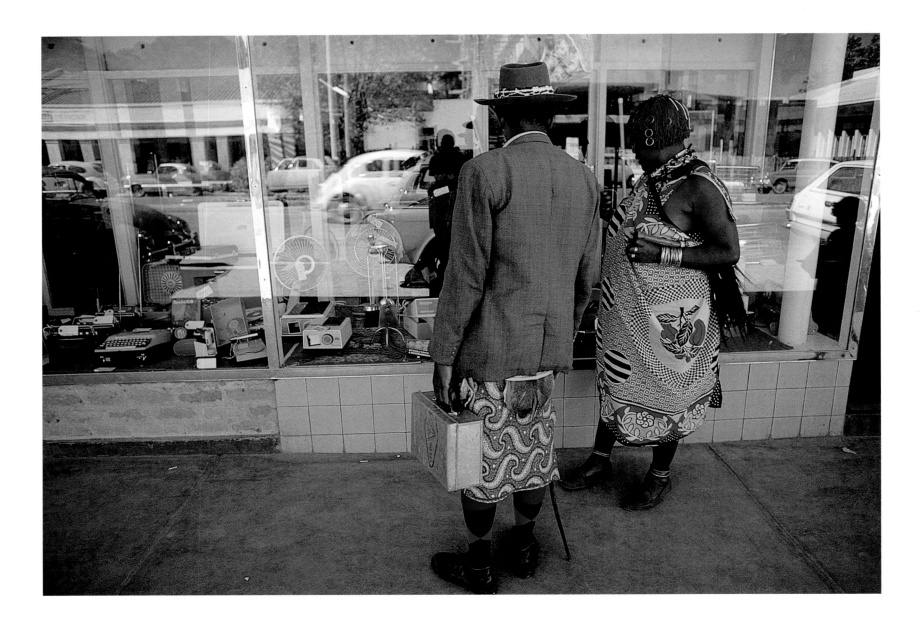

1969, Mbabane, Swaziland
Sporting fashions from two worlds, a village chief and one
of his wives window-shop in their nation's bustling
capital. The woman's beringed, rust-red wig distinguishes
her as a diviner.
Volkmar Wentzel

Mbabane was made the capital by the British after the Boer War.
Its winters are bright and sunny, its summers warm and thunder-
ous. With tree-lined streets, cricket field, meeting places of Par-
liament and the High Court, Mbabane is a bit of England and
Africa combined. Mornings, I found, can be as chill and foggy as
those of London. One bright morning I stood near the "robot"
—Mbabane's only traffic light—to watch the crowd swirl by.
Smartly dressed wives of white farmers and engineers, Swazi princes
in shiny black Mercedes cars, market-bound Swazi women bal-
ancing baskets of produce on their heads, and countryfolk with
loinskins and shoulder cloths—the parade was as varied as it was
interesting. As I turned to leave, a tribesman on horseback clattered
through the traffic, hurrying to beat the light before it turned red.

August 1969, NATIONAL GEOGRAPHIC
from "Swaziland Tries Independence"
by Volkmar Wentzel

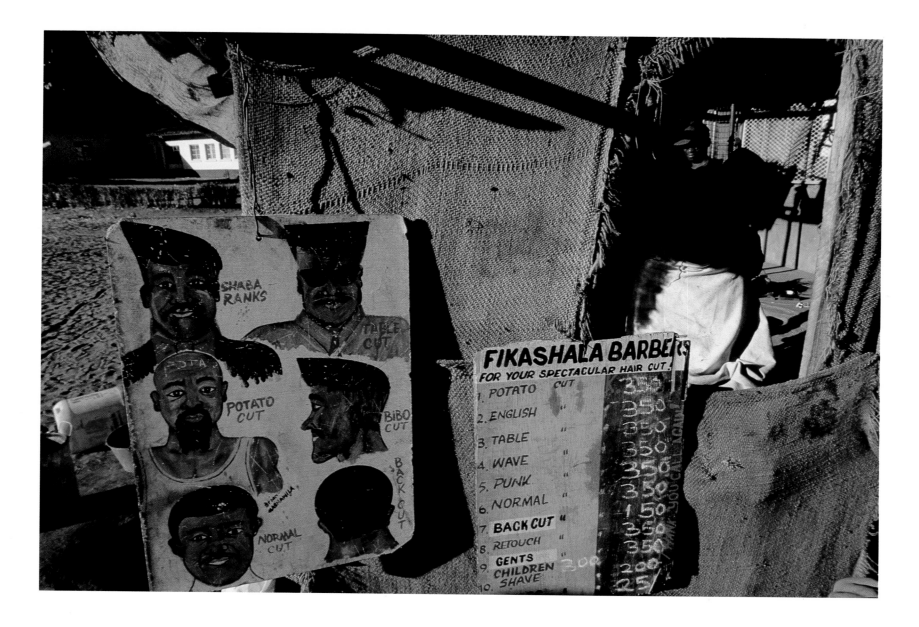

The many stamps in my passport—I got one every time I crossed the river—were proof that Zambezi is frontier. The river flows through or forms the border with six countries. We had traveled from Zambia, across the Caprivi Strip in Namibia, farther on through Botswana, and back again to Zambia through Zimbabwe. The Zimbabwean town of Victoria Falls was visibly more prosperous than its sister city, Livingstone, across the bridge in Zambia. But I found an older, mellower Africa in Livingstone. Its Maramba market attracts people from miles around—Africans buying clothes and getting haircuts and stocking up on provisions, and occasionally tourists…in search of bargains before heading off for whitewater rafting or bungee jumping on the river. This most touristy reach of the river had once been the front line in the bush war….

1996, Zambia
Trendy hairstyles beckon locals to a barber stand in a Zambezi River village.
Chris Johns

October 1997, NATIONAL GEOGRAPHIC
from "Down the Zambezi"
by Paul Theroux

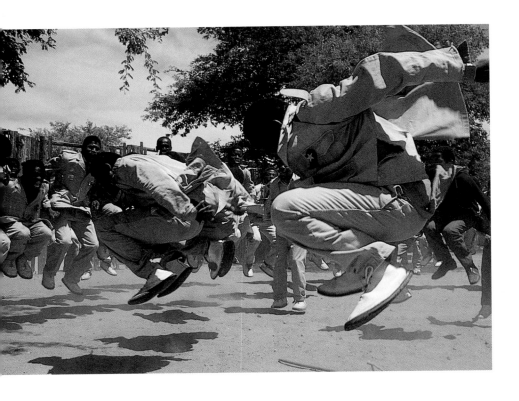

1990, Gaborone, Botswana
Rousing chants and stomping made thunderous with oversize white bucks help Zion Christians "drive the devil underground" during Sunday worship. The Zion Christian Church is one of southern Africa's largest denominations.

Peter Essick

right:

1993, Mauritius
Joyous abandon sends young Mauritians into the warm waters of the Indian Ocean. The country has one of earth's fastest-growing populations and is one of Africa's few functioning democracies. Of Indian, African, and Asian descent, her people thrive on tolerance: "Muslims celebrate Divali, a Hindu holiday; Hindus celebrate Id al-Fitr, a Muslim holiday; and everybody celebrates Christmas."

Joseph Rodriguez

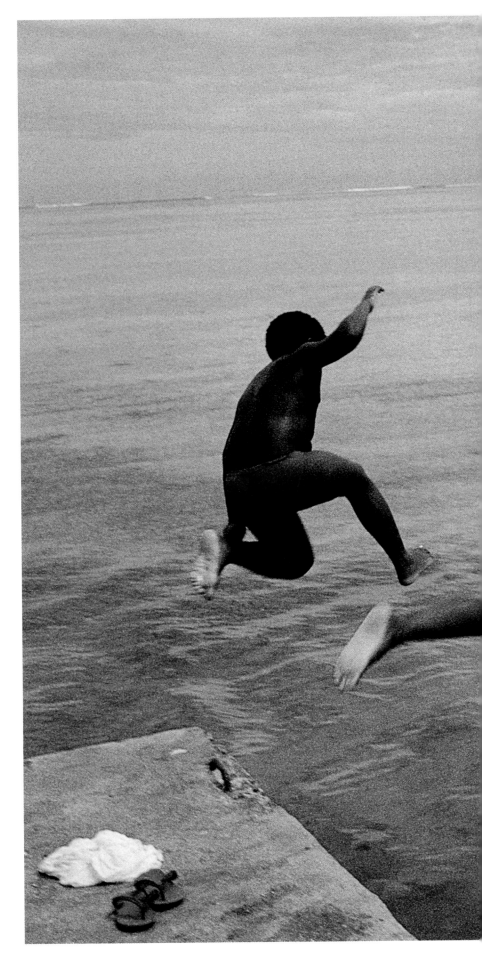

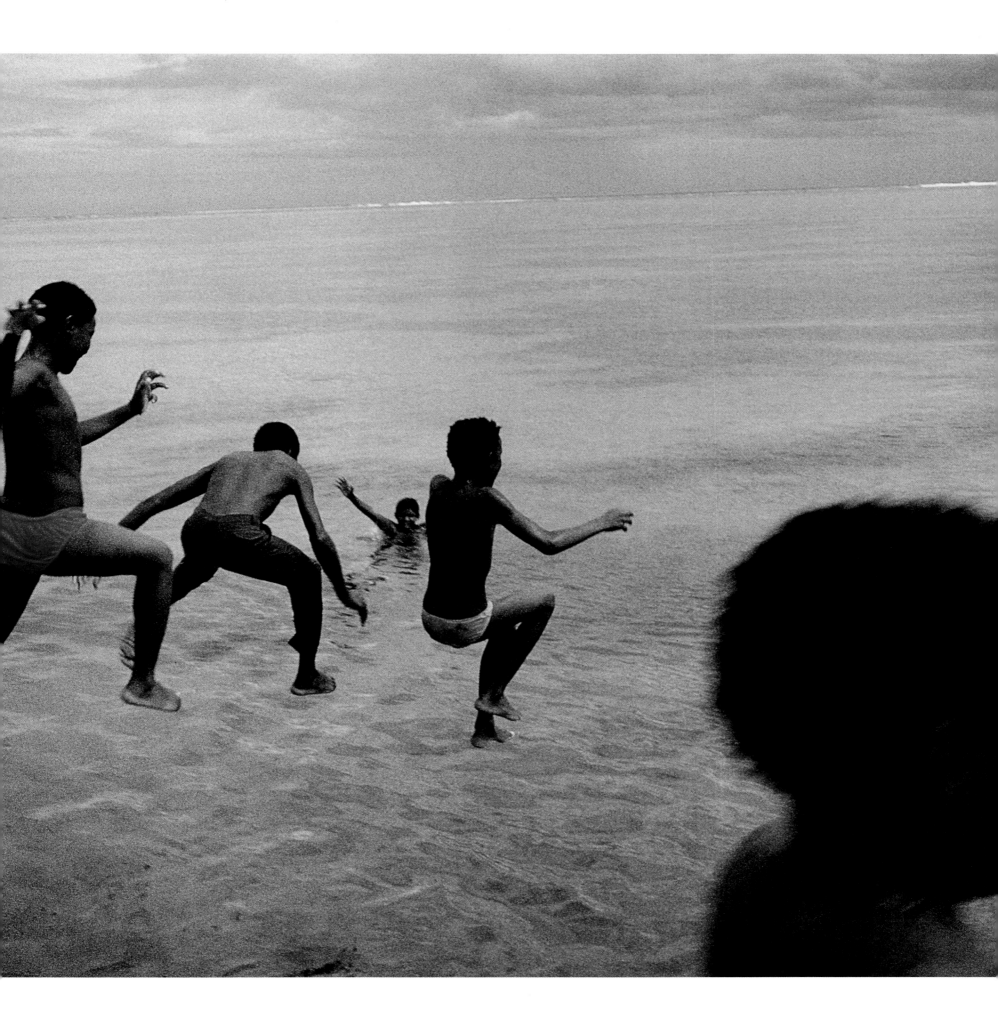

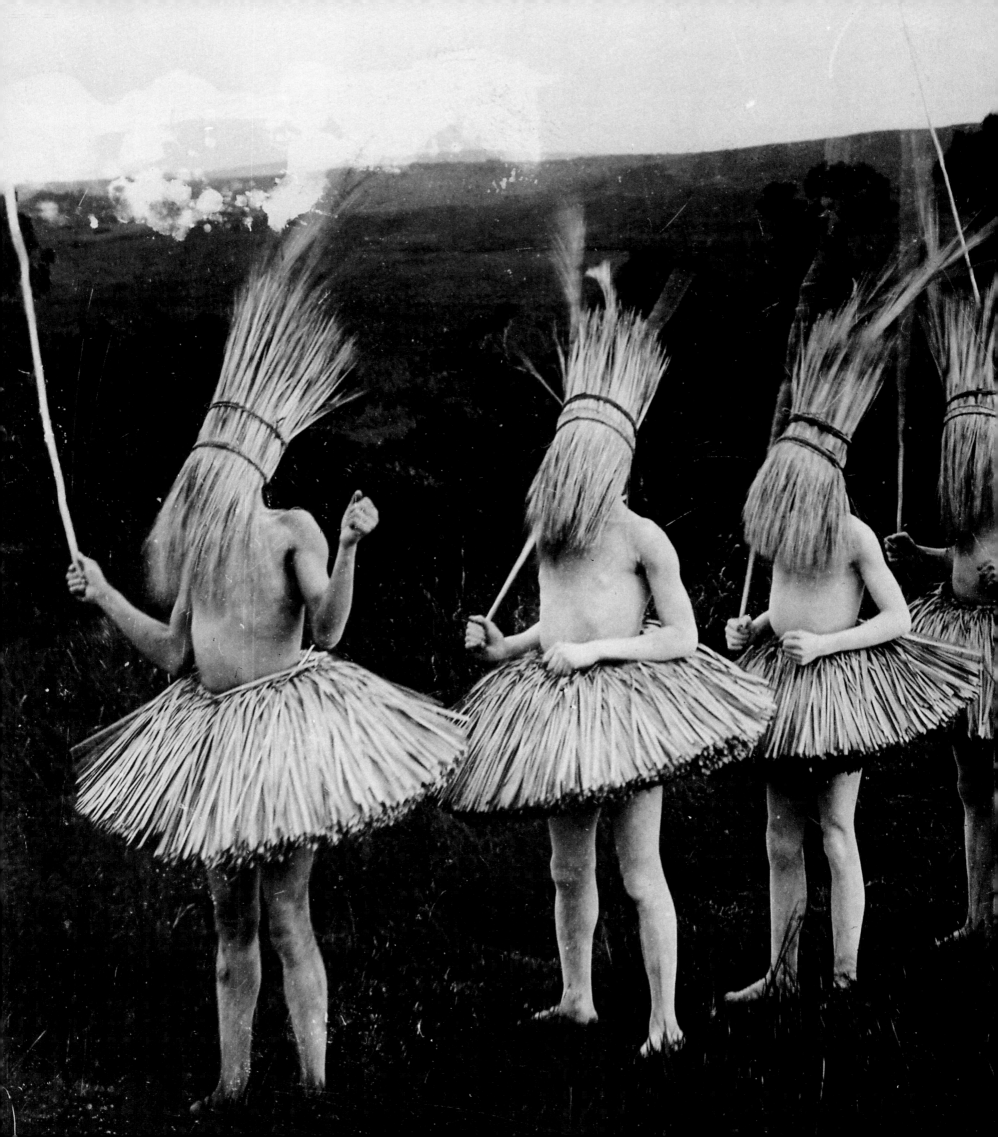

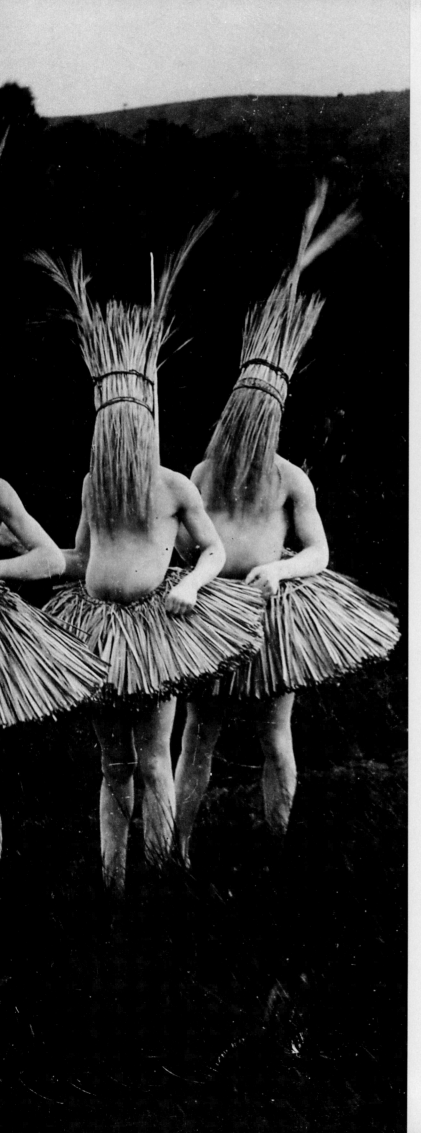

South Africa

"South Africa…isn't all jungle, lions, elephants, and half-naked blacks, as the movies…suggest, but instead a homelike land, where European-descended people have been implanting towns, industries, and institutions…," wrote Melville Chater in a 1931 NATIONAL GEOGRAPHIC story. Typical of its time, the story centered on European influence and gave but a nod to the native inhabitants. Four decades later, in Joseph Judge's "The Zulus: Black Nation in a Land of Apartheid," the magazine fully focused on the heritage, fierce pride, and controversial issues facing South African blacks, who compose 75 percent of the population. Since then, the magazine has returned often to portray the lives and struggles of these people in their country recently freed from apartheid.

above:

1993, South Africa

Pale statues on the verdant veld, Xhosa youths covered with clay break from hunting, an age-old rite of passage into manhood.

James Nachtwey

left:

1925, Kentani, South Africa

Clay-smeared Xhosa boys in reed masks and grass skirts dance in farewell to childhood. As the annual puberty ceremony ends, the boys will torch their disguises to emerge as men.

Alfred S. Hart

1960, South Africa
Oblivious to their worth, namesakes of Highgate Ostrich
Farm, near Oudtshoorn, eye the world from seven feet up.
These profitable birds yielded pricey feathers for hats and
dusters and after full lives, skin for handbags and wallets.
Their flesh was cured into dried meat called biltong.

W. D. Vaughn

I tried to stay apart from the human strife in the Union of South Africa; and sometimes I was successful. I watched the brave new buildings rising in bustling Johannesburg, and sampled its sophisticated restaurants, and joined friends in their homes in peaceful city suburbs.... I went to the compounds of the City Deep Mine, which is a city-beneath-a-city, a goldstrewn catacomb a mile below the downtown streets. I went to watch the dancing of the miners. I saw the rippling dance of the Xhosa men; the step dance of the Bacas; and the fierce stamping of the Zulus.... As each dancing group finished its turn it snaked out of the arena, but the beat of its drums did not falter, and would rock the compound all night. These men danced not for an audience, but for sheer pleasure.

September 1960, NATIONAL GEOGRAPHIC
from "Africa: The Winds of Freedom Stir a Continent"
by Nathaniel T. Kenney

A chilly rain outside was turning to snow as Zaniwe Tsapa, a Griqua, washed a week's worth of dirt and labor from her husband's overalls, pounding them with a rock.... Every day she is up before dawn and back home at dark. She is a cook on the farm of an Afrikaner couple, J. P. and Iona Botha. Their 20,000 acres near the town of Trompsburg are dedicated to wool. Zaniwe's cinder-block house is one of ten in the farm's worker compound, spartan, without electricity, but not shabby. I saw on Zaniwe's face what I had come to call "the look." All the women farm workers have it in the half hour or so before sunset. They sit outside looking straight ahead, their expression unfocused and impenetrable. It seems their gaze curves back into their innermost, weariest selves.

February 1993, NATIONAL GEOGRAPHIC
from "The Twilight of Apartheid"
by Charles E. Cobb, Jr.

1988, South Africa
Farmhands fight fatigue on their way home from a government-owned vineyard near Cape Town. Abundant and cheap, the labor supplied by black workers has long fueled the South African economy. At the time this picture was made, male workers earned about $60 a month; women about half that.

David Turnley

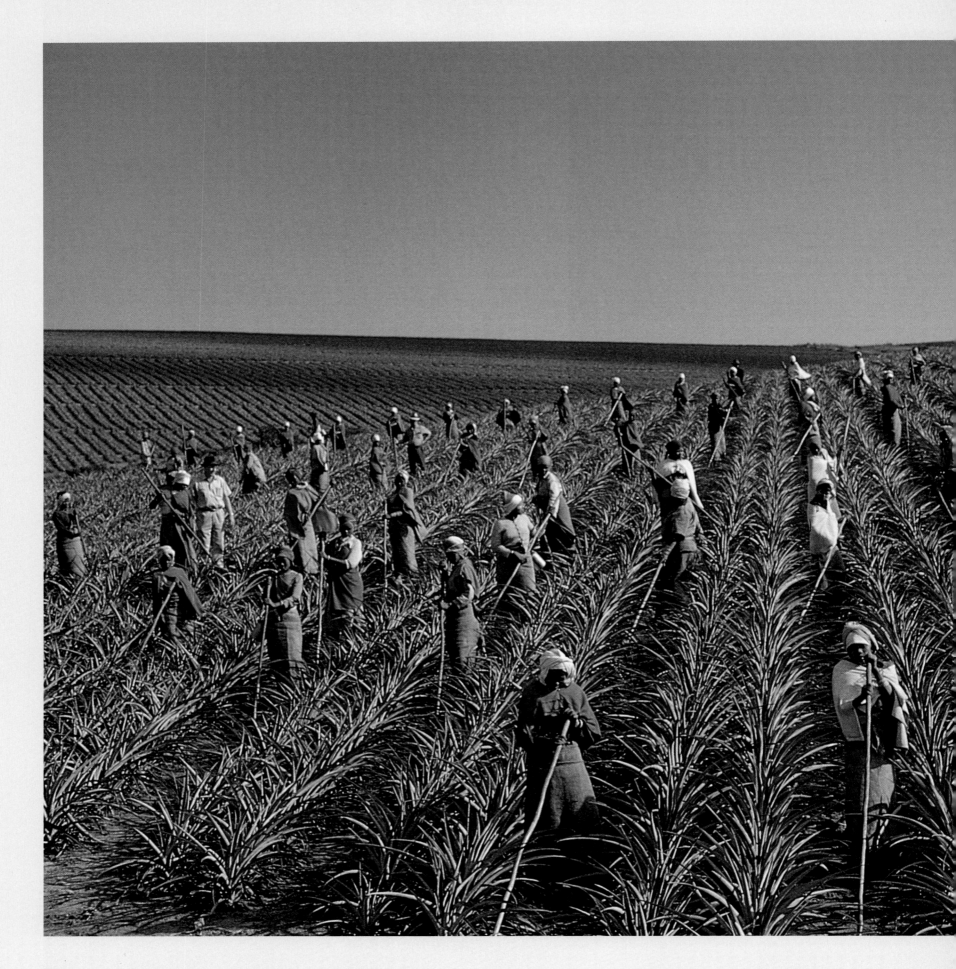

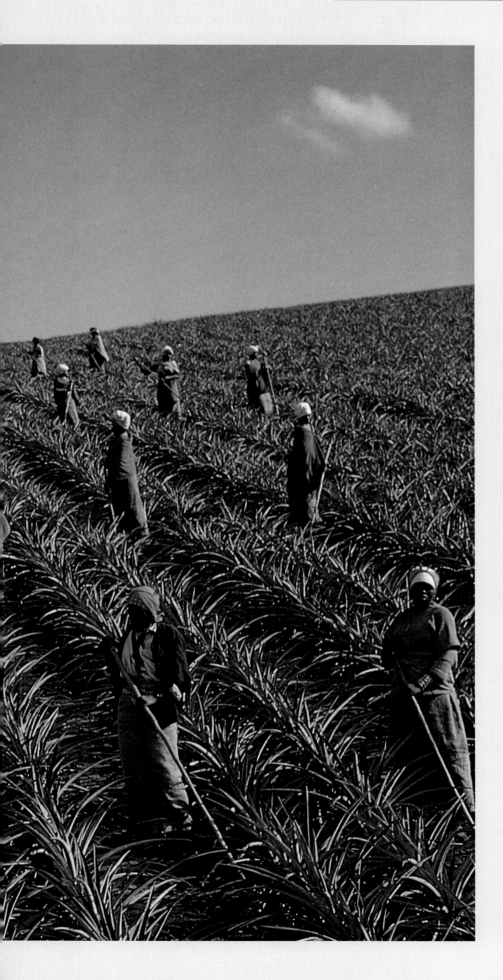

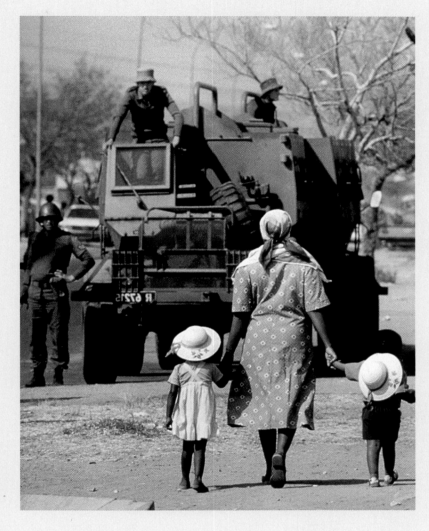

1988, Soweto, South Africa
Grim evidence of apartheid, an armored vehicle greets
a mother and her children out for a stroll in this black
township 15 miles from Johannesburg.
David Turnley

left:
1962, South Africa
Bantu women armed with crude hoes cultivate the fields
of Silverdale, John J. Meyer's pineapple estate near East
London. The fruits of their labor, along with other
exports including grapes and rock lobster, will grace
tables in Europe and the United States.
Tor Eigeland

1974, Johannesburg, South Africa

Ebony sculpture in an eerie gallery, a Xhosa tribesman coated with black paint is bombarded by light. This test at a gold-mine research center helped measure the body's capacity to withstand heat below ground.

James L. Stanfield

right:

1988, Swartruggens, South Africa

Sunbeams spotlight deacons of the Dutch Reformed Church as they lift their voices in Sunday hymns.

David Turnley

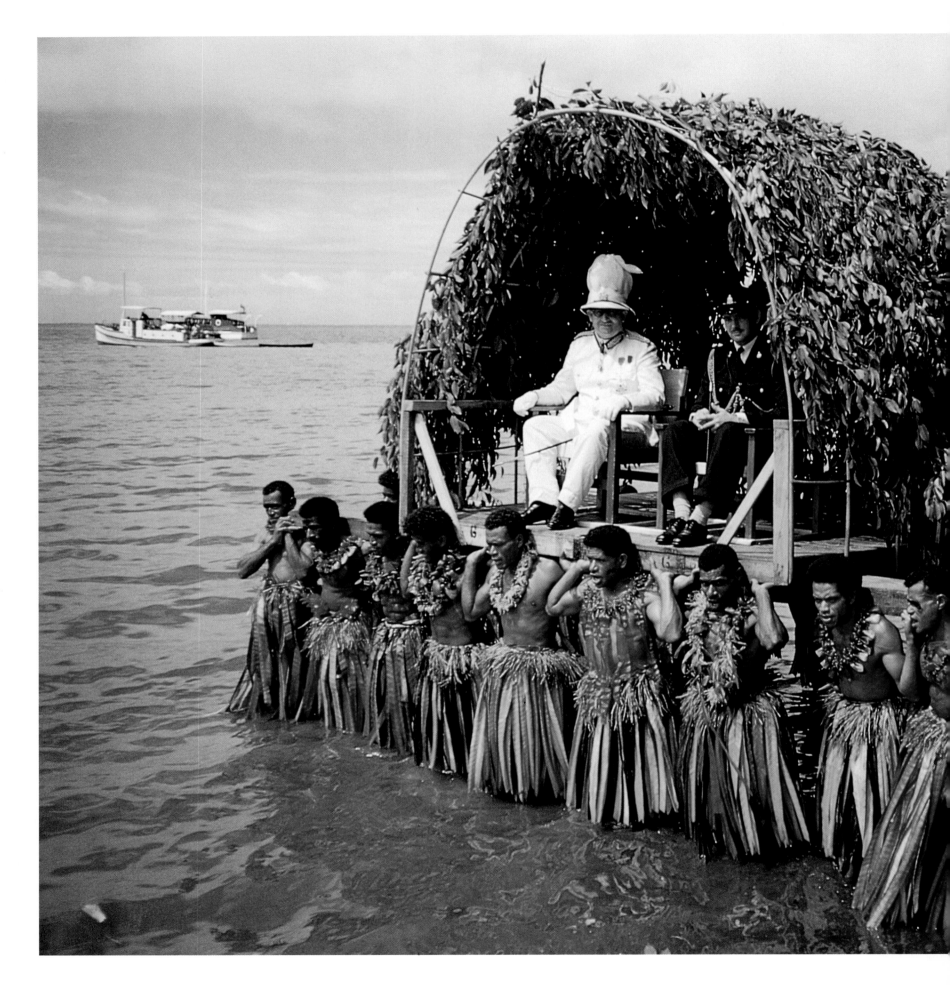

OCEANIA

By Roff Martin Smith

1958, Fiji
Chanting Fijians ferry colonial governor Sir Ronald Garvey and his
aide-de-camp from yacht to shore on an embowered platform — an
honor traditionally accorded high chiefs.
Luis Marden

following pages:
1997, Tahiti
Personal escort ashore by smiling islanders concludes a lagoon
cruise for French tourists.
Jodi Cobb

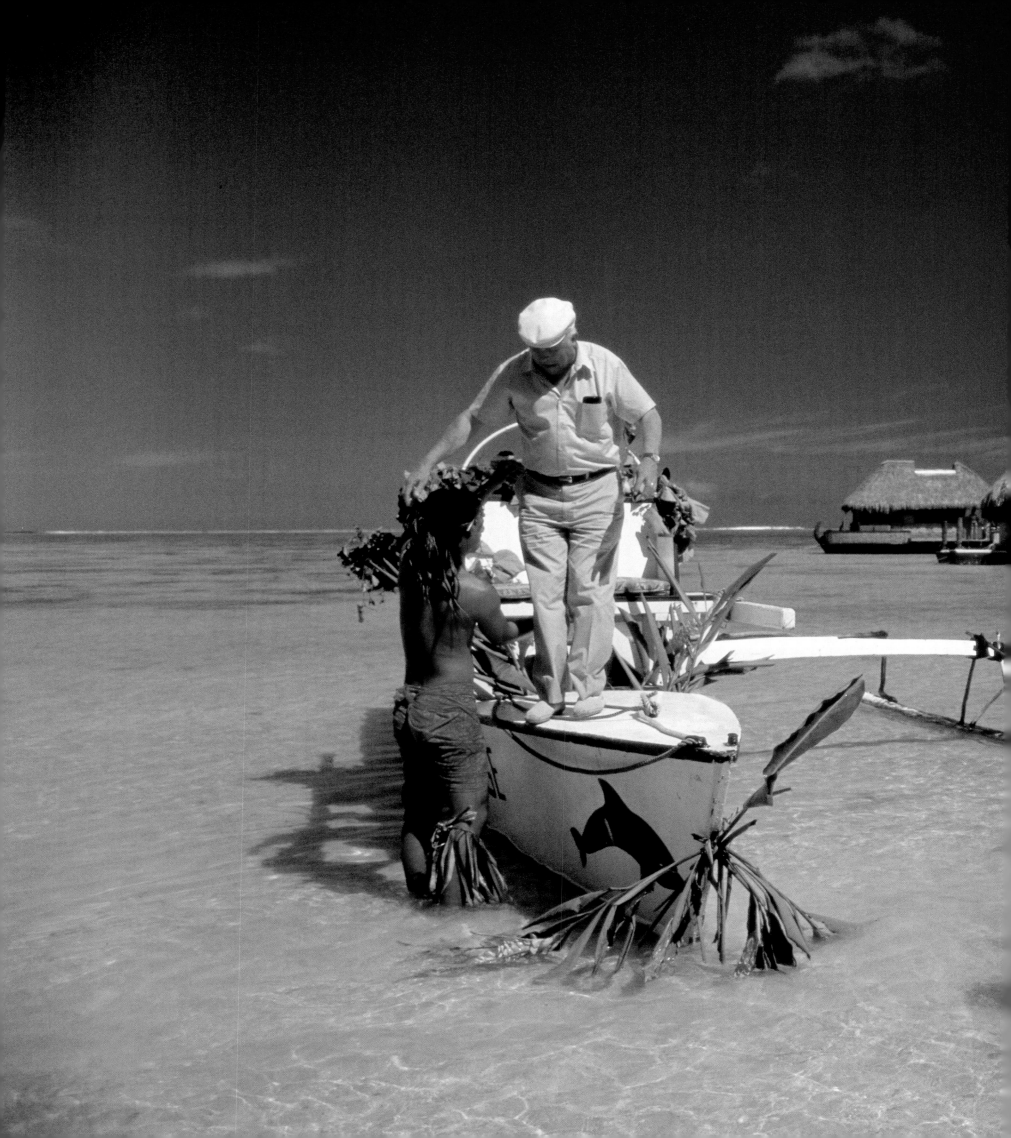

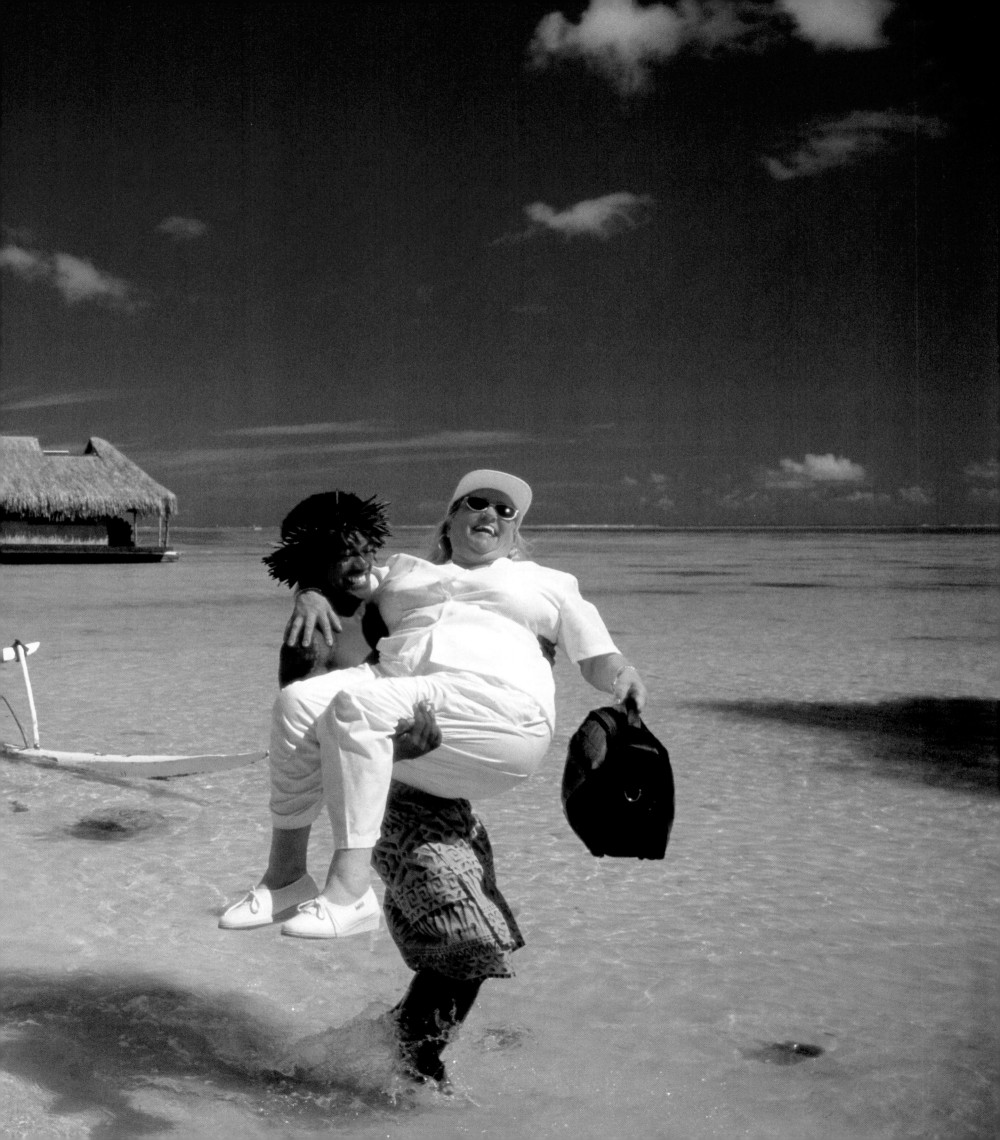

Dusk was falling over Australia's lonely Highway 66, a skinny ribbon of bitumen that follows the Tropic of Capricorn westward into the dusty heart of Queensland. I was three days out of Rockhampton and the southern end of the Great Barrier Reef, riding around the continent by bicycle on a 10,000-mile odyssey that would become a three-part series in NATIONAL GEOGRAPHIC magazine. I'd hugged the coast since leaving Sydney but decided the Australia I was looking for would be found in the sunburned reaches where ranchers measure their property in square miles, fly to town in the family Cessna, and send their children to school by radio. Ahead was the town of Comet, a solitary streetlight illuminating the general store. I pulled over to buy a carton of milk. As I scooped up my change, I asked the man behind the counter if I was finally in the outback. He smiled and shook his head. "No, mate. Not yet. You've got to keep going a ways. It's somewhere farther on out there." He waved his hand vaguely towards the west.

Over the next few months, as I traveled 10,000 miles around this continent, I'd hear the same reply so many times, from Longreach to the Gulf of Carpentaria, from the Great Sandy Desert to the Nullarbor Plain. The outback is always just over the next horizon, unfettered by the here and now. It isn't until you've lived here for some time that you begin to understand that the outback isn't a place you can reach even in the lowest-range four-wheel drive. It's a place in the Australian mind. Part myth, part ballad, it's the freedom of the drover, the camaraderie of the shearing shed, and the laconic wit of the slouch-hatted diggers who waded into legend (and a hail of bullets) at Gallipoli in 1915. It is *Waltzing Matilda*, Australia's lilting, unofficial national anthem, about a happy-go-lucky vagabond who steals a sheep for his dinner, is spotted by the police, but drowns himself rather than submit to being locked up. It is Australia's soul.

Tapping into that soul is the reason NATIONAL GEOGRAPHIC keeps returning time and again to the empty voids "beyond the black stump." It isn't just Australia that has lured us into the antipodes. The islands of Oceania—such as Fiji, the Solomons, Papua New Guinea, New Zealand—have captivated our imaginations, and our lenses, as well. It helps, of course, that the seas are the color of turquoise, the strange and wonderful landscapes are filled with flora and fauna found nowhere else on Earth and touched with the romance of distance. In Australia, where I have done most of my coverage for NATIONAL GEOGRAPHIC, I've come to understand that in searching for this elusive outback, we search a little for our own lost, last frontiers. And so NATIONAL GEO-

GRAPHIC has celebrated the rough-and-tumble of the bush—the half-wild Brahmin bulls being mustered by chopper; the craggy-faced shearer drinking a quiet beer as the sun sinks into the scrub; an Aborigine spearing a goanna in the desert. Photographers bring back images of termite mounds jutting up like so many tombstones in the savanna grasses around the wild Gulf country, or the primitive silhouettes of baobab trees in the Kimberley, or man-eating saltwater crocodiles lurking in the mangroves. Yes, the overwhelming majority of Australians live in cities—NATIONAL GEOGRAPHIC remarked on that when it visited Australia for a cover story way back in 1916. But it knew then, as it knows now, and as Aborigines have understood for some 40,000 years, that the land shapes who and what an Australian is. And over time the magazine has learned to see the land a bit more as the Aborigines do: a billion-year-old canvas on which dreams are painted.

Certainly those dreams have changed a lot since a fledgling NATIONAL GEOGRAPHIC discussed the prospects of a handful of far-flung English colonies in an 1897 article about Earth's unmapped areas, three full years before those colonies federated themselves into a nation called Australia. In a sense NATIONAL GEOGRAPHIC and Australia have grown up together. Both kicked off the century full of bristling confidence about taming the wilderness and physical achievement. "The southern continent of Australia is in the hands of men of the same origin as those who have developed to such a wonderful extent the resources of Canada and the United States," the magazine wrote then, "and therefore we look for equally satisfactory results as far as the characteristics of that continent permit." Like a social studies textbook, the magazine focused on fact—wool bales being hauled to market, freshly scrubbed city streets, soldiers going off to war—with a nation-builder's appraising (and generally approving) eye. That 1916 photo of the pipe-smoking gent boxing a kangaroo seemed to say it all.

NATIONAL GEOGRAPHIC visited Oceania often over the next few decades, sailing the archipelagoes in a schooner in 1928, tramping the jungles of Papua New Guinea ("To the Land of the Head-Hunters") in 1955, diving for pearls in Tahiti in 1997. Covering Australia generally meant filling jerry cans with spare petrol and driving Land Rovers into the bush. By the time I came to Australia in 1982, on the 50th anniversary of the opening of the Sydney Harbour Bridge, the magazine's coverage had pretty well settled on Australia as a last pocket of empire. A quirky anachronism that had somehow managed to survive in sunny isolation, much the way its marsupials did after their continent went walkabout 65 million years ago when Gondwanaland broke up. At the Anzac

Day parade in Sydney after I arrived, the New South Wales police band, in white pith helmets, played "God Save the Queen," which self-conscious Australians preferred to their own national anthem.

People referred to radio as "the wireless" in those days. Social climbers looked for their names in the Queen's Birthday and New Years' Day Honors lists in the hopes Her Majesty might have conferred a knighthood on them, and many Australians spoke of England as "home." Bush legends like *The Man from Snowy River* were ripe with imagery for photographers and writers alike, but there was little exploration of the complex relationship Australians have with their unique land and heritage. Even in the way the magazine photographed Australia in those days there was a postcard's wistfulness: A shirtless bloke, beer in hand, called a "wide" in an informal cricket match in a leafy city park; a bevy of uniformed private school children smiled in their straw boaters in a 1979 article called: "Big, Breezy, and a Bloomin' Good Show: Sydney."

Of course, Australia was just one of the screens dotted across the Pacific on which the magazine and its readers projected lazy tropical romance. From the statues on Easter Island to the 1928 photo of four wooden idols on the New Hebrides where, the caption explains, "the author witnessed a weird ceremony," NATIONAL GEOGRAPHIC's stories on Oceania touched a special part of each of us. Here, perhaps more than anyplace else on the globe, is where readers wanted to preserve the notion of a simple carefree existence. Troubles in paradise were duly noted—like the time Papua New Guinea headhunters murdered a colonial patrol officer who was to have guided a National Geographic bird-watching expedition in 1955—but couched in ways that heightened the sense of romance and danger, rather than delved into any uncomfortable questions. When NATIONAL GEOGRAPHIC came down under, the wish list was simple: photographs of kangaroos, Aborigines throwing boomerangs, and colonials who played cricket on hot summer days—in January. If the story was out in, say, the Solomons, Tonga, Fiji, or Tahiti, look under Rousseau. And for the most part, Australia and the rest of Oceania seemed only too happy to oblige.

For Australia the wake-up call came early one day in September 1983. Australians turned on their TVs to see a yacht called *Australia II* win the America's Cup, a long-shot victory that seemed to jump-start the 1980s. Buoyed by success, they strode onto the world stage as players in their own right, rather than as England's bucolic country cousins. Where one Australian entertained the world with *Crocodile Dundee,* another bought 20th Century Fox. Fosters' Lager and Vegemite and "putting a shrimp on the barbie" became part of the world's vernacular. Throughout the '80s, a deep

sense of confidence seemed to spread around the country.

It was infectious. NATIONAL GEOGRAPHIC devoted its entire February 1988 issue to Australia's bicentennial—one of the few times the magazine (which was celebrating its own centennial that year) had done a one-topic edition. The pictures that sprang from

1972, West Irian, New Guinea
His brother's death leaves this Asmat headhunter with two families to care for.
Malcolm S. Kirk

the pages proclaim a new Australia. A toddler dances on the table at a Greek wedding in a Sydney suburb; a Lebanese woman, fleeing her war-torn homeland, sobs with relief as she arrives at Sydney's airport; a Filipino boy is comforted by a new mate on his first day in school. Along with the visually pleasing image of traditional Aboriginal dancers silhouetted against the delicate pink

Kakadu sunset, the magazine's increasingly demanding readers were challenged with the gritty black-and-white realities of Redfern, Sydney's version of the South Bronx, and the bruised face of an Aborigine woman whose boyfriend had just beaten her.

Perhaps the most telling photograph of the lot was the portrait of the two middle-aged women from Whyalla, South Australia, quintessentially and sturdily English, dressed in their whites for an afternoon of lawn bowls. There was an elegiac tone to the image, as though it were a museum exhibit of late 20th-century colonial British heritage, held at arm's length for critical appraisal. Which is exactly what Australians were starting to do. Questions which a few years earlier would have come only from the radical fringe—Should Australia drop the Queen and elect a president instead? What about getting rid of the Union Jack on the corner of the flag?—suddenly became part of mainstream debate.

Over in French Polynesia, radical questions about national identity have been asked for a generation. Riots on the streets of Papeete over France's decision in 1996 to resume nuclear testing on Mururoa and Fangataufa Atolls brought the magazine's writers and photographers to Tahiti. Instead of relegating the troubles to a cursory mention, obscured in romantic imagery, as might have been the case a generation ago, NATIONAL GEOGRAPHIC led with it. The action-blurred campaign photo of Polynesian independence candidate Oscar Temaru contrasts with the settled image of French Polynesia's Francophile President Gaston Flosse, wearing the tricolor and reviewing the troops on Bastille Day. Like the spreads that precede them, they are elegant images, done with the glossy panache readers have come to expect from NATIONAL GEOGRAPHIC. But unlike the photographs of years ago, these work harder, bring home deeper truths. Beauty and romance are still big themes—the cover for the 1997 Polynesia story, of the classically beautiful woman wearing black pearls, must be one of the magazine's most stunning ever. But today's readers, writers, and photographers understand that beauty, like that strand of pearls worth thousands, often comes at a price.

In growing into their uniqueness, Oceania and especially Australians have taken that deep breath and looked hard at their often brutal past. A few years ago the Australia High Court ruled that the continent had not been *terra nullus,* or no-man's-land, when the First Fleet arrived in 1788. That Aborigines had held clear title to their land. The landmark ruling sparked a spate of claims over valuable national parks, pastoral leases, and billion-dollar ore bodies which could have divided a less easy-going nation. Instead, there is more a feeling of a family squabble. And a sense

that things will sort themselves out, justice will prevail, but without any irreparable rifts. A few years ago when I was writing a story on Aboriginal affairs for another publication, I stood on the dried bed of Victoria Lake, in far western New South Wales, looking out over thousands of skeletons in the stone-hard mud; the largest Aborigine burial ground ever discovered. It had been uncovered when engineers from the water board drained the lake to inspect a dam. It was undoubtedly a sacred site. It was also a lake that provided the city of Adelaide with drinking water. It could have been the subject of a bitter legal battle. Instead, the Barkindji people and water board officials met on the lake bed and with goodwill began to work out a compromise that, it is hoped, will protect both the graves and the drinking water. "The spirits knew we were trying to help them," John Mitchell, a tribal elder, told me. "And they have helped us. Taking care of these graves together has brought Aborigines and Europeans closer. That is the best thing."

Of course, not all history's skeletons will disappear as easily as those along Victoria Lake. NATIONAL GEOGRAPHIC has remained in touch with this. Magazine and readers are both more willing to confront the issues. No longer is it possible to stand on the edge of an Aboriginal graveyard in the Great Sandy Desert, look at the crumbling crosses, and comment on the tireless work of the missionaries as might have been the case a few decades ago. Today the camera eye is more likely to focus on the dates on the stones and provoke questions like: Why are so many dying in their twenties and thirties? What is being done about it? And by whom?

Readers still love it when NATIONAL GEOGRAPHIC introduces them to strange new people all around Oceania. Feathered, tattooed, and ocher-painted, they used to stare from the magazine's early pages like incarnations of Rousseau's noble savages. In the caption to a 1928 photograph of a well-muscled islander, holding his long fishing spear in a classic pose, readers are told: "Of a light brown color and with handsome features and splendid physique, the Samoan is considered the perfect type of Polynesian." Like a Grecian urn being presented for examination.

Photographs today have to carry an element of universal humanity—often, even preferably, touched with gentle, revealing humor. Consider the 1997 photograph of the laughing, middle-aged tourists being carried ashore by equally laughing Tahitians. And contrast it with Luis Marden's 1958 photograph of the stiffly formal viceroy-like figure riding in a sedan chair carried by natives. When readers smile at the modern image, it is a smile of recognition with no trouble seeing themselves in any of the roles. It is also a poke at the simplistic way they used to view the world.

Readers today are only too well aware that the idyll of traditional life along a palm-fringed lagoon or jungle stream comes at a high price. "My grandmother was a cannibal," a Papua New Guinea-born mining executive confided to me one afternoon in Port Moresby, when we were talking about the effects that pollution from the giant Ok Tedi copper mine was having on village life along the Fly River. "We are talking about someone I can remember from my childhood who actually ate human beings. We don't want to live like that anymore. And why should we have to? We want jobs and money and a good lifestyle like anyone else."

Chasing that means changing the myths. While in the rain forests of Papua New Guinea that may mean juggling Stone Age and Silicon Age values, in Australia it means looking at the cities. American fast-food chains, movies, music, and television shows are fast making Sydney into a version of Omaha or Sacramento or Hartford. When I came here in 1982, finding an American staple like Oreo cookies meant searching the imported gourmet foods section in a high-toned department store—and then paying almost ten bucks a packet. Now I just head to the supermarket.

Convenient. But even to an expatriate Yankee like me, Australia's rush to embrace a bigger, bolder, badder Americanized culture sometimes seems too uncritical, and unquestioning. Once, on my long trek around the continent, I took a blank map of the United States into a video arcade in Melbourne and asked the kids who were wearing Chicago Bulls gear if he or she could point to Chicago. No one had a clue where it was, but they could give me the latest stats on Michael Jordan's scoring percentage or Dennis Rodman's tattoos. Rap music, pumped-up Nikes, and baseball caps worn backwards have become part of Australian street credo.

And not just among the kids who hang out in big city video arcades. When I rode into Bidyadanga, a remote Aboriginal community in the Great Sandy Desert, the first thing the kids wanted to know, once they understood I was an American, was whether I knew Michael Jordan. Had I met Shaquille O'Neal? Been to a Chicago Bulls game lately? And, as an aside, had I ever gone out with Pamela Anderson? "Of course," I joked, "But we broke up. She wanted me only for my body." We shared a laugh. I noticed one of the older guys wincing. A friend of his explained that it was from the pain of his still-healing scars from his initiation into adulthood. I marveled at this juxtaposition of cultures. I snapped a photo of some of the younger kids, giggling shyly before the lens, in their Charlotte Hornets gear. It ran in February 1998.

Finding out where this is going is what will keep NATIONAL GEOGRAPHIC coming back, heading out west where the rain doesn't fall, looking for that elusive outback. Seeking to discover what dreams Australians are projecting there now. And, we hope, spurring readers to find some of their own. No longer are pictures of Aborigines captioned: "The Happy Native Kangaroo Hunters: Queensland," as in December 1916, or are stories run like: "A Schooner Yacht out of Boston Drops in at Desert Isles and South Sea Edens in a Leisurely Two-Year Voyage," which appeared in August 1937. But neither has NATIONAL GEOGRAPHIC magazine lost its wonder at the world, its sense of romance, or its dedica-

1993, Irian Jaya Province, Indonesia
Open-air market draws local customers for T-shirts.
George Steinmetz

following pages:
1993, Fiji
Five-year-old Olivia Kerecagi sprawls on local handiwork
during community weaving in the village of Yandrana.
James L. Stanfield

tion to bringing both to its readers. And while the magazine is aware that readers today are harder-edged, more savvy, immersed in a culture of instant communication, it also knows that a large part of each of us still wants to believe in palm-fringed Edens where civilization hasn't yet left a footprint in the sand. To move with the powerful throb of a didgeridoo on a starry desert night. And to know that if we ourselves can't share the mythical, carefree life of a drover in the outback, we can still hear about those who do.

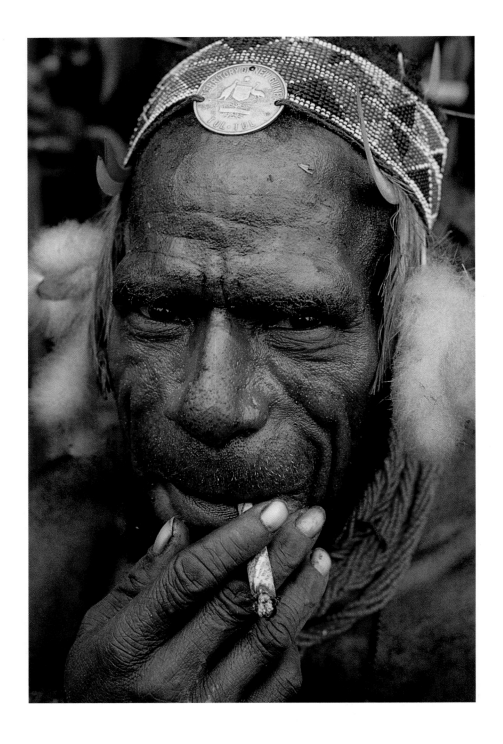

1962, Mount Hagen, New Guinea
Forehead medallion distinguishes this "tul-tul," or village leader,
decked out for an intertribal fair. He wears a beaded headdress
and face paint the color of the northern cassowary,
a fierce island bird.

John Scofield

right:
1994, Papua New Guinea
Prized by New Guineans for its colorful feathers and lean,
dark meat, a cassowary falls victim to hunting dogs in the
Hunstein Forest.

Jay Dickman

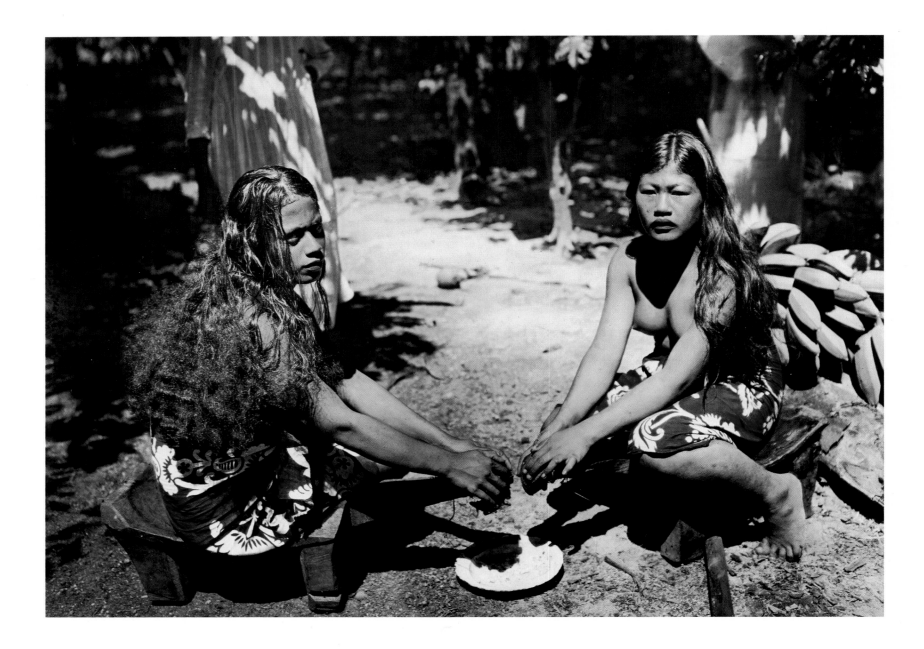

1925, Rimitara, Austral Islands
In a scene reminiscent of a Gauguin canvas, young island
women grate coconut on the long necks of stools
fashioned for this purpose.

Rollo H. Beck

right:

1997, Papeete, Tahiti
Western finery replaces native dress at a Sunday service,
where the sermon is offset by rousing *himenes,* Tahitian-
style hymns.

Jodi Cobb

"There it is!" James Michener wrote in 1951. "Vast, insignificant
Polynesia, ruled badly by many different nations, victimized by
all kinds of robbers. It is not rich. Its people seem to have few
causes to be happy. [Y]et these trivial islands have imposed on his-
tory the most lasting vision of the earthly paradise. Why?"

Simplicity is one answer. Quandaries seem to lose their urgency
in Polynesia, as if blown away by the sweet Pacific breezes. Fecun-
dity is another. Food grows on trees and swims in the sea.…
Beauty is a third. Nowhere on earth can one so quickly overdose
on breathtaking gorgeousness. And then there are the people.
Answering his own question, Michener continued: "Without these
remarkable people, the island [Tahiti] would be nothing."

June 1997, NATIONAL GEOGRAPHIC
from "French Polynesia: Charting a New Course"
by Peter Benchley

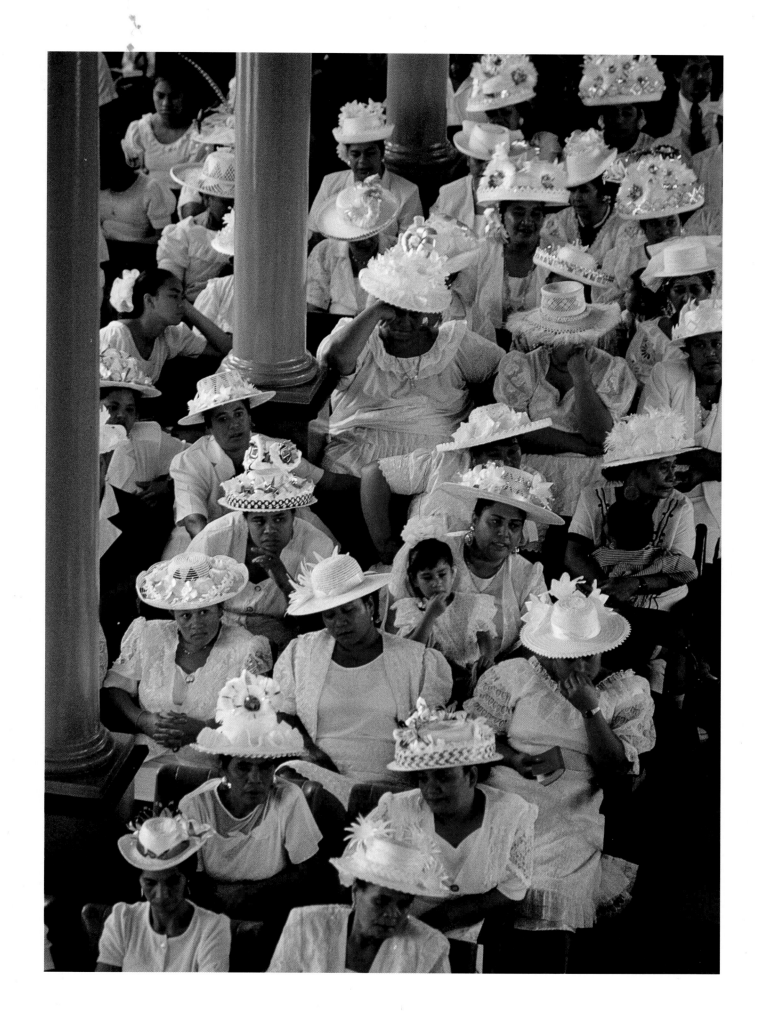

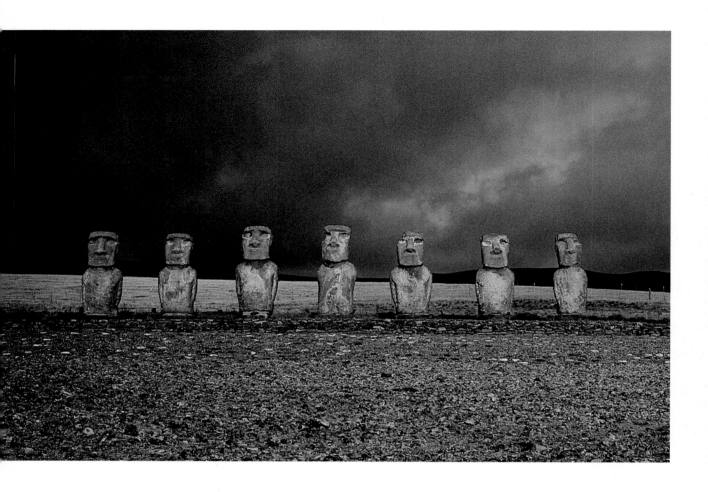

1962, Easter Island
Great stone statues called "moai" gaze across the volcanic landscape in mute testimony
to the culture that produced them centuries ago. Who carved the 14-foot, 16-ton
monoliths and why, as well as how they were transported, has long been a mystery.

Thomas J. Abercrombie

right:
1993, Easter Island
Painted reveler at a dance following a memorial parade of boats glows with symbols
evoking the gods of his ancestors.

Bob Sacha

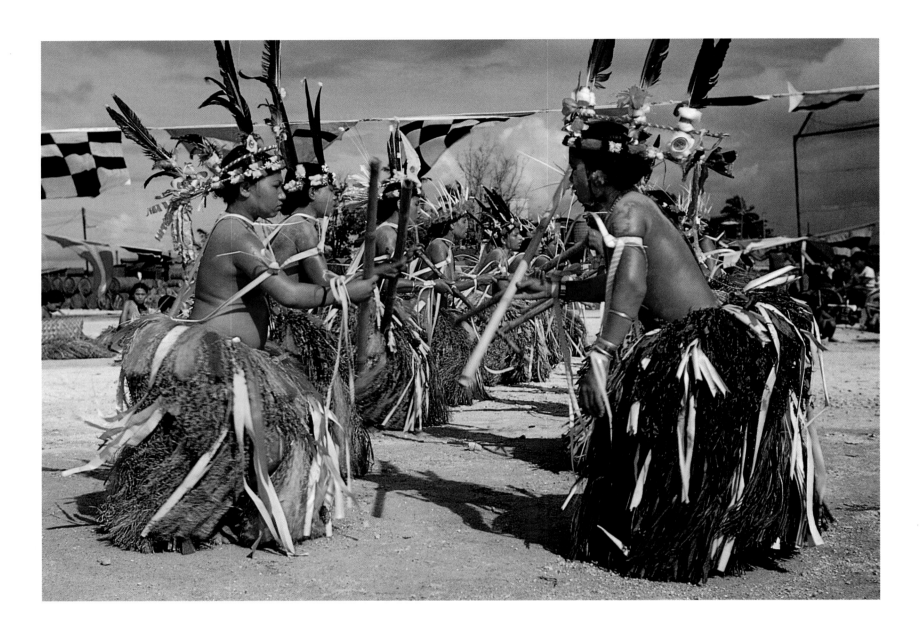

1952, Yap Islands
Following World War II, the beat goes on in U.S.-occupied Yap. Here women step to the chant of a stick dance. Thirty pounds of grass rustle in each skirt; and headdresses display lively collages of feathers, flowers, and for one creative dancer, a cigarette package.

W. Robert Moore

At first glance the Yap people might seem to be among the most primitive island folk in Micronesia. But their rejection of foreign ways does not mean lack of a well-developed culture. They possess one of the most complex native social systems in the western Pacific and are proud enough of their own traditions and customs to want to retain them. Until recent years these islanders were seafaring people. They sailed their outrigger canoes southwest to the Palaus and roamed among the atolls hundreds of miles to the east. A number of the [islands] still look upon the Yap chiefs as their masters. Although Yap has experienced the control of Spain, Germany, Japan, and now Uncle Sam, foreign influence has made little impress. The Japanese, for instance, made youngsters wear clothes in school; the moment classes were ended, off came the clothes!

December 1952, NATIONAL GEOGRAPHIC
from "Grass-skirted Yap"
by W. Robert Moore

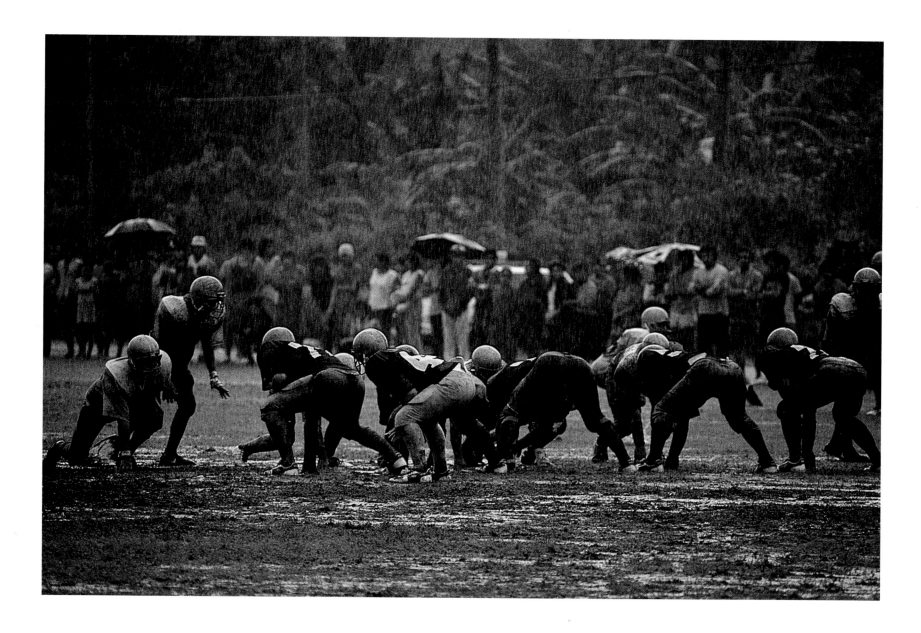

"Traditional Samoan society, [explained Ili], is both communal and authoritarian. Each village is composed of one or more *aiga,* or extended families, some numbering hundreds of members. Each aiga chooses its matai. Communal land is vested in the matai, who oversees its distribution. Matai belong to the village *fono,* or council, which sets policy and adjudicates grievances and once held the power of life and death.

"Today," continued Ili, "the younger generation has more knowledge of the outside. Fewer and fewer are looking to the land. They are dreaming of how to get money in their pockets. I am trying to think ahead, to see what we can do to match the times. The matai system has to change; it has to provide new solutions for new problems. But it will never disappear."

1985, American Samoa
Drenched but determined, high school football players vie for the big goal: A scholarship to a stateside school offers a way off the island and a chance to follow in the steps of Samoans who have played on professional teams.

Melinda Berge

October 1985, NATIONAL GEOGRAPHIC
from "The Two Samoas: Still Coming of Age"
by Robert Booth

1925, New Zealand
**Maori girls greet with a giggle and the customary
pressing of noses, the hongi. It is accompanied by
a low "mm-mm."**
Carlos E. Cummings

The women are no less dignified and proud of bearing than the men and exhibit a grace of movement and litheness of body unknown in any but South Sea races. Were it not for the tattooing of the lips and chin after marriage, many of them would be extraordinarily beautiful. Some of their customs are very amusing, and one can scarcely repress a smile to see the women saluting their friends in the street by rubbing noses. They carry the babies slung upon their backs, as do our Indian squaws their papooses. Indeed, in the Maori, one is constantly reminded of the American Indian.

August 1925, National Geographic
from "Waimangu and the Hot-Spring Country of New Zealand"
by Joseph C. Grew

Haka! Once Maoris put on this startling display of hostility to intimidate their enemies. Now it is performed to welcome visitors. Four men…froze for a moment with feet apart, knees bent, fists clenched, then charged the cold air with a throaty, blood-curdling chant that was music and war cry, agony and triumph: "*Ka mate, ka mate!*—It is death, it is death! *Ka ora, ka ora!* It is life, it is life!" It was a show of power, with punching arms, flashing teeth, rolling eyeballs, and thrusting tongues, until the final leap brought them, thundering, back to earth. "This haka," Marino panted, "the Maori Battalion did on the island of Crete before our first bayonet charge against the Germans, and…." His voice dropped to a whisper, "I've seen those soldiers, madame, with my own eyes. They were no cowards, yet they turned and ran…."

1984, New Zealand
Tribal custom and shared service in World War II bind two Maori veterans at a memorial day ceremony.
Yva Momatiuk and John Eastcott

October 1984, NATIONAL GEOGRAPHIC
from "Maoris: At Home in Two Worlds"
by Yva Momatiuk and John Eastcott

Australia

"What began as an article on [Australia's] bicentennial grew to consume this entire issue," Editor Bill Garrett opened the February 1988 magazine. Its words and pictures spirited readers to coast and outback, from Tasmania to the Great Barrier Reef. Showcased were the peoples and their heritages: the Aborigines of ancient Dreamtime, the first white settlers—English convicts, and the diverse residents of today. The issue delivered a full update on a land covered some 60 times, starting in 1897 with "The Great Unmapped Areas on the Earth's Surface Awaiting the Explorer and Geographer." As these images reveal, there is still much to cover, and the coverage is still going strong.

above:

1916, Australia

Giant nests six to ten feet high were denounced as the work of the white ant, the "hated...termite of unusual destructive ability."

Herbert E. Gregory

left:

1996, Cape York Peninsula, Australia

Like open-air stalagmites, termite mounds tower above charred grassland. The insects play a vital role in enriching the soil by recycling dead wood and grass.

Sam Abell

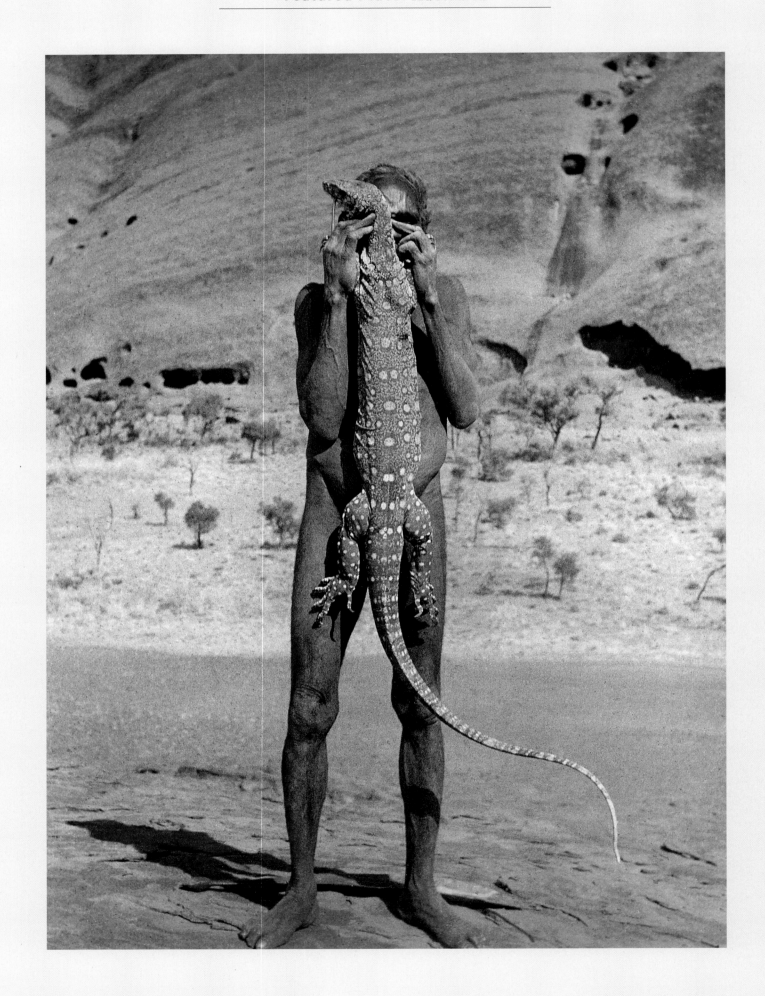

Looking carefully at the floor of the cavern, we see stone spear-points, scrapers, and the bones of the animals people hunted. Overlying these objects are more recently used artifacts: beer cans, plastic bottles, and corroded batteries.

On the walls, beside finely drawn paintings of fish and an echidna, or spiny anteater, are crude images of goats, pigs, and buffalo, brought here for the first time about a hundred years ago—dramatic evidence of one culture's retreat in the face of another.

In the silence of the now empty rock complex, the spirit of the old inhabitants is still palpable. The ashes of their last fire seem fresh. But the Gagudju have left Malangangerr and now live elsewhere in the park. Many have relinquished their ancestral lands altogether.

We feel an almost overwhelming sense of loss, for the Gagudju's culture—a remnant of one going back 40,000 years or more—may well disappear over the next few generations, a casualty of human movement and dimming memories.

<hr/>

February 1988, NATIONAL GEOGRAPHIC
from "The First Australians"
by Stanley Breeden

<hr/>

To go bush. To escape, for a while, into nature. To draw sustenance from the land. Physical sustenance. Spiritual sustenance.

For a few hours I go bush, drive outside of town, stop and gulp the astringent eucalyptus-scented air.

"Come, look," says my guide, Kerry, and in the spindly arms of a mangrove tree shows me the bower of a fawn-breasted bowerbird. It is a delicate structure. Two parallel rows of slender branches that curve toward each other, lined with bits of green glass and shells plucked from the banks of a nearby river. An elegant ruse by the male to attract the female for mating.

It is quiet. The bower—exquisite. Forgotten are the heat, dust, and flies of Aurukun. The blanket of darkness lifts. Momentarily, I feel restored.

The bower of a bird. The hush of a swamp. A glimpse of the tender connection of the Aborigine and the land. How it nurtures. How it heals.

<hr/>

June 1996, NATIONAL GEOGRAPHIC
from "The Uneasy Magic of Australia's Cape York Peninsula"
by Cathy Newman

1995, Western Australia
Imprinting the outback, the six-foot flightless emu—Australia's biggest bird—leaves its mark as one of many creatures unique to this continent isolated by continental drift.
Cary Wolinsky

left:

1946, Central Australia
Delicacy of the bush, the giant lace monitor lizard is prized by this Aboriginal hunter and his kin. The meat has been likened to poultry.
Charles P. Mountford

Nine white and Aboriginal ringers were working this muster. The "plant" of 32 horses had been hobbled to limit their grazing range. Two motorbikes, the Toyota truck, and one ringer's yellow baseball cap were the only clues that this was the late 20th century. The night was cold and the fire felt good. The ringers lit hand-rolled cigarettes with pieces of kindling and played an Australian version of mumblety-peg called knifey.

In the cattle yard—an old one made of gumwood and wire—cows bellowed for their calves. "It's good when they're singing out like that," said ringer Jamie Kop. "If they're sleeping, that's when you start thinking. A bird's only got to swoop down on them, one will jump, and the whole lot takes off. It's a funny sound when that wire breaks."

The cows were still sobbing at dawn as we ate breakfast.

The beauty of a man and horse working together was a joy to watch that day as Bobby Hunter, who oversees Stuart Creek, led the drafting. While ringers held the mob in a circle, he rode through it as if through water to cut out 95 "fats" he judged ready for market. The rest would "go bush."

April 1992, NATIONAL GEOGRAPHIC
from "The Simpson Outback"
by Jane Vessels

The aborigines are required to work regular hours for food and clothing. They work at kitchen and garden labor, in crews that gather oysters for sale in Darwin, as hunters, and as hands on construction projects. Tiwi children have attended school since 1954.

But the Government does not interfere with the ceremonials and personal life of these remarkable people. Moreover, at intervals it frees whole families to "go walkabout," to resume for weeks at a time the primitive life of the bush. Thus civilization has made little inroad on the Tiwi of Melville. We were still able to study Tiwi culture largely as it has existed since the Stone Age....

In the evenings at our camp the Tiwi sat smoking stick tobacco in their crab-claw pipes as they thinned canoe paddles or scraped ceremonial spears whose many barbs represented the alligator tail.

And often they gambled at the game Ten High with civilization's cards till it was too dark to count the spots. I never mastered all its intricacies, but the natives played the game swiftly as they slapped down the cards and wagered sticks of tobacco, pieces of calico, or articles of clothing....

March 1956, NATIONAL GEOGRAPHIC
from "Expedition to the Land of the Tiwi"
by Charles P. Mountford

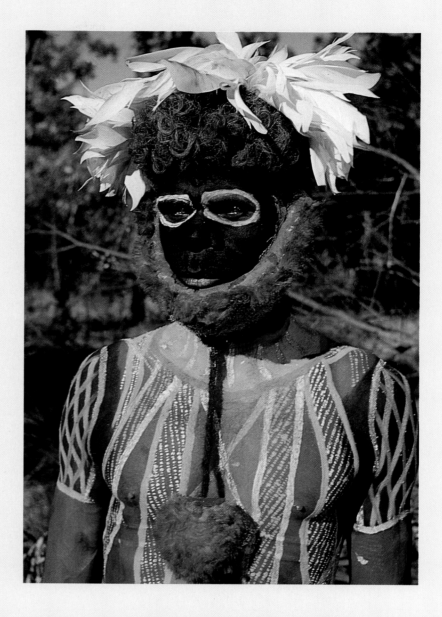

1956, Melville Island, Australia
For a *corroboree,* or funeral dance, for his late uncle, a Tiwi tribesman wears a false beard and paint to prevent the dead man's spirit from recognizing and harming him.
Charles P. Mountford

left:
1992, Simpson Desert, Australia
Lighting a hand-rolled cigarette with kindling, ringer Steven Miller ends a long day's work on Anna Creek, world's largest cattle station.
Medford Taylor

following pages:
1916, South Queensland, Australia
Boulders called Two Brothers, "relics of a bygone geologic age," draw tourists to Bald Mountain.
Herbert E. Gregory

1931, Central Australia
Head ornaments of grass and feathers complete ancient Aboriginal costumes for the "wild duck" dance at a corroborree.
Wilson and MacKinnon

right:
1988, Whyalla, South Australia
British roots run deep in Australia's playing fields. Lawn bowlers Joyce Coulton and Melva Stephens don traditional whites for the game.
Michael O'Brien

Australians seem to be moving ever closer to a new national identity, a truly separate people composed of many parts but distinct. Malcolm Muggeridge once remarked: "To be fair to Australians, they don't afford excessive respect to anybody." But, through sports and business and politics and the arts, they are requiring more respect from the world than ever before—"a-waltzing Matilda" toward a future their forebears could not have dreamed of in their own version of Dreamtime.

February 1988, NATIONAL GEOGRAPHIC
from "Australians"
by Joseph Judge

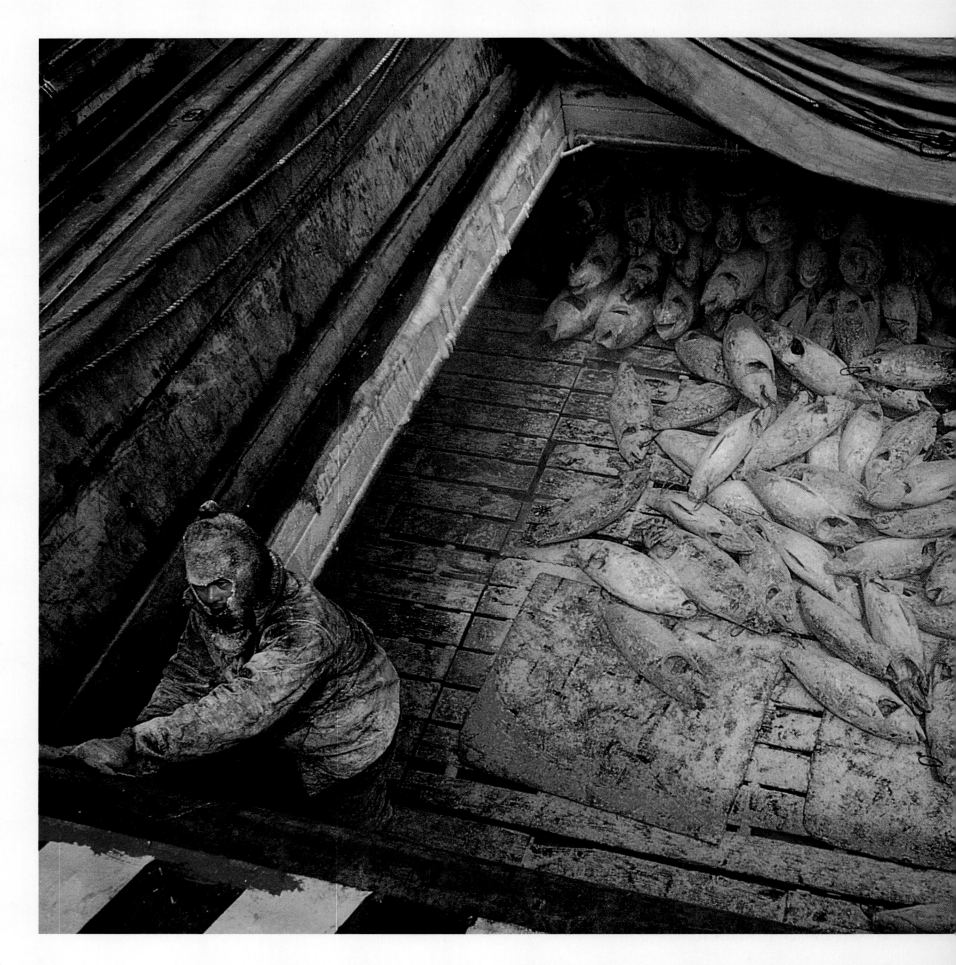

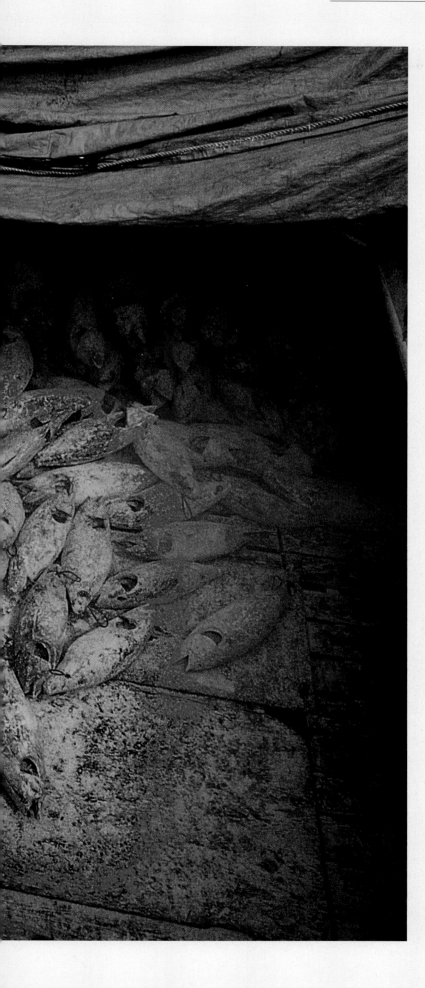

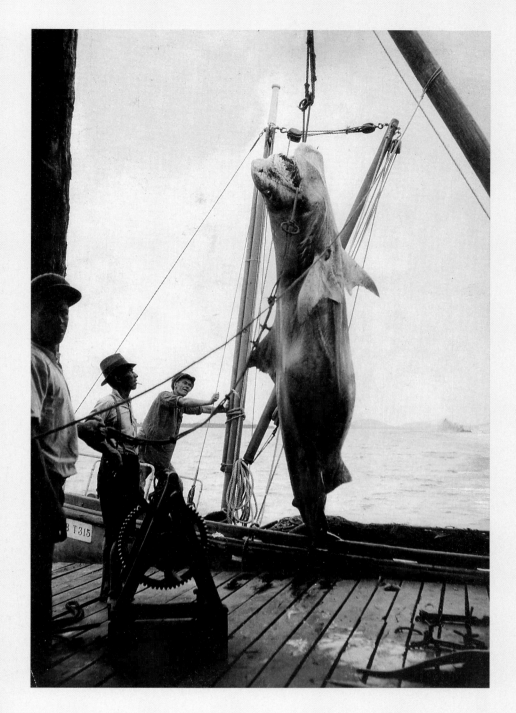

1932, New South Wales, Australia

Skinner Charlie Ping (center) studies a 16-foot tiger shark, which he will soon reduce to its parts for use as food, shoes, and luggage.

Norman W. Caldwell

left:

1987, South Australia

Spectral catch, bluefin tuna caught at deep sea and blast-frozen in the hold await shipment to Japan.

David Doubilet

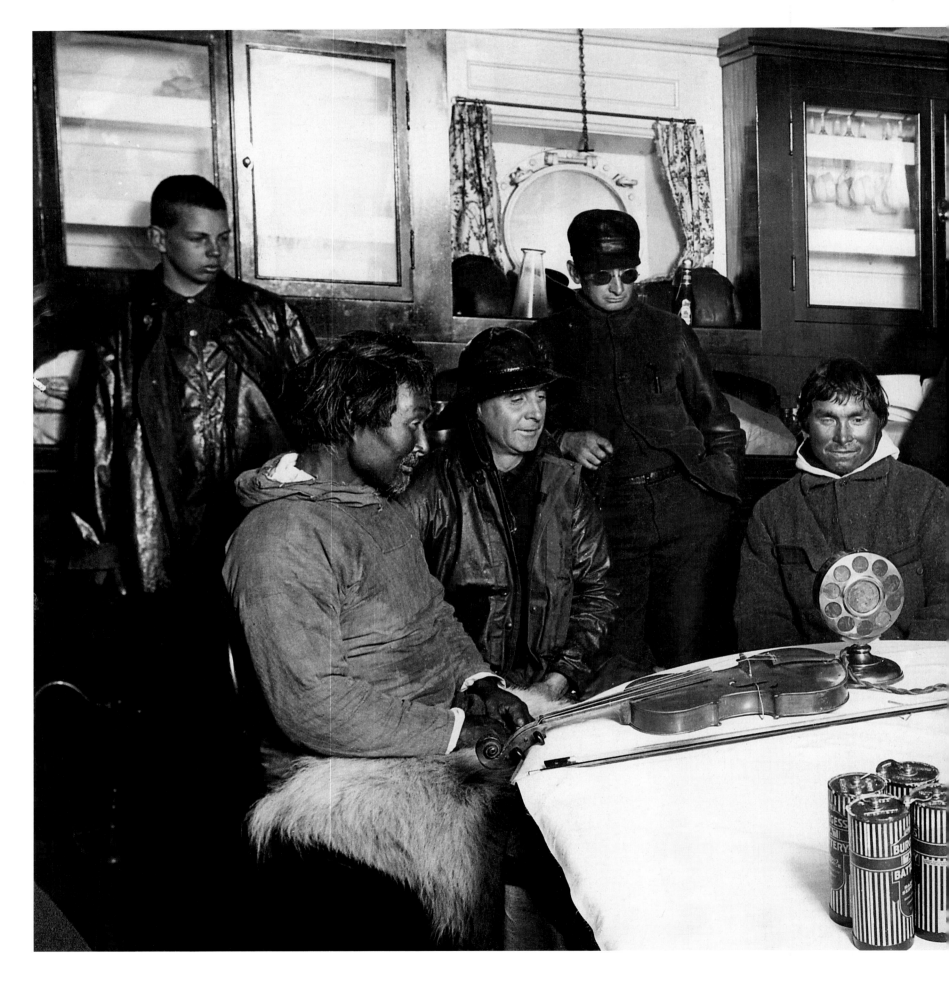

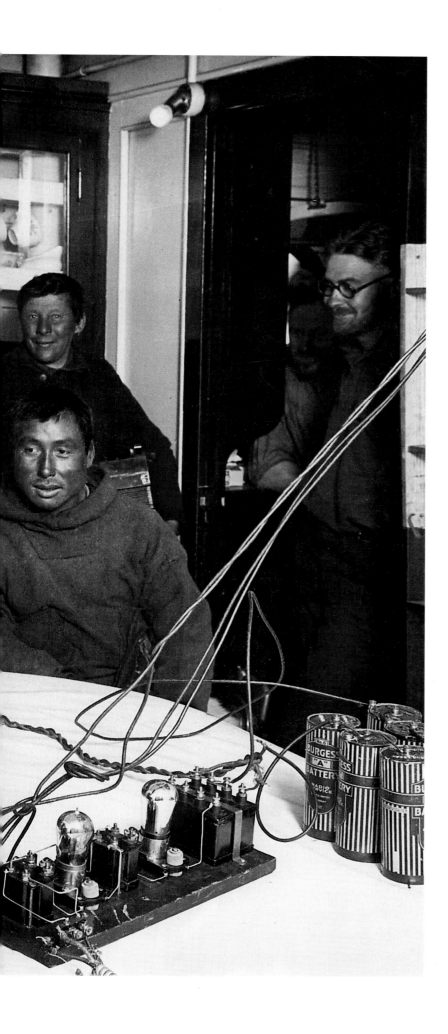

POLAR REGIONS

By Kim Heacox

1925, Etah, Greenland
Shortwave radio links the Arctic expedition led by Donald B. MacMillan (third from left) to the rest of the world. The first polar explorers to have radio contact with home, MacMillan's crew communicated daily with the National Geographic Society, which helped fund the expedition.

Jacob Gayer

following pages:
1990, Antarctica
Seamless world of snow and sky swallows huskies and their handlers, members of the 1990 International Trans-Antarctica Expedition. The six-man multinational team traversed the continent by dogsled.

Will Steger

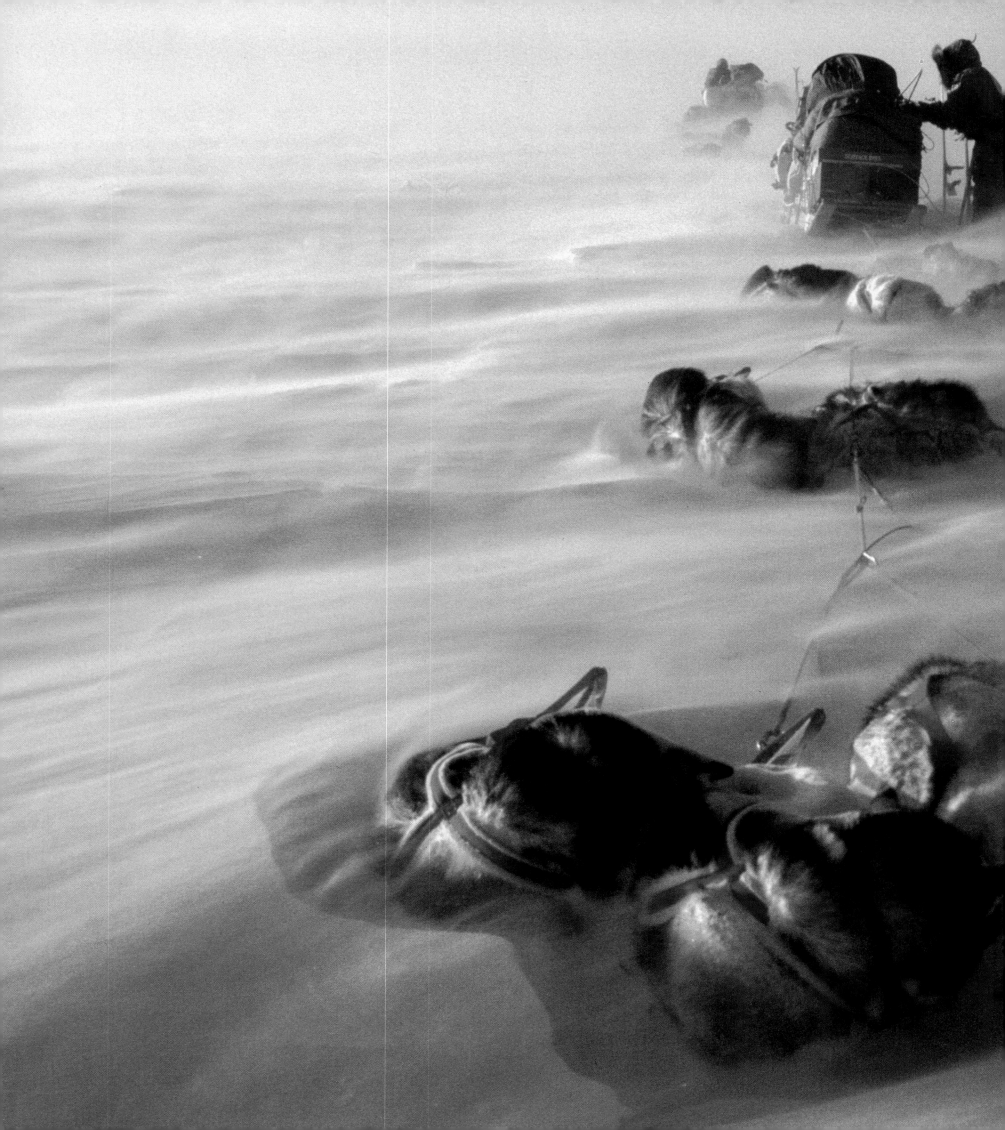

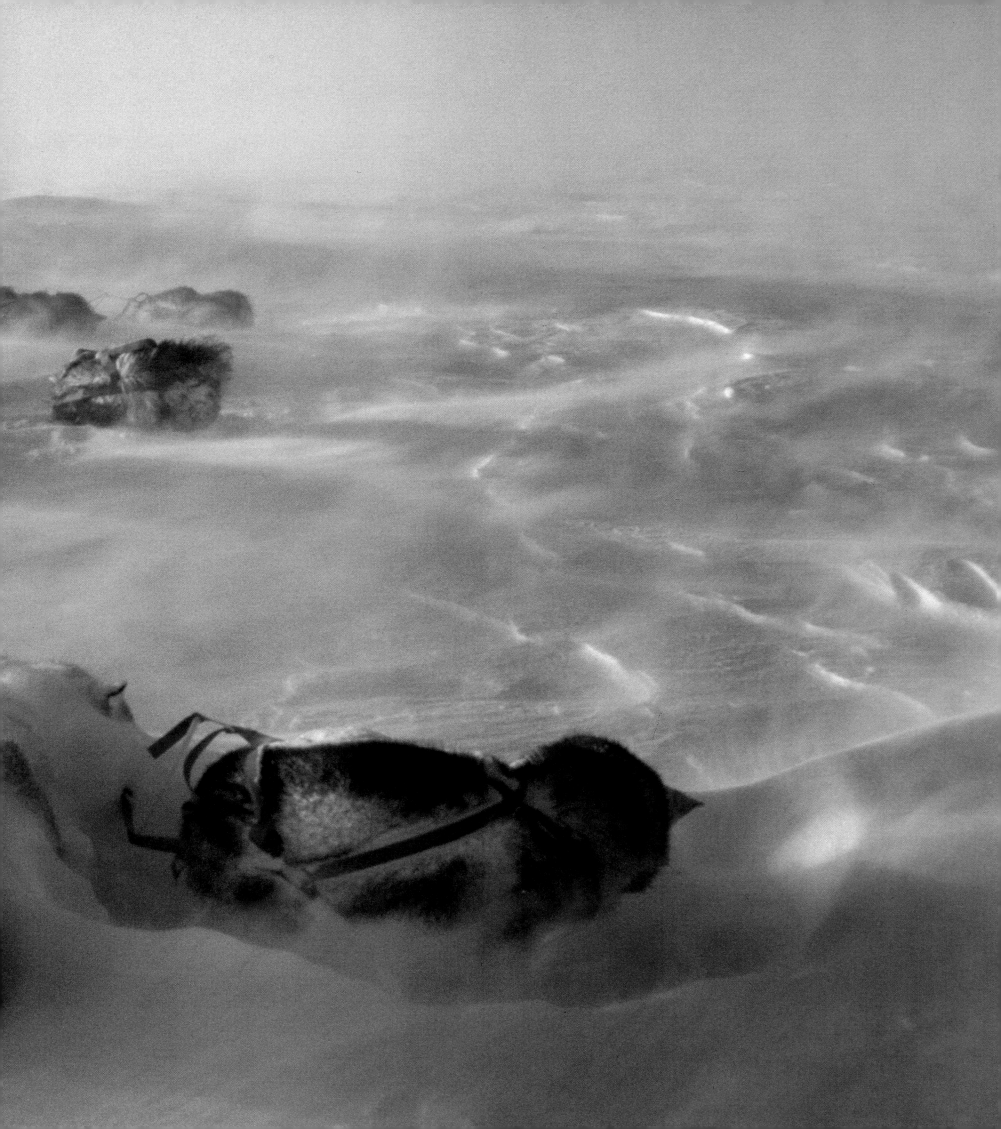

It is an irony of polar travel that death often comes with sleep. Wrapped in wool but weakened from exhaustion and malnutrition, the expeditioner closes his eyes and never wakes up. He is beyond frostbite and fatigue and fear. He is too tired to fight or feel pain or harbor regrets. His final moments fall into a dream, peaceful and warm, and he leaves us.

Think of Robert Falcon Scott and his tentmates on Antarctica's Ross Ice Shelf, en route back from the South Pole, 11 miles from a food cache but pinned down by a fierce storm, trapped, too weak to move, scratching out their final letters to a wife, a mother, the people of England. "These rough notes and our dead bodies will tell the tale," wrote Scott.

They were found eights months later in their tent, which by then was an icy sarcophagus. Their countrymen who discovered them left them there in frozen repose, and built a cairn of snow over them with a wooden cross on which they inscribed the final line of Tennyson's *Ulysses*: "To strive, to seek, to find, and not to yield."

It is fitting that Herbert Ponting's photographs from that expedition are in black and white, for they seem as austere as the place itself, white in summer, black in winter, a six-month day followed by a six-month night. Life followed by death.

Color is unimportant, for without technicolor reds, greens, yellows, and blues, a brutal truth emerges. Shape and dimension speak for themselves. Details become vivid in patterns of ice, the interplay of sun and shadow, the silhouettes of minuscule men on an eternity of snow. Scott and Ponting didn't need to say Antarctica was profound, they just needed to say Antarctica. And they did.

In March 1924, a dozen years after Scott's death, NATIONAL GEOGRAPHIC magazine featured a portfolio of Ponting's work with the opening claim: "The aims of polar explorers have been as pure as the air of those high latitudes." To this day, Ponting's photographs sing with artistry and journalistic merit. One shows what the caption calls a "figure…of Lilliputian size" dwarfed by the "crenelated barrier" of the Barne Glacier and Mount Erebus, "the great White Queen of the Antarctic." Another captures men sitting at a blubber stove, burning seal fat. Yet another shows a trio of penguins hopping across an ice floe to reach the sea. The caption reads: "These quaint creatures of the Antarctic have a layer of three-quarters of an inch of pure fat under their skins. The oil…from their blubber burns much more fiercely than seal oil. Penguin eggs provide an addition to the menu of the explorer; the flesh, after it freezes, is cut into strips and is…eaten on the march."

Never mind penguin ecology or the environment. Those terms would not enter our common vernacular for decades. Never mind wildlife conservation. In Scott's day the objective was to reach a geographical prize—in his case the South Pole—claim it for God and country, and return home.

It was no different in the Arctic. For more than 300 years men had dreamed of attaining two great prizes: the Northwest Passage and the North Pole. The first because it might provide a strategic Europe-Asia trade route across the Western Hemisphere; the second because it was the top of the world. In 1818, 70 years before the National Geographic Society was founded, a British naval expedition landed on the western shore of Greenland and two officers stepped onto land to meet a band of Eskimos. The officers were Commander John Ross and Lieutenant William Edward Parry. The Eskimos were, in their own language, Inuit, "the People," for they had assumed they were alone in this world. They wore clothing and footwear made of sealskin and furs, and stared at their visitors as if they were celestial beings. Ross and Parry wore the same regalia they would have worn on the coast of Africa: cocked hats, shining swords, and black boots that melted into the snow. They had an anglicized Eskimo with them, and in a dialect he could barely understand the Eskimo heard the Inuit ask the British, "Where do you come from, the sun or the moon?"

Photography, like the study of ecology, was not even a child then. It was florid journal entries about Eskimos and castle-like icebergs and summers awash with a radiant midnight sun that began to color men's minds with hues and honors they could not escape. When in the 1840s Sir John Franklin and his 128 officers and crew disappeared in their quest for the Northwest Passage, and his indefatigable wife, Lady Jane, with her Helen of Troy magnetism, inspired ship after ship to search for him, the cause gained international attention. The Arctic had made a martyr. Franklin was to the Arctic what Scott would one day be to the Antarctic: a hero. A bungling hero perhaps, but a hero nonetheless.

"Is Franklin the only man who is lost?" asked Henry David Thoreau in his new book, *Walden*, "that his wife should be so earnest to find him?" Thoreau compelled his reader to "Be…the Lewis and Clark and Frobisher, of your own streams and oceans; explore your own higher latitudes…be a Columbus to whole new continents and worlds within you, opening new channels, not of trade, but of thought."

Transcendentalism resonated with Thoreau, but not with a young Robert E. Peary. Born in Pennsylvania in 1856 (two years after *Walden* appeared), he nursed a hole inside himself that only fame could fill. "I shall not be satisfied that I have done my best until my name is known from one end of the world to the other,"

he wrote to his mother when he was 24. His higher latitudes would be the North Pole, nothing shy of it, and certainly nothing metaphorical or transcendental. The National Geographic Society awarded him its first grant, and the Peary Arctic Club of New York outfitted him with a ship, crew, and supplies. He made base camp on the north end of Ellesmere Island, then pushed beyond. On April 6, 1909, he wrote, "The Pole at last!!! The prize of 3 centuries, my dream & ambition for 23 years. Mine at last. I cannot bring myself to realize it. It all seems so simple...."

Among the photographs Peary made at the North Pole is one of his advance party: Matthew Henson (the black man who clerked in a hat shop when Peary first met him) and four Eskimos, Ooqueah, Ootah, Egingwah, and Seegloo. How appropriately surreal they appear, at once brutal and angelic, their presence in this place as strange as the gray gauze sky. Their fur-rimmed faces and mittened hands contradict their deep footprints in the soft snow. A flag planted atop a pressure ridge rests at ease, unfluttered by wind.

In a future controversy that Peary could not imagine, this photograph would be analyzed to determine if indeed he reached the Pole. Skeptics and supporters alike would study the positions of the shadows, the time of year and time of day, perhaps something in the eyes of the men Peary photographed, if only he'd been closer to them when he tripped the shutter. Does a photograph unveil a soul? Does it steal it? Or does it freeze a moment in time and leave the crystals to weather the winds of fashion, tradition, and history?

Like many kids growing up in America in the 1950s and 1960s, I had access to a library of NATIONAL GEOGRAPHICS on a bowed shelf in my family's basement den. The tattered yellow spines stared back at me with mystery and allure. The pages opened like a vault. The photographs spoke volumes. I remembered the "A" places most: Alaska, Africa, Australia, Antarctica, the Arctic.

Shortly after college I began my real education and moved to Alaska, where I met a Japanese photographer named Michio Hoshino. For weeks at a time Michio would go into the wilds and not come out. He apprenticed himself to Eskimos and Tlingits. He listened to their stories and learned what they meant when they said a good hunter is a patient hunter, somebody who brings the animals to him. Michio became a good hunter. His rifle was his camera; his stories his photographs. He worked on assignment for NATIONAL GEOGRAPHIC and framed his images in a way that made wildlife and natives ache with challenge and change. Moose bellowing in morning mist. A bear with dew on its nose. A snowy owl alighting on its nest with a lemming in its beak. Michio didn't capture these animals, he freed them. He didn't want

portraits, he wanted stories. He wanted the dynamic, not the static. He wanted the universe in a raindrop; the curve of the earth around a single flower one inch from a bootprint.

"Oil in the Wilderness, An Arctic Dilemma," reads the title to an article in the December 1988 issue. Its opening page is a

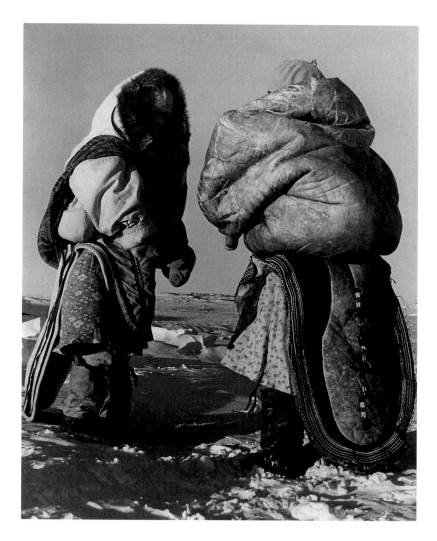

1949, Port Harrison, Quebec, Canada
Babysitters pack their young charges in the voluminous hoods of their parkas.
Richard Harrington

wide-angle photo by Michio of a boatload of dead caribou, antlers stabbing the sky, a tangle of legs and hoofs over the gunwales. Steering the boat across an autumn river are two Gwichin Indian hunters. The land is their grocery store. From these caribou they will fashion boots and mittens; they will cut meat to feed their families. It has been this way for a long time, yet already things are different. The caribou were shot with rifles. An outboard engine powers the boat. And now industry wants to drill for oil where the caribou bear their calves. The hunters are not smiling.

Eleven years earlier, in November 1977, NATIONAL GEO-GRAPHIC printed the story "Still Eskimo, Still Free," about the Inuit of Canada's Northwest Territories. Written by Polish-born Yva Momatiuk and photographed by her husband, John Eastcott, a New Zealander, the story combines heartbreak and hope as ancient subsistence ways struggle beneath the weight of a spreading cash economy. Elders talk about when it started falling apart, when snowmobiles began to swarm the Arctic and people stopped using sled dogs. When mineral and seismic research camps appeared, and ecotourism arrived. Upon first seeing this story I couldn't help but think that it all started to fall apart with Ross and Parry in 1818.

I close my eyes and still see how Eastcott framed the pensive faces and smiling eyes and proud postures. I remember the young Inuit woman off-loading a catch of Arctic char from her fishing boat, the family jigging for trout with hooks handmade from caribou antlers, the villagers playing blackjack while waiting for the annual supply ship. Early in the story, a double-page photo shows a family traveling by skiff across open water. The mother bears her baby on her back, huddled against the wind. The father, with the stub of a cigarette in his teeth, handles the tiller. His son sits next to him. Their faces seem severe as the land. But near the end of the story a full-page photo shows that same man, Kiyok, in a tent. He smiles, perhaps because for the moment his family is safe and sheltered and well fed, and he has a diversion. He wears a wristwatch and a nylon jacket and plays with battery-operated toy cars he got through a mail-order catalog.

I've seen native cultures wither away in Arctic Alaska and heard parallel stories from Canada. The people must now straddle a chasm deeper and wider than anything they've ever encountered, with one foot in the Ice Age and one foot in the jet age. Unlike Thoreau, who when he tired of his own solitude walked from his wilderness cabin at Walden Pond into bustling Concord to dine with Ralph Waldo Emerson, these people don't easily walk between worlds. They have lived in their icescape for hundreds of generations and accepted it as if no other place or life differed. They had no welfare or paper money. They had no choices, until now. Now the choices are many and difficult and often irreversible.

These are the same people after all from whom Ross, Parry, and Franklin could have learned so much, and did not. They are the people who fall asleep in the bitter cold but do not leave us; rather, they awaken ready to hunt and fish and live another day. They are the same people Danish explorer Knud Rasmussen found in the 1920s to have "infectiously bright spirits."

I was thrilled in September 1997 when NATIONAL GEO-GRAPHIC ran a feature story entitled, "A Dream Called Nunavut." The Inuit of Canada had achieved their own territory, Nunavut, meaning "Our Land," carved from existing lands in Canada's Northwest Territories. The transfer would affect 770,000 square miles—one-fifth of all Canada—and take place on April 1, 1999. In all this area live only 26,000 people, more than 22,000 of them Inuit. The photographs by Joanna B. Pinneo show the sparsity and rewards that come from living in the far north. I wondered then as I do now: Could natives in Alaska achieve the same thing, their own sovereign state?

I wanted to talk about this with my friend Michio, but a rogue bear in Kamchatka had killed him the year before. I cried then for his young wife and son and all the people he had touched. That a bear should kill the best wildlife photographer in Alaska seemed to me, as I heard another mourner say, "both a betrayal and a benediction." It reminded me that the far north is a place of discovery, but also of loss.

Not until after he died did I learn that Michio first came to Alaska because of a single NATIONAL GEOGRAPHIC photograph. Taken by George Mobley, it showed the Eskimo village of Shishmaref isolated on Alaska's wind-scoured northwest coast. Then a young man in crowded Japan, Michio stared at the image and wondered: How can so few people live in such a vast, wild area?

He would spend the rest of his short life exploring that juxtaposition, framing the large and small elements of Alaska, allowing each to complement the other. If one person can make a photograph, can one photograph make a person? Change a life? Put a soul on a path previously unimagined? I believe it can.

It happened to me with Antarctica. While researching a high school report in my family den 30 years ago, I found the July 1957 issue of NATIONAL GEOGRAPHIC with an article by Paul A. Siple entitled: "We Are Living at the South Pole." The first double-page photo hit me hard. It showed a solitary airplane on a vast whiteness and barely discernible human tracks leading from it. The caption read: "First Plane Lands at the South Pole. Navy Men Plant the Stars and Stripes on a Frozen Sahara." The issue was 11 years old then, a bit dusty in my hands, but still powerful. I was 17, with two older brothers in Vietnam and a mother who cried herself to sleep as she prayed for their safe return. Military matters didn't charm me then. I was dismayed to think that not even cold Antarctica could rebuff humans and their consummate nationalism.

But then came the Antarctic Treaty System with international bans on nuclear testing and minerals exploration. And the southern whale sanctuary. And most recently, in December of 1997,

ratification by the last treaty nation, Japan, of the protocol for environmental protection. Could we explore Antarctica in ways that explored new realms of the human spirit? Could we plant new ideas instead of old flags? I found myself hoping Antarctica would reconstruct the way we see the Earth and our place in it.

I went south to be a part of this new vision, and promised myself no expectations. I crossed the dreaded Drake Passage, where gale-force storms toss ships about like toys. But the water was calm. "Drake Lake," the captain called it. "You'll get your comeuppance on the return trip." I awoke one morning to see rose quartz alpenglow on peaks of the Antarctic Peninsula. I asked the first officer what mountains they were. "It's the Danco Coast," he said, "but the peaks themselves have no names." Mountains without names? Was there still such a place? My heart soared as I remembered the words of conservationist Aldo Leopold, "Of what avail are forty freedoms without a blank spot on the map?"

The Arctic is an ocean surrounded by land; Antarctica is a continent surrounded by oceans. At the North Pole one stands on sea ice, elevation maybe 10 feet. At the South Pole, in the frozen heart of *Terra Australis Incognita,* one stands atop a great plateau of ice more than 9,000 feet above sea level. The Arctic has as many as a million indigenous peoples; Antarctica has none. It is the highest, driest, windiest, coldest, and loneliest continent on Earth. Though 'lonely' is a matter of opinion. I have yet to meet a penguin that requires or desires my company.

"A Land of Isolation No More," announced an April 1990 NATIONAL GEOGRAPHIC article on Antarctica. One photograph showed tourists bathing in thermal-heated waters at Deception Island. Another showed a Weddell seal lying on a beach in front of an abandoned whaling boat, where thousands of its kin had been slaughtered in the first half of the 1900s. Yet another showed a woman adventurer emerging from a snow-encrusted tent, and behind her a Twin Otter aircraft with icicles on its wings. "To me Antarctica had become a very human place," wrote author Bryan Hodgson, "whose citizens—scientists and seamen and laborers alike—viewed it not as an icy abstraction but as a fascinating world of living creatures and scientific mysteries."

Having been to Antarctica several times, I feel I must accept partial responsibility for the end of its isolation. Yes, there are moments when I wonder what I've done. And there are others when I feel blessed beyond measure, for I have seen heaven on Earth and will now speak on behalf of penguins and seals as best I can.

The February 1998 issue of NATIONAL GEOGRAPHIC faces me as I write this chapter. It offers a cover story on Queen Maud Land, Antarctica. Two back-to-back photographs by Gordon Wiltsie cover a three-page gatefold. One is a vertical sweep of a granite fang that bites ice and sky with a mountaineer suspended from it, midway up an interminable pitch. The other shows a horizontal sweep of that peak with two Nordic skiers on an icy plain

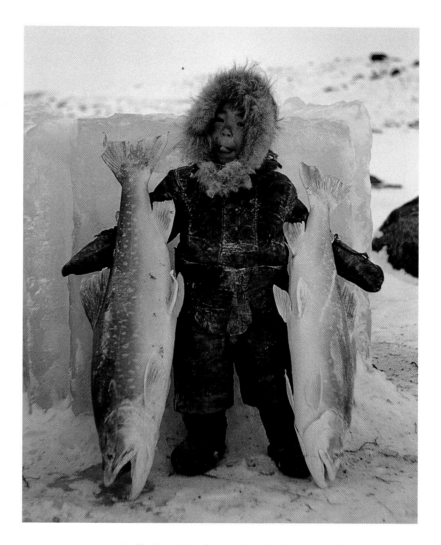

1971, Pelly Bay, Northwest Territories, Canada
Eskimo girl guards two arctic char, frozen within minutes of capture.
Guy Mary-Rousseliere

following pages:
1992, Stonington Island, Antarctica
Polar gales batter the Stars and Stripes at East Base, the United States' first post in Antarctica, built in 1940.
Robb Kendrick

beneath. I stare at the images until I realize I am no longer at my desk, but back in Antarctica, bundled against the cold, fighting sleep to stay awake, to stay alive. Every minute is too precious to close my eyes. As it should be. Then I blink and turn the page.

1942, Nunivak Island, Alaska
Dreams of flight inspire Eskimo youths as they ready a homemade model plane for take-off. Commonplace on the remote island by this date, airplanes linked its 200 inhabitants with the outside world.

Amos Berg

right:

1991, Chukchi Peninsula, Siberia, Russia
Members of the Second Reindeer Brigade from the village of Yanrakynnot, seminomadic Chukchi herders face the frozen tundra from the warmth of their *yaranga,* or tent.

Natalie Fobes

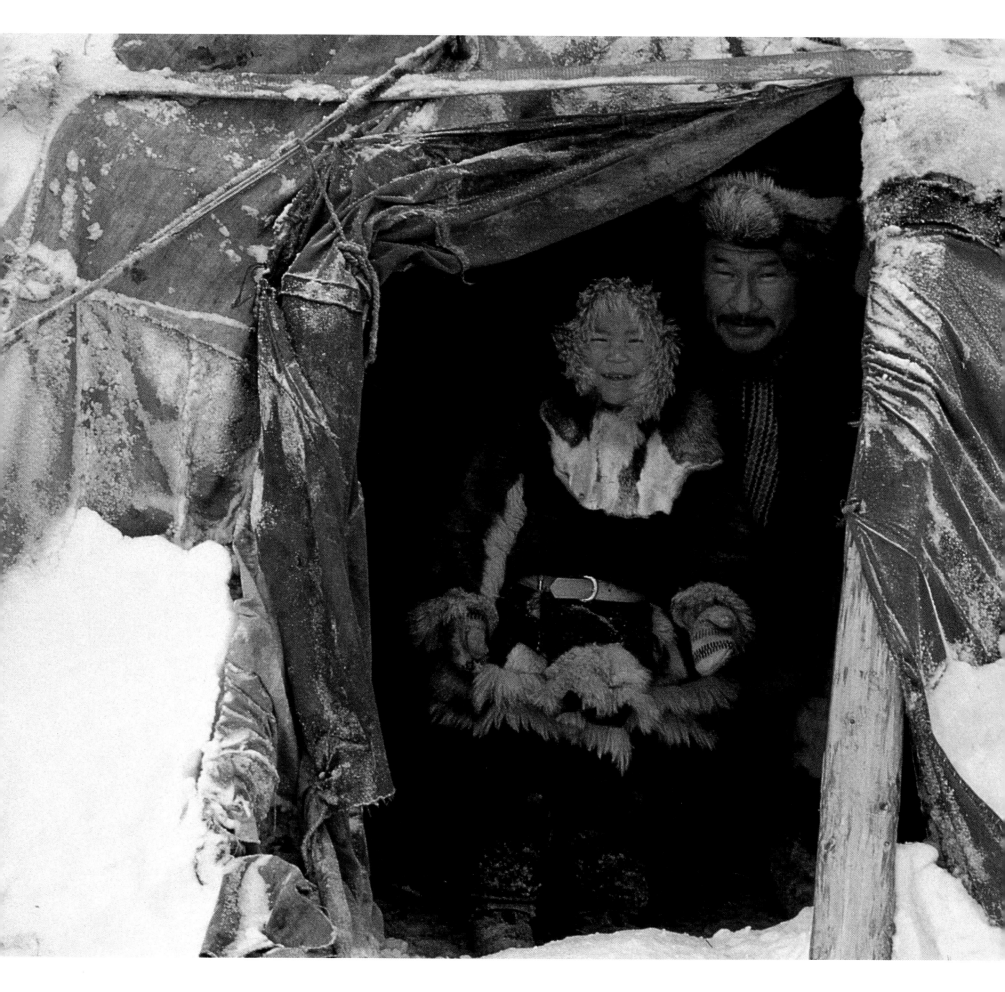

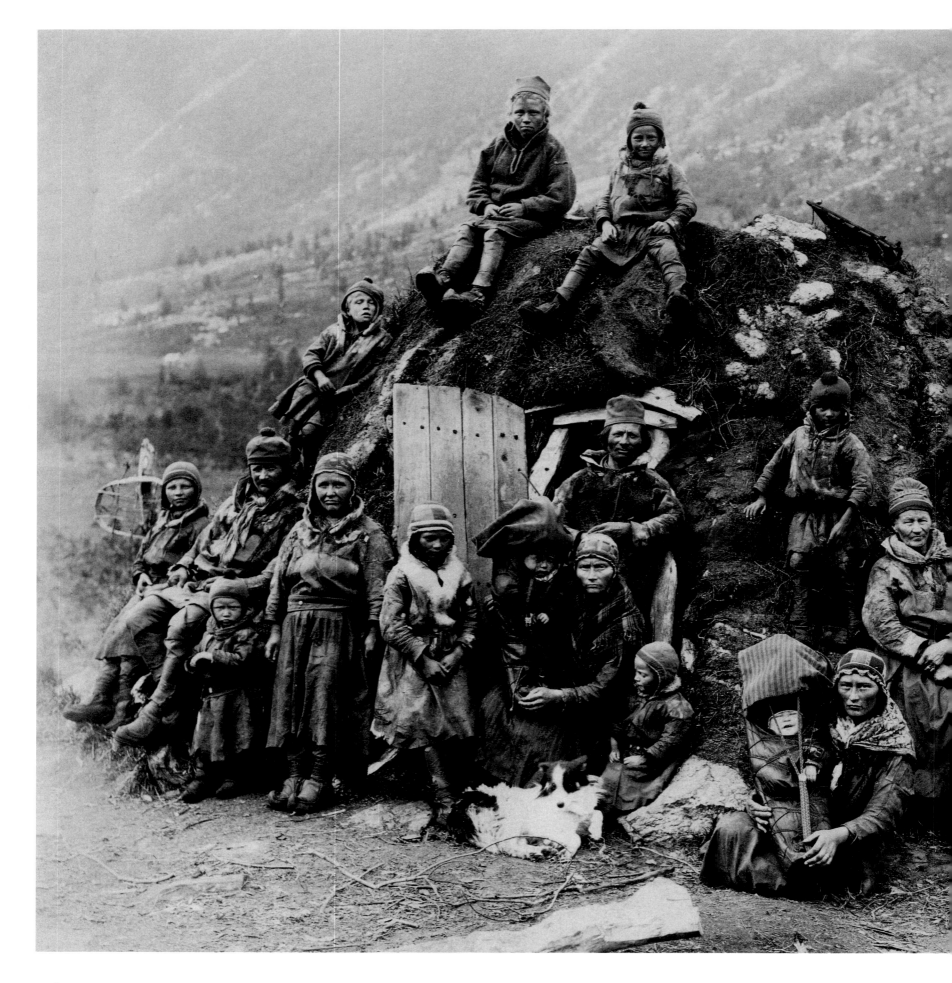

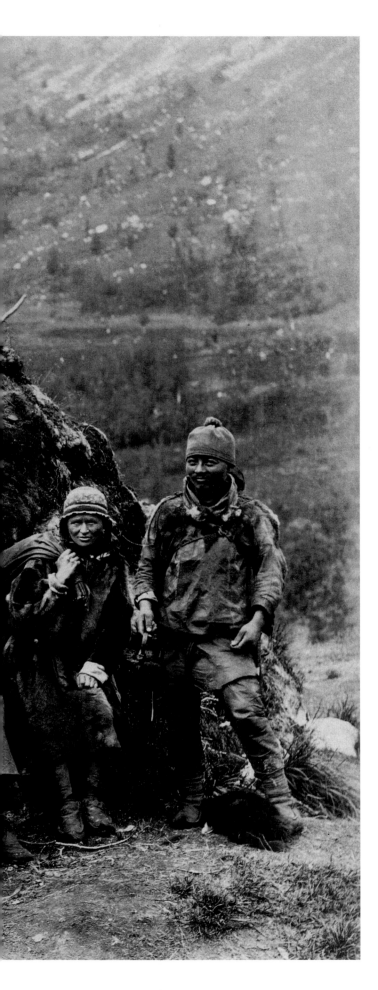

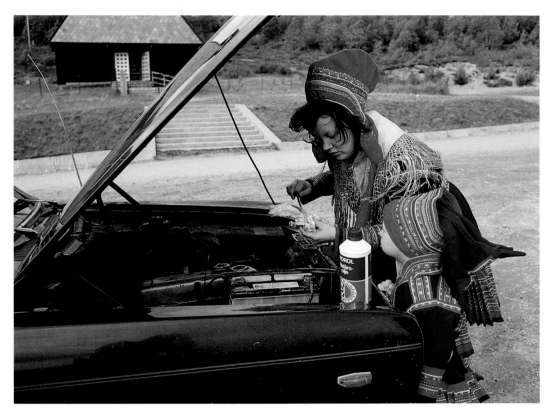

1983, Masi, Norway

Traditionally dressed Saami woman and her child perform a modern ritual: checking the oil. Widely known as Lapps, the Saami people have been reindeer herders for thousands of years; they now live in communities where electronics, concrete sidewalks, and supermarkets prevail.

Sisse Brimberg

left:

Circa 1890, Norway

Outside a dwelling called a *gammer*, Lapps in Norway's Finnmarksvidda region gaze solemnly at the camera. Each dome-shaped, single-family hut was built of peat blocks and covered in sod. Decor varied by hut, as each family cultivated its own medley of grass and flowers on the sod roof.

Charles Harris Phelps

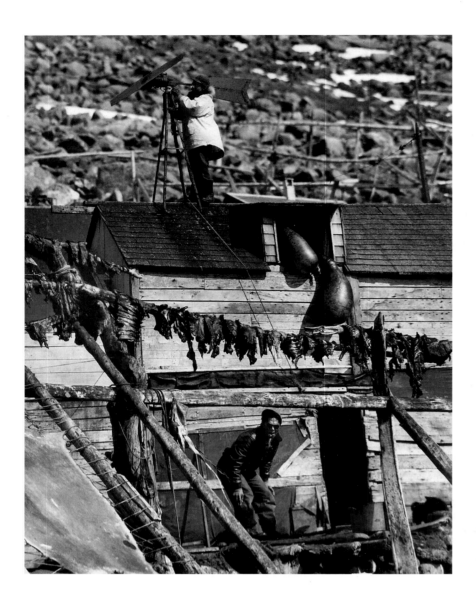

1951, Little Diomede Island, Alaska

Inflated like balloons, walrus stomach linings dry from the window of a hunter's shed for later use as food containers. A line of meat dries below them. The Eskimo on the roof repairs a wind charger that powers the radio.

Audrey and Frank Morgan

right:

1992, Sireniki, Siberia, Russia

Seafaring Yupik Eskimos butcher the day's catch—a 2,000-pound bull walrus—before an admiring beach crowd. Some of the meat went to feed foxes at a state-run fur farm.

Natalie Fobes

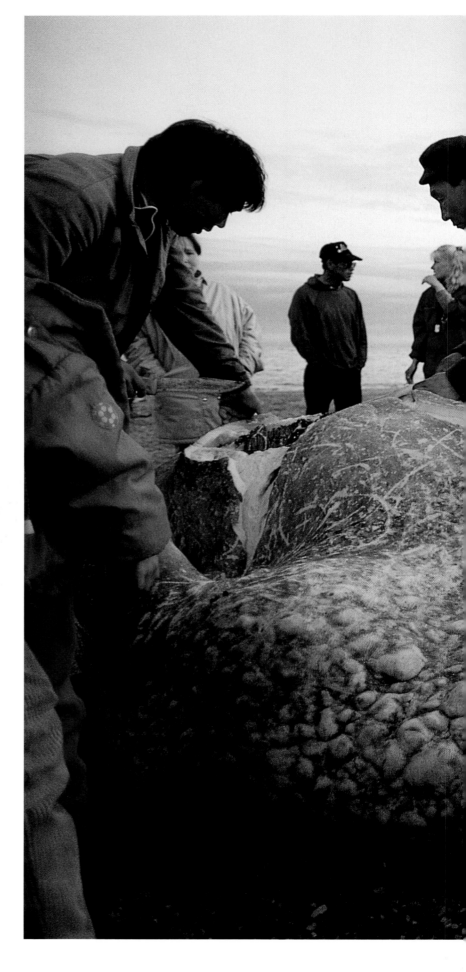

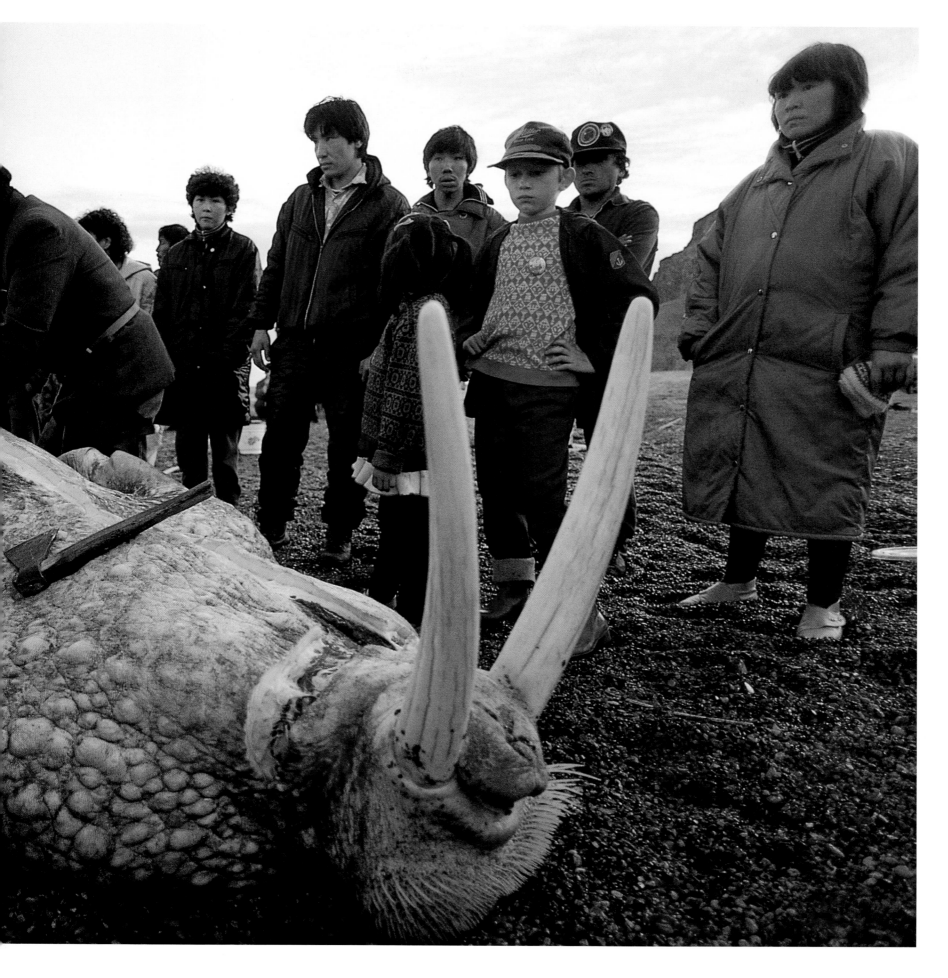

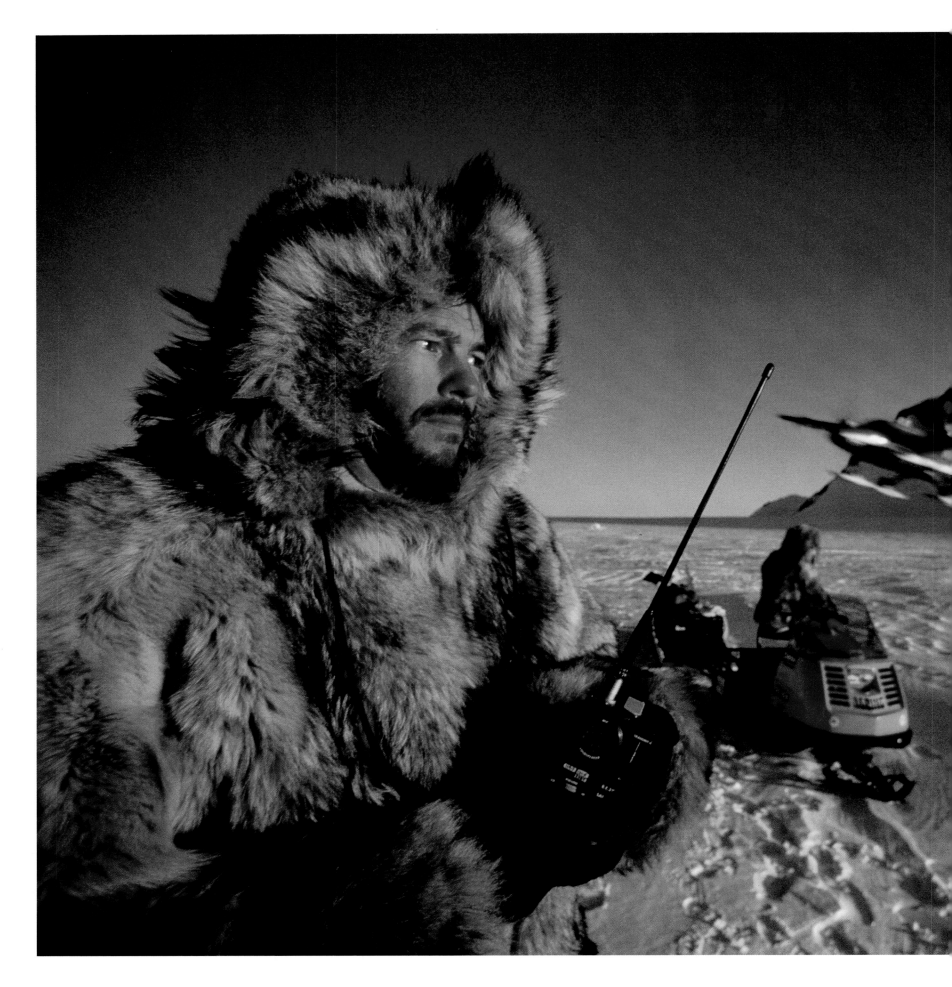

1911, Antarctica

Triumph dimmed by exhaustion, engineer Bernard Day returns to base camp after driving one of the first motor sledges used in Polar exploration, during the South Polar Expedition led by Robert Falcon Scott.

Herbert G. Ponting

left:

1983, Antarctica

Latest technology equips members of the British Transglobe Expedition as they prepare to cross Antarctica by snowmobile, the most challenging stretch of their Pole-to-Pole circumnavigation of the Earth.

Ranulph Fiennes

following pages:

1996, Antarctica

Disks of pancake ice, spun into their shape by violent waves, crowd together as winter deepens, sheathing Antarctic seas.

Maria Stenzel

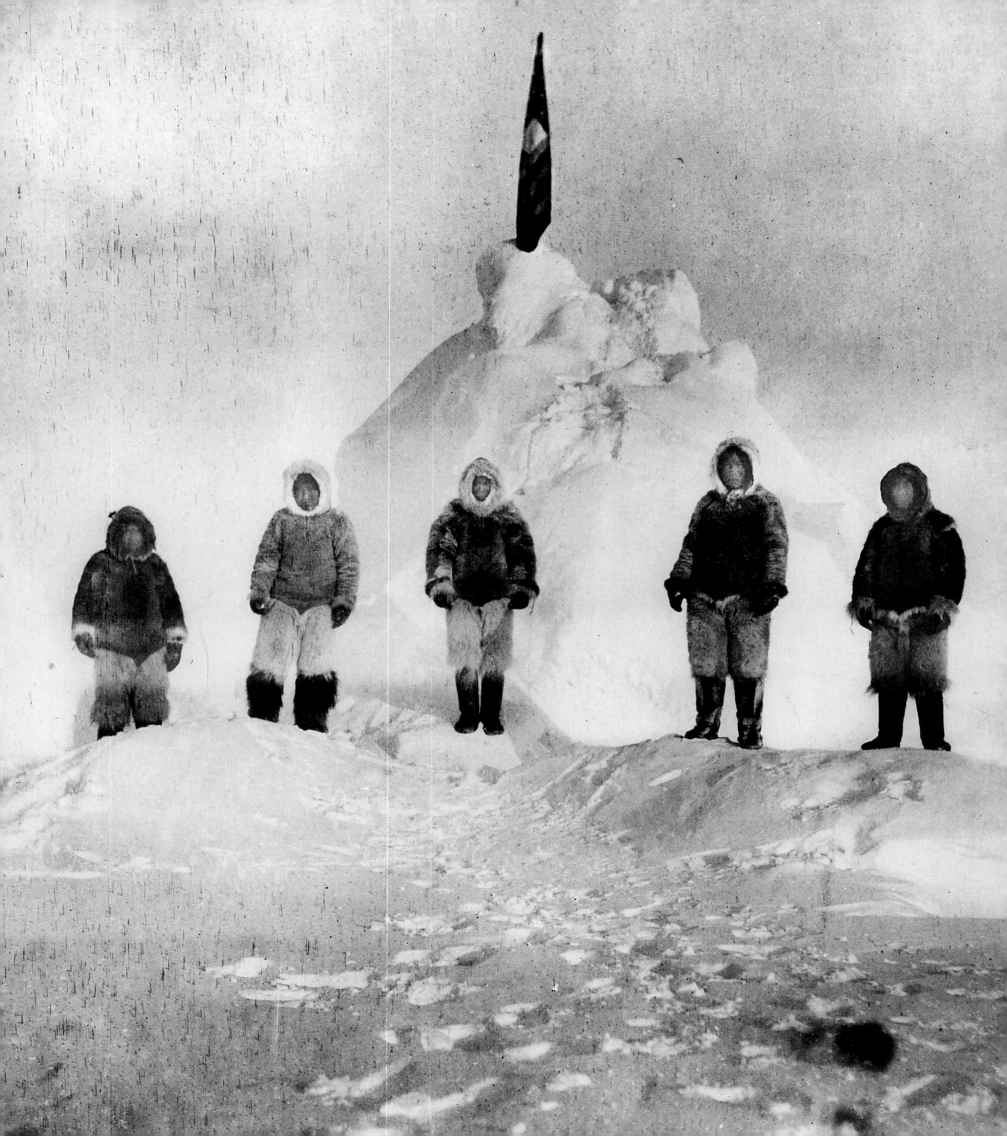

North Pole

Looking back on Robert E. Peary's 1909 discovery of the North Pole, Gilbert Grosvenor wrote in 1920: "Peary's success was made possible by long experience…and by an unusual combination of mental and physical power— a resourcefulness which enabled him to…surmount all obstacles." NATIONAL GEOGRAPHIC has since followed a dozen other expeditions to the Pole, detailing their obstacles and the resourcefulness that conquered them, from Richard E. Byrd's historic flight in 1926, to the under-ice voyage of the U.S. nuclear submarine *Skate* in 1959, to skier Jean-Louis Etienne's solo trek in 1986.

We were not expecting company this far north, latitude 88 degrees, 19 minutes. The only signs of animals we had seen were some fox tracks heading southeast and a lone seal that popped its head out of a lead we were crossing. All of a sudden a polar bear appeared over a pressure ridge. Like us, it seemed tired and disoriented, and it may have been starving.

I had just put on my parka and was getting ready to chop ice for dinner when I saw the bear closing in, only 30 yards away. "Ho!" I yelled, alarming Erling, who was pitching the tent. I went for the .44-magnum handgun that I had worn on my hip when we were farther south. But I had packed it in the sledge, thinking the danger from bear attack was past. Sightings of polar bears this far north are extremely rare. Suddenly I thought: "NATIONAL GEOGRAPHIC! I've got to photograph it!"

The camera wasn't loaded, and I fumbled with the film as Erling, now gripping his own revolver, looked at me in disbelief. "No, no," he shouted, "We have to shoot first!"

March 1991, NATIONAL GEOGRAPHIC
from "The Hard Way to the North Pole"
by Borge Ousland

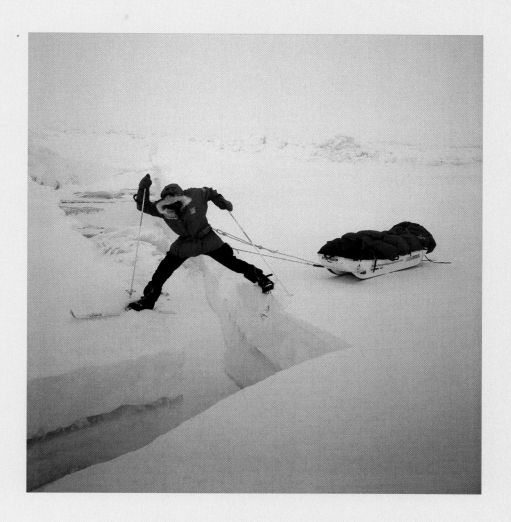

1991, Arctic Ocean

En route to the North Pole, Erling Kagge straddles a crack in a 30-foot-thick ice floe. He and fellow Norwegian Borge Ousland were the first to reach the top of the world without "support"—no motors, no dogs, no resupply.

Borge Ousland

left:

1909, North Pole

"Mine at last!" wrote Robert E. Peary in April 1909, staking his claim as the first to reach the North Pole. The explorer planted Old Glory, then photographed his assistant Matthew A. Henson (center) and the Eskimo crew that helped them attain their goal.

Robert E. Peary, Robert E. Peary Collection

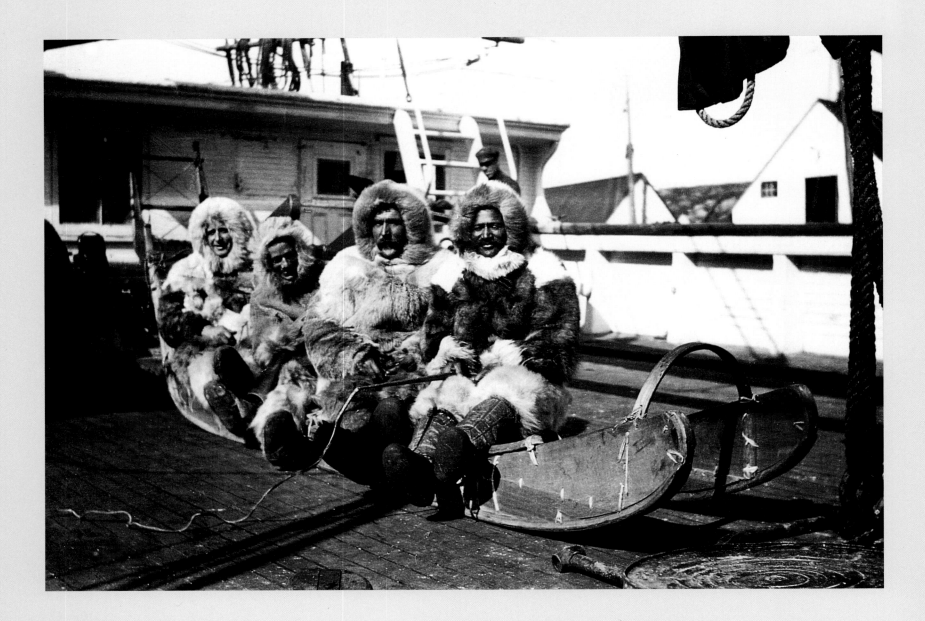

1909, Battle Harbour, Newfoundland
Flush with triumph on their return from the Pole, members
of Peary's team pose for reporters on the deck of the
***Roosevelt* on September 16. Donald B. MacMillan sits at**
far left; Matthew Henson at far right.
E. F. Carson, Robert E. Peary Collection

What young man with red blood wouldn't follow such a man and spend every ounce of his energy to help place him at the goal of his ambition? Not one who signed his contract in the old Grand Union Hotel in New York expected to go to the Pole; not a man went north for that purpose. Each wanted to do his little and that little his best to place Peary there. Such was our admiration for this great explorer. I write this in answer to the oft-repeated statement that Peary's men were very much disappointed in not being permitted to accompany their commander to his last camp. We entered upon this enterprise with no misunderstanding. We knew what we were facing…that he might go beyond the limit of safety, but, if so, we wanted to be with him and were eager for the start.

April 1920, NATIONAL GEOGRAPHIC
from "Peary As A Leader"
by Donald B. MacMillan

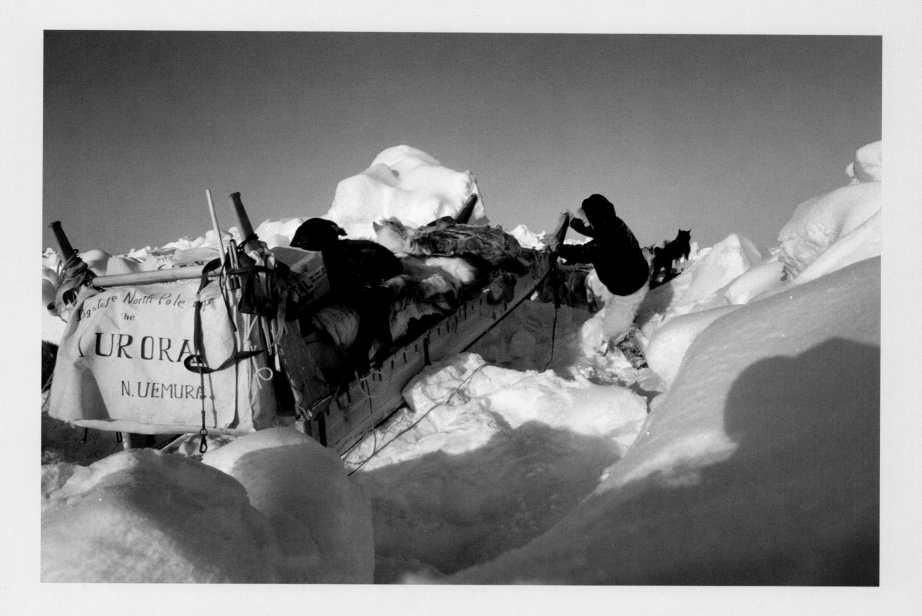

By now I have crossed enough ice hills to disgust me. If I had companions like the Nihon University team from Tokyo that is heading separately for the Pole, I could share the everlasting jobs of hacking through the ice and helping the dogs haul the sled. But how can I complain? I have chosen to go alone of my own free will. That is the challenge, and I must meet it. During times of monotony the dogs are a diversion. No two have the same nature. There is the dog that always pulls to the right side, another that pulls dead center…. There is the dog that cries "Yap!" even when the whip does not touch it, and another that never cries, no matter how much it is whipped. And finally…the dog that casts a sidelong glance at me as if to say, "Can't you see I'm doing my best?"

September 1978, NATIONAL GEOGRAPHIC
from "Solo to the Pole"
by Naomi Uemura

1978, Arctic Ocean
On his way to becoming the first person to reach the Pole alone, Japanese explorer Naomi Uemura muscles his sled through a path he hacked in one of countless ice ridges rising as obstacles across the frozen ocean.
Naomi Uemura

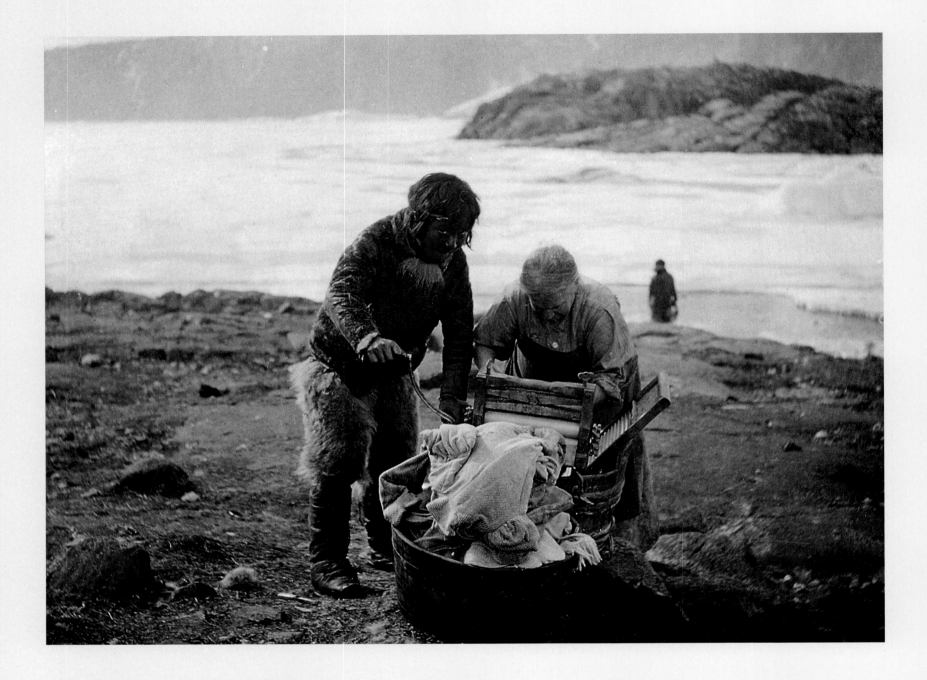

1894, Bowdoin Bay, Greenland
Briefly identified by Peary's crew, a man called Flaherty helps a Mrs. Cross wring out wash near Anniversary Lodge, on Bowdoin Bay. Peary established base here from 1893-95, during his exploration of Greenland. In these years Peary defined the boundaries of northern Greenland, proving it to be an island instead of a continent extending to the Pole.

Robert E. Peary Collection

Believing that even more extended discoveries could be made in northeast Greenland by again crossing its ice-cap, Peary [raised] funds for the purpose by a series of lectures.... With 8 men, 12 sledges, and 92 dogs, he ascended the inland ice March 6, 1894, and...advanced 134 miles.... Storm-bound by violent gales and extreme cold, Peary saw his dogs die and his men frosted.... He sent back the disabled force and marched on with three selected men.... Being finally obliged to return...he reached Bowdoin Bay on April 15 with only 26 living dogs of the original 92.

July 1907, NATIONAL GEOGRAPHIC
from "Peary's Twenty Years Service in the Arctics"
by Major General A. W. Greely

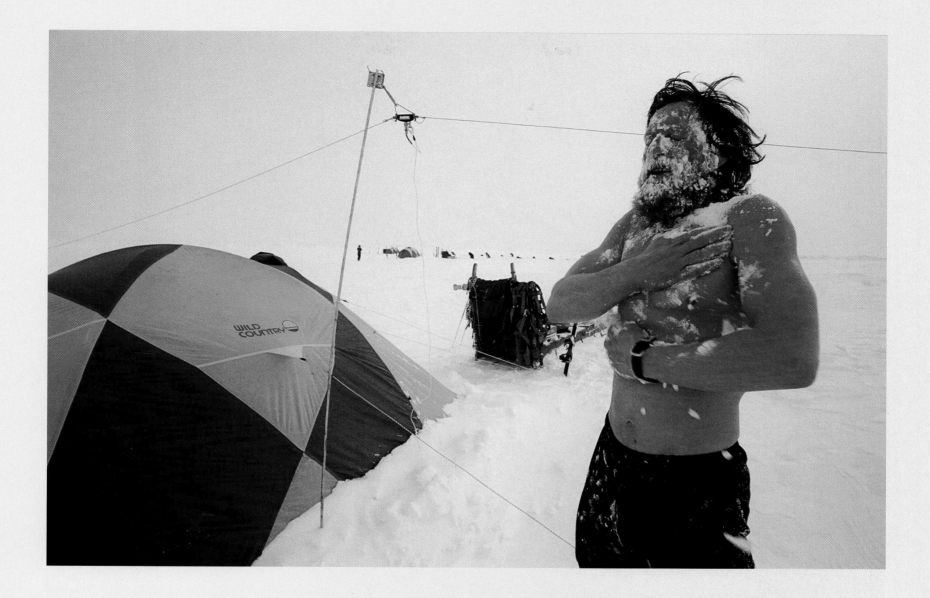

Everything that could go wrong did during the first 24 hours of our journey across the Arctic Ocean.... Ulrik Vedel's dogs plunged through thin ice. Victor Boyarsky fell into the water while trying to save them.... Then Ulrik went in.... It took a day for him to thaw out.... All around us the ice was shifting, tilting, and bobbing. The sea was chaotic, shattered into a mishmash of unstable pans. When we encountered a zone of open water and broken ice hundreds of miles long to the north the next day, we had no choice but to retreat.... No sooner had we worked our way back to our starting point...than we were pinned down by a blizzard for eight days. Most of us came down with bronchial infections. Then Ulrik decided he did not want to continue on the journey. We had to come up with a new plan. There would only be five of us....

January 1996, NATIONAL GEOGRAPHIC
from "Dispatches from the Arctic Ocean"
by Will Steger

1996, Arctic Ocean
Russian Victor Boyarsky performs morning ablutions during the International Arctic Project, which he undertook with America's Will Steger and three other explorers. The 1,200-mile trek took them from Siberia to Ellesmere Island via the North Pole. Linked by Internet to classrooms around the world, the expedition raised student awareness about the Arctic environment.

Gordon Wiltsie

following pages:
1998, Arctic Ocean
Human huskie, Will Steger struggles through frozen wasteland in a bid to journey solo from the North Pole across the icebound Arctic to Canada. Illness and breakdown of communications equipment forced him to abandon the quest after 12 days alone on the ice.

Per Breiehagen

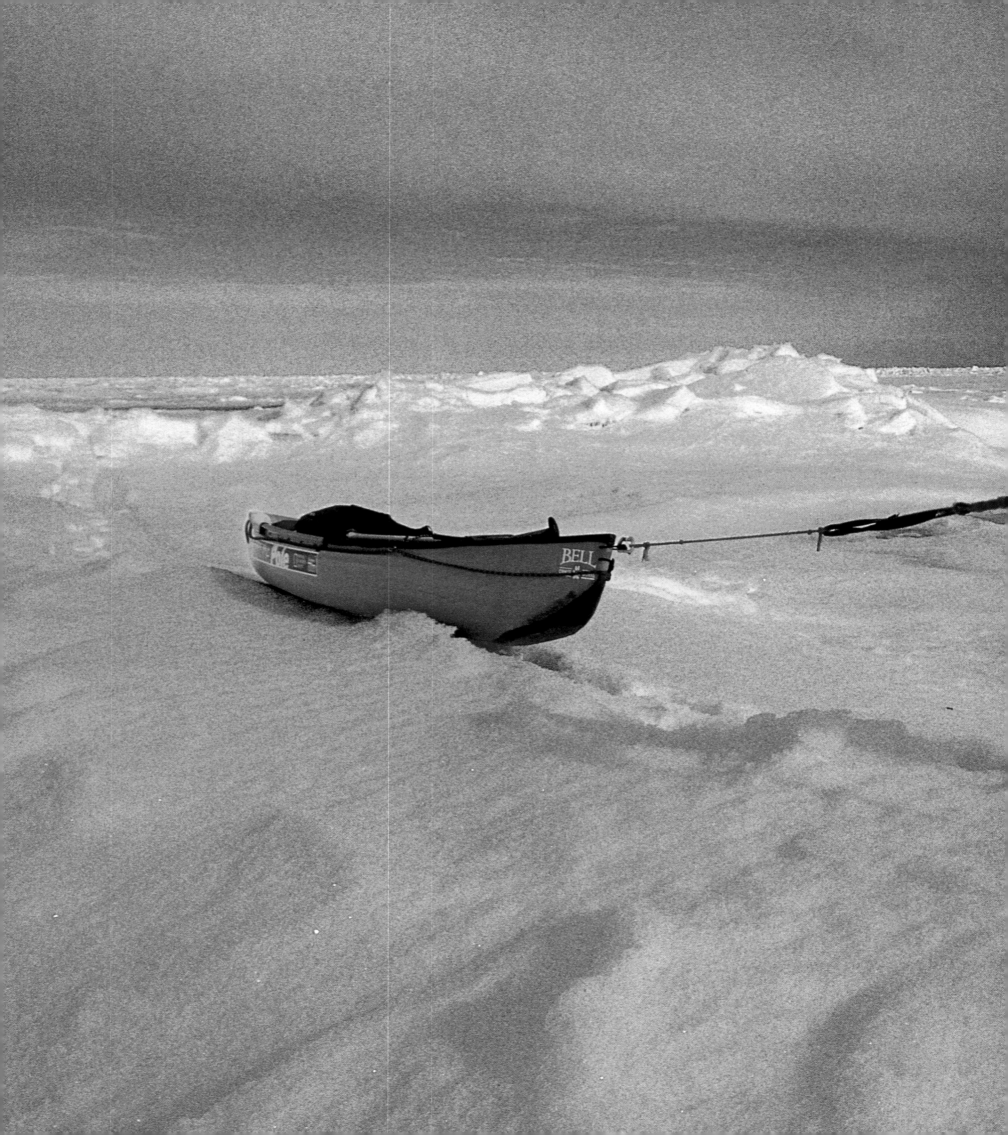

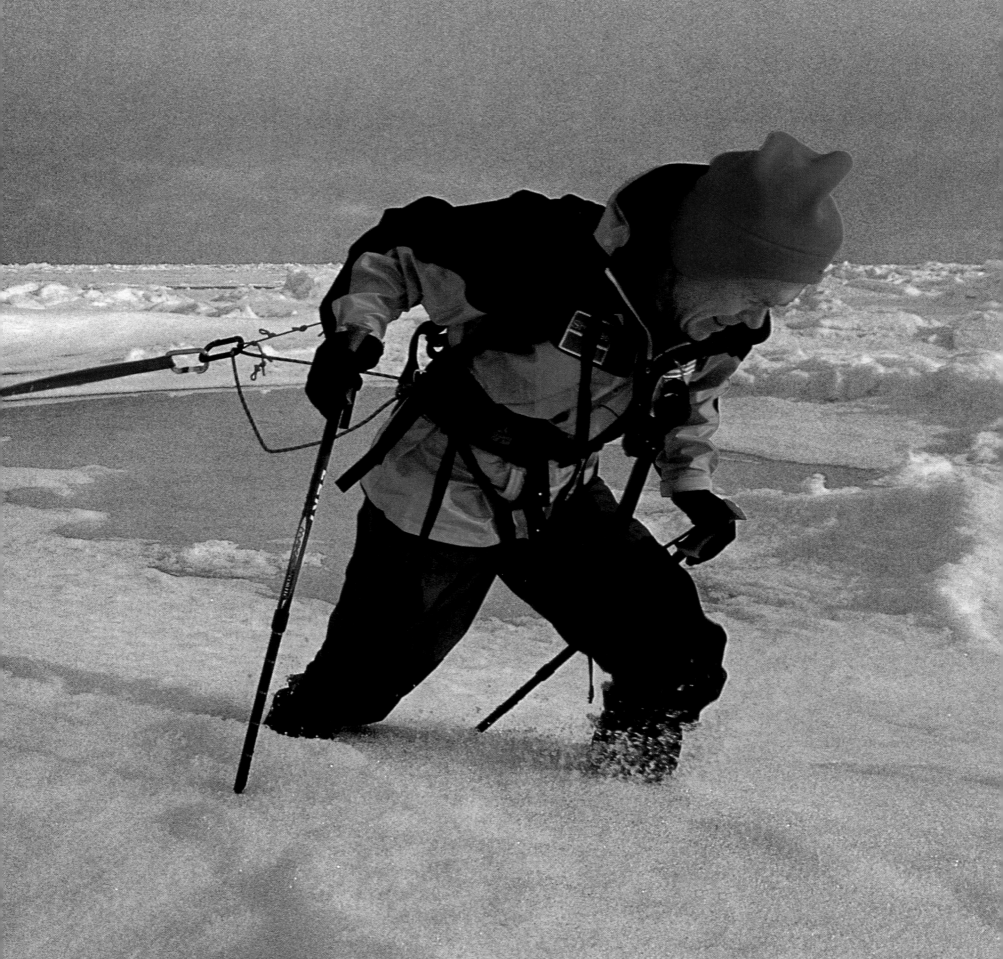

ABOUT THE AUTHORS

Leslie Allen has covered North American subjects for the *New York Times, American Heritage, Nature Conservancy,* and other periodicals and books. As a freelance writer and editor, she covers topics on nature, the environment, and American social history. Previously a senior staff writer for National Geographic books, she authored *Liberty: The Statue and the American Dream.*

Seattle schoolboy **Loren McIntyre** had circumnavigated the Earth before he was old enough to vote, carrying notebook and camera to Japan, China, India, Africa, the Mediterranean, and the Amazon. After retiring from the Navy and State Department, he made films and did two dozen freelance assignments in Latin America for NATIONAL GEOGRAPHIC. Now 81, he travels to the Amazon every year.

Erla Zwingle is a freelance writer who lives most of the year in Venice, Italy. She has written for magazines on subjects that include travel, science, sports, music, and photography. Four years as assistant editor at NATIONAL GEOGRAPHIC, seven years as managing editor of *American Photographer,* and a degree in art history have all nurtured her fascination with photography as business and cultural expression.

Formerly an editor at the National Geographic Society, **Thomas B. Allen** writes frequently for its publications. He has covered China, Mongolia, and Japan, and was a contributor to the Society's 1982 book *Journey Into China.* An authority on military subjects, he is author of National Geographic's *The Blue and the Gray* and "Remember the *Maine?*" for NATIONAL GEOGRAPHIC magazine.

K. M. Kostyal, a longtime contributing writer and editor for National Geographic TRAVELER, has covered Turkey, Israel, and Jordan for that magazine and has written on history, culture, and travel for other publications. Kostyal is author of the National Geographic book *Field of Battle: The Civil War Letters of Major Thomas J. Halsey.*

During 27 years of covering Africa for publications including *Time, Life, Geo,* and *New York Times Sunday Magazine,* **Robert Caputo** has since 1980 written and photographed Africa, South America, and Asia on a regular basis for NATIONAL GEOGRAPHIC magazine. His films include National Geographic's "Zaire River Journey" and TNT's "Glory and Honor."

Roff Martin Smith is a geologist who turned to journalism after moving to Australia in 1982. He worked for the *Sydney Morning Herald* and *Melbourne's Sunday Age* newspapers, then covered the South Pacific for *Time* magazine. In 1996 he began a 10,000-mile bicycle trek around Australia. His journal of that trip was a three-part series in NATIONAL GEOGRAPHIC.

A fascination with Antarctica has led **Kim Heacox** to that continent nine times. In addition, he has covered Africa, the Galápagos, and the Arctic. He is author and photographer of four books on Alaska, and he wrote National Geographic's *Visions of a Wild America.* He is twice winner of the Lowell Thomas Award for excellence in travel journalism.

ACKNOWLEDGMENTS

Our thanks to the Image Collection, whose help was invaluable in shaping this book. We are especially grateful to Director Maura A. Mulvihill and to William C. Bonner, Flora Battle Davis, Susan Riggs, Aleta (Ricky) Sarno, and Paul Petty. We also wish to thank Thomas J. Abercrombie for his guidance.

The following people went out of their way to help us identify the photographs and the NATIONAL GEOGRAPHIC articles that give a full picture of places then and now: Peggy Candore, Holly Legler, and Deshelle Downey. We are also grateful to Martha Christian and Lyn Clement for their final review of the book.

ILLUSTRATIONS CREDITS

Page 4 E. Thomas Gilliard and Henry Kaltenthaler, American Museum-Armand Denis Expedition; 8-9 Floyd H. McCall/ *The Denver Post;* 18 Acme Photo/Acme Newspictures, Inc.; 40 Laurence/Department of the Interior; 46 Burton Holmes from Galloway; 68-69 Alex Webb/Magnum; 119 Jim Nachtwey/Magnum; 158 Pierre Verger © Anders & Company; 202 Elmendorf from Galloway; 218 Burton Holmes from Galloway; 226 George Rodger/Magnum; 270 Wilson & Mackinnon © The Australian; 273 from Norman Ellison by Norman W. Caldwell.

INDEX

Boldface indicates illustrations; *boldface italics* indicates photographs by the person referenced.

Library of Congress CIP Data
Photographs then and now / [prepared by the Book Division].
 p. cm.
 Includes index.
 ISBN 0-7922-7202-1 (reg). — ISBN 0-7922-7203-X (dlx)
 1. Travel photography. 2. Documentary photography. 3. National Geographic Society (U.S.)—Photograph collections.
I. National Geographic Society (U.S.). Book Division.
TR790.P487 1998
779—dc21 98-23421
 CIP

Composition for this book by the National Geographic Society Book Division. Color separations by CMI Color Graphix, Huntingdon Valley, Pa. Printed and bound by R. R. Donnelley & Sons, Willard, Ohio. Dust jacket printed by Miken, Inc., Cheektowaga, New York.

Visit the Society's Web site at www.nationalgeographic.com.